SpringerWienNewYork

Gerda Buxbaum (Ed.)

FASHION IN CONTEXT

SpringerWienNewYork

IMPRINT

Gerda Buxbaum
Modeschule Wien in Schloss Hetzendorf/Fashion Institute Vienna
Magistrat der Stadt Wien | MA 13
Hetzendorfer Straße 79
1120 Vienna, Austria
www.modeschulewien.at

This book is published on the occasion of 10 Years Hetzendorf Gespräche/Hetzendorf Symposia

Concept: Gerda Buxbaum, Doris Rothauer
Editorial: BÜRO FÜR TRANSFER/Doris Rothauer (rd), Barbara Hofleitner (hb) www.buerofuertransfer.at
Photo editor: Barbara Hofleitner
Layout and Cover Design: Julia Oppermann
Translations from German into English: Lovorka Autischer, Jennifer Taylor, Harald Weiler
Language Editing: Peter Blakeney, Christine Schöffler www.whysociety.org
Printing: Holzhausen Druck & Medien GmbH, 1140 Vienna, Austria

Printed on acid-free and chlorine-free bleached paper

SPIN: 12110643

Library of Congress Control Number: 2008943660

With numerous illustrations, mostly in colour

ISBN 978-3-211-78924-7 SpringerWienNewYork

DISCOURSE & EDUCATION

TECHNOLOGY & INNOVATION

VIRTUALITY & SMART CLOTHES

ECOLOGY & SUSTAINABILITY

TEXT & CODE

HETZENDORF SYMPOSIA I – X / INDEX

BIOGRAPHIES

TALKING ABOUT FASHION

…continuously takes place everywhere. It's an omnipresent topic, a topic which *belongs* to everyone and which everyone believes to understand…

However, the expert opinions differ already on the very definition of fashion:
Is fashion a specific or abstract embodiment of a universal design phenomenon or does it, in the common sense of the word, refer solely to Western clothing?
A serious, theoretic discourse on the interdisciplinary phenomenon of fashion is relatively new in the German-speaking area – a virtually infinite sequence of specialised topics and fields, interrelated among each other as well as with every other area of everyday life, constitutes the focal point of research: myth, lifestyle, gender, bodies in consumer culture, cycle of culture (cultural studies), social agendas, uniformity, identity (and its loss), taste and globalisation, consumer research and market analysis, branding, flexible specialisation, reduction and kitsch, divas and jeans washing, decoration, cult accessories, must-haves, body extensions, display of abundance, fashion and colour trend research, fair trade.
We chose *Fashion and …* as a symposium theme already in the year 2000 – the focus was always on the context, relationships and connections, on fine-tuning the terminology and raising the awareness. In addition, the aim was to encourage a discourse between the industry, artists, journalists, designers and fashion institutions. We wanted to discuss, clarify, raise questions, give impulses, bring together experts and establish contacts – in the Hetzendorf Castle. The venue and its acceptance, as is well known, are essential to distinguish fashion cities from the rest…
This book is published on the occasion of the Tenth Hetzendorf Symposium entitled *Fashion and Text*, where all ten Hetzendorf Symposia are reflected upon in a new light through a selection of lectures, designer or company profiles as well as biographies of all the speakers.

As the principal of the Fashion Institute Vienna and the head of the Baccalaureate Programme in Fashion, I was very proud to be able to offer our students these additional international and multifaceted perspectives and networks in the form of the Hetzendorf Symposia.
Therefore the first thank you goes to the school's benefactor, the Municipal Department 13 of the City of Vienna under the guidance of Anton Krotky, for approving and funding both the Hetzendorf Symposia and the book in your hands, as well as to the Association of Patrons of the Fashion Institute Vienna for mental and financial support.

A special thank you goes to all the speakers who came to the Fashion Institute and delivered their presentations, discussed and explained with an immense commitment and ardour, and who in part did so without demanding a fee.
I would also like to thank my amazing team who were responsible for bringing this publication to life: Doris Rothauer and Barbara Hofleitner for editorial work, Julia Oppermann for a meticulous layout and Lovorka Autischer for an equally meticulous and competent translation.
All of them merit a great acknowledgement for the dedication and passion they invested in this book.
Thank you to Springer Publishers, especially to Angela Fössl, for her trust and her spontaneous assent to our topic fashion in context. To be continued?

Gerda Buxbaum

TRADITION & CHANGE

OLDIES IN POWER PLAY

Fashion gives us a sense of the present like nothing else. When a certain fashion is not worn any more, if it is not trendy any more – it is out. The former connection with the present now lies in the past, and as a result the consumers do not feel fashionable but old-fashioned, they feel *bygone*. Still, an old fashion keeps undermining the connection with the present whereas a new fashion constantly keeps establishing it. Therefore fashion seems to secure an eternal presence in the present, an observatory of the current times. However the creative process of fashion lies in the past, so *being worn* is always the determining factor in fashion.

"It (the tradition) should be protected from the fury of vanishing just as it should be stripped off of its no less mythical authority."

A central issue in the always mistakenly separated phenomena of fashion and traditional costume could not have been expressed more clearly than done by Theodor Adorno: to which extent and in which form should tradition be cherished, and to which extent can it or should it be broken? The cultural historian Wolfgang Kos provides a vivid image from the realm of pop music, which – just like clothing – brings the new into the everyday and seems to be in an infinite loop: "In pop music, for instance, records are constantly released, which could become pop songs, however they only become pop songs when they become popular. Before that, they are like an unexposed film. They are exposed only through response, through repetition – like on the radio, for instance. Without power play, without repetition and recognition value, not a single pop song can be created. In a certain sense, the song, when it enters the market, is not finished. It must be carried on, thought about; it must be lived and used." Persistence and change in the fashion system, both of them being system immanent and central poles of the fashion phenomenon, are equally presented in this chapter.

Gerda Buxbaum

literature
• Adorno, Theodor W., *Kulturkritik und Gesellschaft I*, Gesammelte Schriften vol 10/1+2 (Darmstadt: 1998) 317.

LECTURES

elke gaugele /
fashioning life

The 20th century began with a facelift. At first glance, this rhytidectomy carried out in 1901 seems to be quite paradox. Eugen Holländer, the surgeon, was also an art historian, and his procedure was allegedly an emancipatory act in the sense that not only it led back to the initiative of the patient, a Polish aristocrat, but also to her own pattern designs. Even the facelift of an actress, which was conducted by the surgeon Erich Lexer in 1906, was supposedly based on the patient's self-experiments in which she tightened her skin by applying adhesive tapes on the forehead and elastic bandages on the scalp.[1] In order to appear as dynamic subjects of the modern era, some women designed examples of a young-lively visage and, at the beginning of the 20th century, substituted the textile bandaging techniques with surgery, adopting it as a new body technology.

TOP LEFT: FACIAL TREATMENT IN CHARLES H WILLI'S LONDON SURGERY IN 1932, WHO WORKED WITH AN ELECTRIC DEVICE INSTEAD OF APPLYING THE CLASSICAL METHOD OF KNIFE AND SCALPEL

This latest form of subject constitution established a new relationship between a surgeon and a patient, but also between medicine and art, body and image, fashion and technology. A central element of the modern subject constitution is, according to my thesis, the biopolitical dynamics of *fashioning of life* – subjecting your life to fashion.[2] The human body becomes in its organic materiality the object of fashionable imprinting.[3]

In the following paragraphs, this thesis of *Life Fashioning* is illustrated through movements between bodies and fashion in the discourses of what is referred to as dress reform movement of the emerging 20th century. Furthermore, it reveals the intensification of these developments at the beginning of the 21st century.

LEFT: DIGITAL TATTOO PHILIPPS ELECTRONICS. THE BODY AS TOUCH-SCREEN: CURRENT BIOTECHNOLOGICAL DEPTH DIMENSIONS OF THE ORGANIC ORNAMENT

Fashion is put into the perspective of Michel Foucault's concept of governmentality – technology of the modern era used to construct identities or subjects. According to this theory, modern mechanisms of power do not only affect subjects and their bodies externally.
Subjects are constructed more by what is referred to as *technologies of the self* and position themselves through an individual body praxis of fashion in relation to the modern era, to time, to life and also to technological progress. Modern, according to the Grimm German Dictionary from the middle of the 19th century, means both being "new ... according to the current fashion, way, mode, manner, kind, art or habit" as well as working "with means of the modern technology."[4] Already in the definition of the term modern, fashion is combined with temporality and new technologies.

1 Cf. Sander L Gilman, 'Die erstaunliche Geschichte der Schönheitschirurgie' in Angelika Taschen (ed), *Schönheitschirurgie* (Cologne: 2005) 85. The first documented European female cosmetic surgeon was the Parisian dermatologist Suzanne Noel (1878-1954). Noel worked in the field of reconstructive surgery during the First World War and published 'La chirurgie esthétique et son role social' in 1926. At the same time, there were several female surgeons working in the USA, such as Anna D. Adams in New York 1915.

2 Referring to the American culture expert Stefan Helmreich, who in his study of artificial life uses the term 'fashioning of life' to describe complex interactions in the laboratory. Stefan Helmreich, *Silicon Second Nature: Culturing Artificial Life in a Digital World* (2nd edn, Berkeley, CA: University of California Press, 2000)

3 Cf. Winfried Menninghaus, *Das Versprechen der Schönheit* (Frankfurt am Main: 2007) 265

4 Jacob Grimm and Wilhelm Grimm, *Deutsches Wörterbuch*, 16 vols in 32 fascicles (Leipzig: S. Hirzel 1854-1960); vol 12, 2437

While in the 18th century there was an unrivalled range of philosophical treatises and relevant tractates on beauty and its importance in the experience of the arts and nature was still being written, their production decreases in the 19th century. Parallel, the last two decades of the 19th century were characterised by an increased publication of practical beauty manuals outlining the goal – especially for women – of enhancing physical attraction through healthy food, physical activity, cosmetics and clothes.[5] The theoretical discourse on aesthetics reflected the increasing importance of fashion for capitalism, for everyday culture and for personal self-building.[6] Even Charles Baudelaire described fashion in the middle of the 19th century as a dynamic that helps individuals reach their beauty ideals. In 1863 he writes that fashion "has to be regarded as a sign of striving towards the ideal ... as a more or less successful renewed attempt at beauty ..."[7] According to Baudelaire, fashion is modernity, an aspect of art which is "evanescent, ephemeral and random, and whose other half is eternal and inconvertible."[8]

In the 20th century the field of industrial mass production of fashion is expanding. Ironically, clothes are declared to be a second skin and are understood as the performative appearance of the *physical ego,* or its expression of individuality and uniqueness. Analogous to the idea that clothes represent the second skin of human beings, pattern designs and tailoring become a bio-material construction process, which now, as techno-organic production, refers to skin, clothes and flesh in equal fashion. From historical perspective, various surgical processes were introduced between the 1840s and the 1900s, which are still used today in aesthetic modifications of the body.

NEXT PAGE TOP LEFT: ANN SOFIE BACK, 2008

"Under the clothes there is always flesh", stated the physician Heinrich Pudor in 1903, one of the founders of the so-called reform movement, which fought for the abolishment of the corset, among other things.[9] Only the naked man, wrote Pudor, is the real man and he should be presented in a most natural way. This idea, supported by the life reformers, sounded the bell for the biggest fashion headline of the 20th century: revealing the body.[10]

NEXT PAGE TOP RIGHT: NAKED PEOPLE: A TRIUMPHANT SHOUT OF THE FUTURE, LONDON, 1893

The naked truth should aesthetically emerge in the form of a young, firm and muscular, yet thin and animated body. The sculpture of Apollo Belvedere used to be considered an ideal of the male body, whose proportions are still used as standard proportions for the male body today. However, in

5 Winfried Menninghaus, *Das Versprechen der Schönheit* (Frankfurt am Main: 2007) 260

6 ibid., 261

7 Charles Baudelaire, 'Der Maler des Modernen Lebens' in Friedhelm Kemp and Claude Pichois (eds), *Charles Baudelaire – Sämtliche Werke und Briefe: Aufsätze zur Literatur und Kunst 1857-1860*, Vol 5 (Munich: Carl Hanser, 1989) 213-258; 249

8 ibid., 225

9 Heinrich Pudor, *Die Frauenreformkleidung. Ein Beitrag zur Philosophie, Hygiene und Aesthetik des Kleides* (Leipzig: 1903). I would explicitly like to draw attention to the historical and political context of the authors quoted here. Activists of the life and dress reform movement, such as Heinrich Pudor or Paul Schulze-Naumburg, developed into political actors of anti-Semitism and to publicists of the ideologies of the National Socialism. Since 1912 Heinrich Pudor published only anti-Semitic writings, which were mainly released by his own publishing house. Paul Schulze-Naumburg published, among other works, also *Art and Race* (Munich: 1935). Henry van de Velde was a 'Conseiller esthétique de la reconstruction' during the German occupation of Belgium and was regarded as collaborator and treated with hostility after the Second World War. In contrast, the seizure of power by the National Socialists and the occupation of Europe compelled Walter Benjamin in September 1933 to go into exile in Paris and to commit suicide in September 1940.

10 Winfried Menninghaus, *Das Versprechen der Schönheit* (Frankfurt am Main: 2007) 265

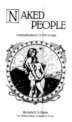

11 Kerstin Kraft, 'kleider.schnitte' in Gabriele Mentges and Heide Nixdorff (eds), *zeit.schnitte. Kulturelle Konstruktionen von Kleidung und Mode – Textil-Körper-Mode. Dortmunder Reihe zu kulturanthropologischen Studien des Textilen* (Berlin: 2001) 68; Adolf Zeising, *Neue Lehre von den Proportionen des menschlichen Körpers* (Leipzig: 1854)

12 Cf. Hannah Landecker, *Culturing Life. How Cells Became Technologies* (Cambridge MA/London: Harvard University Press, 2007)

13 Michael Weisser, *Im Stil der Jugend. Die Münchner Illustrierte Wochenschrift für Kunst und Leben und ihr Einfluss auf die Stilkunst der Jahrhundertwende.* Vol 1 from the series *Ästhetik der Alltagswelt-Dokumente zur Geschichte des Design* (Frankfurt am Main: 1979) 22

14 Henry van de Velde, 'Was ich will' (1901) in Jürg Mathes (ed), *Theorie des literarischen Jugendstils* (Stuttgart: 1984) 106–110

15 Cordula Seger, 'Weiblichkeit und Ornament um 1900 – Die Ambivalenz des Organischen' in Annette Geiger, Stefanie Hennecke and Christin Kempf (eds), *Spielarten des Organischen in Architektur, Design und Kunst* (Berlin: 2005) 69–80; 69

contrast to pre-modern times, the bodily symmetry was regarded as the law of nature. In 1854, Adolf Zeising argued in his New Theory of the Proportions of the Human Body that the proportion 3:5, the golden ratio, was a basic morphological law of nature. As a result, the golden ratio proportions were taken as a basis for modern cosmetic surgery.[11] Hence, central to the civil project of *standard body* was not only the naturalisation of mathematical and geometrical rules but also the practical linking of the ideal with the norm through technologies of plastic self-regulation. The role model for the female body around 1900 was the statue of the Venus de Milo. "She", wrote Pudor, "as is generally known, never wore a corset, her waist circumference would amount to 62,5 cm in life-size, she has muscles and she regularly took physical exercise." The ideal of the naked, revealed body fosters the plea to regard your own body as a sculpture and to shape it as such.

The establishment of a sculpture-like body as the fashion of modernism goes hand-in-hand with the ideas of the modern natural sciences, where life is regarded as technology and fosters the discovery of technologies of the living matter. In her work Culturing Life, Hannah Landecker used the example of Tissue Engineering to demonstrate the ideas and practices of biological sculpturing and temporality and to point out how living matter has been modified in the 20th century to correspond with human concepts and how it lives in time and space: "The reshaping of cellular living matter has been oriented step-by-step to a manipulation of how cells live in time."[12]

OPPOSITE PAGE TOP: VICTIMLESS LEATHER - A PROTOTYPE OF STITCH-LESS JACKET GROWN IN A TECHNOSCIENTIFIC "BODY". TISSUE CULTURE&ART PROJECT BY ORON CATTS AND IONAT ZURR, 2004

While the organic model of the 19th century design was still focused on the plant organism with its morphological features and its developing form, Henry van de Velde's search for the new ornament at the beginning of the 20th century was already about the idea of mass production of ornaments. The aim to be united with life and with all living creatures, the bio-logics of the Art Nouveau, is already incorporated in the idea of the organic ornaments of technology and organism.[13] "Nothing is justified if it is not an organ or a connector of various organs," wrote van de Velde in 1901, "an ornament which is not organically annexed should not be shown."[14] The discourses of reform movement spring from a male-oriented position of the artist – the discoverer and creator, who allows the female body to emerge as a figuration of the organic and a part of the living nature as *"a living, moving creature".*[15]

OPPOSITE PAGE BOTTOM: REFORM DRESS BY EDUARD JOSEF WIMMER-WISGRILL OF THE WIENER WERKSTÄTTE, 1920

A central criterion of the reform dress and, as a result, of modern fashion, was the fact that it contained elastic textile materials in order to emphasise the bodily movement. Organic-springing movement was regarded as beautiful while the mechanical, automatic movement was seen as dreadful. The beautiful body of the modernity should be presented in all its strength and its firmly formed muscles. Pudor realised already in 1903 that sports clothes were the ideal clothes for the modern human.

Sports, hygiene, health and birth optimalisation were in the centre of regulative control and the measures employed to optimise the entire living population. Policies for an improved capacity to bear children were central for the supporters of the movement fighting for abolishment of the corset. This was an argument all reformers around 1900 agreed upon, since physicians diagnosed the corset not only as a cause of damage to all *inner vital parts,* such as heart, lungs or stomach, but also as the cause of miscarriages.

For the first time in history, biology – with its constructs of nature and life – was also reflected in politics, and that shift pushed production and reproduction of life and naturalness to the centre of attention, which was described by Michel Foucault as biopolitics and biopower. "It was nothing less than the entrance of life into history," wrote Foucault, "the entrance of phenomena characteristic of the human race into the order of knowledge and power, into the field of the political technologies."[16]

On the level of the body image, a perception is emerging, hand-in-hand with the development of photography and film, which focuses on a "new understanding of the body principle" and is closely connected to a process of visual discipline that attempts to "use new images to teach clear perception of the real body form."[17] This should, as Schulze-Naumburg puts it, culminate in the "sculptural body ideal", which should be regarded as a "comprehensive perception of all anatomical, biological and motoric moments of the body".

On the one hand, this referred to the perception of one's own body within a regime of comparison and observation. In The Own Dress of the Woman dating from 1903, Anna Muthesius wrote that women should be very aware of "their physical advantages and, even more importantly, of their physical disadvantages."[18] On the other hand, it referred to a meticulous perception and qualification of the apparently objective body images and different body parts generated by the media. In the observational grid of this comparing, these penetrating looks, the materiality of the female body does not only appear as soft and shapeable, but also as a part of a subject constitution, which requires a regulative examination. Foucault described this disciplinary process in *Sexuality and Truth* as a normalising as well as pathologising movement, in which the power is developed in particular through examining the differences, through their perversion and also through the permanent

16 Michel Foucault, *Sexualität und Wahrheit* (Frankfurt am Main: 1983) 169

17 Paul Schulze-Naumburg, *Die Kultur des weiblichen Körpers als Grundlage der Frauenkleidung* (Jena: 1910) 6; 10

18 Anna Muthesius, *Das Eigenkleid der Frau* (Krefeld: 1903)

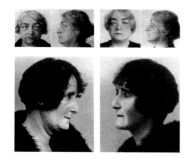

search for new methods of correcting these anomalies.

Facelifts are a part of this process and, at the same time, emancipatory subject creations of the 20th century, since youth was, from the beginning on, a part of the aesthetics of modern beauty, part of its body fashions and its sexes. Additionally, this *youthful-dynamic* advanced to become a projection surface of the modern times – which was to be redefined – and it was compressed to become a discourse, where the critique of civilisation, culture and politics was ascribed to the old and the rigid. Facelifts are subject to the same understanding of progress in which improvement is reflected in rejuvenation and expression of life.

TOP LEFT: FACELIFT OF SUZANNE NOEL'S PATIENT, FROM A NOEL, LA CHIRURGIE ESTHÉTIQUE ET SON ROLE SOCIAL (PARIS: MASSON ET CIE, 1926)

LEFT: CHARLES H WILLI, FACIAL REJUVENATION. HOW TO IDEALISE THE FEATURES AND THE SKIN OF THE FACE BY THE LATEST SCIENTIFIC METHODS (LONDON: CECIL PALMER, 1926)

The medium of photography, in the sense of chronophotography, documents an apparently objective development, which corrects these *anomalies* of the modern era and creates a modern subject in a positively valued techno-organic development, by comparing pictures before and after.

In this sense, the centrality of the biological aspect, as an expression of life and of morphological ability to be transformed, is produced and communicated also through modern visual media such as magazines, photography or film.

In his famous essay The Work of Art in the Age of Mechanical Reproduction, Walter Benjamin does not only describe how methods of mechanical reproduction used by photography and film changed the sensory perception at the beginning of the 20th century, but he also identifies, as a result, the desire to catch objects in reproduction up-close and personal.[19] The reflection has become portable and detachable from the performer.[20] Benjamin even goes so far in this context to state that the processes of film production equal those of surgery. While the painters, just like a magician, always maintain the natural distance from the treated object, the film, according to Benjamin, proceeds in the opposite manner. The camera, just like a surgeon, operatively penetrates the human tissue and constructs, by means of this technological penetration, representative models of an apparatus-free reality.

"The painter observes in his work a natural distance from the object, the cameraman, in contrast, penetrates deeply into the texture of the object. The images both of them walk away with are immensely different. The painter's image is a total, the cameraman's image is manifoldly fragmented, and its parts are assembled according to a new principle. The

19 Walter Benjamin, 'Das Kunstwerk im Zeitalter seiner technischen Reproduzierbarkeit' in Rolf Tiedemann and Hermann Schweppenhäuser (eds), *Walter Benjamin – Gesammelte Schriften I.2* (Frankfurt am Main: 1991) 431-508; 479

20 ibid., 491

21 ibid., 495

filmic representation is for today's people incomparably more meaningful, because it guarantees an apparatus-free aspect of reality, which every work of art is entitled to demand, particularly because of its intensive penetration with the apparatus."[21]

Art does not only lose its aura in the modern era, it also loses its hegemonic position in the definition of beauty to a pragmatically understood, technologically (re)producible beauty of the modern media and entertainment culture. Art Nouveau propagated, as the lastest art form, the physical representation of the *beautiful body* on its own, before it was transferred to the modern mass media and its stars in films and revues.[22] In particular, film takes over the production of beauty ideals, and film stars become role models of a modern beauty concept whose plastic bodies, with its cosmetic, pharmaceutic, medicinal and technical aids, constitute a part of a modern beauty industry that turns into fashion. The montage is another method with which film establishes a new dimension of aliveness. Something new emerges, writes Wolfgang Bock, "this is how even in the film an autonomous life of the second grade emerges, which obeys not only organic but also aesthetic rules."[23] The Hollywood image production of the 1920s was primarily a production of faces, which was not only closely connected to close-ups, but also to the growing cosmetics corporations.[24] In this way, for example, Helena Rubinstein created the vamp image for Theada Bara, who was systematically constructed by the Fox Studios as a femme fatal and America's first sex bomb, while her cosmetic products targeted the *new*, modern, businesswoman. Still, Rubinstein did not regard everyday beauty primarily as a means of erotic seduction, but rather as a "necessary equipment in battle for employment and new social duties."[25]

Now, when the initially mentioned art historian takes a knife and commences the facelift as a technology of modern subject creations, this act appears, in retrospect, to be constitutionally logical for the processes of the modern era. They are not only a part of a media-technological shift of body images in Benjamin's sense that penetrate deep into the texture of reality. Beauty has abandoned the sphere of art and has established itself in everyday culture as a disciplinary pragmatism of life in a cross-over of fashion, media, economy and the modern life sciences – as a *Fashioning of Life*.

22 Umberto Eco, *Die Geschichte der Schönheit* (Munich: 2007) 19

23 Wolfgang Bock, 'Das Modell zwischen Denkbild und Werkzeug' inWolfgang Bock and Siegfried Gronert (eds), *Das Modell als Denkbild. Jahrbuch der Fakultät Gestaltung Bauhaus-Universität Weimar 4*, July 2005 (Weimar: 2005) 12-23; 19

24 Thomas Koppenhagen, 'Schönheitsmasken' in Helga Gläser, Bernhard Groß and Hermann Kappelhoff *Blick Macht Gesicht* (Berlin: 2001) 309-338; 309

25 Helena Rubinstein quoted in Michaela Wunderle, *Apropos Helena Rubinstein* (Frankfurt am Main: 1995) 36

elisabeth von samsonow /
myth and fashion

I.

The argument ventured here is that there is no such thing as fashion in and of itself, in other words, that there is no way to define what fashion actually is. Fashion is a fluid thing, similar to the modernism with which it is allied, and within which the devotees of fashion live, the *moderni*. There are a series of institutions whose job it is to define what modernism is to them, to look into when it really began and if it still persists, and if not, when it ceased to be – so why should things be any easier with fashion?

Roland Barthes, who dedicated his famous system to fashion, tackled the topic by calling in a ponderous semiological and linguistic apparatus, yielding an abundance of fine distinctions but few insights into the currents running deep through this so-called fashion and defining its quintessential character.

The impossibility of describing fashion as an object is to be circumvented in the following with an attempt to relate fashion to myth.

With myth we mean here everything that is interpreted in a new way through fashion. Myth is not simply an old, traditional, canonised subject that is obscured by a new one, but rather the very material of fashion, its substance. Of interest here is the relationship of myth to fashion, the coefficient that they together form. In this coefficient, myth supplies a highly constant baseline, an unchanging dimension, while fashion plays variations on top of it, thus representing an aspect that by necessity is continually fluctuating. The respective degree of their admixture is then not simply an index of the more old-fashioned or very newfangled, rather it indicates a power relationship that is expressed directly in the formation of a garment and a figure.

This is one way to describe a system of fashion that in reality consists of an oscillation between myth and mimicry. A system such as this is an excellent way to lend contours to the efforts women expend in fabricating their own femininity and personality. Every woman is affected by the mimesis of her predecessors, and especially by those which in bundled form provided a model for those before her. In a certain sense, she is thus dancing an open and free choreography within a defined cone of light. The blurrier the details of the myth, the more risky, modern and fashionable the performance. And the more distinctly the myth asserts its presence, the more monumental, venerable and majestic the appearance.

II.

We will now arrange an encounter between two prominent women – Julia Maesa, a Syrian arch-matron, and Fanny von Arnstein, nee Itzig – in order to illustrate the thesis we have proposed above. Both are rich, influential and clever. Both have intellect with gender and vice-versa. Through their confrontation we hope that each woman's singular character will come to the fore.

Julia Maesa, sister of Julia Domna, comes from the Bassianid lineage, which means nothing more than that her father is called Bassianus. He was a Syrian coachman and, tellingly, was apparently a patricide. At the minimum, Julia Maesa attained the stature of South American and Asian politicians and despotic female presidents of the 20th century, for example. Her sister, Julia Domna, marries Septimius Severus, commander of the 4th Scythian legion in Syria, and gives birth to Caracalla. She is responsible for commissioning a biography of Apollonius of Tyana. Later, it becomes evident that this worthy deed is possibly connected with the fact that the sisters later worked tirelessly to establish a self-styled state religion. Julia Domna commits suicide following the murder of her son Caracalla, and her sister, Julia Maesa, is then banished to Syria, doubtlessly regarded as a threat to Roman order. In Syria, however, she finds virtually ideal conditions for engineering the fall of Caracalla's successor, Macrinus. She endows the Roman legionnaires with presents as well as bribes to bring about Macrinus' defeat at Antioch. The general carrying her banner into battle is a eunuch named Gannys. Directly following the victory, on 8 June, 218 AD, Julia Maesa's grandson Varius Avitus is brought at dawn to Valerius Comazon and, in the middle of Syria, proclaimed Emperor of Rome. Macrinus is murdered shortly thereafter, and the Julias, being Julia Maesa with her daughters, set off for Rome accompanying the young emperor, who takes the name Marcus Aurelius and pretends to be the biological son of Caracalla. The new emperor Varius Avitus has inherited from his mother the status of a sun priest of Emesa and has no intention of downplaying this role. Instead, he travels with his god in tow, the black meteorite of Emesa.

The Julias are deified, and the new emperor establishes his religion of the Sol invictus in a mighty temple on the Gianicolo. Heliogabal, the emperor's Syrian cult name, a felicitous bastardisation of the oldest names for the sun, proceeds to castrate himself in the course of spectacular ceremonies in honour of his god. Further details of his reign are provided in Artaud's fascinating book, but in any case he definitely took things too far, and this is also the opinion of his grandmother, who instigates Heliogabal's murder at the hands of the praetorian guard on 11 March, 222 AD. His mother also falls victim to the assassins. Julia Maesa is thus in a position to give and take away the highest offices in Rome; more precisely, right after Heliogabal's murder, she appoints the next so-called Severinian emperor

to the throne, the son of her other daughter, Julia Mamaea. In summary, this means that three Julias were at work here, and their work resulted in no less than three Roman emperors. The story of this threefold goddess demonstrates the resounding success of this matrilineal hereditary power in Syria, which dispatched its sons as cardboard candidates to patriarchal Rome. Rome's suspicions of Syria as a bed of unrest were therefore well-founded. Tellingly, the female politicians surrounded themselves with eunuchs, or created them. In order to shed light on the function of eunuchs in ancient Rome, we can enlist the story of Hierapolis, where a subtle programme of emasculation controlled the course of events ever since the city was founded. I will only briefly recount the tale of the mythical Queen Stratonice here so that readers may better comprehend the motives behind Julia Maesa's actions.

Lucian of Samosata, a contemporary of the Julian trinity, describes in De Dea Syria how Stratonice, who incidentally later married her stepson under humorous circumstances (he otherwise would not have been able to recover from an enigmatic illness), received instructions from Hera in a dream to build a temple. After some hesitation, she moved to the place described by the goddess, outfitted by her nameless spouse with the necessary funds and assistants. The king lent her for this purpose his favourite advisor, Kombabus. Shrewd and cautious, and experienced in dealing with Oriental despots, Kombabus castrated himself before his departure, just to make sure no one could harbour any suspicions of his conduct. Naturally, Stratonice falls head over heels in love with the clever man during the three years of building the temple. She confesses her love to him and even makes brazen advances, throwing all care to the wind. The king back home hears rumours of the affair and has Kombabus arrested and brought before him. He is contemplating his execution, when Kombabus suddenly demonstrates just how astute his precautions were. He demands that the king return to him a small pot that he had entrusted to him for safekeeping before the journey with Stratonice, scoffing that the king apparently wanted to enrich his coffers with the pot's precious contents by executing his friend. The king, denying having any such thing in mind, has the pot brought to him, opens it and thus brings to light Kombabus' character. Kombabus is rewarded and appointed to the highest offices, but he instead leaves the royal couple and moves to Hierapolis as the first priest, inaugurating a strange cult. Young men now follow Kombabus' lead and unman themselves during orgiastic rites, throwing their testicles into houses, whose inhabitants are henceforth responsible for furnishing and supporting them as priests and monks. The women are enamoured of the priests, known as Galli, and lie beside them affectionately, without arousing the jealousy of their husbands.

This story shows how the women knew how to take advantage of the men's typical competition for power to enhance their own standing. The servant

of the goddess is the son beyond rivalry with his own father, one who gives up the male mimesis in favour of a highly powerful female, or more specifically, in favour of a potentiation of mother calories. Within this scheme, the castration of Heliogabal seems consistent with the safeguarding of the power of his mothers and aunts, who in the end can never be absent in the parade behind the sacred black stone of Emesa in the holy processions.

To achieve a power monopoly the grade of the all-powerful grandmother, our equation between myth and fashion had to be put off balance toward the myth side; it would then look in the special case of Julia Maesa something like this:

MORE MYTH THAN FASHION = CULT

The emperor-dropping by the Julias is accordingly to be understood as a cult experiment, one that could only succeed as long as they saw themselves as representing Dea Syria. Julia Maesa is perhaps less a woman of the world than the world as woman. In this function, however, she can work as a contrast agent, bringing out in more detail the contour of the woman of the world, the sophisticated and fashionable female.

We now leave Rome for Vienna, and find ourselves in the second half of the 18th century. Fanny von Arnstein steps onto the stage. In 1776 Franziska Itzig, daughter of Berlin-based Jewish court coin minter Daniel Itzig, later court banker for Frederick the Great, marries Adam Arnsteiner, who would later become Baron of Arnstein. They take an apartment in the middle of the city, on the fashionable street called the Graben. Fanny has enjoyed an excellent education and is interested in good conversation, the latest news, people. She begins to hold salons, rubbing shoulders with the Viennese aristocracy, and even meets the emperor. She forges contacts with the grand ladies of her day: Madame de Stael, Rahel Varnhagen and Henriette Herz; Schlegel is seen at her parties. Fanny conquers society with her clever and attractive nature, so that her salon is soon regarded as the only one in Vienna that is by no means boring. Even Lord Nelson shows up at her summerhouse in the Braunhirschengrund district, with his splendid Lady in tow. In the 1790s there is a scandalous affair with the fascinating Prince Carl von Lichtenstein, which comes to an abrupt end with his appalling death in a stupidly instigated duel with Baron Weichs. The two duellists had exchanged words either in front of or because of Fanny. People know that Fanny is somehow involved in this dreadful matter, but it doesn't harm her good reputation and no one reprimands her for her role.

In her old age, Fanny makes a name for herself as philanthropist, founds the Viennese Musikverein and is counted as a great friend of people. Her whole life long she was regarded as someone who was able to bring people together. One might say that she lived for interaction. Unlike Henriette

Herz, Dorothea Schlegel or the oft-belittled Caroline Pichler, she did not actually produce anything. And it is in this very role as a non-producer that she attracts our interest and ensures her immaculate aura of class. She imitates the example of the aristocratic princesses with her donations to worthy causes, just like her career and that of her husband was generally geared to attaining the dream of the barony – successfully, as it turned out.

Like Julia Maesa, Fanny is a stranger in the field where she exerts her power: she is of the Jewish faith and thus belongs to a culture different from the society in which she lives. She is in possession of great wealth, like Julia Maesa, and makes effective use of this privilege. But in Fanny's case, a different pattern emerges. Symptomatic of this is the scandal that took place early on in her marriage due to her hair. A guest opens the wrong door by mistake and sees the young woman combing her hair, which she should have cut off on the day of her wedding as a good Jewess, henceforward covering her bare head with a wig. The guest, indignant, complains to old man Arnsteiner, but the refractory daughter-in-law escapes without a reprimand. However, following the birth of her only child, a daughter, Fanny is often forced to hear how her failure to bear a son is presumably a punishment for her refusal to cut her hair. Fanny is not under the protection of a Great Mother, but rather under the pressure of a Great Father, under whom she can only gain a modicum of freedom.

She seems to represent the true woman of the world, who in a complex process of assimilation appropriates the world as action radius in the form of the people she is able to influence. She is a woman of the world to the extent that she unites a personal calibre with a good position to create a successful persona, going well-beyond the means offered by the average myth-fashion coefficient. This is a very European concept of the woman of the world; she is the pacemaker, the one whose parasitic intelligence ascends to neo-mythic credential. Visually, she is noticeable for the certain thinning of her silhouette, which Roland Barthes, caught in the web of signifiers, notes merely: "After all, the broad (or voluminous, *the author*) lies on the borderline of the aesthetically acceptable, at least in modern clothing, which usually regards the sleek and narrow as elegant."[1]
Compared with the Roman matrons, whose all-suppressing silhouettes adorn the processions, our European heroine looks quite skinny. She does not take up much space, makes sure that nothing protrudes infelicitously, controls her gestures to make sure that they remind one as little as possible of gestation, as Gerburg Treusch-Dieter once remarked. She represents the type of the *good daughter*, preserving her juvenile demeanour into a ripe old age.

Belonging to the right social class is essential, as is wealth: but what becomes of it is little more than a role as ornament to her husband, who

1 Roland Barthes, *Die Sprache der Mode, Système de la Mode*, translated by Horst Brühmann (Paris: 1967) 141

takes on the father role. Even though she lives up to her title of a woman of the world by realising her social potency to the maximum, the scale of this power is dictated first by the father and then by the husband. Her mixture of talent and cultivation must always be displayed as a nobility of attitude, as prettiness and charm, a girlish femininity that captivates with gentle virtues and empathy. Hilde Spiel mentions in her delightful Fanny von Arnstein biography that Fanny had a habit of excusing herself for her vehemence, that she tried desperately, and in vain, to curb her inner drives. Because an excess would have spelled the end of the woman of the world who, instead of standing above all things, had her action radius right in the midst of them.

In the case of Fanny, the myth/fashion equation would have to look like this:

MORE FASHION THAN MYTH = CULTIVATION

In contrast to Julia, Fanny is forced to watch as her religion increasingly wanes in significance within her own family, which corresponds to the progressive blurriness of myth. Everyone but her is baptised, and she is the last to be buried according to the rites of her forefathers, following a life that was not exactly lived in the orthodox manner. Julia Maesa, by contrast, was able to infect all of Rome with the religion she imported, more and more taking possession of the mythical power of mimesis, which she entered into unconditionally from the very start.

In a grammar of modernity, not every woman of the world has to be an empress or a baroness, but one sees how this standing, brought into being by that self-fashioning creature woman, in a certain sense emerges all by itself when the memory of a mythic dimension can be summoned to life by her performance. At least the trend to be observed of late toward greater abundance and colossal shapes would be an indication that a motherliness, however conceived, is once again at work in the background, sending its ripples out to envelop our fashion icons. Furthermore, there is a new feminist attention to the silhouette, which no longer views Twiggy-ness as a smart figure, but rather as the nadir of political femininity. It would appear that the good daughter, clad for example in the sleek battle dress of the chic career woman's suit, has at least for the time being lost her attraction. The fact that it was possible to successfully usurp the name *Notre Dame*, i.e. Madonna, for a new design that conveys women's evolving power, indicates something like an attempt to install a model of neo-matronliness.

daniela mauch /
on the development of the sports fashion system – a sociological observation

The emergence of sports fashion, or the system of sports fashion, will be explained through five phases and its evolution in the examples of swimwear, skiwear and tennis fashion. Before we start, we should clarify the term *sports fashion system* as well as the difference between *sports fashion system* and sports fashion. When you hear the term sports fashion you usually think of a very specific type of clothes worn for the purpose of sport activities. Yet the link between sports and system refers to something much more sophisticated. Sports fashion houses and fashion designers, for instance, play a very important role in this system. Also the models are important, since sports fashion should be also presented to the public. Another important part of the system consists of various interaction events, like sports fashion shows that present the latest collections. Additionally, the fashion body, the ideal of beauty, plays a central role since the ideal of beauty has enormously changed because of the influence of sports.

Let's start with the basic requirements that need to be fulfilled in order to make the emergence of such a *sports fashion system* possible. First of all, there has to be a fashion system. Evening wear, children's fashions, female-male fashion, wedding clothes – these are all different categories that constitute a fashion system. On the other hand, the existence of a sports system is of equal importance. Without skiing or tennis there would be no skiwear or tennis fashion. In addition to that, the sports system has to influence the fashion system. Fashion has to be inspired by sports, it has to embrace sports if the sports fashion, or the *sports fashion system* with all its layers, should come into existence. These layers come from the organisation and the designers to the fashion shows. Another very important aspect is that sport has brought functionality into fashion and likewise into the fashion system. The question is how did functional fashion, this sports fashion, develop?

In the first phase, from approximately 1850 to 1900, during the time of the so-called forerunners and pioneers of sports fashion, basic conditions for the emergence of *sports fashion system* were created. At that time the fashion used for sports was barely different from everyday fashion. Functionality was of no importance at that time. One of the reasons for this lies in the fact that only a small number of people did sports. Especially women were in minority. As a result, there was only a modest demand for adequate sports clothes. The garments worn by sportswomen, such as corsets or bustles, were tailored in a manner that restricted the movement enormously.

The example of swimming fashion demonstrates how functionality in the field of sports fashion has developed. The women went into the water wearing whole-body bathing suits, which consisted of ankle-length bloomers and a waisted long-sleeved coat dress. Underneath it, they were wearing a corset especially designed for swimming. These clothes, obviously, tried harder to satisfy the demands for decency and modesty than to support mobility. It was not only the cut of the clothes that obstructed the movement.

It was also the material, predominantly hydrophilic woollen material, that constricted swimming.

The situation was similar in skiing where the corsets as well as high-heeled ankle boots were worn. The ladies added to this voluminous cut pleated or flared skirts made of heavy loden. The unimpregnated woollen materials absorbed lots of moisture. So the clothes were primarily supposed to fulfil the function of providing prudency.

Tennis fashion was also hardly different from the everyday fashion of that time. Tennis was a prestigious sport, and the people playing it were trying to demonstrate their wealth and social status instead of taking care for the functional aspects of the clothes. The clothes were symbolic of their wealth. Very often you could see ladies wearing bustles, exaggerated skirts without any function whatsoever, for purely aesthetic reasons.

The second phase, taking place between 1900 and 1920, can be regarded as the beginning of a change and as the phase in which the sports fashion was founded. Through the upvaluation of the role of sports in society, a specialised sports fashion started to develop. Sport suddenly became a medium of health promotion, and for the first time, it influenced the fashion. The first tendencies towards fulfilling functional criteria in fashion could now be observed.

The corset was finally abandoned in swimming: the trouser legs were short-ened from ankle-length to knee-length, long sleeves became short sleeves and the materials changed from wool to lighter cotton. This modification enabled the ladies to make the right movements when swimming for the first time. This development, of course, clashed with the imperatives of decency and modesty, but the fact that women were starting to expose their legs and arms had to be accepted nevertheless.

Similar to the swimming fashion, first effective changes in skiing fashion fol-lowed. However, before the ski trousers could assert themselves in the world of fashion, women selected the so-called variable suits, the skirt-trouser models. Women could decide for themselves when to pull down a skirt and when this practice should be abstained for modesty reasons.

In contrast to the fashion of swimming and skiing, tennis fashion did not experience any significant changes regarding functionality. Owing to the primarily status and prestige-oriented attitude, this process was delayed in time. The sole, really minimal change could be seen in the shortening of a floor-length skirt to an ankle-length skirt and later to the knee-length skirt.

The 1920s can be regarded as crucial point in the development of sports fashion. The entire period up to the 1960s constitutes the third phase in the development of sports fashion. This phase can be referred to as the phase of establishment and individualisation. In this time, sports fashion with func-tional clothes fit for doing sports was established. There was an attempt to clearly distinguish between street and everyday fashion on the one hand and sports fashion on the other hand. Sports fashion was supposed to be

restricted exclusively to the acts of doing sports – a clear line between sports fashion and everyday fashion was drawn.

In order to make swimming fashion functional, bathing suits were provided with very plain, simple and tight tailoring. The disappearance of sleeves and the introduction of the short leg trouser led to a decreased friction surface thus reducing water resistance. The material also allowed a better mobility. In 1927, for instance, chemical fibres, which would be subsequently used in sports fashion, were successfully obtained. Most fabrics were artificial silk woven with fine lastex threads. Thus the materials were much more elastic, and they provided the swimmers with a much better fit. Significantly reduced water absorption than was the case with wool or even cotton dramatically reduced the time needed to dry the bathing suit.

Skiing sport experienced a significant change in 1924, when for the first time Winter Olympics in Chamonix took place, which increased the degree of familiarity and popular interest in this sport. As a consequence, the demand for adequate sports clothes increased. The maximum freedom of movement possible for this sport was offered by the Norwegian suit especially designed for skiing. It consisted of a blouse-like, wide ski anorak and tight-fitting plus fours. Later, wedge-shaped trousers were added. From the 1950s onwards, significantly lighter, more elastic and form-stable chemical fibres replaced the natural fibres previously used. As a consequence, the tailoring could be designed tighter. Especially because of the elasticity, it was finally possible to make necessary movements without fearing that the seams of the suit will burst. Skiing fashion in this phase developed to an almost unisex fashion – women's and men's skiing fashion resembled each other so much that no sex-specific differences could be detected. This tendency remains until today. The process of change in tennis fashion was developing, but significantly slower than was the case with skiing or swimming fashion. From the 1920s onwards, female tennis players wore short pleated tennis skirts, sweaters and short-sleeved blouses.

The body ideal in fashion was also clearly influenced by sports and, starting from the 1920s, the ideal of beauty was much more athletic than before. This can be seen very well in the fashion body ideal of a slim, agile, athletic woman – the so-called *Sports Girl* of the 1920s with long legs, narrow hips, flat breasts and short hair. The body was not shaped by a corset anymore, but by doing sports. Even the pale tan, which was highly popular in the end of the 19th century, was off the table. Sun tanned skin was desired in order to look young, healthy and sporty.

After this sport-specific functional sports fashion had been established, a new and fourth phase began in the 1960s and 1970s. Hand-in-hand with the fitness wave of the 1970s, numerous new sport disciplines emerged. Aerobics and jazz dance, for example, also influenced the demand for new sports fashions. Recent research in the field of textile technology, such as the invention

of elastic materials like the elastan fibre *Lycra*, increasingly influenced sports fashion.

Tailoring could be tighter and tighter without impeding the body movement. In addition to functional criteria, this phase was also characterised by sexual connotations in sports fashion. The garments were cut in such a way that they emphasised the figure, they were tighter and the sportswomen revealed more of their body than was previously the case.

This change could be clearly seen in the field of swimming fashion. Here, many elastic, especially form-stable materials were used, which were very light and, due to their inferior water absorption, dry very quickly. The 1960s and 1970s, the decades of sexual liberation, led to invention of so-called mini bikinis. They were produced out of *Suntex*, a sun-permeable material, which could be used to tan the body all over.

In the skiing fashion, the garments of this phase consisted of racing suits, jet trouser or salopettes, quilted anorak and ski overalls. All of them were tight and accentuated the figure. Since these suits were manufactured from of mono-elastic or bi-elastic fabrics, they fitted well to the body. This phase in skiing fashion was characterised by increasing differences between serious sports fashion and hobby sports fashion. Depending on the degree of professionalism with which the sport was done, one could differentiate between highly functional racing suits for professionals or outfits consisting of salopettes and anorak for hobby sportsmen.

Similar to swimming fashion, the influence of the sexual revolution could be clearly seen in tennis fashion, as the female tennis players presented themselves to the public in tight mini tennis dresses that accentuated the waist.

Finally, comes the last phase, the so-called phase of explosion and multiplication, which takes place from approximately 1980 up to the present. In this period of time, the whole sports fashion system increased almost like an explosion, an infinite flood of trend sports such as snowboarding, inline skating, skate boarding, mountain biking etc. generated the birth of new sports fashions. Nowadays, sports fashion is characterised by vast diversity. In this phase, functional aspects can be detected primarily in the use of materials. In professional swimming fashion, for instance, whole-body suits out of highly specialised, extremely light material are produced, which are designed to optimally fit to the body. In addition, the fabric surface imitates a shark's skin, which dramatically reduces water resistance and, as a result, increases the gliding effect and enables the swimmer to move more quickly. In a 200-metre race swimmers wearing these suits could make an advantage of up to six metres. Naturally, such an advantage is an essential factor in professional sports.

In contrast to the highly functional professional sports fashion, there is also a less functional hobby sports fashion. By imitating the latest summer trends, fashion and aesthetic aspects are in focus, such as the introduction of sports-unrelated details such as sequins and beads.

Very tight bikinis demonstrate that the eroticisation of the body is still playing an important role.

Skiing fashion also developed in the course of time into a highly functional fashion, where numerous details optimise sports activities, be it a ventilation zip in the breast/armpit/thigh area, snow protection gear inserted under the jacket hem in order to keep the snow away or even cushioning for the body parts especially at risk. Atomic, for instance, offers heatable skiing shoes and matching gloves. There are also underwear with an integrated heat-generating battery. O'Neill has made a ski jacket with an integrated navigation system – the GPS device indicates speed, weather forecast, 3D maps of the surrounding area and routes with distance indications. With wireless technology such as Bluetooth one can establish a phone connection, as brought on the market by Burton, for instance. Research in the field of electrical engineering has made a significant contribution to the comfort of skiers, and we can only anxiously expect what the future will bring.

Even in the female tennis fashion, the recently developed materials are adjusted to the needs of the sportswoman. Double-layered materials that can absorb moisture very well, lead it to the surface and then let it evaporate, cater to a sense of well-being. One can still see generously fit tennis dresses, very tight skirts, plunging necklines, all of which eroticise the body even more. In addition, and this is especially true in tennis fashion, the difference to the common women's fashion for summer cannot be really clearly defined any more. There are even tendencies that remind us of the beginnings of the development of sports fashion.

from upper left to lower right:

bathing costume from 1870

skiers at the end of the 19th century

tennis costumes in sans-ventre style

bathing costume dating from 1900

skiing fashion at the beginning of the 20th century

adjustable ski suit, die woche, 1909

tennis costume at the beginning of the 20th century

bathing fashion dating from approximately 1920

suzanne lenglen in her tennis clothes with a short skirt by jean patou

female skier in wedge-shaped trousers and waisted jacket, 1952/53

female skier in tight overalls, 1972/73

female skier in figure-accentuating ski overalls, 1976/77

highly functional swimming fashion, front view

current tennis fashion, short little skirt

current tennis fashion, top

current skiing fashion, 2008

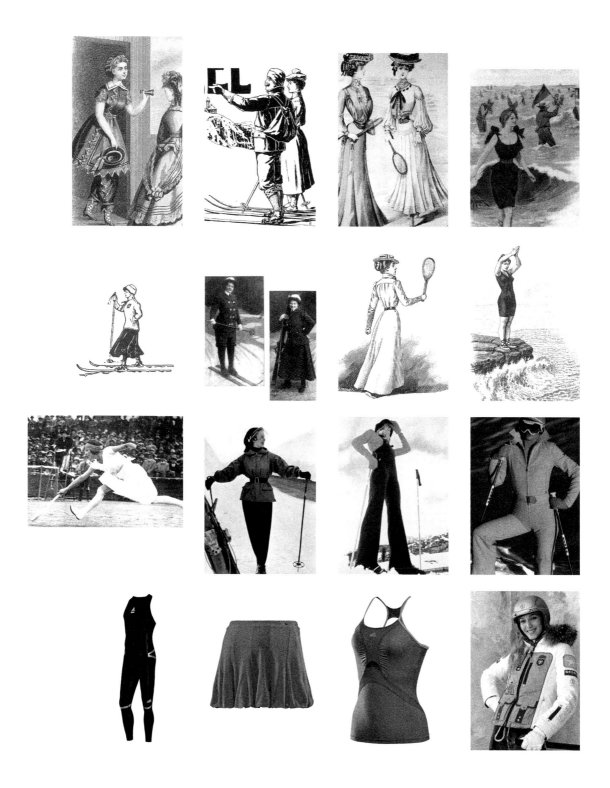

viola hofmann /
supportive of the state and somehow chic – the changing political outfit

Fashion in Politics?

In modern society, clothes have become an instrument of visualising personality. Being perceived as fashionable or stylish is a desirable status, which distinguishes people as creative, free and self-confident subjects. The social and economic dynamics of what's *in and out* demand the permanent *updating* of one's personal appearance to the fashion of the moment. However, momentary and seasonal fashion trends seem to bypass the field of politics. If we take a look at the outfits of the Western officials, see left, we will be confronted with a very static appearance. Classical suits and costumes in subdued colours and tried-and-tested tailoring dominate the wardrobe of the officials.[1] Even the dressing habits of female office holders, who are offered more choices in terms of dressing also in the work world due to culturally generated gendering practices, appear to have levelled off in the last decades. The current dressing culture with its emphasis on reserved fashionable modifications reflects the expectations imposed on the administrative office and its representatives. Accepting these long-established dress codes – *fitting in* on political level – helps politicians to be portrayed as professional and gracefully distant.

LEFT: GERMAN FEDERAL CABINET, 2002

Various PR agents come to a very similar conclusions when commenting on the general issue of clothing in politics. Politicians, according to most of their recommendations, should opt for "something plain, simple, classical", which reduces their clothes to the essential.[2] Business clothes in the field of politics, as has been stated by many experts, are an exterior requirement with which correctness and seriousness are symbolised.
In contrast to continuous negotiation between the old and the new, recognition dynamics in politics are based on the image of reliability, discipline and sovereignty which finds expression in stable vestment. The bourgeois suit, brought to perfection between 1830 and 1870, reflects the idea that "plain clothes represent a basic requirement for a functioning democratic state".[3] Orderliness, self-control and virtue became important criteria for middle-class men as they could be interpreted as a rejection of everything excessive or extravagant. With a new bourgeois-male clothing culture, the aristocratic lifestyle and perception of fashion as one restricted to the female domain was renounced. Political key representatives of social democracy appropriate a typical habitus of the middle class, when they want to attain the middle class–supported power. In this way, even the middle-class (clothing) culture has become a sign of power.[4]
Systems of ideas, values and concepts of democracy formed in the 19th century are reflected in the current clothing practices of politicians. Civil clothes worn during political routines and their public, immaculate habitualisation characterise the political everyday and shape the representation of politics in terms of grace and appropriateness.

1 These and subsequent observations have been based on analysis of longitudinal section of politician photos over a period of time lasting from 1949 to 2005. Cf. Viola Hofmann, *Das Kostüm der Macht. Das Erscheinungsbild von Politikern und Politikerinnen von 1949-2005 in 'Der Spiegel'*, Unpublished dissertation, (Dortmund: 2007)

2 Doetsch (2000) 120

3 Mentges; Devoucoux (1999) 23

4 Cf. Brändli (2005) 216-217

Lifestyle as a New Programme

As can be seen on the right, the daily newspaper *Rheinpfalz* published in 2007 a photo series of Vladimir Putin, presenting the former Russian head of state in various outfits – one time in a serious dark blue suit, one time in a military outdoor combination exposing his upper body and another in a black single-breasted suit with dark sunglasses. After these and similar pictures, a lot of negativity was voiced. They described these self-portrayals as brute, banal, clownish, vain and overloaded with testosterone.

RIGHT: VLADIMIR PUTIN – VARIOUS OUTFITS

In spite of all the criticism directed at these enactments, one has to bear in mind that they result from a gradual change in the representation of politicians. The change is achieved primarily by strategic use of the body and the clothes. As suggested by the caption "Statesman, Rambo, Cool Guy: Vladimir Putin Has Many Faces", depending on the nature of public appearance, the politician is attributed a different roles. Clothes create material clues informing us about people we usually know only from mediated distance. Today, the politicians' scope of duties also includes permanent self-presentation, within the institutional field of politics and beyond. The interaction between the media and politics requires clearly visible official representatives, and the politicians further foster this requirement by adapting to the media and cultural conditions and by attempting to perfect their qualities of self-presentation.

In the course of this markedly personalised politics, the professional presentation of the body takes an increasing importance and comes to the fore as a crucial instrument.[5] In this context, the looks, the body and the clothes have become integral presentation means of medially communicated politics. The outer appearance is increasingly functionalised and integrated in the personalising strategies. Controlling the outer image and its strategic use could be included in a modern politician's job description.

It is not only the "big politics" but also the "micropolitics of everyday life" that play an important role in a continuous struggle to fulfil the expectations of the public.[6] The latter is an essential element in sensualising the abstract aspect of politics and in sustainably keeping the political officials in the back of the mind of the citizens. Above all, "the role-distant presentation of a politician as a private citizen, as a human being with all his edgy personality traits", as a man with a completely normal private life, is going to promote the profile of political aptitude of a representative.[7]

Dramatisations of politician's everyday life could already be seen in the first years after the Second World War, when the politicians allowed various media an insight into their nearest social environment. Similarly to the prestigious official level, also the private sphere was characterised by the

5 Cf. Tänzler (2005) 44

6 Dörner (2006) 5

7 Bußkamp (2002) 51

proper presentation of body and clothes. As an example, Chancellor Adenauer could be taken, see left, who is, as a real role model, preparing to cook in a suit with a protective apron.

LEFT: CHANCELLOR ADENAUER 1957 – PROPER LOOK EVEN AT STOVE

Via professional image strategies, alternative physical representation forms are spread on the everyday level. The reinforced thematising of the private sphere could be seen in a modified habitus. The politician is presented in his casual or sport clothes. From a modern perspective, presenting oneself in very intimate and fashionable clothes is, on the political level, very innovative and stands in contrast to the formal dress codes.
The representation of politics follows general social changes. After the second half of the 20th century, the distanced discretion of the private sphere becomes significantly loosened, and the attitude towards the private life starts to change. The unspoiled authentic expression of the true self becomes a project of personal development for every individual. This brings to life a communicative play with openness, which demands new and submissive forms of privacy and simultaneously immediate habitualisation.[8]
Clothes and fashion create the circumstances necessary to experience these forms of interaction. As the fashion sociologist Ruth P. Rubinstein has pointed out, modern clothing conventions are continuously moving between the conflicting priorities of formal and informal and reflect the ideas of public and private. Individuals adapt their clothing behaviour depending on the surrounding environment, thus fulfilling their social expectations. Officials working in public require a self-controlled and externally controlled look, while in the field of work unobserved by the public, convenience can determine the type of clothes.
Rubinstein sees a new development in recent looks, which is only partly assigned to particular roles and is actually far more influenced by momentary and situational conditions. According to this theory, public and private occupations are permanently subject to a subjectively-guided dynamic. Social backstages are turned into frontstages by means of clothes and vice versa. With increasing fluidity of personal clothing behaviour, public areas are individually conquered and finally restructured.[9]

A tendency towards casual clothes in official domains can be seen in the 1970s. Even in politics, the ubiquitous political clothing image of the previous decades is replaced by alternative, contemporary image of politicians. Politicians present themselves in the so-called *home stories* as natural and informal, they go on the streets during the election campaign wearing their casual clothes, they run and ride a bike wearing sport clothes.
Physical health, which since 1970s has been a focus of a changed body awareness due to the wave of aerobics and jogging movements, in mobilised in the representation of politics. The health condition, which is documented

8 Cf. Weiß (2002) 55

9 Cf. Rubinstein (1995) 44-46

in these self-representations, responds to the latest social paradigms. Also in the world of business, the idea of mutual dependence between body and mental capacity was introduced in this time. The good health of people in high positions symbolises their leadership skills, discipline and mobility.

The body image of the prosperity-promising stout politician, which circulated primarily in Germany during the years of economic wonder, has worn out. Highly demanding physical activities accentuate the presence, or at least the cultivation, of physical force and stamina, which fuels political duties. Images of politicians participating in marathons, parachuting, biking races or playing football communicate that, even on the official level, energy potentials are required. In the Image top right for instance, Minister of Foreign Affairs of that time, Joseph Fischer, is shown running in a functional dress.

As consequence of the differentiating processes on the everyday and business level, flexibility and vitality have infiltrated the field of politics and gradually modified political clothing culture.

In terms of fashion, visually communicated lifestyle designs expand traditional role models and offer identification patterns, which should eventually support the process of election decisions.

TOP RIGHT: MINISTER OF FOREIGN AFFAIRS FISCHER 1998

Designer Bettina Schoenbach implemented this change very skilfully. The designer from Hamburg was presented as Angela Merkel's personal stylist under the title *Supportive of the State*. Schoenbach significantly changed the perception of the German chancellor. "Angela Merkel looks like Angela Merkel here, pragmatic and straightforward. But also supportive of the state. And somehow chic."[10]

As has been illustrated by the quotation from *Elle*, the acceptance is not only measured exclusively by graceful outfit, being *chic* is what counts as well.

RIGHT: ANGELA MERKEL AFTER HER STYLE CHANGE SHORTLY BEFORE THE 2005 ELECTIONS

TV producer Ralph Burkei came to a similar conclusion. Reaching a target group is based on the carefully targeted communication of *lifestyle, fashion and young dynamics*, which can be seen in the example of the broadcasting company VIVA. In order to leave nothing to chance, the broadcaster employs a wide range of costume designers, stylists and trend scouts who implement the current trends. Conformity to the star and youth culture promoted by the media can be structurally recovered in personalised politics.

"The similarities to the communication of political content by means of images is apparent. The so-called *dress codes* are present everywhere and

10 *Elle* (2006) 107

depend on the expectations of the target group, being the voters, but also on the personality of the wearer."[11]

The culture and clothing theorist Karen Ellwanger has asked her students how politicians, in their opinion, should be dressed. Among other things, it was stated that they should not look too classy, nevertheless serious and trustworthy. They should conform to their role in a serious and trustworthy manner, perhaps through wearing something like a uniform. On the other hand, the students also placed value on the desire that the politicians start reflecting social changes and represent every societal status.[12]
Maybe the recommendations of the PR agents should be reviewed in light of this statement. In the field of politics, the individual rhythms of *in and out* have been established with the rise of personality-oriented politics. Seriousness alone is not enough to become acknowledged as a state representative. Situational synchronisation of aspired image, outer appearance and expectations of target groups have become essential in representation of politics, thus requiring that as many options as possible for identification be offered.

This means that the politicians should, in addition to their official business hours, be striving to *leave a good impression* at all times and in all places. Consequently, as advocated by the TV producer Ralph Burkei, the so-called weak influence factor, such as the outfit, should not be regarded as an accessory, but as a consistent theoretical and practical instrument in politics.[13] To conclude with a personal prediction, a professional team consisting of stylists, designers and costume designers is going to gain an enormous importance in the presentation of chic, casual, sporty, professional, serious, state-supportive outfits of politicians.

11 Burkei (2000) 126

12 Cf. Ellwanger (2002) 112

13 Cf. Burkei (2000) 126

literature
- Burkei, Ralph, 'Kleidung und Maske' in Altendorfer, Otto, Wiedemann, Heinrich and Mayer, Hermann, *Handbuch des modernen Medienwahlkampfes. Professionelles Wahlmanagement unter Einsatz neuer Medien, Strategien und Psychologien* (Zwickau: 2000) 124-129
- Bußkamp, Heike, *Politiker im Fernsehtalk. Strategien der medialen Darstellung des Privatlebens von Politikprominenz.* (Wiesbaden: 2002)
- Brändli, Sabina, *Der herrlich biedere Mann. Vom Siegeszug des bürgerlichen Herrenanzugs im 19. Jahrhundert* (Zürich: 1998)
- Devoucoux, Daniel and Mentges, Gabriele, 'Steife Zylinder für angepasste Bürger. Die Badische Revolution in den Bildern der Mode' in Landeszentrale für politische Bildung Baden-Württemberg (ed), *Schlösser*, Book 4 (Stuttgart: 1999) 21-23
- Doetsch, Holger, 'Verhalten vor der Kamera – Wie setze ich mich richtig ins Bild?!' in Altendorfer, Otto, Wiedemann, Heinrich and Mayer, Hermann, *Handbuch des modernen Medienwahlkampfes. Professionelles Wahlmanagement unter Einsatz neuer Medien, Strategien und Psychologien*

(Zwickau: 2000) 114-123

- Dörner, A, 'Politik als Fiktion' (2006) 7 *APuZ*, Inszenierte Politik, 3-11
- Elle, *Staatstragend*, ein Bericht von Melanie Kunze (August 2006) 106-107
- Ellwanger, Karen, 'Kleiderwechsel in der Politik? Zur vestimentären Inszenierung der Geschlechter im politischen Raum' in *Kleider machen Politik. Zur Repräsentation von National staat und Politik durch Kleidung in Europa vom 18. bis zum 20. Jahrhundert*. Exhibition Catalogue from the Landesmuseum für Kunst und Kulturgeschichte Oldenburg (2002)
- Hofmann, Viola, *Das Kostüm der Macht. Das Erscheinungsbild von Politikern und Politikerinnen von 1949-2005 im Magazin 'Der Spiegel',* Unpublished Dissertation (Dortmund: 2007)
- Mentges, Gabriele, 'Uniform - Kostümierung – Maskerade. Einführende Überlegungen' in Mentges, Gabriele, Neuland-Kitzerow, Dagmar and Richard, Birgit (eds), *Uniformierungen in Bewegung. Vestimentäre Praktiken zwischen Vereinheitlichung, Kostümierung und Maskerade* (Münster: 2007) 13-27
- Mentges, Gabriele, 'Für eine Kulturanthropologie des Textilen' in Mentges, Gabriele (ed), *Kulturanthropologie des Textilen* (Berlin: 2005) 11-54
- Tänzler, Dirk, 'Repräsentation als Performanz: Die symbolisch-rituellen Ursprünge im Leviathan des Thomas Hobbes' in *Andres* (2005) 19-44
- Rubinstein, Ruth P, *Dress Codes. Meanings and Messages in American Culture* (Boulder/Oxford: 1995)
- Weiß, Ralph, 'Vom gewandelten Sinn für das Private' in Ders. and Groebel, Jo, (eds), *Privatheit im öffentlichen Raum. Medienhandeln zwischen Individualisierung und Entgrenzung. Schriftenreihe Medienforschung der Landesanstalt für Rundfunk Nordrhein-Westfalen*, Vol 43 (Opladen: 2002) 27-87

wolfgang kos / fluttering accessories for the mind – thoughts and ideas of a cultural historian

Everything is fashion and all areas of life tend to be flooded by fashion or fashion-like phenomena. Backwards and forwards, today there is actually hardly any fashion-resistant field. That is why there is something restrictive about so many bilateral considerations such as fashion and art, fashion and architecture or fashion and photography – the lived life, life as a whole if you want, could be the appropriate vis-à-vis term for fashion. ...

In a way, fashion is a battlefield permanently aspiring to expand, all the more as the field expands. It is about as much power of interpretation of the present as possible, perhaps also about conquering the future, at least the near future.

Fashion is something imperialistic, something aggressive; it is all about elimination and ousting at least a part of the public. It's about territorial disputes in the public arena and the power to invade already conquered or still fallow regions, the power to extinguish whatever is there, to overtake anything that doesn't bring acceptance and media power quickly.

Malcolm McLaren from the Sex Pistols once stated that only the medium of fashion possesses this exceptional power to create mass identity because it's a weapon. And this weapon used to be the ragged T-shirts or self-harmed faces – to some extent a forerunner of the piercing trend. We're familiar with this game of anti-fashion becoming fashion: by stressing this revolutionary moment, the success stories of fashions seem to be presented, in retrospect, as conquering expeditions. ...

Fashions need spaces of medial resonance, they need to be discussed and commented upon. Fashion is a phenomenon of extreme medialisation. The integration of the wide population strata into fashion in the early nineteenth century was accompanied by a variety of new fashion magazines. Later on, movies, movie stars, pop stars, or recently even sports or TV hosts – publicly visible role models – took over this role of being exemplary and creating fashion. Without the permanent presence of the media or the stage, no trend or craze can be perceived, discussed or brought into existence. And in order to be available for differentiation criterion and appeals, every fashion propagandist needs players who will sense the obligation to change. So there must be a fundamental dynamic; the fashion players have to be compelled to demonstrate an obligatory workload of mobility. Should they refuse that, it's going to be tough. Fashion is, in a way, an obligation – an obligation that needs to be fulfilled in order to make the fashion system function or to prevent an individual from being indifferent to fashion. ...

Another issue which matters to me is epigonality. On the one hand fashion, the new, attempts to be original, special, something that hasn't been seen ever before, the individual, the recognisable. Yet another criterion, of course, is that this functions as a role model for the many others who are doing similar things. The history of art also demonstrates that extremely successful periods are always marked by similar variations, which can be found in many other places. I would argue that fashion, or a successful fashion campaign – to

use this relatively aggressive word – or even a new shift in fashion detected in Paris, London or on the Belgian dance floor or somewhere else, isn't effective because it can be seen everywhere but because it can be easily duplicated with slight modifications – sometimes very original modifications. It is these modifications, these variations, this epigonality, which is often underestimated. Carlo Ginzburg, a historian dealing with the history of mindsets, once said that average works of art are more meaningful to a historian than the extraordinary – the latter fall out of the context of time. ...

You have already noticed that as an art historian I'm especially interested in fashions when they become recognisable in various fields of society, when they complement and comment on each other. When they create a critical mass functioning beyond the level of partial fashions, such as the fashion of clothes, and when they in doing so display formal and aesthetic distinctive features reflecting different mindsets, attitudes and ideologies.

In retrospect, the idea is to determine an aesthetically valid correctness and the spectrum of the common and the normal in order to recognise and evaluate significant deviations and modifications. Although I am not sure whether Tom Wolfe's flippant remark that the size of the shirt collar tells you everything about the stock market cycle has ever been true, I do believe that fashions make certain periods, desires, unsettled feelings or even boredom felt. For trend researchers and journalists, fashion is an early warning system and for the historians, a tool for measurement afterwards.

According to Bazon Brock, people got used to calling changes that can be seen on the level of objects fashion. Since there is a correlation between this level of objects and the social conduct it would make sense to understand fashion as short term modifications in the social conduct of the people. But where does the long term aspect begin? ...

The lived-in world, as well as the sense of time, consists of many, many slow experiences; it is numerous long, wide, aesthetical, formal experiences in which we can recognise ourselves again – not just a rapid succession, a staccato of always new fashions.

How do fashions reach quantities and qualities that make them effective? The German pop theorist and writer Diederich Diedrichsen once wrote that the new keeps coming, yet nothing vanishes. According to that idea, something like a key phenomenon does not exist.

The idea of the new coming as a real bombshell and clearing out the old is obviously extensively abrogated in reality. It could be compared to a giant apartment in which new residents keep arriving, yet the clothes from the previous inhabitants are still there; some of the residents eating organic foods, the others still enjoying their cheese kransky; everything taking place in a co-existence, everyone doing their own thing – but with a lot of commitment and with a lot of passion for self-definition. And the interesting thing about this phenomenon is that there is a barely comprehensible parallel co-existence of styles and conventions, where there is rarely the aspiration to oust the others out.

The violent aspect of fashion innovation, so typical of the late twentieth century, has obviously been replaced by relativism – the further development has shifted to microspheres, to superimpositions, to fine overlaps and hybridisation. There is no contrast between high and low any more, rather a heterogeneous mix comparable to what is referred to as smart shopping. You take an item and complement it with a completely different one, which might be much cheaper or not used at the moment and therefore unexpected and surprising. The industry has reacted to this development by offering as many individual items as possible.

The succession of waves has ended up in the reconciliation of many different waves. The question which arises here is: what happens when waves of various speed and intensity are layered one upon another? Very complex systems emerge. Fashion is rapidly changing, but what happens when the old fashion does not get off the stage because the people still like it, because it has become mainstream, the rule, or because it entered a sphere isolated from fashion and its cyclicality, what happens when the new, as it were, enters a timeless level? ...

According to Georg Simmel, in the rise of every fashion lies the seed of its own death. I'm not so sure about that, since there is this perseverance of fashion, an increase in surviving fashions. One of the reasons for this is, for instance, sentimentality. People change from mobility to immobility when they find their personal standard of happiness at a certain stage in their lives, and they do not want to give that up. This immobility is reflected in pictures and signs. People want to stay faithful to the time which keeps escaping them. People become indifferent to fashion because they are tired of selecting. Additionally, goods produced just for sales attain emotional values. People associate various memories with them; they become the safe havens in the world of rapid growth. They evoke trust, and this is how objects and attitudes emerging from fashion somehow end up on the defensive, changing into the inactive.

Silvia Bovenschen wrote in her work *Über die Listen der Mode* (On the Cunning of Fashion): Fashion is characterised by a permanence of change. Fashion itself is a permanent crisis.

Here comes this image again. Boris Groys speaks of a radical historicism, since the new constantly keeps creeping into the system of fashion. However, I regard this as a rather mechanistic image of a natural paradoxical situation. Fashion is a paradox, after all. ...

But what happens when the borders between fashion and non-fashion keep becoming blurred, when almost everything has to be filtered or contaminated by fashion, when everything is about style and trend, when everything is somehow designed and pre-arranged?

This diffusion is something very interesting and possibly very complicated for big corporations. A dilution of the fashion effect can be detected, in spite of the fact that it is discussed so extensively. From a certain point of wide appeal, fashion no longer serves as a tool for differentiation but rather for the hidden assimilation of the masses by fashion corporations.

credits / images

page 10: © Jael Rabitsch, 2008, Fashion Institute Vienna

elke gaugele / page 14-19

page 14: Facial treatment in Charles H Willi's London surgery in 1932, who worked with an electric device instead of applying the classical method of knife and scalpel. © Getty Images / Hulton Archive in Angelika Taschen (ed), *Aesthetic Surgery* (Cologne/London/Los Angeles: 2005) 88

page 14: Digital Tattoo Philipps Electronics. The Body as Touch-Screen: current biotechnological depth dimensions of the organic ornament. <http://www.design.philips.com/probes/projects/tattoo/index.page> (accessed 10 October 2008)

page 16: Ann Sofie Back, 2008. <http://www.annsofieback.com/blog/16th Sept 2008> (accessed 10 October 2008)

page 16: Naked People: A Triumphant Shout of the Future, London, 1893 <http://209.197.70.148/naturism/images/nakedpeople.jpg>

page 17: Victimless Leather – a Prototype of Stitch-less Jacket grown in a Technoscientific 'Body'. Tissue Culture&Art Project by Oron Catts and Ionat Zurr, 2004 <http://www.tca.uwa.edu.au/vl/images.html> (accessed 25 June 2008)

page 17: Reform Dress by Eduard Josef Wimmer-Wisgrill of the Wiener Werkstätte, 1920 © Georg Mayer / MAK

page 18: Facelift of Suzanne Noel's patient, from A Noel, *La chirurgie esthétique et son role social* (Paris: Masson et Cie, 1926) Private archive Sander Gilman, Chicago. In Angelika Taschen (ed), Aesthetic Surgery (Cologne/London/Los Angeles: 2005) 88

page 18: Charles H Willi, *Facial Rejuvenation. How to Idealise the Features and The Skin of the Face by the Latest Scientific Methods* (London: Cecil Palmer, 1926) Private archive Sander Gilman, Chicago. In Angelika Taschen (ed), Aesthetic Surgery (Cologne/London/Los Angeles: 2005) 89

daniela mauch / page 26-31

page 31: Bathing costume from 1870, *Journal illustrée des Dames*, 1870

page 31: Skiers at the end of the 19th century (unknown source)

page 31: Tennis costumes in Sans-Ventre Style, In Ingrid Loschek, *Fashion of the Century. Chronik der Mode von 1900 bis heute.* (Munich: 2001) 18

page 31: Bathing costume dating from 1900 (unknown source)

page 31: Skiing fashion at the beginning of the 20th century, In Carol Belanger Grafton, *3,800 Early Advertising Cuts. Deberny Type Foundry.* (New York: 1991) 62

page 31: Adjustable ski suit, Die Woche, 1909

page 31: Tennis costume at the beginning of the 20th century In Carol Belanger Grafton, *3,800 Early Advertising Cuts. Deberny Type Foundry.* (New York: 1991) 61

page 31: Bathing fashion dating from approximately 1920 In Carol Belanger Grafton, 3,800 Early Advertising Cuts. Deberny Type Foundry. (New York: 1991) 59

page 31: Suzanne Lenglen in her tennis clothes with a short skirt by Jean Patou In Ingrid Loschek, *Fashion of the Century. Chronik der Mode von 1900 bis heute.* (Munich: 2001) 73

page 31: Female skier in wedge-shaped trousers and waisted jacket, 1952/53 © Bogner

page 31: Female skier in tight overalls, 1972/73 © Bogner

page 31: Female skier in figure-accentuating ski overalls, 1976/77 © Bogner

page 31: Highly functional swimming fashion, front view © Adidas

page 31: Current tennis fashion, short little skirt © Adidas

page 31: Current tennis fashion, top © Adidas

page 31: Current skiing fashion, 2008 © Bogner

viola hofmann / page 32-37

page 32: German Federal Cabinet, 2002, Presse- und Informationsamt der Bundesregierung, digitale Bilddateien 35118

page 33: Vladimir Putin – Various Outfits, *Die Rheinpfalz*, No 276, 28 November 2007, 03_POLI

page 34: Chancellor Adenauer, 1957 – Proper Look even at Stove, Stiftung Haus der Geschichte der Bundesrepublik Deutschland. *Bilder und Macht im 20. Jahrhundert* (Bonn: 2005) 105

page 35: Minister of Foreign Affairs Fischer, 1998, *Der Spiegel* 1998, No 38, 27

page 35: Angela Merkel after her style change shortly before the 2005 elections, *Frankfurter Allgemeine Sonntagszeitung*, No 27, 10 July 2005, 31

MOVEMENTS & TRENDS

HOW WOULD YOU RECOGNISE THE PRESENT IN THE FUTURE?

By fashion, the philosopher Boris Groys would say. Because "it is precisely that which is in fashion today, which has the greatest chance of remaining preserved in the future – not as eternal truth, but as a permanently retained feature of a particular period. Above all, the new functions as fashion in history, since fashion stands for radical historicity." When confronted with the question *If you could travel fifty years into the future and look back upon the times we are living in today, what would you recognise as unmistakably characteristic of our times and today's fashion? How would you recognise the present in the future?* fashion students sometimes lapse into silence. It is obviously a difficult question; there are hardly any clear answers to give.

There are labels and short formulas needed in order to be able to orientate oneself in the flood of images in which fashion is communicated. Trends must have names so that the shops can dramatise them, and the buyers can consume them. A single item does not make a trend, rather it consists of many *requisites* in a series; it is an arrangement, a lived-in world.

According to the German communication and design theorist Norbert Bolz, the ideal of trend research is real-time analysis – to be present at the moment the new emerges and to give it a name. Trend researchers are name-givers. Facts lying before people's very eyes become visible to them only when they are given a name. That is why people very often get the impression that the trends are created, but they are only given a name. Trends are transferable, autopoietic cultural patterns. Similar to myths, legends and ideologies, a megatrend acts as an idee directrice, a directing idea. The trend guru Mathias Horx is of the same opinion and adds that it is not only about the *BN* – the brand new – rather it is about socio-cultural trends: a sum of the societal relationships as well as issues of culture, daily life, consumption, about the paradigm change in society or the state, and about the phenomenon of changes in value.

The constraint of permanent, constant change is putting pressure on the creatives – that is why the following questions arise: Which creative energies urge the cultural process forward, and what is the meaning of free, innovative imagination?

Andreas Bergbaur, the current press spokesman for Raf Simons, talked about the necessity for contemporary designers to cross borders more than ever, to keep pushing them further, expanding them, changing them, and to change fashion's perspective on the body.

There are attempts to estimate the lengths of the amplitudes, of the waveform-like movements, and to define parameters to predict their ups and downs, their ins and outs. Diverse fields in the fashion phenomenon are marked by the perpetual exploration of poles, borders and their shifting. And the tension remains with the question: What is still possible beyond *anything goes*?

Gerda Buxbaum

LECTURES

PORTRAITS

IMAGES

andreas bergbaur / contemporary fashion strategies of the 1980s and the 1990s

The term *Contemporary Fashion* does not refer to, as is often misunderstood, fashion happening now, in the present – it rather describes a very special group of designers with a very specific statement and attitude. As Angelique Westerhof has appropriately put it: "Contemporary Fashion is what pushes the boundaries of fashion forward." Indeed, the representatives of this movement transgress the boundaries of fashion, they keep pushing them forward and they keep modifying the body perspective. It is a fairly small group of designers, a so-called avant-garde. Since the term avant-garde is a historical term, *Contemporary Fashion* has replaced it as a denomination for these avant-gardists of the 1980s and the 90s.

To describe the phenomenon, the difference between high fashion – show collections shown exclusively on the catwalk – and the collections for sale should be explained. Contemporary Fashion is featured in show collections where the designer creates an image linked to a statement, which stimulates the public perception as well as the sales effect. The best example of this is the revival of haute couture and with it, the big French fashion houses such as Balenciaga, Dior, Givenchy, etc. These companies live off their image and through it primarily sell accessories – fashion products that generate the real turnover, which in turn finances the show collections. The couture itself has been nonviable for a long time, not even in France, although Paris still represents the centre of the international fashion scene.

In the following paragraphs several exemplary positions in Contemporary Fashion that created an international furore are illustrated. The examples are not supposed to represent topicality, but innovation.

The forerunners of Contemporary Fashion in the 1980s were, for instance, Jean-Paul Gaultier, Christian Lacroix or John Galliano. Their strategy was first to tell a story with their collection, to select and elaborate themes. Also the label Comme des Garçons of the Japanese artist Rei Kawakubo started to design collections, already in the 1980s, which deconstructed the Western costume, bringing completely new forms into fashion and contradicting the prevailing ideal of beauty. An example of her working technique is to dismantle and reassemble garments: for instance, by sewing a sleeveless suit jacket onto a dress or by mixing various historical and cultural styles, such as a classic kimono with suit lapels, a corset with a shirt or a Biedermeier form with flattened shoulders. In addition to that, Rei Kawakubo's sense of colour and pattern mix is captivating. She is one of the few designers who tried almost all techniques – classical materials, such as a checkered fabric, are combined with African patterns or flower patterns from the 1970s.

Another example is Martin Margiela from Antwerp, who studied under the guidance of Jean-Paul Gaultier. His first collection, based on the concept of oversizing and sampling, was presented in 1988. Classical sampling –

assembling various garments to obtain a new garment – is actually a technique borrowed from music. Examples of Margiela's sampling techniques include a T-shirt with an applied photo of a trench coat in original size or a dress put onto a man's trousers so that you cannot say whether the person is wearing a pair of trousers or an apron. All his garments originate from a mannequin. He takes a pattern design, works on it over and over again, makes jackets, trousers, dresses and puts once again semi-finished pattern designs onto them. With this method Martin Margiela makes visible what has remained hidden in fashion so far – the construction aspect in the process of their creation. During shows and presentations the clothes are to the fore, the models remain in the background and are not supposed to be seen, because it is not about a person or a personality. Margiela takes this philosophy of deconstruction a little further: no colours, no logo, no brand name, no interviews, no personal appearances. The label was originally only a white label, now it consists of three lines filled with numbers. Each number stands for an individual line: no. 10, for instance, stands for men's collection, no. 6 stands for women's collection. Apart from that, the label is anonymous, nameless – branded with four stitches on the inner side and thus recognisable only for those who know what to look for. At the same time, everybody who knows recognises the label by its outer appearance. That makes it even more successful – the background brand-awareness creates the image.

Even Helmut Lang worked with the technique of deconstructing classical Western garments: by exposing the inner pockets of men's trousers outwards or by *skeletisation* of T-shirts and vests until only the cuff, the polo neck, the zip remained.

Another representative of the sampling and deconstructing technique is Hussein Chalayan, born in Nicosia and at home in London. His work is characterised by a mixture of various cultural influences and styles as was the case, for instance, in his winter collection 2002, in which he gradually dismantled and deconstructed an original costume from Chechnya through repeatedly adding Western garments to it. At the end there was just a black coat on which only several stripes of the original costume could be seen.

RIGHT: HUSSEIN CHALAYAN, FROM THE COLLECTION AUTUMN/WINTER 2002

The Englishman Alexander McQueen samples historical garments and fetish objects. An example of this is a Spain-inspired collection in which a vest and a suit jacket turn into a dress or a corset, which disintegrates and reveals the frills of a classical flamenco ensemble, classic leather fetish garments such as masks, lacings, corsages are combined with classical negligees, underwear, high leather boots, satin trousers, an ethnic coat is made out of a voluminous blend of fur and hair, or a historicising milkmaid cloak has

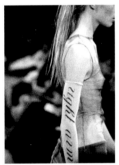

a giant pale lilac lacquered hood – Haute Couture operating with shock and taboo-breaking strategies.

The Dutch duo Viktor & Rolf use colour as well as a special blow-up technique in order to modify perception. Their winter collection 2001/2002 was exclusively black, the summer collection 2002 entirely white. They create gigantic details such as a waistcoat with a plunging neckline, exaggerated puff sleeves turning into wings, giant collars, bows, ties. They exaggerate and manifold, for example they put the same collar design five times on top of each other.

TOP LEFT: VIKTOR & ROLF, READY TO WEAR, COLLECTION 4 (WHITE), SPRING/SUMMER 2002

Another example of fashion renewal is the Antwerp designer Ann Demeulemeester who primarily deals with the image of women in her fashion. Her models do not conform to the classical beauty ideals as we know them from Paris, rather they reveal a cruel yet simultaneously fragile image of women. Her role model is the singer Patty Smith, to whom she refers to time and again. That is why her collections have something *rock*. Another form of expression she uses is written word. An example is her 1998 collection: sleeves with handwriting, transparent T-shirts with inscriptions etc. The feminine and simultaneously harsh line of her work can also be seen in the use of material – she loves using leather as if it was woven fabric. Another example would be her knitted ensemble consisting of military trousers, boots and belt – very martial and soft at the same time.

LEFT: ANN DEMEULEMEESTER, FROM THE COLLECTION SPRING/SUMMER 1998

Casting arranged by the representatives of Contemporary Fashion significantly changed fashion shows in the 1990s. The strategies ranged from street castings to film, and most of the designers work with very special models who work only for them and thus increase the effect of recognition. One of those designers pushing the castings into a very extreme direction is definitely Raf Simons. He took Punks, Mods and Skins as his role models; his models were predominantly young people under eighteen. Another example is Veronique Branquinho. One of her role models is Laura Parker, a character from David Lynch's *Twin Peaks*: a very dreamy school-girl-like apparition, yet menacing at the same time. The collections here were very Victorian – high collars, long skirts, trousers with narrow waists and cuffs, ponchos. Everything was very tight, delicate and fragile.

Another method of enhancing the atmosphere is repeatedly presenting one and the same outfit – you get to see it three times, five times, eight times. In one of his shows Raf Simons directly referred to the German music band Kraftwerk from the 1980s: red shirts, black ties, classical men's trousers, very pale make up, red lipstick and the music by Kraftwerk.

In addition to references to film and music, it is the fine arts that established a close relationship to fashion in the 1990s. On the one hand, visual artists are inspired by fashion; on the other hand they are inspiration for many fashion designers. Artists such as Beverly Semmes or Vanessa Beecroft use fashion as a medium in their installations as is the case, for instance, with oversized space-filling garment sculptures by Beverly Semmes. Vanessa Beecroft arranged performances reflecting the public image of the models, and thus the image of femininity. In the New York Guggenheim Museum she exhibited young girls in Gucci underwear and Gucci pumps, in Kunsthalle Vienna the girls were completely naked except for the Gucci boots.

A groundbreaking exhibition including fashion designers and artists alike took place during the Florence Fashion Biennial in 1996, where more than forty designers and artists – ranging from Orji Yamamoto and Karl Lagerfeld to Martin Margiela, from Tony Cragg and Roy Liechtenstein to Beverly Semmes – exhibited their work.

Martin Margiela is one of the more conceptual *exhibition organisers* among the fashion designers: his exhibition on perishableness was legendary – the exhibited clothes, previously infected by fungi, were rotting in the course of the exhibition.

The Antwerp designer Bernhard Wilhelm represents a contraposition to highly intellectual fashion with his extremely naive prints and graphics resembling children's drawings, as could be seen in his 2002 collection, in which oversized sweaters were decorated with big colourful dinosaurs and flower patterns. His models are carefully selected from his circle of friends or from the streets. The men's collection 2003 was presented by a break dance group.

In conclusion, one can say that Contemporary Fashion designers intensively focus on target groups and topics. They are looking for niches in order to establish a very specific image; only the second step involves sales and marketing. Once the image has been established and branded internationally, the process of marketing and sales in cooperation with big fashion houses starts and eventually the sales of their own label can take place – such was the case with Alexander McQueen and Gucci or Helmut Lang and Prada.

andrea kirchner /
colour connections

Colours involve questions: how do sudden emotions towards a colour emerge, certain colours that suddenly appear on the market, who is behind all this, at whose mercy are we, how can this happen actually?

There is, in fact, only one answer to these questions: it is us who dictate the colours and let them be created. It is in us, our aspirations, emotions, desires, which are behind all this. Colour is like a key, a code for expressing the things we cannot always create with language or pictures. The colour is a very subtle, abstract form of representation.

A brief glimpse on why it is we who create this awareness: if we consider the colour beyond the measurements, beyond the rules of physics, beyond all the oscillations and wave lengths; we arrive all the way back at the archaic, at the archetype colour. One says that colour is in fact the absolute archetype of human being. If we think of our origins, we think of a pure white light. Look at the example of a rainbow. There are always seven colours in a rainbow, starting with red. Its structure is very simple: red – orange – yellow – green – blue – indigo – violet. Green is in the middle – that is why this colour is always symbolic of harmony.

These are the seven primal principles of human existence, the mirrors of our inner desires, our inner being. It is the language of life. Whenever we look into colours, the world reveals itself. This is, of course, a very advanced stage, but actually very simple. It is because we carry this within ourselves that we can communicate with colours so beautifully.

The market and fashion know very well how they can reach us and with what we can be attracted. It is always very interesting to observe these phases – be it in fashion or in our personal lives – when, for example, one strongly dislikes a specific colour and says, *this colour isn't trendy, I don't like that colour* or *I don't feel good in that colour*. Often, the reason why we do not like a particular colour is closely linked to a certain lack of this colour quality in us. It would dare us to look into a place we do not want to see. That is why there are these phases – and we all know them – where we suddenly dislike or prefer a particular colour. It is a rhythm we are governed by.

Colour is closely related to consciousness. Consciously experiencing a colour is a very introverted as well as a very powerful subconscious process. Colour is deep within us, and this is why we can be manipulated with various colour trends in fashion.

Colour sends out signals, it wants to communicate with us. Colour often wants to attract our attention to something, to point something out; colour has the power to give us a key. If we take that key and unlock gates, we are faced with completely new horizons. It is like a code of our primal being, of our desires and the desire for completion. All of us share a deep desire to be complete, just like a rainbow appears to be perfect and complete. With colours, we try to achieve something that might not be achieved elsewhere in life.

Colours are messengers of our hidden emotions. Through the colours we wear and decorate our flats with, or even through the colours we prefer in food, we can express many aspects of our personality, aspects that we are often unfamiliar with. They are spontaneous inner expression.

Colour is a form of language, though not a spoken one. If one looks carefully, it is often almost similar to a sound or a vibration. It is on more subtle level – a kind of image become form.

Colour is closely related to our collective consciousness, collective senses and desires. It is very exciting to observe how similar our statements are although we might never communicate with each other.

Colour is the absolute forefield where nothing has yet become form – where there is simply the inspiration and the impulse that one must give. One must activate something in people, which must dye their fabrics or create prints, so to say. It has solely to do with impulse, with fundamental oscillations, and I would like to illustrate this through the colour blue.

It is a colour, interestingly enough, which has been trying to enter the fashion market for many seasons. It has been rejected for a long time because it is regarded as conservative – it doesn't really have a foreground position. We were longing for something else. After the turn of the 20th century and after the shock of 9/11, when one can say we fell into a grey area, people were attracted to red, orange and everything evoking vitality and confidence – while blue is a rather cautious colour.

But there is something of definite interest: if you look at various fashion collections, you will see that almost every designer has launched a blue collection. It just has not been accepted by the market so far. There is an uncertainty about how it happened that we are suddenly confronted with so much blue. Two seasons ago, the colour turquoise was very strong, almost as if to presage blue on the market - and now it is totally about blue.

What is the first quality we associate with blue? For most of us it is the water, it is expansion, being free, floating in boundless space. The interesting point, however, is that the water is not really blue. It is a type of reflection that we perceive as blue. The colour, once again, is not clearly defined. Blue often symbolises peace and quietness – when we see the colour blue we can relax, our thoughts can calm down, we become contemplative, we feel at peace. But if we are exposed to the colour too much, it could slow us down or make us feel tired. That is the reason why many people who are rather passive by nature cannot stand blue, since it makes them even more tired.

Blue often reminds us of reflections, transparencies, of a somewhat unreal world. These images inspire companies producing fabrics and embroidery – they look for the appropriate fabrics and for ways of implementing these qualities, of incorporating transparencies into patterns.

Blue has much to do with absolute infinity, with distant horizons, with freedom of thought. Blue is here to make our spirits free. We have infinite possibilities of creating new thoughts.

In German there is the expression *to talk into the blue* – it is not only a saying, it has a definite background story. It means that somebody is talking into the distance without really knowing what he is saying. Blue is a metaphor for the distant, the far away, unreachable, not clear or defined.

In Vienna, there was the example of Yves Klein and his *Blue Revolution*. Yves Klein said that he associated blue with falling into infinity. It creates a feeling of absorption. He used to lie on the meadow for days and just observe the sky looking for the absolute blue. Blue also symbolises divinity, the transcendental. He believed to have created a very specific blue – one refers to it the *Yves Klein Blue*, which it is also called in all of Jil Sander's collections.

Another example is Picasso's *Blue Period*. For Picasso, this was a period of living on the edge since he was struggling for existence at that time. This period, naturally, had something to do with melancholy because his life was so strenuous and difficult. He simply tried to dive into another world, a blue world.

Notwithstanding its freedom of thought or infinity, the extreme form of blue can suddenly change into melancholy, almost into a sorrow. That is another reason why blue has been off the cards in fashion – there was a slight concern of pushing the world's instability even more towards melancholy. Infinite dimensions, perspectival illusions – we know from painting that one can create with blue the so-called aerial perspective where blue is depth. In perspective painting, one uses blue to create the effect of more depth, more space.

On the other hand, when we look at sky blue we get the impression that blue is a light colour. We immediately feel that we are being lifted, that we are floating, sky blue is associated with entrancement and transcendence. It is wonderful to see that there are exactly these two qualities, just as in real life, the light and the heavy – life is polar.

Blue is also a symbol of establishing relationships, of friendship, brotherhood, bridging the gaps between the opposites, of uniting the light and the dark, it is a symbol of sympathy.

What else is blue? Femininity, devotion, intuition. We know that red is a symbol of action, of the absolute, sometimes even aggressive, while blue is usually regarded as passive. This passive quality is not necessarily negative, it is an absorbing quality. And it also symbolises motherhood. We are all familiar with ancient Madonnas whose robes are usually an extreme hue of navy blue, symbolising protection, patience and devotion.

Blue flowers are a symbol in our culture. In nature, for instance, an iris is

associated with beauty and perfection. The iris was considered to be the absolute in beauty preparation in Egypt. One simply had to put this blue quality, this femininity, on the body. Women used to wash with it and bathe in it. If we imagine a blue flower we immediately think of fidelity. Why? Just think of a forget-me-not, a very strong symbol of fidelity.
The Blue Flower of Desire written by Novalis, is an imaginative novel, narrating about aspects present in the lives of all of us. All of us share a desire for something indefinable. This desire is beautifully depicted in this novel.

What else is blue? Dreams, fantasy, secluding oneself. The sphere as one of the three basic forms is a symbol of blue. Blue animals, which are rather rare and colour their feathers blue only at specific times, are associated with secrets.

The blue hour – the night side. We describe the night as being blue, although it actually appears black. Here again, you have this symbol of a secret. The blue hour begins around dusk – it is the first time in the day to relax, to let go.
Blue enables us to look into various worlds. Blue is like a bridge. We can look into our world and we can look into another, more mysterious world. Blue is a bridge helping us to reach that world. When blue shifts towards turquoise it is unbelievably communicative. It is not reserved or meditative any more – as soon as a little bit of yellow steals in, it becomes extremely communicative.

Another interesting aspect is that blue is the colour of working clothes and uniforms. Why? It is the aspect of order that plays an important role here. Blue has an ordering structure. It has somehow a quality of equality, of not hierarchically differentiating from others.
Despite a chaotic situation, blue can have a very withdrawn quality, whether on fabric prints, embroidery or elsewhere, whereas red immediately carries you away. Blue is distances itself and often has a neutral role.

Following another tradition blue is associated with boys and pink with girls. There are many explanations, but none sufficient, for this phenomenon. One of the better is that blue is a feminine quality, so people try to balance the masculinity in a newborn boy by dressing him in blue clothes. Vice versa, girls are dressed in pink to balance out lacking masculinity.
Blue establishes relationships. If you blend blue and red, you obtain a rather earthy colour. The blue colour is no longer so distant, it is not so far away, now it moves closer to us. In contrast, green and yellow stress this airy quality of blue.

Blue can be on borderline, especially in case of green – here you often have conflicts about whether a hue is still blue or already green. In any case, in these border areas blue can become very empty, approaching passivity, and even unnoticeably subtle.

li edelkoort / a profile

(edited by rd, statements philip fimmano) Li Edelkoort is one of the world's most renowned trend forecasters. Her work has pioneered trend forecasting as a profession; from innovative trend forums for the Première Vision textile fairs to long-range lifestyle analysis for the world's leading brands. By announcing the concepts, colours and materials which will be in fashion two or more years in advance the Edelkoort team helps professionals to interpret the foreshadowing signals of consumer tastes to come, without forgetting economic reality.

"Trend forecasting is not something that dictates what trends are. It is a kind of archaeology, where one is digging all around and finding pieces of information – a fragment of a ceramic, a little hairbrush, a way of making food, and so forth – and by analyzing and putting all these pieces together one can form a picture of society, the only difference being that it is done for the future instead of in the past."

"When Li is working, she is reading the newspaper, talking to students, visiting exhibitions, travelling, shopping, eating out in restaurants and constantly scanning information. She stores all these fragments in her brain and at a certain moment she identifies a correlating movement she thinks is growing. And this is when she predicts a trend."

The headquarter of Li Edelkoort is based in Paris. The company consists of several units: Trend-Union, Studio Edelkoort, Edelkoort Editions and Heartwear. For Trend Union, Li produces her general Trend Book every six months in a limited edition of 200 copies. She expresses the forthcoming trends in pictures, words, fabrics and materials that originate from all over the world and carefully compiles them by hand with her team. While Li is travelling looking for fabrics and other sources, she is simultaneously collecting thousands of images. The result of this six month research is the main Trend Book,

which is a forecast of the two years ahead aimed at professionals from fashion, textiles, marketing, merchandising and packaging.

"Our target group is visual people, they understand images and tactilities perhaps much more than they understand words."

Eight other books are part of a constantly renewed trend forecasting library:
- The Colour Card for the season is a large fabric edition of the season's colours, complete with a trend book of colour harmonies and scissors with which to cut and develop specific colour cards.
- The Beauty Book sets forth the trends for the cosmetics, make-up and perfume industries.
- The Pattern Book defines motifs and colours for the coming seasons.
- The Key sets forth the key shapes, forms and details for the casual clothing industry.
- The Menswear Colours is created for the men's fashion industry.
- The Lifestyle Forecasting Book presents the newest trends in the field of design, interiors and decoration.
- The Well Being Bible, created for the growing well being market, consists of fabric swatches, colour combinations and images.
- The Architecture Book is an analysis of the upcoming movements in architecture and building concepts, materials and colours.

"As a fashion designer you have to look around, you have to know about lifestyle issues, like design, cosmetics, food and even cars. The big fashion companies often have their own trend people in house. They are doing similar work to us, but specifically and exclusively for their own brand."

Alongside the trend books, Edelkoort Editions issues two magazines biannually: View on Colour and Bloom. The latter arose from the increasingly important trend of gardening in the 1990s and explores the connection between nature and design.

"The magazines reach a wider audience since they are distributed in higher numbers and are less expensive than our other products. The trend books range from 1 500 € to 2 200 €, depending on the product. The magazines sell for 65 €, which is an inexpensive price for such a trend tool. The magazines are available on the Edelkoort website or at selected magazine stores."

Studio Edelkoort is a think tank and consultancy unit for brands, designing and defining strategic directions regarding a brand's identity, as well as conceiving and designing products. By means of studies, the studio helps their clients understand the past to better visualise the future, in order to better accompany them during the various stages of the strategic process. This involves understanding how the company functions, why it does and what is its nature. Complementing the strategic work, the studio intervenes in the product and graphic design, packaging, publicity, concepts and events. Studio Edelkoort operates on the mass market as well as that of luxury products. The clients range from cosmetics, like Shiseido or Procter & Gamble, to the car industry, with Nissan's Micra being one of the outstanding reference products where Li Edelkoort was at the origin of the first concept.

"In the last century, art was the driving force for culture. In the 21st century it will be design."

In 1993 Li Edelkoort co-founded Heartwear, a non-profit association which helps artisans in developing countries tailor their products for export without compromising the skill, knowledge, culture and environment of the region involved. Heartwear has chosen to manufacture high-quality products and to distribute them on a smaller scale: by mail order, direct sales and wholesaling. Once Heartwear has established a link with a region or a collective, it tries to sustain a long-term relationship by developing and evolving the local specialty on offer. For instance, Heartwear

has developed indigo textiles for home and fashion with artisans in Benin, ceramics with potters in Morocco, and khadi cotton and silk in India.

Profits are re-invested in the home country with the ultimate purpose of making these cottage industries independent and generating an economic pulse in the region through local and export markets.

"Heartwear is an example of how trends can generate and influence charity work and humanitarian aid."

Born in Holland in 1950, Li studied fashion and design at the School of Fine Arts in Arnhem and upon graduation became a trend forecaster at the leading Dutch department store, the Bijenkorf. There she discovered her talent for sensing upcoming trends and her unique ability to predict what consumers would want to buy several seasons ahead of time. In 1975 she moved to Paris working full-time as an independent trend consultant. From 1999-2008, she was also highly influential as chairwoman of the renowned Design Academy Eindhoven.

In 2003 TIME Magazine named her as one of the world's 25 Most Influential People in Fashion. In 2004 she received the Netherlands' Grand Seigneur Prize for her work in fashion and textile, and in 2005 Aid to Artisans honoured Edelkoort with a Lifetime Achievement Award for her support of craft and design. In March 2007 she was named Chevalier des Arts et des Lettres by the French Ministry of Culture, and in 2008 she was made a Knight in the Order of Oranje Nassau, the Dutch Royal Family. Li Edelkoort also curates exhibitions for museums, and in 2007 she founded the Designhuis in Eindhoven, a cultural space that presents innovative design. Archeology of the Future, a major retrospective about Li's work, will be on display from January 22 - March 8, 2009 at the Institut Néerlandais in Paris.

www.edelkoort.com

christopher breward /
fashioning histories of the city:
researching clothing in london

This is a paper about fashion and the city. More specifically it is a paper about the ways in which I approached the subject of fashion and its role in the lives of Londoners during the modern period in my book *Fashioning London: Clothing and the Modern Metropolis*, published by Berg in 2004. Unsurprisingly it derives its theoretical underpinnings from the exciting work that has been completed over recent years by scholars in the disciplines of cultural studies, art and design history, architectural criticism and theory, human and cultural geography and social and economic history.[1] Yet while several groundbreaking texts emerging from these fields of study have acknowledged the important connections to be made between histories of place, sartorial cultures and defining moments of modernity, the crucial status of fashion as a motor for urban change and the formation of metropolitan identities has so far been rather overlooked or taken for granted.[2]

Such academic myopia is partly due to the ubiquitous presence of fashion in the day-to-day rhythms of city life and to its tantalising ephemerality. This has perhaps had the effect of setting fashionable clothing beyond the sights of historians with more *serious* political concerns or a scrupulously empirical bent. A relative paucity of published work in this field is also a result of the tendency of many scholars to dismiss fashion as a superficial symptom of modernity rather than seeing it as an active agent of progress in the manner of other creative practices such as architecture, film or fine art. Furthermore, like the metropolis itself, fashion is marked by the complexity of its many-layered meanings, which makes any attempted analysis an especially fraught endeavour. It is a bounded thing, fixed and experienced in space – an amalgamation of seams and textiles, an interface between the body and its environment. It is a practice, a fulcrum for the display of taste and status, a site for the production and consumption of objects and beliefs; and it is an event, both spectacular and routine, cyclical in its adherence to the natural and commercial seasons, innovatory in its bursts of avant-gardism, and sequential in its guise as a palimpsest of memories and traditions. These shared characteristics endow both cities and clothes with a vital energy that begs further explanation and helps to define the structure and focus of what follows.

In the absence of a discrete literature of urban fashionability, I want to open this paper by isolating just three statements on method from the richness of general theoretical works dealing with the nature of urban culture. Though they represent only a partial approach to the practice of constructing a sartorial history of the city, in their different ways these texts have guided me toward a useful working framework for studying fashion in its spatial and temporal contexts; one that moves beyond the frustrations imposed by disciplinary boundaries and recognises the very special circumstances that endow London fashion with its unique emotional, economic

and aesthetic imprint. First, working in an arena that initially seems very remote from the concerns of the fashion historian, literary theorist Julian Wolfreys is interested in the representation of London in nineteenth-century literature, as a terrifying and unfathomable spectre. He is critical of the way in which many historians have attempted to use the writings of authors such as William Blake or Charles Dickens as a key to understanding the *real* London because in his view the written and the material city are both fugitive experiences, contingent only on the particular position of the beholder. In this sense the city exists for Wolfreys almost as a form of filmic representation, in constant flux, knowable only through traces and chance recollections. In effect the written city is not so far removed from the circumstances pertaining in fashion culture, where representations of fashionability are bound into a system of periodic renewal and retrievable in fragments, never as a coherent whole:

"Attempts to write the city's sites and spaces carry in them an understanding, at the level of grammar, syntax, rhetoric and enunciation – in short at all levels of form – of the excess beyond comprehension which is the modern city… It hovers beyond the possibility of simple representation, but is never yet reducible to a series of simulacra. *London* does not name a location or base. Instead it names a multiplicity of events, chance occurrences and fields of opportunities… In assigning a city a history we overwrite a past on to what has always been a city in the act of becoming, a city always in the process of self-transformation. Such an overwriting erases the transformative becoming-modern, the city's constant movement towards a future which is yet to arrive."[3]

Geographer Nigel Thrift works against interpretations of urban culture based around theories of representation in his plea for a theory of the city, which prioritises its haptic properties as a phenomenon that is felt, heard, smelt and tasted as much as it is seen, as a place situated in the concrete world of the here and now rather than residing solely in the imagination or as a figment of purely scopic regimes. In this request he echoes the demands of recent fashion theorists for a study of clothing which acknowledges its proper relationship to the body, and opens up a space in which fashion, as much as architecture and planning, can be interpreted as a visceral part of the metropolitan experience:[4]

"The linguistic turn in the social sciences and humanities has too often cut us off from much that is most interesting about human practices, most especially their embodied and situated nature, by stressing certain aspects of the visual-cum-verbal as *the only home of social knowledge* at the expense of the haptic, the acoustic, the kinaesthetic and the iconic… Non-representational thinking argues that practices constitute our sense of the real… it is concerned with thought in action, with presentation rather

than representation… it is concerned with thinking with the entire body. In turn, this means that non-representational models valorise all the senses, and not just the visual, and their procedures are not modelled solely on the act of looking."[5]

The influential work of sociologist Michel de Certeau bridges the disparate positions of Wolfreys and Thrift by upholding the status of the city as an archive of many competing pasts, which are nevertheless *embodied*. He acknowledges its mysterious and subjective character but locates this in the sensate sphere of demotic actions, offering the silent stories of every-day life as a means of uncovering the obscured significance of metropolitan space. This combination of the mythic and the material which typifies de Certeau's account of the urban experience offers a fascinating model for extending the study of the metropolitan to an examination of dress; for the defining features of fashion, both as a concrete object produced and con-sumed in metropolitan situations, and as an ephemeral and unstable cipher for shifting desires and attitudes, would seem to hold as much, if not more potential than other elements of material culture for tracing the interplay of time and space which identifies the city as a cradle for modernity:

"Gestures and narratives… are both characterised as chains of operations done on and with the lexicon of things. Gestures are the true archives of the city… they remake the urban landscape every day. They sculpt a thou-sand pasts that are perhaps no longer nameable and that structure no less their experience of the city… The wordless histories of walking, dress, housing or cooking shape neighbourhoods on behalf of absences; they trace out memories that no longer have a place. Such is the *work* of urban narra-tives as well. They insinuate different spaces into cafes, offices and build-ings… With the vocabulary of objects and well-known words, they create another dimension, in turn fantastical and delinquent, fearful and legitimat-ing. For this reason they render the city *believable*, affect it with unknown depth to be inventoried, and open it up to journeys. They are the keys to the city; they give access to what it is: mythical."[6]

Other authors have of course already utilised such methods as those noted above and produced sophisticated accounts of the city and its myths. Richard Sennett for one has traced a fascinating history of city planning, urban experiences and their relationship to modernity through a careful deconstruction of the developing symbolism of the body in Western culture. His bodies, though, are generally abstracted or naked, or both; their veins, nerves and sinews adapted to the development of circulatory transport systems, receptive to the neurosis of the faceless urban crowd, or flexed in defence of political regimes and metropolitan institutions. But the body clothed and fashioned, as a signifier of the commercial, social and leisure spheres of the city, is largely absent from Sennett's reading.[7]

A handful of exemplary texts have positioned the idea of fashionability as a central concept of urban culture more emphatically, but I think it would be fair to suggest that these authors have been concerned primarily with other agendas than that of plotting the story of a city through the sartorial habits of its inhabitants: Valerie Steele with establishing a material history of the Paris fashion industries and their global dominance; Elizabeth Wilson with tracing the experiences of women in urban landscapes that have generally been defined as dangerous or constricting – where fashion is only one of several phenomena which have marked that experience as pleasurable or compromising; and Mark Wigley with uncovering the guilty and ambivalent debt owed by those modernist architects who planned the cities of the early twentieth century to the feminised sphere of fashion.[8] So, the productive identification of the relationship between fashion, space, time and place as a tool for the examination of metropolitan culture or the construction of urban histories has not thus far been directly approached as a meaningful project in its own right.

Geographer David Gilbert has, however, provided an appropriate template for the task ahead.[9] He suggests five historical themes which might be considered in any attempt to chart *the long-term development of the geography of fashion's world cities*. First Gilbert identifies the emergence of *modern* urban forms of retailing and consumption from the eighteenth century onward as a prerequisite for the rise of the fashion city. Such innovatory practice of commerce and display were concentrated in different and competing sites across the globe, but their development was marked at different stages in Paris and London, then Berlin and New York and finally in the twentieth-century Milan and Tokyo. Secondly he notes the economic and symbolic systems of European imperialism introduced during the eighteenth and nineteenth centuries, in which trade and labour established as part of the colonial project. This coincided with the increased circulation of stylistic codes for the exotic and the luxurious which placed European capitals at the centre of this real and imagined geography. Thirdly, and deriving from this same mobilisation of imperial power, fashion emerged as a currency that encouraged cities and nations to compete, its value equivalent to the promotion of state architecture, exhibition culture, grand street plans and organised tourism.

Gilbert also considers the influence of an American engagement with European fashion in the twentieth century as a defining factor in a popular, global understanding of the generic fashion city. In this conflation of influences, Hollywood imagery branded an understanding of Paris as world fashion capital on the Western consciousness, while New York developed as a particularly concentrated example of the promotion of a city as a spectacle of commercial culture. London, in this vision, featured either as a bastion of tradition and conservatism or as a gothic formation of fog-shrouded

alleyways, the frightening home to high fashion's *other*. Finally Gilbert positions the development of a symbolic ordering of cities within the fashion media as a key influence on the ways in which fashion is currently understood in an urban context and vice versa – noting the growing tendency of stylists, photographers and advertisers to conflate urban culture itself with the consumption and experience of fashion. As he suggests, "if fashion culture enjoys inventing and re-inventing its urban geography, it retains a certain conservatism about its world centres". For Paris, New York, Milan or London "the rhetoric is sometimes one of newness and dynamism, but more it is of an almost organic sense of fashionability growing out of the rich culture of metropolitan life".[10] This tension between longer histories and future projections situated in fashion's status as a phenomenon of the present is perhaps what lends clothing and its representations such potency as a measure of city life and its development.

Taking the suggestion of Gilbert on board, my work therefore aims to examine the relationship of London's spaces and the inhabitants to the production and consumption of fashionable clothing from the late eighteenth century to the present. In researching a series of discrete case studies spread across two hundred years of change and stasis, I have endeavoured to pull together sources and methods that in combination shed new light on the developing material culture of the capital. In practice this has meant using the Museum of London's extensive dress, ephemera and other visual collections, drawing in items that are unfamiliar, or which when considered together with more *traditional* evidence provide new insights into the status of fashion as an important aspect of London's social, cultural and economic history.[11] This approach presents fashionable clothing as a further resource through which the story of a city might be written, and demonstrates how the production, retailing and wearing of dress in London has contributed toward the shaping of different locales, informing the material, emotional and spatial experience of city life across all levels of society.

The book I produced on the subject centers on particular areas of London and the iconic figures associated with them. Its organisation pays light-hearted homage to the picturesque tradition of categorising the city's teeming streets under the headings of a colourful gallery of characters, such as Laroon's Cryes of London Drawne after the Life of 1687, or the later investigations of Mayhew and Dickens.[12] In this way I hoped to illustrate the rise and mediation of identifiable *London styles* across different sectors of the clothing and retail trades and the population at large, and tell the story of the city through its garments, with fashion joining architecture and other material artefacts as a form of urban biography.[13] While individual case-studies included a close analysis of one or more garments, chosen either because of their links with the geographical area under study (generally they were made, worn or sold in the vicinity) or to suggest

the broader social and aesthetic concerns of the local population during the relevant period. From a consideration of the material object, chapters developed to incorporate discussion of the representation of fashionability in space, linking clothed bodies to the built environment, the life of the street and the wider dissemination of *London style*.

In this manner I set out to reposition London's own clothing cultures as an important influence on the development of global fashions. I focused on Londoners as arbiters of a distinctive and compelling sense of style. And I showed how the production and consumption of clothing has echoed and influenced London's economic fortunes, cultural status and demographic health during the modern period. However, while I provided some evidence for the ways in which fashion ideas have been developed, made concrete and disseminated in London at key moments, my book made no pretence at offering a smooth and all-encompassing fashion history. Rather it foregrounded fashion as a *memorialising* practice which underpins our comprehension of space and time as vividly as the built environment or the social, economic and cultural infrastructures through which its forms and shifting meanings are manifested.[14] In this sense its content is as subjective as any remembered event, and as fragile as the state of any discarded garment.

The first chapter concentrated on the development of Savile Row, Bond Street and the district around St. James's Palace as a locus for one of the most influential and long-lived London styles – that of the early nineteenth-century gentleman dandy. The juxtaposition of the tailor's workshop and the dandy's dressing room linked issues of production and consumption, while contemporary accounts and examples of dress illustrated the extensive nature of the male wardrobe and showed how London manufacturers and retailers established themselves as the originators of the typical dandy's look. Visual and textual material focused on those personalities and pastimes associated with the dandy lifestyle, drawing out the connections to be made between high- and low-life in the formation of a modern fashionable style. The emergence of the West End as a centre for leisure and retailing concerns focused on aristocratic patronage provided the architectural grammar and the concomitant organisation of streets, parks and squares during the period and offered a spatial context for considering issues pertinent to the public display of masculine tastes and desires.

Chapter 2 broadened out the theme of contrast in geographical and racial terms, presenting the elite dressmaker's showroom and the sweatshop as prime sites for the construction of fashion-related identities in the mid-nineteenth century. Beyond these specific spaces the section also considered the importance of the *urban exotic* in fixing London as a centre for imaginative explorations in metropolitan fashion cultures. The elaborate artifice on display in Regent Street is linked here with the

aestheticisation of poverty and *otherness* by journalists writing on the East End. The second-hand clothes trade and growth of immigrant communities in Whitechapel, Wapping and Bermondsey offered an ideal opportunity for showcasing the sublime confusion of clothing worn by the London poor alongside the opulent choices of the wealthy, while the figures of the foreigner and the middle-class shopper were elided in a potentially dangerous manner. This was a period where the contrasting textures and colours of clothes lent themselves to authors who where attempting to describe the feel and atmosphere of the Victorian metropolis.

Chapter 3 concentrated on fashion as an important component in the development of London's mass-leisure industries in the late nineteenth and early twentieth centuries. Orientating itself around the Strand, it aimed to show how ordinary Londoners engaged with an idea of their city that was both cosmopolitan, bohemian, fun-loving, modern and seemingly democratic. The extravagant dress worn by actresses and music-hall performers established a pattern of accessible *glamour* that linked the risqué attractions of burlesque to the promotional techniques of London's new garment industries. Supporting ephemera and visual material was used to consider the role played by the city's burgeoning culture of theatre and fashion promotion in both fixing and circulating a fashionable style of London dress. Despite the local prominence of designers such as Lucile and style-leaders such as Marie Tempest, this was also a period when fashionable Londoners looked out toward other centres for their stylistic cues – to Paris, Berlin and New York – while the developing touristic and official culture of their city increasingly embraced a repertoire of city-types, whose clothing and context announced a forward-looking version of London that prioritised the spectacular, the innovative and the unashamedly sentimental aspects of urban living. Thus the dapper guardsman, the chorus girl and the newly emancipated working woman were as representative of a London version of style as the gaudy attractions of a frenetic Oxford Street.

Through the inter-war figures of the Society hostess and the suburban housewife, Chapter 4 traced the divergent strands of conspicuous pleasure and conservative respectability that typified London fashion culture after the First World War. Elite provision continued along the lines established in the late nineteenth century, with Mayfair and Kensington emporia offering aristocratic women bespoke service in opulent surroundings. At the same time the reorganisation of the ready-made garment industry along Fordist lines provided middle-class women with well-made suits and frocks which became a staple of suburban good form. These conflicting worlds met at intersections engineered by London's transformation into a modern twentieth-century city. At the cinema, in the dancehall and on the underground the democratic potential of metropolitan fashion was refined for a new generation.

Reconstruction and transition provided the major themes for Chapter 5, which looked to Mayfair and Belgravia, the working-class districts of South London and the no man's land of Soho as the districts which established themselves in the minds of consumers, visitors and commentators as the cradles for a distinctive London style in the post-war period. The contribution of elite London designers including Digby Morton, Victor Stieble, Hardy Amies and Norman Hartnell to the creation of a refined form of English elegance in women's wear formed the background to a more sustained analysis of the concurrent rise of New-Edwardian dressing for men in the 1940s and early 1950s. Men's wear in this period takes on a particular prominence due to its London roots and its links through to subcultural forms of dressing in the following decades. The terrain is perhaps a familiar one, but the chapter endeavoured to show how these enduring styles interweaved with the geography and changing social fabric of London's *bohemian* and subaltern quarters, mirroring those patterns of gentrification and redevelopment that in their different ways went on to transform areas such as Brixton and Hackney, Islington and Covent Garden.

Chapter 6 unpacked the most famous period in London's development as a fashion city. In the youthful figure of the Dolly Bird, the world's media found an icon for Swinging London, and on the surface her emancipated lifestyle and challenging dress sense symbolised all that was progressive about the capital in the 1960s. Looking to the Kings's Road as the main artery of London's fashion renaissance, the study also charted the more reactionary currents that flowed beneath the Swinging City, noting its elitist tendencies, sexist assumptions, amateurism and nostalgic sentimentality. In the end, the heady excitement of 1965 seems to have been captured most effectively in the mirage-like output of the image-makers. Beyond the puffery of the lifestyle magazines and *experimental* films, however, the real legacy of the Dolly Bird was the emergence of the nihilistic Punk in the following decade.

The last chapter presented late twentieth-century London as a fashion city defined through its long-standing culture of innovative entrepreneurship and a corresponding sense of confusion and decay, which have perversely encouraged creativity. This was illustrated through examples of progressive design and retailing which blurred the boundaries of fashion while drawing on London's extraordinarily rich cultural fabric. The roots of this phenomenon can be traced through the fashion training provided by London Art Schools and in an older tradition of small scale workshop production, which has always dominated the London fashion trades. But the continuing attraction of London to global brands and international consumers was here considered through an examination of the thriving network of counter-cultural street markets unique to the city, such as one of the major themes of the book (of the tension between individualism and commodification which has continually generated new versions of urban fashionability),

and through an ongoing emphasis on the diversity, contingency and mystery of London as expressed through its clothing.

This sense of contingency and wonder brings me finally to a quotation by the architectural theorist Ignasi De Sola-Morales. Cited by Julian Wolfreys in his work on the nineteenth-century urban text, I think it reinforces how close the fugitive experience of the city and the fleeting meanings of fashion are, suggesting not least through its evocative idea of the *fold* how one might be constitutive of the other. Ultimately it provides an eloquent motto for anyone seeking inspiration in London's sartorial past:

'The city is comprehensible only as a culture of the event: a culture that in the moment of fluidity and decomposition leading toward chaos, is capable of generating instants of energy that from certain chaotic elements construct... a new fold in multiple reality... The event is a vibration... a point of encounter, a conjunction whereby the lines of a limitless itinerary cross with others to create modal points of outstanding intensity... It is a subjective action, producing a moment of pleasure and fragile plenitude.'[15]

literature/notes

1 Important publications on the culture of city life include:

 M Auge, *Non-places: Introduction to an Anthropology of Supermodernity* (London: Verso, 1995)

 W Benjamin, *The Arcades Project* (Cambridge, MA: Belknap, 1999)

 W Benjamin, *Charles Baudelaire: A Lyric Poet in the Era of High Capitalism* (London: Verso, 1983)

 M Berman, *All That is Solid Melts Into Air* (New York: Simon & Schuster, 1982)

 I Borden, J Kerr, A Pivaro and J Rendell (eds), *Strangely Familiar: Narratives of Architecture in the City* (London: Routledge, 1996)

 V Burgin, *Some Cities* (London: Reaktion, 1996)

 M de Certeau, *The Practice of Everyday Life* (Minneapolis: University of Minnesota Press, 1998)

 M Davis, *City of Quartz* (London: Verso, 1991)

 R Finnegan, *Tales of the City: A Study of Narrative and Urban Life* (Cambridge: Cambridge University Press, 1997)

 D Frisby and M Featherstone (eds), *Simmel on Culture* (London: Sage, 1997)

 D Harvey, *Consciousness and the Urban Experience* (Baltimore: John Hopkins University Press, 1985)

 D Harvey, *The Condition of Postmodernity* (Oxford: Blackwell, 1989)

 D Hayden, *The Power of Place* (Cambridge, MA: MIT Press, 1995)

 H Lefebvre, *Writings on Cities* (Oxford: Blackwell, 1996)

 D Massey, *Space, Place and Gender* (Cambridge: Polity, 1994)

 M Miles, T Hall and I Borden (eds), *The City Cultures Reader* (London: Routledge, 2000)

 D Olsen, *The City as a Work of Art* (New Haven: Yale University Press, 1986)

 S Pile, *The Body and the City* (London: Routledge, 1996)

 J Raban, *Soft City* (London: Harvill, 1998)

 A Rifkin, *Street Noises: Parisian Pleasure 1900-1940* (Manchester: Manchester University Press, 1993)

W Rybczynski, *City Life* (New York: Scribner, 1995)

R Sennett, *Flesh and Stone* (London: Faber & Faber, 1994)

W Sharpe and L Wallock (eds), *Visions of the Modern City* (Baltimore: John Hopkins University Press, 1987)

N Thrift, *Spatial Formations* (London: Sage, 1996)

S Watson and K Gibson (eds), *Postmodern Cities and Spaces* (Oxford: Blackwell, 1995)

J Wolfreys, *Writing London: The Trace of the Urban Text from Blake to Dickens* (London: Macmillan, 1998)

S Zukin, *The Culture of Cities* (Oxford: Blackwell, 1996)

2 Important exceptions include:

C Breward, *The Hidden Consumer: Masculinities, Fashion and City Life 1860–1914* (Manchester: Manchester University Press, 1999)

S Bruzzi and P Church Gibson (eds), *Fashion Cultures: Theories, Explorations and Analysis* (London: Routledge, 2000)

N Green, *Ready to Wear, Ready to Work: A Century of Industry and Immigrants in Paris and New York* (Durham, NC: Duke University Press, 1997)

F Mort, *Cultures of Consumption: Masculinities and Social Space in Late Twentieth-Century Britain* (London: Routledge, 1996)

L Nead, *Victorian Babylon: People, Streets and Images in Nineteenth-Century London* (New Haven: Yale University Press, 2000)

M Ogborn, *Spaces of Modernity: London's Geographies 1680-1780* (New York: Guilford Press, 1998)

P Perrot, *Fashioning the Bourgeoisie* (Princeton, NJ: Princeton University Press, 1994)

E Rappaport, *Shopping for Pleasure: Women in the Making of London's West End* (Princeton, NJ: Princeton University Press, 2000)

D Roche, *The Culture of Clothing* (Cambridge: Cambridge University Press, 1994)

V Steele, *Paris Fashion: A Cultural History* (Oxford: Berg, 1998)

E Wilson, *Adorned in Dreams: Fashion and Modernity* (London: Virago, 1985)

E Wilson, *The Sphinx in the City: Urban Life, the Control of Disorder, and Women* (Berkeley: University of California Press, 1991)

3 J Wolfreys, *Writing London: The Trace of the Urban Text from Blake to Dickens* (London: Macmillan, 1998) 7

4 See J Entwistle, *The Fashioned Body: Fashion, Dress and Modern Social Theory* (Cambridge: Polity, 2000); J Entwistle and E Wilson (eds), Body Dressing (Oxford: Berg, 2001)

5 N Thrift, *Spatial Formations* (London: Sage, 1996) 7

6 M de Certeau, *The Practice of Everyday Life*, Vol 2 (Minneapolis: University of Minnesota Press, 1998) 141

7 R Sennett, *Flesh and Stone* (London: Faber & Faber, 1994)

8 V Steele, Paris Fashion: *A Cultural History* (Oxford: Berg, 1998); E Wilson, *The Sphinx in the City: Urban Life, the Control of Disorder, and Women* (Berkeley: University of California Press, 1991) and M Wigley, *White Walls*, Designer Dresses (Boston: MIT Press, 1995)

9 D Gilbert, 'Urban Outfitting: The City and the Spaces of Fashion Culture' in S Bruzzi and P Church Gibson (eds), *Fashion Cultures: Theories, Explorations and Analysis* (London: Routledge, 2000) 7.24

10 ibid., 20

11 For discussions of methods relating to the use of clothing as a historical source, see N Tarrant, *The Development of Costume* (London: Routledge, 1994); L Taylor, *The Study of Dress History* (Manchester: Manchester University Press, 2002); V Steele, *Fashion Theory*, Vol 2, Issue 4 (Oxford: Berg, 1998)

12 See S Shesgreen (ed), *The Cries and Hawkers of London: The Engravings of Marcellus Laroon* (Aldershot: Scolar Press, 1990); H Mayhew, *London Labour and the London Poor* (Harmondsworth: Penguin, 1985); C Dickens, *Sketches by Boz.* (Harmondsworth: Penguin, 1995)

13 In its biographical emphasis, this project draws inspiration from a tradition of historical, creative and sociological writing about London whose content has aimed to define the capital's shifting character through an analysis of the lives and attitudes of its people and its physical and material environment. Important twentieth century examples, drawn from the work of academic, journalistic, popular and cult authors include:

- F Madox Ford, *The Soul of London* (London: J. M. Dent, 1905, 1995)

- P Cohen-Portheim, *The Spirit of London* (London: Bastford, 1935)

- S E Rasmussen, *London, the Unique City* (London: Jonathan Cape, 1937)

- R J Mitchell and M D Leyes, *A History of London Life* (London: Longmans, 1958)

- S Humphries and G Weightman, *The Making of Modern London 1815–1914* (London: Sidgwick & Jackson, 1983)

- S Humphries and J Taylor, *The Making of Modern London 1945–1985* (London: Sidgwick & Jackson, 1986)

- M Moorcock, *Mother London* (London: Secker & Warburg, 1988)

- P Wright, *A Journey Through Ruins: The Last Days of London* (London: Radius, 1991)

- R Porter, London: *A Social History* (London: Hamish Hamilton, 1994)

- I Sinclair, *Lights Out For the Territory* (London: Granta, 1997)

- S Inwood, *A History of London* (London: Macmillan, 1998)

- I Jack (ed), *London: The Lives of the City*, Granta 65 (London: Granta, 1999)

- P Ackroyd, *London: The Biography* (London: Chatto & Windus, 2000)

- J White, *London in the Twentieth Century: A City and its People* (Harmondsworth: Viking, 2001)

14 See M Kwint, C Breward and J Aynsley (eds), *Material Memories: Design & Evocation* (Oxford: Berg, 1999) for discussion of material culture as a memorialising tool.

15 I De Sola-Morales in S Whiting (ed), *Differences* (Boston: MIT Press, 1997), cited in J Wolfreys, *Writing London: The Trace of the Urban Text from Blake to Dickens* (London: Macmillan, 1998) 203.

andreas bergbaur / images

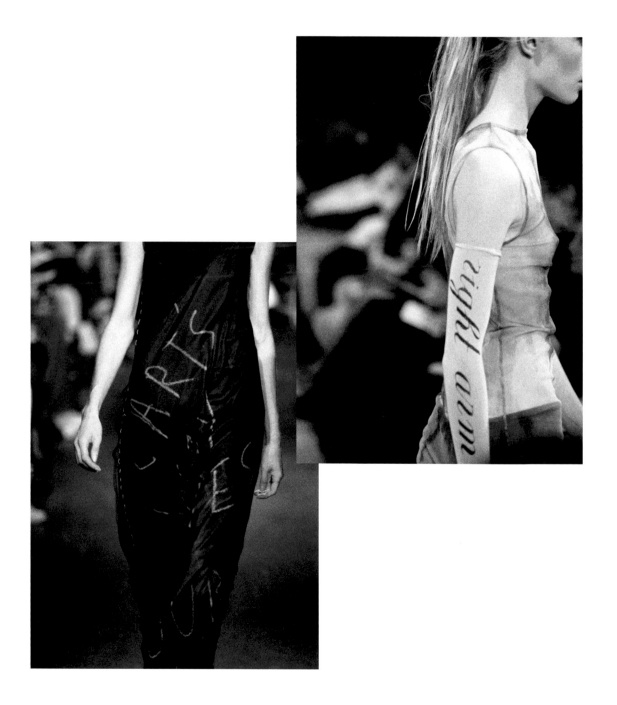

left: ann demeulemeester, from the collection spring/summer 2000
right: ann demeulemeester, from the collection spring/summer 1998

andreas bergbaur / images

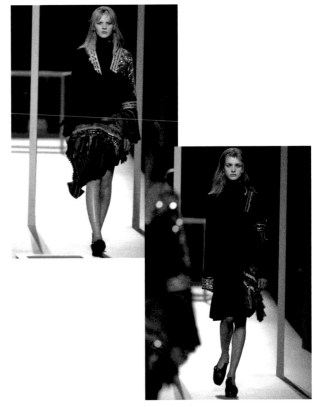

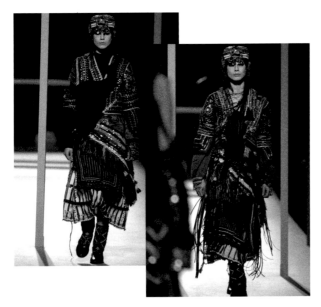

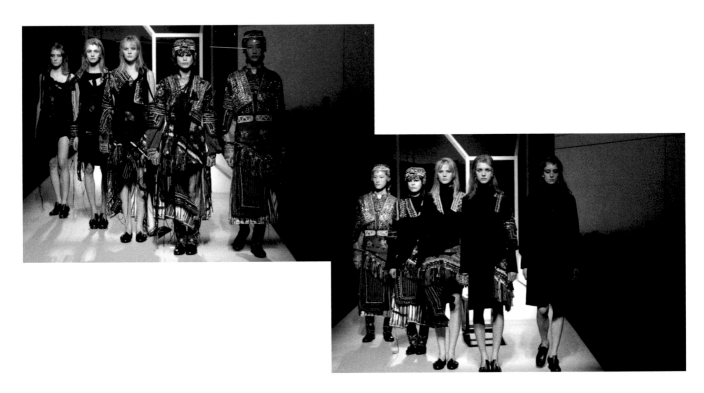

hussein chalayan, from the collection autumn/winter 2002

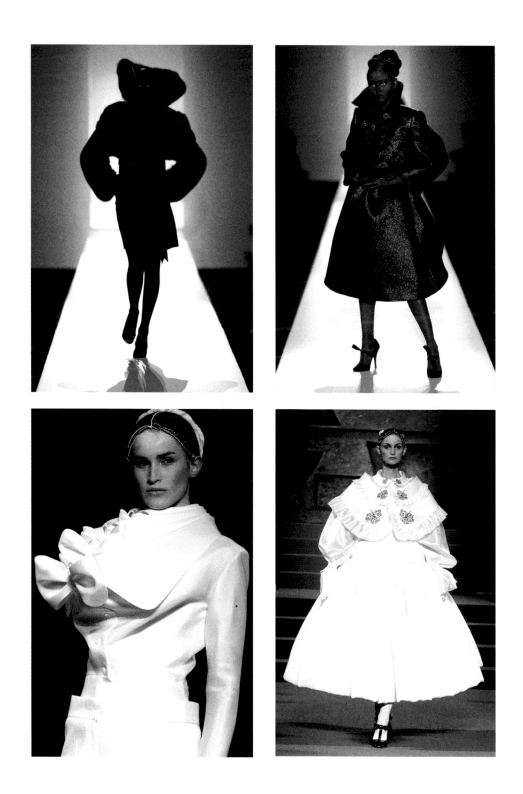

viktor & rolf, ready to wear, collection 3 (black hole), fall/winter 2001/02

viktor & rolf, ready to wear, collection 4 (white), spring/summer 2002

andrea kirchner / images

blue embroideries manufactured in vorarlberg, austria

collage, fashion institute vienna

edelkoort / images

winter 2008/09 visuals

credits / images

page 42: © Ogidan, Tokio, *Street Fashion Magazine*, No 9, 2000

andreas bergbaur / page 46–49

page 47: Hussein Chalayan, from the collection Autumn/Winter 2002, © Chris Moore

page 48: Ann Demeulemeester, from the collection Spring/Summer 1998

page 48: Viktor & Rolf, Ready to Wear, collection 4 (*White*), Spring/Summer 2002, © Peter Stigter

li edelkoort / page 54–55

page 55: Winter 2008/09 visuals, © Philippe Munda

andreas bergbaur / page 67–69

page 67: Ann Demeulemeester, from the collection Spring/Summer 1998

page 67: Ann Demeulemeester, from the collection Spring/Summer 2000

page 68: Hussein Chalayan, from the collection Autumn/Winter 2002, © Chris Moore

page 69: Viktor & Rolf, Ready to Wear, collection 3 (*Black Hole*), Fall/Winter 2001/02, © Peter Stigter

page 69: Viktor & Rolf, Ready to Wear, collection 4 (*White*), Spring/Summer 2002, © Peter Stigter

andrea kirchner / page 70–71

page 70: Blue Embroideries manufactured in Vorarlberg, Austria

page 71: Collage, Fashion Institute Vienna

li edelkoort / page 72

page 72: Winter 2008/09 visuals, © courtesy Trend Union, Paris

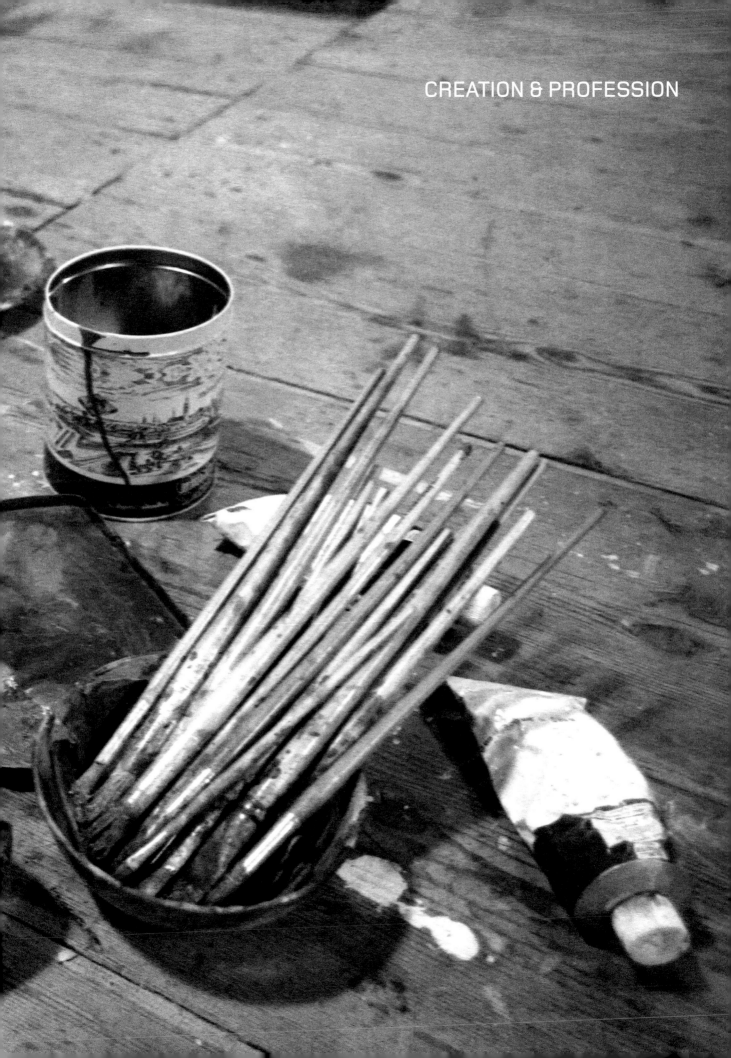

CREATION & PROFESSION

SIGNATURES

So many brushes, paint pots, an infinite number of opportunities – you just have to choose your own individual path, your line, for the contours, the niche or the commerce.

It is a long way from an absolute beginner to a fashion icon whose signature is recognised at first glance by society. Careers always were and still are created in completely different ways: there are no hard and fast rules. Some designers come from graphic design (Karl Lagerfeld) or literature (Rei Kawakubo). There are art historians (Tom Ford), while others are architects (Gianfranco Ferre) or autodidacts (Helmut Lang, Vivienne Westwood). Some start as window dressers (Giorgio Armani) and others study one fashion programme after another. Many have to leave their countries in order to become famous. More and more designers who send their collections to the catwalks of Paris, London or New York come from all over the world.

The Austrian Rudi Gernreich, who launched one of the most revolutionary fashion trends of the twentieth century in America – the partial revelation of female taboo zones – transformed from an outsider into a fashion icon with a single clear-cut idea.

Givenchy's ingenious designer Alexander McQueen on his approach to fashion: "I use things that people want to hide in their heads. War, religion, sex: things we all think about but don't bring to the forefront. But I do, and I force them to watch it."

Miuccia Prada points out the importance of respect: "Everything you do is political. The way you treat women, if you have respect for them or not, this is a political choice. I don't think that if you are interested in politics, you have to have bad clothing."

In this chapter, fashion designers report about their own story, about their problems and successes, about the difficulties of founding a label and finding a suitable logo. They speak about building a team, about lacking support and contacting the press, about failing and beginning anew again and again. They demonstrate what you *need to have*, compare the importance of creativity with commercial talent and speak about presentation and dramatising the appropriate story...

Gerda Buxbaum

LECTURES

PORTRAITS

IMAGES

yella hassel /
fashion – art or commerce?

Fashion is often misunderstood as a one-off creative act of a fashion article X. We see the brooding head of a solitary, exceptionally gifted designer, we see flying, painting, creating hands – we think we can feel the orgy of creativity. But this idea of fashion design, as beautiful as it might be, is nothing but a romance, a glorified illusion that has nothing to do with reality. What is reality? It is not *Bang!* – a product is created, and *Bang!* – it is finished. The fashion article X has a life's journey subject to successive modifications. These modifications are, again, subject to various aspects and requirements, which are also constantly changing. I am talking about creative, artistic and economic aspects since design is always a complex process, it is not a process taking place within a creative, elitist circle. The time of glorified, other-worldly design geniuses is passé.

LEFT: PYRAMID

In this chart, the hierarchy of design is roughly presented. At the top you can see the couturier. The couturier develops, seemingly without any restrictions whatsoever, his own materials, embroidery and tailored unique copies. The soul of these collections is an absolute personality cult, which is the case with Valentino, Christian Lacroix or Fausto Sarli, whose work is highly elaborate. It is free in terms of creation and is not called the *high art of fashion* without reason.

In the second section the prêt-a-porter designer is represented. This type of fashion designer is, just like the couturier, inspired by the artistic environment, yet the soul of the collection here is definitely the label – it is the product or the brand name that is strongly associated with the designer's personality. Dolce & Gabbana, Rei Kawakubo or even Giorgio Armani are representatives of this designer type, since their fashion bears a clear personal statement.

In this section, design stands for the demand to reinterpret elegance, discreet glamour and/or extravagant hedonism. Some designers create with a lot of fun and irony, they take fantasy trips into various fields, others follow puristic or intellectual fashion philosophy, as a contrast to rapid consumption. The collection development has a different tendency in prêt-à-porter, since the copying of sample garments is one of the requirements dictated by the sales factor.

And one layer further down, the wider range of designers is presented. Here you can find the most cunning troop of all: highly contemporary, extremely modern yet affordable copiers such as H&M, Zara and A.P.C. designer teams. As busy as bees, they skim – in the truest sense of the word – the still warm ideas from the latest prêt-à-porter and Haute-Couture collections and adapt them for their carefully targeted young, fashion-

hungry clients. Here designs get stolen and copied so quickly that one can hardly believe it! An example of this could be seen at the Oscars 2000. Hillary Swank was awarded an Oscar for the best female role. Only several days later, the original design by the U.S. fashion designer Randolph Dukes could be found as a knock-off at A.P.C.

What these copiers do is very simple, bold and just brilliant. They have seized the opportunity to bring fashionable trends to the market at the same time as the designer collections, or sometimes – due to their incredibly rapid production and distribution system – even before they enter the market. In this segment, the balancing act between art and commerce has to be perfect.

The residuum of design – to put it polemically – is characterised by cheap mass suppliers such as C&A, Quelle or Woolworth. Design plays only a subordinate role in this section, it is strictly oriented towards a wide target group, which is less demanding as far as fashion is concerned and therefore more likely to accept the price compromise. For the creators it is predominantly a matter of the production process, the merchandisers and retailers have taken over the role of designers. They develop sales programmes according to strictly economic production requirements, focusing primarily on producing a high number of copies while keeping development and production expenses as low as possible.

Commerce is a criterion of the mass suppliers, and it includes a thorough analysis of the economy as well as of the way to become as commercially successful as possible. Here it is not a question of formulating a design statement, it is a question of mass sales and turnover.

What does a fashion designer do?

During the fitting process, tailoring and lines of coarse cotton clothes are controlled, only then are the actual fabrics definitely determined. In big couture houses, the *golden hands* of tailors are busy with marking run of threads for hours and days before a single garment can be tailored.

The first original pattern is usually completely sewn by hand and fitted before definitely tailoring it for the selected catwalk model. Traditionally, the French couturier always manufactures one outfit on his own. Only the closest co-workers know which outfit that is going to be, and they keep that information a well-protected secret. A couture collection consists of 40 to 120 pieces, approximately 20 to 60 image looks are presented on the catwalk.

RIGHT: JOHN GALLIANO, CLEOPATRA, FROM THE COLLECTION FALL/WINTER 1997/98

An example of artistic inspiration as a theme of a highly elaborate prêt-a-porter collection can be seen in John Galliano's autumn/winter show in 1997, when the Cleopatra theme was taken as inspiration. The implementation of

the antique theme obtains a new fashionable statement with introduction of modern elements such as metal beads and necklaces. In this case, the outfits are fitted several times in the studio. In contrast to haute couture, the employment and complexity of handiwork is rather low. Prêt-à-porter collections consist of 90 to 400 pieces, approximately 30 to 90 looks are shown on the catwalk.

In addition to a fashion show, for a designer's fashion collection to become admired and appreciated, it is also important to succeed in dressing high-ranking personalities from the public realm for red-carpet occasions. The link between company image and free advertisement on the part of the celebrity is extremely important since the odds of an image upgrade – resulting in increased sales – is very high.

It is only in the rarest occasions that a celebrity decides which clothes or which designers they will wear. Therefore, many designers offer their latest creations and hope for PR. The more famous a celebrity is, the more attention the designer is given by the press. For many designers it is the best form of advertising. And the celebrities? Ideally, they get a spectacular garment for an evening, their fabulous picture appears in all important magazines and the odds of eventually obtaining that beautiful robe as a present are pretty good.

Fashion magazines are the most important medium to make a collection or a fashion theme popular. When fashion magazines promote themes such as Cleopatra, it stimulates the sales of the designer selling Cleopatra fashion. Designers are therefore always trying to provide the fashion journalists working on fashion editorials with their pattern samples.

Internationally renowned designers shaping the modern fashion image are people like Tom Ford or Karl Lagerfeld, who represent more than one label simultaneously. They are disciplined *24/7* workers, observed all the time. It is not only their fashion, but also they themselves as designers, who are constantly in the centre of the media attention.

Nevertheless, the times when there was a difference between an acknowledged star designer and a newcomer are over. The media is not only hungry for new fashion trends, they are constantly trying to spot new designers. The velocity with which a new brand can become famous was never so soaring as is the case today.

Young designer collections of this kind, however, are usually not acquainted with traditional structures. The creative teams are often not even trained designers, they are stylists at best. Without knowledge of production or marketing, the survival of these new labels is often just a short-lived success. The star helps to establish an image value, but in the end, it is the business know-how, continuity and profitability that counts. What is in today is forgotten more quickly than the *new creatives* would like it to have. New design stars disappear as quickly as they appear. An example of this is the

failed collection by Stephanie von Monaco.

Succeeding in the design world is hard work. Even if the origin of fashion lies in the creative field, a new collection that aspires to express something special is also designed in a creative process, which succumbs to many different factors: spirit of the times, trends, demand for creativity, individuality, exclusiveness and quality, artistic expression, analysis and copying. (An example of copying would be the noble jeans versions, which can be found in graded versions at Valentino, Dolce & Gabbana, but also at H&M and finally as a cheap version at C&A.)

The economic interests in the context of fashion all revolve around market research, target group analysis, fashion scouting, trend checking, price categories, production and distribution.

Designing fashion is a creative process that does not take place only at the top. The design and the collections have to be adapted for particular target groups, they have to be modified and made customer-friendly. Design is not only determined by the creative elite but also by design teams sensing the spirit of the time and taking commercial decisions.

Trends à la carte:

In earlier times, the designer had to fly around the globe to carry out his *store-check* and see the latest trends of the season in the fashion capitals of the world. Many designers used to buy their pattern samples there, which were then produced for the collection in a more or less lavish version. Nowadays, the presentation of the latest fashion on the Internet represents an enormous simplification of copying designs. The access to online collections has in the meantime become available in all fields of design. After the collection is presented, the trends and important fashion themes are summed up and published on the Internet as fast as a lightning. Today research takes place on the computer. The copiers who used to bribe a photographer to obtain the pictures from the latest fashion show now have their access over the Internet.

Whether fashion is art or commerce cannot be clearly determined. Fashion design should not be regarded as an exclusively creative process in the sense of art – design has rather become a continuous creative process within a lifespan of a fashion article, with all its changing demands on creativity or commerce. Image geniuses are required today, people active in a flexible field of design. They are familiar with the structures of collections and production, and they determine which trends and themes are selected.

A good designer stands between the poles of exclusive creativity and commerce. He sees and recognises the importance of both sides and uses his creativity to communicate between idea and hard currency in order to unite them both.

ute ploier / a profile

(edited by rd, statements ute ploier) Since 2003, the Vienna-based fashion designer Ute Ploier has been working on establishing her own label specialising in men's wear – with a lot of success. As there are a lot of male designers who make fashion for women, Ute Ploier wanted to swap the roles and find out what it is like to design for the opposite sex.

"Every collection is a project in itself. I'm not a formal designer. For me, it's all about the idea, the concept, the social aspect. There are many men who design only women's fashion. I wanted to reverse that and see what it's like when a woman makes fashion for the opposite sex – to create when you are not a part of the system."

With her graduation collection *Noli me tangere*, she was the first Austrian female designer to be awarded the prestigious Prix Hommes for the best men's collection at the 18th International Fashion and Photography Festival in Hyères in 2003. In January 2004 she presented her men's collection entitled *Electrification* during the Men's Fashion Week in Paris. Ever since, she has been launching two collections a year and selling her products to selected boutiques in Europe, USA and Japan. Her collections have been published in international magazines such as I-D, L`Officiel, Another Magazine or Arena Homme Plus. In 2005 she was awarded the International Unit-F Award for Press and Sales. Since then, she has been represented by the Parisian Press Agency Totem, whose clients include designers such as Raf Simons, Bernhard Willhelm or Veronique Branquinho, among others.

"You can't start a business without a base capital. After graduating from university you don't have access to the studio any more, which means that you have to set up an atelier on your own and finance the entire sample collection alone. Nowadays I can live from my shows, but they are not exactly cheap – 10 000 - 12 000 € can be gone quickly. The Unit F Press Award has helped me a lot, but it's still hard."

Ute Ploier's style is characterised by critical analysis of social hierarchies as well as the related role-playing and issues of masculinity. Her designs feature dresscodes and set pieces from various social milieus while remaining wearable and above all comfortable. Her garments are distinguished by unusual textile combinations and manufacturing techniques.

"Everybody has to try and go their own way, there is no patent remedy. It is about becoming personal in the world of fashion and presenting one's own little microcosm to the outer world. This is what makes you special and different from other designers. In addition to that, you should be technically adept, you should speak foreign languages, be communicative and be able to lead a team."

Ute Ploier was born in Linz, Upper Austria in 1976. At the age of eighteen, she went to London where she studied Fashion and Graphic Design at the Central Saint Martins College for a year. In 1996 she began her professional training in the fashion department of the University of Applied Arts Vienna where she was taught by Jean-Charles Castelbajac, Viktor & Rolf and, most recently, Raf Simons.

"Not every designer is a good teacher, but you profit enormously from working with them."

"My creative education was very good. What lacked, however, was the opportunity to do internships. I think it is of enormous importance to include work experience in the curriculum along with creativity."

www.ute-ploier.com

from the collection blue print, spring/summer 2009

mari otberg / a profile

(edited by rd, statements mari otberg)
justMariOt stands for fashion and art by Mari
Otberg. When the Berliner artist founded her
women's wear label in London in 1998, she was
praised by the Herald Tribune as the shooting
star in the German fashion sky.

In 2003, the justMariOt shop opened on
Gipsstrasse 9 in Berlin Mitte – this is where the
designer creates her fashion and art, both of
which are of a highly distinctive style she refers
to as arty/quirky/decadent and self-ironic.

Otberg is famous for her spectacular artistic
multimedia dramaturgies, which caused a great
stir already during her study years. Her collec-
tions are available in Germany, England,
Switzerland, Italy, New York, Japan and Kuwait.
Mari Otberg's works of art, i.e. hand embroidery
and drawings, are continuously presented in
exhibitions and sold to private collectors.

"Thinking globally is very important for your
independence. Already as a student, you have to
be willing to compete with the big names and to
do that you need to be bold and megalomaniac.
Bad times, in which nothing seems to go right,
come time and again, but you have to keep
trust in yourself and remain persistent."

In artistic terms, Mari Otberg is characterised
by a unique, unconventional style arising from
the idea of the total work of art. justMariOt's
creations include limited editions with hand-
embroidered T-shirts as well as female busi-
ness suits and wedding dresses made to meas-
ure. Masterful unique copies can be acquired as
collector's items.

The artist does not follow any of the current
trends, rather she finds her inspiration in her
own stories, themes and moods. With a passion
for detail, she tries to create a world of images
as well as her own universe. Among her fans and
customers count, for instance, musicians from

Berlin Philharmonic Orchestra, actresses Susan
Sarandon and Jessica Schwarz, choreographer
Sasha Walz, TV star chef Sarah Wiener, milliner
Fiona Bennett and many more.

"You have to change from one season to
another, which is, naturally, difficult if you
have already found your own style. You can't
be unfaithful to yourself, you can only create
something which fits into your own universe."

Mari Otberg completed training as a tailor, fol-
lowed by an art school, before deciding to study
fashion design in Bremen and Hamburg. After
her studies she went to London where she
worked as an assistant for Vivienne Westwood.

"The work involving creative design is just a tiny
little component of my work, the rest is organi-
sation and the whole machinery that goes with
it. You've got to accept the fact that you can't
do everything well and that you just have to
find somebody to do it for you. In the beginning,
you don't know at all where your strengths and
weaknesses lie, you've got to do everything on
your own anyhow."

In 2001 she presented her first show Pearl in
a Battlefield in London, in cooperation with the
English International Ballet. Back in Berlin, she
opened her first shop in 2003, the perfect room
for her collections, decorated with an elabo-
rate wall painting and pink lamp shades. The
peak of her career so far was the presenta-
tion of her autumn/winter collection 2006/07
in Berlin. Entitling her collection I want to be
… Sanssouci, Otberg created a world between
melancholy and lightness, reality and magic.
The theme of the collection was reflected in
presentation of Heinrich Heine's highly-topical
socio-critical narrative A Winter's Tale. A self-
produced film by Sören Haxholm and Axel Wei-
rowski conjured a mystical world of the actor
Enie van de Meiklokjes on the screen. The music
for the show was composed by Markolf Ehrig.

"The problem is that if you arrange a nice show once, your aspirations can only increase. You'd like to use a new venue, you'd like to employ new models. That's also why you cannot avoid sponsors. All great shows in Paris are sponsored, not a single designer is paying for it on his own."

www.justmariot.com

anne-marie herckes / a profile

(edited by hb, statements anne-marie herckes)
Since 2006 Luxembourger Anne-Marie Herckes has been, under the identically-named label, designing miniature collections with a lot of passion for detail – her accessories feature diverse dangling fashion objects ranging from bows, bags and boots to jackets and trousers.

Her miniature collections are available in select boutiques in Paris, Luxembourg, Antwerp and Tokyo and are shown twice a year at the Paris Fashion Show.

"You always have to finish a project even if you are facing difficulties and the problems appear to be impossible to solve. Unusual problems require unusual solutions, which again often lead to remarkable outcomes."

Anne-Marie Herckes studied fashion design at the Royal Academy in Antwerp/Belgium as well as at the University of Applied Arts/Vienna. After her studies she practised under the guidance of Viktor & Rolf in Amsterdam and the Greek fashion designer Kostas Murkudis in Berlin. The Luxembourger demonstrated her skills for the first time under her own name in her graduate collection at the EU Young Fashion Summit 2006, which surprised with skilful yet sophisticated cuts as well as with a fine selection of soft and fluid fabrics. In the same year the Museum of Modern Arts Grand-Duc Jean/Luxemburg appointed Herckes to design a *tag* for the employees of the museum, which should help the visitors identify the museum officials more easily. This is how this now-thirty-year-old woman discovered her passion for accessories.

"You should always think of what Karl Lagerfeld once said: Don't design anything ugly, it could sell!"

www.anne-marieherckes.com

uli schneider / a profile

(edited by rd, statements uli schneider) The luxury label Uli Schneider was founded in 1990, with headquarters in Hamburg since 1994. The label is set up as a company with approximately twenty employees working in the creative department, the pattern studio, and production and distribution departments. A label-owned storehouse is responsible for shipping the entire merchandise to the customers around the globe. Uli Schneider is represented in approximately 120 stores in Europe, Asia and America, in addition to her own showrooms in Hamburg and Düsseldorf.

The fashion label is targeting the high-end market and produces exclusive women's collections with a clear-cut, pure statement. An avantgarde label with its own signature – unmistakable, convincing and steady. The self-assured sense of style exuded by the collections and the high-quality proprietary fabrics are important features. Understatement and the finest materials, transparency and clean lines characterise the style.

"Clarity is achieved by form, reduced clean-lined cuts and top-quality materials as well as by colours that slightly blend into each other. We are famous for working with silk alot, which is then pleated in a special manner."

Uli Schneider, the founder of the label and the company, is studied in couture.

"I was lucky to study at a college offering free painting as one of the subjects. I attended both courses and worked far more in the field of free painting, theory of colours and nude study, which enabled me to look at the human being and the human body in a completely different way."

In 1985 she was awarded her first prize, *Les Jeunes Createurs* in Paris. In 1987 she founded the agency *Art & Couture* in which she worked as a design consultant for prestigious fashion companies. In 1990 she presented her first own collection and the label Uli Schneider was born.

"Personally, I started with a small collection consisting of thirty to forty garments. I went with it to the fair in Düsseldorf expecting – especially as I put my heart and soul into that collection – to quickly enter the market and be well-accepted. But, of course, that was not the case. You have to present yourself over and over again; you have to repeatedly prove that you have your own signature, a certain distinctive feature that the customer can associate with your statement."

Nowadays, a collection consists of about 200 garments. There is a major line, *Edition Couture*, involving carefully selected handmade individual garments, mainly for evening wear, as well as *Uli Schneider Stars*, which features the favourite designs of the past years updated with fabrics of the latest collection.

"We start designing fourteen months before the collection goes on sale. We go to fabric fairs to obtain impressions of the latest trends and colours and to find inspiration. Then the free design phase starts. This phase – during which the collection is invented – lasts approximately three to six weeks. Then the collection has to be realised: patterns are designed on paper as well as on dolls. It takes approximately three months to finish all 180 to 200 garments, which means you have fittings and modifications over and over again; you keep searching for new lines and playing with the materials."

"The most important thing is the value of brand recognition, the recurrent work with the same statement, with the same material. This is not only important for the brand, but also for the woman wearing it."

www.uli-schneider.de

flagship-store, ABC-street 1, hamburg, germany

brigitte felderer /
real things

Today's audience must be more than familiar with Rudi Gernreich's clothes – already in the late '50s the designer knew that the clothes should satisfy completely different needs, other needs than just the sole provision of decor for an aspired social status. Gernreich's fashion didn't set out to prescribe sophisticated cuts, new silhouettes or hem lengths. Rudi Gernreich did not want to revolutionise Haute Couture, rather the position people usually assume with relation to their clothes.

"I almost forget what I have on today" – the mantra of one of his first collections presented in Algonquin Hotel in New York in 1959 – puts in a nutshell Gernreich's fashion programme. Clothes, as imagined by Gernreich, naturally should not be inconspicuous, but neither were they about the recurring *good advice* of various women's magazines to dress *according to your type* in order to emphasise the individual personality. Every treacherous sign of submitting yourself to a fashion doctrine, which pretends to generate individual *real* femininity and yet remains manufactured, should be avoided. Rudi Gernreich did not want to create femininity, nor did he want to sell prestige symbols, and he certainly did not want to show off his technical skills. As an avant-garde fashion designer, he recognised that fashion encounters its public essentially through the mass media – in reality, only an elite circle sets eyes upon the exclusive creations of the great fashion houses. Gernreich's scenarios represented an attack on the conventions of *good taste* as well as on social taboos – he polarised, scandalised and provoked reactions of disgust.

With his ideas and designs, Gernreich addressed social compromises, he attacked the common sense of American society in the 1950s and 1960s. His provocations brought Gernreich not only closer to the contemporary art scene of Los Angeles, where he had lived since his emigration from Vienna in 1938, he also translated artistic themes into the field of fashion – a field dominated by exactly those regulations of conformity and commerce, of unfreedom and inhibition, which the artists of this generation rejected and equally celebrated as the content or method of critical art production.

Gernreich found it more contemporary to speak about clothes as *gear* or *second skin* completing their wearers and preparing them for the harsh conditions of the engineered future. These gears, inspired by a fascination with the technology of his time, were at the same time symbols suggesting that other forms of life, other social realities and forms of relationships were easy to imagine and represent. Gernreich's fashion was an aesthetic scenario to anticipate social change and to set it in motion. His futuristic designs can be read as striking innovations and social visions, however without becoming assimilating space uniforms that turning every person wearing them into an anonymous user of a likewise anonymous technological system. Rudi Gernreich's *uniforms* do not emphasise equality or hierarchy,

they do not crystallise those parts of our personality determined by a wish to fulfil the anticipated expectations of significant others. Gernreich's fashion represents a condition for the autonomy, beyond all role constraints, which should lead towards the individually responsible decision-making and self-creation. His models do not deconstruct or exclusively criticise an efficiency-oriented understanding of reality, they rather signalise an Utopia in which, instead of arranging old patterns anew, new social scenarios are born.

Gernreich's *Gear for the Future* involves the form and the form surface as an aesthetic moment. For instance, the seams are replaced by technical elements such as door springs or zippers or even by functional jewellery to which clothes have been attached. Gernreich combines unusual colour compositions as well as materials and artistic fabrics, which were previously used only in furniture design. He no longer makes a clear distinction between formal and casual clothes, he differentiates between conscious nakedness and bashful nudity and he does not confine himself to the celebration of just one beautiful sex.

Gernreich's bathing suits, for instance, can be understood as an expression of a changed body awareness which should not be restricted to the recurring vacations. Later on, Gernreich expanded his bathing suits with visors, over the knee boots or leggings in order to make what was originally confined to the private sphere suitable for public. Even when his bathing suits were so comfortable, tight and free, the body was still abstracted to a formal design element. The clothes did not free the body, but the body filled and completed the clothes. It was not the flair or the logo-aura of a single garment that motivated the female wearer to develop self-confidence since the individuality, from the perspective of the person wearing *Gernreich*, was not to be ascribed to the clothes any more. Already these swimming suits hit the wall as far as their presentability in the press was concerned. The models wore bras, and subsequently set-in cups, to preserve the obviously endangered decency.

Just as the clothes were not supposed to remain confined to special circles of society, they were, in Gernreich's terms, also not supposed to be regarded as a strictly feminine domain. The mentioned bathing suits were dressing a woman and not undressing her. Furthermore, Gernreich already refers to elements of classical men's clothes such as double-breasted button facing, a fake handkerchief pocket or pinstripes in his first bathing suits. Already in these designs, Gernreich ironises every premature association caused by garments. The pre-defined models of sexuality and eroticism illustrated by common dresscodes do not have anything to do with real sensations and Gernreich had a ghastly first-hand experience of suppressing his own homosexuality. Gernreich always resented coming out in public,

firstly due to the justified fear of being persecuted and later to avoid being branded by his sexual preference.

From the start, his designs attempted to create a wide range of visual codes that abandoned the traditional discrepancy between the more or less unvarying men's clothes and permanently changing women's clothes.

The monokini – garments cut out to reveal various body parts and tricots – thongs or even his last project, pubikini, turned Gernreich into an international celebrity. Scandals revolving around his projects only proved in the end that it was because of the incisive details that a clothing garment hit the headlines. If the monokini had remained a plain slip, the public would have only been amused (or thrilled) by the naked breasts, but not by the garment itself.

Gernreich's monokini, however, consisted of trousers reaching up to the costal arch and fastened with shoulder straps. The monokini does not promote being tanned all over – it is not a bikini cut in half, as the name might suggest. The legendary topless dancer Carol Doda was one of the first women wearing this suit in semi-public places. She could have simply omitted wearing one or another top, but in retrospect, her promiscuity, put on display by means of a monokini, was less about being exposed as a victim, rather just the opposite – she wanted to exploit male desires to fulfil her own narcissism and financial interests. The press censorship contributed to the misunderstanding of the monokini – black bars, ripple-effects, draped scarves and discreet camera angles directed all the attention to the breasts, exactly that which Rudi Gernreich had intended to reinterpret. With this scandal, the prudent American public made itself look like a fool – many artists and intellectuals praised Gernreich's breaking of taboos and viewed him as more of an avant-garde artist than a fashion designer.

While Gernreich ironised the Couture and its eliticism, whose anachronism he identified, he still did not refer to the history of fashion or to the traditional manufacturing methods, as is the case with fashion avant-garde today. Gernreich's criticism of the sex policies, of the affirmative character of social conventions is not expressed by deconstructing the present, but by drafting a vision of the future that can be worn on the body: "Today's notion of masculinity and femininity is challenged as never before. Traditionally clothes have been considered as tertiary sex characteristics. But now the clichés are breaking down and people as people are emerging."[1]

The central theme of the EXPO '70 in Osaka was *Progress and Harmony for Mankind*; various proposals for enhancing the lust for life, improving the use of natural resources, establishing trouble-free coexistence and a more efficient organisation of life were to be presented. Rudi Gernreich was

1 *Los Angeles Times*, 2 July 1968

invited to implement his Unisex project, which he created for the January edition of the LIFE magazine. A man and a woman were smooth-shaven, all body hair was completely removed. The couple presented identical outfits – both wore a bikini or a topless mini skirt, long trousers with short tops, in typical Gernreich colour combinations such as black and white, orange and yellow, or red and purple. The designer provided knitted overalls for the cold season, whose turtlenecks could be pulled up to the nose. Hair helmets by Vidal Sassoon (in black and white, depending on the outfit) were also supposed to protect from the cold and the harmful environmental influences. *Time Pieces*, wide cuffs with time function, linked these androgynous beings to the desired time system.

Help Stamp Out Rudi Gernreich! – the creators of an advertisement for an American cosmetic school were confident of wide-spread public support when spreading this aggressive threat to Gernreich and his unisex idea. The German magazine *Stern* published an article from an expert who feared the extinction of the mankind just because people who presented themselves in such a fashion would not develop sexual interests in each other anymore. Many representations of the project unconsciously reinforced the old order: the woman clings to the man with wide-spread legs or even sits at his feet; her look is blank while he stares directly into the camera; he crosses his arms in front of his chest, she only touches her body very softly, as if it were extremely fragile.

An aesthetically equal society, as outlined by Gernreich, was not desired, since it questioned a wide range of social institutions and norms reinforcing the traditional segregation of the sexes. Gernreich did not see his unisex project as a parody but as a serious attempt to reveal what is understood in a culture as typically feminine or typically masculine. With this project he took up the hippie fashion of the American West Coast, which was also oriented against the narrow-minded establishment with its anti-fashion movement (jeans and ethnic clothing). It must be said that Gernreich did not assume any ungraceful prejudices – the young girls and boys, both with long hair, were not interchangeable, quite the opposite: unisex was supposed to represent the same clothes, the same haircuts, the same make-up and thus neutralise culturally determined sex constructs. Gernreich saw the hippie uniform as a proof of his own unisex concept, in which clothes did not lead to an abolishment of differences between the sexes. However, reciprocal attraction should not focus on pre-defined silhouettes, breasts resembling torpedoes or hair coiffed like this and *only* like this. In the concept of unisex fashion, Gernreich decided in favour of abstract, unromantic, technoid garments as he wanted to avoid any kind of typecast. Here again he proves he is a modernist who attempted to create a political awareness with his interventions, and ultimately he became sceptical of the hippies' performance of private anarchism in terms of its political effectiveness.

Real things such as jeans or T-shirts were more suitable instruments of self-representation for Gernreich, which demonstrated and sought enlightenment and resistance. Even if the contemporary press could not understand it at the time – the fashion gazettes largely ignored the unisex project anyway – for Gernreich this project was all about postulating inconspicuous clothes. Unisex was to be regarded as democratic fashion, available to everybody. In Gernreich's words: "an anonymous sort of uniform of an indefinite revolutionary cast".[2]

Gernreich was not a fashion designer in the sense of celebrating predetermined status symbols or stipulated conformity, he understood fashion as a central element in everyone's design of their identity and its social perception. Clothes should be a medium of freedom, not in the sense of prudent wearability or comfort, but more in the sense of being free of all constraints imposed by a middle-class heterosexual culture. When Gernreich eventually states that fashion should primarily be entertaining, it hides the aspiration of a dress code without giving away in advance what might actually come up next.

Gernreich used the mass medium of fashion, in an entirely avant-garde manner, to radically question social taboos and conventions. He turned against fashion as an aesthetic corset of social order and brought forth images of a rigid sexal polarisation. Having been scandalised because of this, he became a seismographic media representative of a new attitude towards life. He reacted to a self-stylised technology and progress-fascinated society with ironic, provocative concepts: monokini, topless, unisex, total look etc. programmatically articulated the desire for freedom of an entire generation. The images of Gernreich's fashion, such as the performance of his self-representation, were messages of cultural awakening whose demands are still contemporary as ever.

2 *Michigan News*, 15 July 1971

exhibition views, rudi gernreich, fashion will go out fashion, steirischer herbst, 2000

ute ploier / images

from the collection charming crooks, spring/summer 2006

from the collection pioneers, autumn/winter 2005/06

ute ploier / images

from the collection timeloopers, spring/summer 2008

from the collection blue print, spring/summer 2009

mari otberg / images

wedding dresses justMariOt, 2008

top left: from mari otberg self-portrait series 4 seasons: summer, 2008
top right: from mari otberg self-portrait series 4 seasons: winter, 2008
right: wedding dresses justMariOt, 2008

miniature couture, 2007/08

uli schneider / images

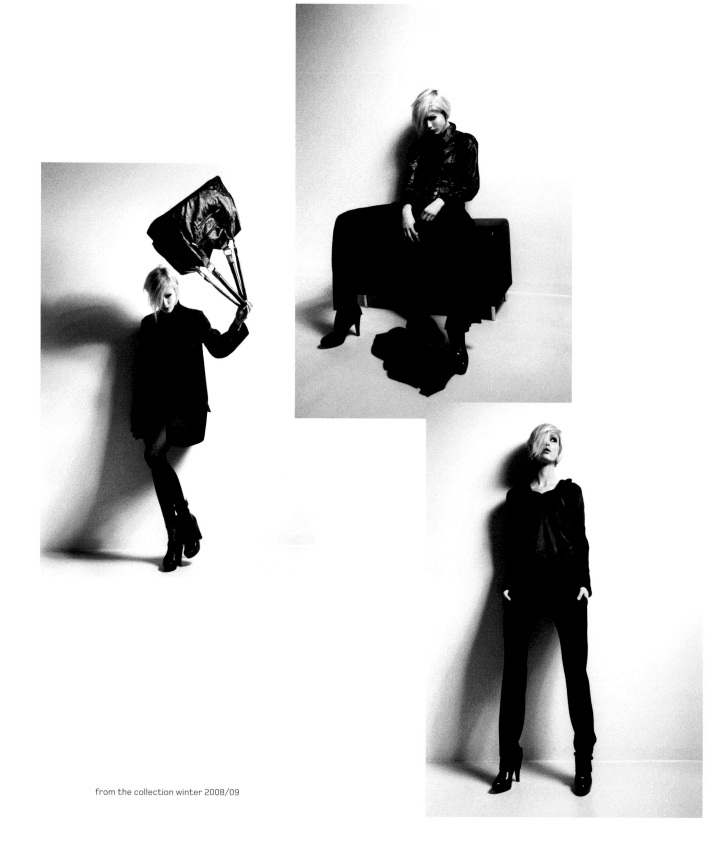

from the collection winter 2008/09

credits / images

page 74: © Claus Haiden

yella hassel / page 78-81

page 78: Pyramid, © Yella Hassel

page 79: John Galliano, *Cleopatra*, from the collection Fall/Winter 1997/98, © Patrice Stable

ute ploier / page 82-83

page 83: From the collection *Blue Print*, Spring/Summer 2009, © Ute Ploier

mari otberg / page 84-85

page 85: *Welcome to Wonderland*, art pieces for exhibition in Berlin, 2006, © Christian Schwarzenberg

page 85: *Labyrinth*, illustration for wedding menu card, 2007, © Christian Schwarzenberg

page 85: *Planting a Tree*, illustration for Bildagentur 2008, © Christian Schwarzenberg

page 85: *100 years Frida Kahlo*, from series celebrating 100 years Frida Kahlo, exhibition in Canada, 2007, © Christian Schwarzenberg

page 85: Limited edition, invitation card for fashion/art event in Berlin, 2006, © Christian Schwarzenberg

anne-marie herckes / page 86-87

page 87: *Brooch Chiara*, Summer 2009, © Anne-Marie Herckes

uli schneider / page 88-89

page 89: Flagship-Store, ABC-Street 1, Hamburg, Germany, © Peter & Francis

brigitte felderer / page 90-95

page 95: Exhibition views, Rudi Gernreich, *Fashion will go out Fashion*, Steirischer Herbst, 2000, © Steirischer Herbst / A.T. Schaefer

ute ploier / page 96-99

page 96: From the collection *Charming Crooks*, Spring/Summer 2006, © Ute Ploier

page 97: From the collection *Pioneers*, Autumn/Winter 2005/06, © Ute Ploier

page 98: From the collection *Timeloopers*, Spring/Summer 2008, © Ute Ploier

page 99: From the collection *Blue Print*, Spring/Summer 2009, © Ute Ploier

mari otberg / page 100-101

page 100: Wedding dresses justMariOt, 2008, © Christian Schwarzenberg

page 101: From Mari Otberg self-portrait series 4 seasons: Summer, 2008, © Christian Schwarzenberg

page 101: From Mari Otberg self-portrait series 4 seasons: Winter, 2008, © Christian Schwarzenberg

page 101: Wedding dresses justMariOt, 2008, © Christian Schwarzenberg

anne-marie herckes / page 102-103

page 102: Miniature Couture, 2007/08, © Anne-Marie Herckes

page 103: Miniature Couture, 2007/08, © Anne-Marie Herckes

uli schneider / page 104

page 104: From the collection Winter 2008/09, © Peter & Francis

DISCOURSE & EDUCATION

FASHION AS DISCIPLINE

The Fashion Institute of Vienna in the Hetzendorf Castle was again the European *Fashion/Discourse Centre* for two days, when international experts from various fashion fields held their short presentations, statements or comments on the current fashion affairs, on methods and opportunities in education as well as the key players of this field. Experts from Italy, United Kingdom, Germany, Switzerland and Austria were invited to get the international discussion on training in fashion in motion. It was a gathering of speakers from the most prestigious fashion schools and universities as well as trend researchers, journalists and representatives from the fashion industry.

The topics discussed involved the curriculum design, the content of the subjects offered, teaching methods as well as public presentation techniques: should students model the clothes they have created? How to communicate with the press or set up an own business? An important although rather sensitive issue was also the question of the integration of practice into the curriculum and avoiding the famous black hole after completing the studies.
What is certain is that the fashion industry has changed dramatically – the position of design as a discipline has shifted from being a predominantly creative to a knowledge-intensive discipline. A wide range of new fashion occupations has emerged, yet the necessary consequences on the part of the educational institutions are still lacking.
What has changed is not only the conditions for fashion; there have also been immense changes relevant for education: fashion creators, designers, lecturers or principals nowadays have to work in a completely different manner than as twenty, ten or even five years ago. They require different skills and different – also spatial – structures in order to function well and to successfully hold their ground against the competition.
A part and an aim of the professional training offered at the Fashion Institute of Vienna is to provide the students with an inspiring and informative environment in the form of a network of contacts. The institute has institutionalised regular confrontation between the students and internationally renowned personalities from the fields of fashion, culture and industry in order to make sure that they follow the dynamic, constantly changing fashion industry.
The fascination of the fashion business is still huge – the opportunities in this field have never been vaster, and the number of fashion students world-wide is constantly increasing, year after year.
The competition among designers has never been as impressive, and their strategies have never been more manifold as today. What counts are the ideas, the individuality, the authenticity, the distinctiveness. Still, public relations, marketing, branding or advertising campaigns alone are not a guarantee for the path to success.
Currently, the basics of education in fashion lie mostly in transboundary experiments, in far-reaching stimulation of the fantasy, but also in real, practice-oriented project work. Education focuses on furthering techniques and skills as well as developing individual artistic creativity.
The chapter on discourse and education has been printed here as a vivid debate, since in this manner the various perspectives and points of view can be best seen and understood.

Gerda Buxbaum

Participants: Dorothea Beisser, ESMOD Munich / Susanne Brandsteidl, executive president of the Viennese Board of Education / Gerda Buxbaum, Fashion Institute of Vienna / Georg Mathias and Bettina Köhler, University of Design and Arts in Basel / Ursula Hudson, London College of Fashion / Gabriele Orsech, AMD Academy of Fashion & Design, Düsseldorf / Mari Otberg, fashion designer, Berlin / Giovanni di Pasquale, Accademia Internazionale d'Alta Moda e d'Arte del Costume, Rome / Ute Ploier, fashion designer, Vienna / Bernd Skupin, arts editor of the German VOGUE, Munich / Barbara Trebitsch, Domus Academy, Milan / Brigitte Winkler, fashion editor, Vienna / Yella Hassel, Fashion Institute Vienna

I.

Hetzendorf stands for a fascinating discourse on issues of fashion – a wide range of trends and diversifications in the entire fashion industry are analysed and transported in the courses offered at this institution. Education was also the topic of the Hetzendorf Talks 2006. The international quality initiative of the Bologna Declaration formed the basis for these talks and is a topic fashion schools are preoccupied with at the moment. The topics of presentations and discussions were: the status quo in fashion education in Germany, Italy and Switzerland, the question of national differences in education as well as whether they exist at all in these times of globalisation and fashion interchangeability, and finally the question of the advantages and disadvantages of various fashion programmes. Is it a problem if only fashion is taught in an institution? Is it better to offer fashion, as is the case in one university, as a part of a comprehensive artistic education?

The Fashion Institute of Vienna in the Hetzendorf Castle was founded in 1946 as a vocational school with various training programmes. The programmes today include Dressmaking, Knitwear, Textile Design as well as two Product Design programmes focusing on Millinery and Leatherwear (which is then again divided in Bags and Shoes). These programmes make the Hetzendorf Fashion Institute unique in German-speaking countries. In 1992 a specialised programme was launched, which could be attended after obtaining the equivalent of British A-levels. The A-leves could be obtained at the Higher Vocational School for Fashion introduced in 1996.
Since 2006, the Fashion Institute also offers a Bachelor Programme in Fashion Studies. This three-year programme is a cooperation with the University for Arts and Industrial Design of Linz, however the courses are held only in Vienna. The students are given an education that is recognised Europe-wide for any further Master Programmes.

I. STATUS QUO OF PROGRAMMES IN FASHION AND PRODUCT DESIGN

ESMOD Munich
Dorothea Beisser, founder and principal of the Esmod School in Munich

Esmod is not a German educational model, it was founded more than 160 years ago in France. Dorothea Beisser had the opportunity to attend this school in Paris from 1974 to 1976, after obtaining her Master Craftsman Certificate in Germany. At that time, Beisser was primarily fascinated with modelling on a dressmaker's dummy, which Paris was renown for. You could simply go up to the dummy without a pattern design, without mathematical formulas and right angles, and experiment with volumes and forms. After her education, various jobs in the fashion industry followed, first in Nizza, then in Paris again, until she started working as a self-employed artist with her own studio for pattern design and tailoring. When the Esmod Paris proposed that she open an Esmod branch in Germany, she accepted and founded the Munich Esmod School in 1989. As of 1994, there is also an Esmod School in Berlin. In each school, there are approximately 180 students being trained over a three-year period. The educational model is French, which is a different standard of education from that in Germany. Any student with the equivalent completion of British A-levels or an advanced technical certificate is entitled admission to the school.

During the first year the range of drawing techniques are taught and cultural aspects discussed. The students are sent out on a shopping spree to investigate the city and see where various designer shops are located as well as analyse the trends in Munich or Berlin. Before creating their first collection, which happens towards the end of the first year,

they learn how to draw figures and faces, how to create detailed hand and foot studies or how to use various painting and colour techniques. The next steps involve creating colours, selecting fabrics or modifying forms. This can be seen in the example of a flared skirt, which needs to be produced in six different variations. The technical drawing includes all details that are important in the further production process. A complete collection plan consists of a women's collection, men's collection and a children's collection.

In the pattern design department the students work on the dummy. Every garment is produced as a pattern and a moulage. In order to see what can be done on the dummy, how creative you can be without having drawn anything, various garments are cut up and put back together again. The first year finishes with an examination in styling and modelling techniques.

In the second year, the collections are expanded with the addition of underwear, for example, and the students work with fabrics instead of paper for the first time. They attend various workshops offered in cooperation with various companies, and they go on internships or participate in competitions.

The third year starts with a visit to the Première Vision in Paris, the largest fabric fair in the world, and it ends with a production of an own collection. During the year the students have to carry out intense trend research, develop their own themes, work on fabrics, but they also work on styling, photo shooting or show room design. Many graduates work as stylists for film or television, where they select clothes for actors or TV hosts.

AMD Academy for Fashion & Design, Düsseldorf
Gabriele Orsech, Head of Arts and Head of Academy

Gabriele Orsech, a trained designer, works as a consultant in the field of colour concept and trend marketing. She is a fashion expert specialising in fashion sociology who has been the Head of Arts of AMD for the past ten years, where she teaches fashion history, sociology and design. Her fields of interest involve inter-disciplinary work and network thinking of design education.

AMD is a private school working exclusively with honorary lecturers. Founded twenty years ago in Hamburg, the same programme is in the meantime also offered in Düsseldorf, Munich and Berlin. The training programmes range from Fashion Design to Textile Management and Fashion Journalism to Interior Design. The programme of Textile Management has been developed in cooperation with Otto Versand – a large German mail order company. It is a classical business studies programme with a textile background, focusing on the fashion and design industries. The programme of Media Communication covers the fields of Public Relations, Styling and Editing. The link between fashion and design in the Interior Design Programme enables a focus on topics such as shop concepts or trade fair planning. The interdisciplinarity of AMD – *looking over the rim of a tea cup* – was already present before the Bologna Declaration was introduced.

Why is a Europe-wide reform of high education necessary?
The education of specialists, which has been encouraged and demanded for the past thirty years, is no longer desired. The business world and politics are looking for generalists – people who are flexible, spontaneous, willing to relocate, people who are able to see further than the end of their noses and who are able to rethink or even change their profession. Colleges and universities used to have a subject catalogue in which the contents of the individual subjects, the lecturers and the

requirements for passing the course were explained. Establishing a network between these subjects did not happen in the education itself, but in practice.

The Bologna Declaration includes establishing networks already at the educational level and has, because of that, introduced a modular structure of the various subjects. You start from the competences required in a certain profession and determine which competences should be provided by the schools. There is a wide range of skills a designer needs to have, which significantly exceeds simple specialisation in fashion design. For instance, there are the soft skills, the communicative competence, the language, job application skills, elocution and skills for setting up a business. Additionally, there are also cultural skills that can be taught in theoretical subjects such as sociology, philosophy, literature, history, art history or design history. Of course, technical skills such as pattern design, finishing, draping, presentation techniques in drawing are still of central significance, however it is fundamentally about connecting these various competences.

Another significant focus of AMD lies in training the visual competence or presentation. The design and production of garments alone is not sufficient, one must also know to present them. One must develop a feel for the modern visual language, one needs to know how to emotionalise, to appeal to all senses. Emotionalising, in this context, naturally implies a certain amount of modernism, catching the spirit of the times. Corporate Identity, creating a logo, a label, the whole marketing concept around a product or a collection are of major importance in courses offered at AMD.

In accordance with the Bologna Declaration, a module consists of three to four subjects. For example, the AMD introduced a business module. Subjects such as business studies had not worked well for years. The students were excited at the prospect of having business studies as one of the courses, however when it was held by a lacklustre teacher, the excitement along with the attendance of the courses rapidly decreased. That is why the AMD united the subjects of calculation and collection design, which means that the students do the calculations for their own collection. Another example is the introduction of a seminar in which the students learn how to set up a business or how to create a business plan for their own collection. Yet another module at the AMD is called Trend Research or Forecasting. In this context, a theoretical subject such as trend marketing is united with the applied subject of visual communication. The results are a trend book and, typically in cooperation with other subjects such as CRD or Multimedia, the production of a video clip.

At the end of the education the AMD organises a huge fashion show in which the students present their collections. The show is accompanied by a show catalogue designed and produced by the students themselves.

In accordance with the Bologna Declaration, the reorganisation implies an unbelievable amount of work and is often dreaded by the lecturers themselves. But, on the other hand, it provides you with a huge chance of preparing a sound basis for networked work and interdisciplinary thinking already during the university years. And this is going to be one of the essential factors for surviving on the market in the future.

BUXBAUM: How do you unite several subjects in a pre-defined amount of time? And what is the most important combination of skills when everything is constantly changing?

ORSECH: The most important aspect is providing the students with a modern way of thinking.

What we at the AMD are trying to avoid is defining the themes. The students should work out their concepts and themes on their own. In reality, they are trained to think for themselves.

BUXBAUM: Which requirements need to be fulfilled in order to be admitted to the school?

ORSECH: In order to be admitted to the AMD you need to have the equivalent of British A-levels or a technical diploma. Additionally, we expect our students to present a comprehensive portfolio, which is often necessary to determine the artistic level of the applicant. Finally, every applicant is interviewed personally.

BEISSER: The admission requirements for Esmod are similar. You need to have A-level equivalents or a technical diploma, but we do not require a portfolio. The applicants are thoroughly interviewed for approximately two hours in order to gain an impression, and there is a short motivation test as well. The amount of time the applicant is willing to invest in the school is a significant selection criterion. The students have weekly lectures amounting to thirty classes of sixty minutes. In addition to that, there are also thirty hours of homework. You need to sacrifice your entire free time, your every free weekend, otherwise you are not going to make it. Everything you achieve from one day to another is the basis for the next ten years, it is a fundament the future designer can build on. That is what makes us different from an average university.

BUXBAUM: Is there some kind of an initiation procedure where the applicants who do not conform to the requirements drop out?

BEISSER: Yes. The previous sixteen years of the German Esmod's existence have shown that the drop-out rate is the highest in the first year of education. In the first year everything is at stake. If you have managed to pass this obstacle, there won't be any more problems in the second or the third year.

ORSECH: At the AMD a similar observation can be made. In the elementary course of study, the students have to work in the open lab on top of the thirty hours per week. Additionally, certain quality requirements need to be fulfilled. Especially in case of a private school, it is of enormous importance not to give the impression that the students are paying for their final certificate or that it can be simply bought.

AUDIENCE: How much does the education cost?

BEISSER: 6800 euros per school year, which amounts to approximately 600 euros per month.

ORSECH: AMD costs 490 euros per month since the school has been upgraded to a college. This is, internationally-speaking, not very much. All the materials required for the classes are included in the tuition fees. We try to cover all the expenses exceeding that amount with cooperations in the fashion industry. This means that the students do not have to finance their collection materials on their own. It is creativity, rather than a material battle, that counts. Some students, for instance, do not pay anything for their final collection, because they are sponsored by their previous internship providers.

AUDIENCE: Creativity is all about working on your own potential and about growing in creative terms. Is there a place for that as well in your strict programme?

BEISSER: Quality is not the same as quantity, as the saying goes, yet the students at Esmod are very well looked after. When the students need to work for a couple of hours more in the evening, the lecturers also stay longer. There is always someone you can address, that is one of our goals.

ORSECH: It is a legitimate question. We have realised that the difficulties increase with the declining entrance age of the applicants, and that is why we take that into consideration already during the selection procedure. If an applicant is already slightly experienced, they usually bring in more potential and the willingness to succeed is much higher. I am an absolute advocate of the achievement principle. You have to be aware that fashion design is one of the most work-intensive courses of study. This simply arises from the fact that you are not only trained in creative disciplines, but also in technical and business disciplines as well, from tailoring to CAD. You have to invest an unbelievable amount of time if you want to obtain such a high level of education within a period of only three years.

AUDIENCE: How is the internship organised?

BEISSER: The school year begins in the middle of September and ends with the exams at the end of June. The internships take place in July. In the first year, the duration of the internship is limited to three weeks, in the second year, to twenty-one days.

ORSECH: The internship is integrated as part of the fifth semester and has to last at least three months. Many international companies do not even offer internships for a period lasting less than a year, but it is then up to every student to make that decision. For instance, if you want to go to New York, you have to know that you must invest five months at once, which means that you won't have any holidays. The internship provides a window to a future professional career for a quarter of all our students – even internationally.

Domus Academy, Milan
Barbara Trebitsch, Head of Accessories Design
Master Programme

The Domus Academy is an educational institution in fashion that culminates with a Master Degree. This implies that the basic knowledge is a pre-requisite, which enables the students to work at a higher level.

The importance of fashion in the business context as well as in the international business system has already been recognised around the globe. The previous twenty years have been characterised by a constant and irreversible change in the fashion system, supported by cultural and market-based globalisation. Simultaneity, synchronicity and the merging of time and space determine the development of ideas today. Determinate trends that used to exist earlier, do not exist anymore. The designer has to shift towards the centre of the entire production system. The school needs to help the designer find their own sources, their own cultural background. At the same time, they need to understand the market, without being influenced by it. You need to develop the ability to unite and manage various levels of fashion and design, from the market up to the communication.

Italy has an exceptional position here, as it has always been the centre of the fashion industry. The production companies are located here. However, a single country of fashion does not make any sense in these times of globalised economy. Italy still offers a wide range of educational models in fashion or internships with famous fashion houses, however financing education in fashion is at the same time becoming more and more difficult.

Currently, fashion education takes place on two tracks. On the one hand, one has to know and respect the economic limitations. On the other hand, however, there is this desire for a free and untamed creativity. In the end, the two tracks meet. A Master Degree Programme offers a suitable and flexible method for students who already possess some knowledge

and experience. Many graduates are employed immediately upon completion of their studies by the companies they worked for during their internship. The cooperation with companies is therefore very important already during the years of study, and many more opportunities for internships should be created. Internship is only one option here, there are also companies that actively and thoroughly follow the students' projects, which means that there is a *supervised* working situation during the years of study.

The amount of time the students spend on their classes, projects and internships is extremely high at the Domus Academy, yet this is how the brutal work reality of the fashion business is already reflected in school. You have to get used to working day and night, during the week and on weekends. Fashion is a part of life and not only a job, and whoever sees it differently should better quit studying and investing all their money into this extremely expensive education. Education in fashion is not about being tough on the students but about making them competitive in the real world.

The students at the Domus Academy come from all over the world: Korea, China, Japan, India, Turkey, England, America. There are twenty-five to thirty participants in every course, which allows for a *tailored* education. The selection of applicants is based on portfolios and digital interviews. In doing so, a great value is placed on applicants with various educational backgrounds, those who have, in addition to fashion design, also studied product design, marketing, etc. In this way, reciprocal learning is fostered.

In the study year approximately six seminar works are required in order to practice developing independent ideas. The first project is always an experience/research project in which various research skills are put to the

test in mixed groups. The projects are always developed in cooperation with external designers who are constantly alternating so that every student comes in contact with two or three designers. This is rather difficult to organise, but it is an enormous enrichment of the programme. In addition to designers and companies, various *idea people* are invited, for instance, art critics. These contacts expand the horizon of the students, who learn that fashion and design is much more than just prêt à porter. In some projects, students from various courses are mixed – for example, students studying Fashion with those studying Accessories Design, which enables them a completely free expression.

It is very interesting to observe the relation between group work and individual work. At the beginning of the education, the students are trained in the first two seminars to work in groups, which helps get them off their high horses. It is important to make the students modest so that they can work on various projects in cooperation with their colleagues, as opposed to only being willing to work alone. It is one of the most difficult aspects of working with fashion designers, because all of them think they are the best and that their colleagues' ideas are not good enough.

The education at the Domus Academy is not organised in accordance with the Bologna Declaration, which is the case in most of the fashion schools in Italy, by the way, because the Bologna Declaration is only valid for Italian universities. The courses at the Domus Academy are recognised by the universities, similar to the British system. This could only be achieved through numerous debates and discussions. It was not easy to adjust the amount of classes and guarantee transparency for the students, because the Domus Academy used to be seen as a lab for crazy ideas in the past, where everybody was allowed to do whatever they wanted.

Today, the main characteristic of the education here is the cooperation with companies, which is why we have so many foreign students. The Master projects are also done in cooperation with fashion companies. It is not unusual to see a project manager of a fashion company who – already after the first seminar work – creates a list of students he would like to supervise during their final Master project. This continuous cooperation has several advantages. On the one hand, the companies get to know the students' works, on the other hand, the students get to know the field of work better they want to work in later.

At the end of the education there is no fashion show, but an interactive exhibition of all Master Degree works.

BUXBAUM: How much time do the students have for the Master project?

TREBITSCH: The project starts in September, and the students have to finish their workbook until mid-November, with all the paperwork and textiles. The presentation and the prototypes come in at the end. So they only have a period of two and a half months to work on it.

BUXBAUM: You claim that it is important to understand the market without being influenced by it. How can you achieve that?

TREBITSCH: The market decides whether you can sell something or not. You have to respect that, but on the other hand, you have to assert your own personality on the market. This is very difficult, and the classes help only by providing the information to the students. At the same time, we are trying to teach the students that they should not blindly obey all the rules they hear at school – that is why discussions and debates between students and teachers are necessary. At the end of every seminar, the students have fifteen minutes time to present their work, which is then discussed so that every student has the opportunity to learn something from the discussion.

It is important that the students know what they want. If someone wants to make a jacket with four sleeves, then it is their decision, which everybody respects.

The market is dominated by big fashion companies, yet people are also always on the lookout for something new. It is not easy to train the students for the second aspect, and if they do not have the family backup to guarantee support over several years, it is impossible to succeed in most cases.

BUXBAUM: In your opinion, where do the graduates have more chances of getting a job – in Dressmaking or in Accessory Design?

TREBITSCH: One of the reasons why we started the education in Accessories Design was the question of job opportunities – it is the field there are more possibilities, the companies are more flexible here.

AUDIENCE: How important is it to make a Master Degree?

TREBITSCH: This depends very much on the situation you are in, on the country you come from and on the feeling you have in relation to entering the market. Particularly talented students do not know this or are not mature enough to recognise it. The Master Degree can, apart from being a degree, be a very useful investment in oneself. You have time to develop your own methods without being tied to a company. Our philosophy is this is not the last year of school, but far more, the first year of work. Thus, it is less about obtaining a Master Degree and more about gaining an awareness of the level you are at.

II.

II. IMPACTS OF GENERAL CONDITIONS AND
STRATEGIES ON EDUCATION

Even educational institutions are influenced
by general conditions that vary from institu-
tion to institution and depend on the economic
structure of a country or on the acceptance
on part of the media. New economy require-
ments shape the fashion industry, just like
the changing customers' requirements or the
demand for increased flexibility and innovation.
Austria does not count among the classical
fashion capitals. How important is, in fact, the
location of an educational institution? How can
and must the educational system react to the
constantly changing general conditions?

London College of Fashion
Ursula Hudson, Director Fashion Business
Resource Studio

The Fashion Business Resource Studio at
the London College of Fashion functions as
an interface between fashion education and
industry. The creative, commercial and technical
skills of the London College of Fashion meet the
fashion and lifestyle industry. Ursula Hudson is
an expert on fashion marketing, specialising in
strategic brand marketing. She consults inter-
nationally leading fashion brands but also public
institutions such as the British Design Council.
She was in charge of the curriculum design for
the first Fashion Retail Academy in London.

The London College of Fashion is a part of the
University of London, together with Central
Saint Martins, Chemberwell College of Arts,
Chelsea College of Art and London College of
Communication. A vast number of students are
trained at these institutions, approximately
700 a year, a hundred of them alone in Art &
Design, which amounts to approximately twenty
to twenty-five students per class. There are
numerous educational programmes, ranging

from advanced training or programmes offer-
ing university degree to courses designed for
students with just a school-leaving certificate.
Individual courses offer specialisations in the
fields of fashion management and business,
fashion promotion and styling, fashion jour-
nalism, fashion design (clothing, footwear and
accessories) as well as beauty science. A strong
cooperation with industry aims at preparing
the students for the work world in the industry.
The Fashion Business Resource Studio is an
individual department at the London Fashion
College, which coordinates and facilitates the
cooperation with the industry. In addition to
enabling and supporting cooperation projects,
the department also organises various con-
sultancy sessions and workshops in which the
graduates are encouraged to set up their own
business.

Fashion is a part of a huge creative industry,
which already should be surveyed during the
years of study. Creative design thinking and
strategic management thinking are the pillars
of such an education. Flexibility, the ability to
work in a team, the ability to solve problems
and the willingness to take risks are the central
skills for successful career, which are taught
alongside creativity.
Additionally, in England the cooperation with
the industry is strongly recommended and
financially supported by the public authorities
already in upper classes of school.

The contemporary educational system has to
be oriented to the future, to our children and
the world they are going to work in. Our chil-
dren's world is basically going to be smaller than
the world of the previous generations.
The children of today are used to travelling to
Europe, America or Australia. For them, the
world is smaller and the distances are less
remote. The technology also alters the world –
the children are nowadays able to access any
kind of information, whenever and wherever

they want to. They have an immediate access to other cultures while their sense of national culture is weakened, as personal identities are not defined in terms of identification with a nation. Today's children are not afraid any more of asking questions, and they regard issues such as environment or global warming as immensely important. The educational system can only guess what the future will bring, yet what it has to offer are values, creativity and innovation.

In England a radical social change towards a creative society is taking place. Creativity makes a huge difference in competition; the creative industries are massively supported.

This means that the educational system in this field has to offer creative capital, and this can only succeed if you respect the demands of the market. Activating the creative capital means more than designing a curriculum. On one hand, values such as flexibility have to be taught, but, on the other hand, learning does not only take place in class. The key sentence here is *learning how to learn* – it is a responsibility you have as a teacher.
Another key aspect is *lifelong learning*. Applying your knowledge in the work world implies permanent self-improvement.

Investing in education is just as important as integrating it into society. In England the main problem the industry is facing is the fact that the educational system is very expensive. After three years of education, the students' savings are for the most part spent so they start looking for security in a regular employment relationship, instead of taking a risk and setting up an own business. Instead of economically implementing their own creative skills, they orientate themselves on the economy from the very beginning. Therefore, the interaction between creativity and economy must be reciprocal. Educational institutions offering programmes in economy have to date been separated from educational

institutions offering programmes in design. Both of these fields have to be united. Creative people need to develop a sense for business and vice versa – business students will need to work on their creative skills in the future.

University of Art and Design Basel
Georg Mathias, Lecturer and artistic head of the Fashion Design Department
Bettina Köhler, Lecturer of art and art history at the Institute for Fashion Design

The Fashion Design Department at the University of Art and Design is called Fashion Design: Body and Dress. An interesting approach since a dress cannot exist without a body. It is about the profession of fashion design and about the general conditions in the fashion field, the economic and social environment as well as about creativity and the creative individual.
The University for Design and Art is a state university consisting of five departments at the moment: Fine Arts, Graphic Design, Interior Architecture, Fashion Design and Teaching Fine Arts. With the exception of Geneva, there are not any art academies in Switzerland, which means that the country lacks an academic tradition in the artistic field. Individual departments function independently of each other although great value is set on cooperation and exchange between single departments.

The central question in their educational system is the question of the general conditions of education and how they influence educational models. Basically, the general conditions in Switzerland are different from those in Italy, England or Germany, both in regard to the market as well as in regard to production. The educational system does not offer a catalogue with answers rather it supports the development of questions, in the sense of the *learning how to learn* methodology. The aim of this educational institution is to support the designers in their

business autonomy as well as to portray the creative work from the business perspective.

In the previous two years, the fashion design programme has been completely redesigned with the new bachelor degree. Central in the process of redesigning the programme was the profession of the fashion designer as well as the educational aims in this context. Which skills do fashion designers need today? How do you appeal to intelligent, creative people and make them unite the aims offered by the institution with their own professional aims; how do you put them in a meaningful context? And how do you convince the authorities that such an educational system is culturally and economically meaningful and significant? Are there different rules during and after the professional training? Do the teachers and the industry measure the quality of an artistic product from different standpoints?

As far as the general conditions are concerned, they might be relevant on three levels:

1. Design
2. Communication
3. Production

Within these three levels two kinds of general conditions can be discovered: on the one hand, the expectations – both internal and external – and on the other hand, the laws that enable the co-existence of all the participants involved in the fashion system. An example of this are the prescribed fashion shows or the fixed dates on which they take place.

On a design level, for instance, it means looking at the relevant factors when designing a collection and looking at the normative/factual conditions. Nothing is more challenging than objectively answering the question: who am I, actually, as a fashion designer? Which skills do I possess as far as the production of a collection

is concerned? Do my strengths lie, for instance, in pattern design? What do I know about clothes at all? What do I know about materials? Should I work on the clothes myself or not at all? Which spatial and financial resources are actually provided?

Only when your own demands are described in detail can you act professionally. The expectations, on the other hand, involve questions such as: how many garments does a collection exist of? How innovative is the collection in relation to the last collection I put on the market? Where does the innovation lie – in materials, in design, in volume or in completely different things? How diverse do the garments of a collection need to be in order to be regarded as a collection? When does the collection cease to be a collection and turn into an accumulation of garments?

In the realm of communication, normative/factual conditions involve times and places for events; the international calendar of fashion shows in Paris, New York and London. Even a showroom only makes sense in certain places whereas, in contrast, the shop with a direct connection to the label can also be at the place of production.

The expectations in communication are set slightly higher. What does it mean for a small independent label to organise a fashion event in their own shop, in their own showroom? Which expectations accompany the customers who appear in such a shop in the afternoon? Does one need to sit comfortably, to drink something nice? Which content is offered? Of course, you can break the conventional expectations and offer beer and water instead of champagne. The only important thing is to be aware of this break in convention and to estimate the consequences. What are the conventions with regard to the image of a woman? Who should walk down the catwalk? Who are the models going to be? Liberties in these fields contribute to

the corporate philosophy only if they are clearly recognisable.

The factual conditions for the production involve distribution, sizes, washability, tariff regulations, employment conditions, etc.
What are the expectations as far as production is concerned? First of all, you have to be accessible and present yourself as a business, as a label, as a company. Furthermore, the garment has to *function* in the production process. The design follows the idea that it is not yet finished – it is only in the production that the body comes into play. Even functionality plays an important role. What happens when I wear a catwalk jacket in the rain and in the wind, every day?

Educational systems have to prepare the analysis of these conditions and enable the interaction with them.

Discussion with Dorothea Beisser, Ursula Hudson, Georg Mathias, Bettina Köhler, Ute Ploier (Fashion Designer/Vienna) and Mari Otberg (Fashion Designer/Berlin), moderated by Brigitte Winkler (Fashion Editor/Vienna)

WINKLER: As a fashion editor for Kurier, I have been regularly attending the most important fashion shows in Paris, Milan, New York and London since 1982. The designer's decision in which city they want to work is just as important as the question whether they want to create works of art or fashion one can wear. In addition, regional differences as far as fashion tastes are concerned have to be considered as well. If you want to be creative, you'd better go to Paris. If you think more in terms of profitability, you will have to select New York. If both aspects are equally important, you should probably go to Milan. My question now for Georg Mathias and Bettina Köhler: why did both of you decide to remain in Basel?

MATHIAS: My 80% teaching load in Basel tipped the balance in favour of remaining in Switzerland. The border between global and regional often cannot be clearly determined. Especially in Vienna or Basel most of the designers first need to become famous abroad before deciding to settle in one city.

HUDSON: I think that the market has changed immensely in the past ten years. Fashion has become more accessible. In previous times, you did not have so many different levels in the world of fashion, and therefore the career options were limited. When I started my career there was the *Designer Level of Fashion*. If you didn't want to work for a famous designer you had hardly any alternatives. Today, in contrast, there are many different options for designers who want to work in the field of fashion. If you work in a big company you work as a global designer anyway. If you work for a smaller label you might have to stay at a peripheral location and work locally. I see the success of a designer in being different, creative, in finding your true self and your personal style.

MATHIAS: It would be wrong to think that the industry is looking for designers who are willing to adjust their taste and way of thinking to the industry. Today, fashion is transboundary even if it remains in a niche.

BEISSER: The courage to go out into the world, even in uncomfortable conditions, is important. You have to work your way up to the top, and you need to want it. The will is actually the most important aspect. My question for Ute Ploier: what did you think of Paris?

PLOIER: I shared a showroom with other designers. The press agency had chosen a concert house for that purpose. I was lucky to have been presenting immediately before and immediately after important designers so that a considerable number of people appeared. Another

important aspect was the fact that the venue was not too remote, it was easily accessible.

BEISSER: When I came to Paris, the city was undergoing a radical change, the market halls were relocated outside, the holes in the ground on construction sites were thirty metres deep. The designers were able to open a showroom in old bistros and shops at a low price.

PLOIER: You cannot set up a business without basic capital. After graduating from university, you don't have access to the lab any more, which means that you have to set up a studio on your own, you have to finance your whole sample collection. A show in Paris costs approximately 12 000 Euro. Now I can live from the shows in Paris, but it is still very difficult. The Unit F Prize for International Press helped me here immensely.

OTBERG: There is a big difference between the English educational model and other schools, since the educational institutions in England have always been closely working with the industry. The situation in Germany is improving, but when I was studying the companies or the press were never involved. That was also the reason why I needed to leave Germany at first, simply to establish contact with the fashion industry.

PLOIER: My creative education at the University of Applied Arts in Vienna was really good. But we could only do our internships on the holidays. To learn how the whole practical world works was extremely difficult. That's why I think it's of enormous importance to include work experience in the curriculum, along with creativity.

OTBERG: The problems appear when you organise a nice show once, and your aspirations can only increase – that's why, in the end, you can't avoid sponsoring. All the big shows in Paris are sponsored, there isn't a single designer who is

paying for their shows from their own pocket. Additionally, there is often the own desire to reach a higher level. You don't want to stay in the same place or to take the same models. You want to, and need to, change from one season to another, even if you have already found your own personal style.

WINKLER: You are saying that it's not enough to be creative, that you also need to be a businesswoman or a finance minister. How do you achieve that?

OTBERG: Working on design is just a small fraction of the whole system, the rest is organisation. However, you have to admit to yourself that you can't do everything on your own, and you have to seek someone to assist you.

BEISSER: The most important thing for a young designer is to do an internship. One can, however, learn a lot from a label; you don't have to start high up.

PLOIER: In the end, everyone has to find his or her own way; there is no patent remedy. It's all about presenting your own tiny microcosm to the rest of the world.

OTBERG: I also believe that there are no patent remedies. There are different skills that make all the difference – understanding that mere creative ability does not guarantee you a successful career, you need to be an entrepreneur too. And if you can't do that, you need to find someone to help you. Courage and persistence are also very important. You can fall flat on your face and reach your lowest point in any career, but if that happens you shouldn't be desperate or give up. I once heard a talk by Paul Smith, he was explaining how from one day to another the whole market broke down. He lost millions overnight, yet he said it with such an ease that I realised that one must be able to endure that.

III.

III. DEBATE BETWEEN SUSANNE BRANDSTEIDL, EXECUTIVE PRESIDENT OF THE VIENNESE BOARD OF EDUCATION, AND GERDA BUXBAUM, GEORG MATHIAS, BETTINA KÖHLER, URSULA HUDSON AND BARBARA TREBITSCH, PRINCIPALS OF AUSTRIAN AND FOREIGN FASHION SCHOOLS

BRANDSTEIDL: Austria is a small country as far as fashion or fashion production is concerned. How can countries with a small production or even without any production at all contribute to this field? What does it mean for Hetzendorf, what does it mean for a fashion school? Which curriculum contents are going to gain on importance in the future? Which competences do our future graduates need to possess in order to be accepted by the global market? The development in schools has, generally speaking, in the past few years shifted from testable contents towards strengthening social and personal competences. Today, 18-year-old school leavers need to be able to speak freely, to communicate their opinions, to demonstrate social competence, to be outgoing when communicating with other people, to be able to transfer knowledge and values. To which extent are these skills included in the fashion school curricula? Do they play an important role for the company which employs them? Do fashion graduates dream of carving out a career in New York, London or Paris? And what does reality look like?
And finally, there is the question of drop-out rate. How many graduates remain in the fashion industry?

BUXBAUM: The situation in Austria is difficult, but not impossible. The most important thing is to ask yourself several questions. Who are we? What are our competences? Which skills do we possess? What is our potential? What is possible? We should not attempt to imitate other institutions or to enter a competitive

relationship with them, since we simply can't do it. We should be tough on ourselves and admit: we've got an unbelievable amount of potential in some areas, in other areas the potential is lacking. We are a small yet rich country. We've got an unbelievable creative potential and a rich history, which can be used but not by reselling the old ideas. The knowledge of history needs to set you free. Your own skills and qualities should be to the fore. You can't say to the students that they don't have any chances here or to send them immediately abroad, they should just be shown the appropriate path. We need a lobby, institutions offering consulting services. We need support from the media, from opinion leaders, from companies – fashion is a medium of communication after all, and without the public the Austrian fashion, even in its best quality, cannot survive.

AUDIENCE/STUDENT: I find Vienna very interesting as location to work and create in, since there are still many things that can be done here. In Milan or New York there already is everything. To stay in Vienna is a challenge, you can still achieve a lot here.

BUXBAUM: The cultural environment is an important factor, and Vienna has an enormous cultural environment. The only problem lies in the fact that Vienna is always perceived through high culture and not through future design. As far as the drop-out rate is concerned, in Hetzendorf the percentage amounts to approximately 50 %. The other half finds accommodation in various areas of the fashion industry: as employees in theatre or film, as fashion journalists or as stylists for an own label. The range of possibilities is vast, and this still has to be pointed out over and over again.

MATHIAS: I, as someone from Switzerland, find Vienna very generous. The square in front of the *Museumsquartier*, for instance, shows how the free space can be extended, and this is

precisely what can be used in creativity too. In Switzerland there are only narrow streets. What one feels in Vienna is that it is a capital and that the cultural offer represents a huge chance.

BUXBAUM: If we take a look at the situation from the perspective of a system, we can identify the American fashion system, the English fashion system, the Italian fashion system, the fashion system of Antwerp. When you walk down the streets of Antwerp, you can detect a certain style drawn through the whole city. The Italian fashion system, on the other hand, is based on manufactures. The Italian fashion is actually a creation of the twentieth century; it was built overnight as the reaction to the Second World War. The system in Austria, again, is nameless. Do we have a fashion system at all?

TREBITSCH: In some cases, the absence of a fix system can be seen as an advantage. There is a kind of spontaneity, a freedom of not being compelled to fit into a system, and it can also be taken as a stimulus for creativity, to create something new.

BUXBAUM: Most of the young designers want freedom yet they can't cope with it. The absence of fashion system in Austria could certainly be an advantage, but on the other hand it is difficult to use this chance.

HUDSON: The teachers have the responsibility to look ahead and, for instance, create a new feeling towards Austria. This could very well be taken into the curriculum.

BUXBAUM: Austria still lacks a theoretic approach to fashion. There is still no interaction between sociologists, psychologists or literary critics. Fashion in this part of the world is still something written on the last page of the newspaper.

BRANDSTEIDL: Education isn't of any such interest in Austria either.

BUXBAUM: Hand in hand with the Bologna Declaration, the quality initiative in vocational schools has been started, which now offers us the chance to change something together.

MATHIAS: The Swiss would be delighted to have somebody such as Helmut Lang, who showed that a transfer of the past, of the tradition and of the traditional dress, for instance, can take place in the future. The fashion institutions in Switzerland also have to make a statement, and a part of that statement is also the opening towards the East.

BUXBAUM: Many students from the East study in Hetzendorf, it's a very rewarding exchange. The geographic and cultural vicinity is certainly an advantage for Vienna.

BRANDSTEIDL: The expansion of the EU is primarily a chance for the market. In addition to that, there is also a chance for a comprehensive cultural dialogue.

KÖHLER: The market also benefits from an exchange of knowledge and experience.

HUDSON: How many Hetzendorf graduates set up their own business or establish their own label?

BUXBAUM: Approximately 10%. The rest find their place in big domestic companies such as Wolford, Swarovski or Palmers. Or they go abroad.

HUDSON: Providing the students with entrepreneurial skills already during their studies as well as encouraging them to set up their own label has, in some countries, helped establish a group of successful fashion designers. This was the case in Belgium, but also in England. A good start, even in Austria, would be to provide the students with the right skills and the appropriate knowledge as well as to offer them an adequate network.

BUXBAUM: Our educational module for the new bachelor system already includes subjects such as marketing, business plan or methods such as team teaching. We have already made the first steps. Marketing is partly taught in English so that the students learn business English terminology as well.

MATHIAS: Being independent doesn't exclude failure or mistakes. From our point of view, it would be of special importance to found institutions which you can address in case of difficulties. These institutions should provide financial support only to a lesser extent; they should far more offer advice on how to get out of that difficult situation since the designers usually aren't able to assess the whole situation objectively. Failure is a huge problem in Switzerland, because nobody wants to show any weakness.

BEISSER: The percentage of ESMOD graduates in Munich or Berlin who immediately go into business for themselves amounts to 3-5%. The school offers the opportunity to coach them further, ESMOD can be contacted at any time. Our students also visit our graduates to see what they do now. Every now and then there are graduates who contact the schools and ask for advice, even ten years after having left.

BUXBAUM: The central requirement for success is the fascination, the passion, which has nothing to do with the brainpower or the anxieties, but rather it feels like an inner burning for something you want to do, no matter what. If you don't have that burning inside, all the knowledge and the good education is of no use. The passion must be felt in a collection. This emotional, invisible aspect of your work is what makes it successful in the end.

IV.

IV. STARTING UP AFTER FORMAL TRAINING

Accademia internazionale d'alta moda e d'arte del costume, Rome
Giovanni di Pasquale, principal

The Academy in Rome was founded in 1920, specialising in the development of pattern designs. Pattern designs were sold there and then used to have dresses tailored. Even today, pattern designs from the 1930s can be found on the flea markets of the Academy. Pattern design has remained the focal point of the Academy consisting of two major fashion departments: couture and prêt à porter.

Forty students from approximately one hundred applicants are admitted to the school every year; the entire number of students thus amounting to approximately 150. The courses offered here do not only focus on transferring theoretical knowledge but also on gathering experiences in the real world. So, for instance, the lecturer in fashion history is a fashion journalist who has already worked with Coco Chanel or an illustrator who has designed for Valentino.

The international ties as well as the communication of the fashion system as an economic system are an imperative for any educational fashion institution, even in Italy. Fashion designers have to develop the skill of linking the past with the future. You always have to keep an eye on the past, study it, gain cultural knowledge from it and know the traditional roots. You have the opportunity of using culture as a tool and using it in your creations.

Bernd Skupin, arts editor of the German VOGUE, Munich

How relevant is fashion in the media? Which opportunities do fashion students and potential designers encounter when wishing to establish contact with the media? What are the do's and the don'ts of the fashion industry?

Today we are confronted with the phenomenon that only print or online media are of importance for fashion; the otherwise almighty medium of television is almost irrelevant in the fashion field – it almost completely fails. There are wonderful documentaries about architecture, a topic certainly as sophisticated as fashion in terms of aesthetics or technical requirements. However, whenever fashion is presented on TV, it is usually in the context of boulevard reporting, the fashion glamour of the celebrities. A serious reporting style on TV about fashion trends and the latest developments in fashion would require dealing with fashion on a deeper level. From this perspective, series such as *Sex and the City* or *Absolutely Fabulous* are by all means fashion relevant since they at least negotiate fashion as a frame of reference, as an apart, real cosmos.

As far as fashion relevant print media are concerned there are two different levels: on the one hand, there are local daily papers as well as the arts section or business sections of bigger national newspapers and magazines, and on the other hand there are the *classical* fashion magazines. Recently, a further category has emerged: magazines placing fashion in the context of art or photography, usually in search of the avant-garde. They are interesting for several reasons: since they strive towards avant-garde, they are open to new developments and young talents, and therefore are a priori internationally-oriented. Big fashion magazines cannot be as open or international because they target the mainstream and depend on the advertisements.

The avant-garde magazines aim at the *global village*, at the international scene of young avant-garde fashion designers, which is not huge but still makes up an important market for independent labels, and this is a niche

market, rapidly developing as an alternative to the industrial textile market.

Fashion journalism in the German-speaking area is only just emerging, even with regard to print media. Or – to put it in a friendly way – the local fashion journalism is reaching a new phase. A historical development underlines this process. In the 1960s and 1970s the attitude towards fashion was rather sceptical and socio-critical, at least in intellectual media circles. Fashion magazines were mostly women's magazines with pattern design supplements and instructions what to wear.
Around the 1980s big fashion magazines were founded (*Elle, Vogue, Marie Claire, etc.*), but this attitude could still be detected for at least a decade. It was only in the 1990s, when the cultural and social relevance of fashion was recognised again, that the need to find out more about fashion emerged. Suddenly it was not enough to put a naïve designer profile next to a nice catwalk. The biggest difficulty at the beginning was to find adequate authors who were willing and able to deal with the fashion system in a serious and intellectual manner. Up to that point, respectable journalists and reporters considered themselves too good to write about fashion. This changed in the course of the 1990s. The publishers of fashion magazines recognised fashion journalism as an individual field requiring special qualifications. You had to be interested in fashion and be willing to dive into the tailor's trade, to travel to fashion shows, to establish and nurture personal contacts with fashion designers.

Fashion journalists are not the same as fashion editors. The latter are mostly stylists with expanded skills. They select clothes from various collections for a fashion show or a story, but they do not write. By the way, fashion editing in its classical form is another interesting occupation fashion students could choose if they can't or don't want to work in the field of design.

Formal training in design is basically a good requirement for becoming a fashion editor.

I would now like to address the question of the importance of the media for fashion designers, especially at the beginning of their careers. The discussion in this forum has shown, from the designer's perspective, that the media have a very strong influence on the designer's career. Speaking from my own point of view, however, this influence is often overrated. The public perception is important, yet the connection to the industry and the fashion scene seems even more important to me. When, for instance, the marketing and distribution strategies of a label aren't developed (yet), the presence in the media is of no use. Especially at the beginning of the career it is of immense importance to establish relationships and a trust base with producers, distributing partners and clients; it is only then that the presence in the media makes sense.

There are several possible ways and strategies for a successful engagement with the press. One of them is to work with a press agency – it is a comfortable though expensive option. Press agencies are professionals with adequate know-how, knowledge of do's and don'ts but also contacts and networks at their disposal. If you opt for a press agency, I would recommend a thorough analysis of the agency's portfolio. Some agencies have specialised in representing young designers, which can be of advantage in certain contexts – for example, when organising collective fashion shows or showrooms. At the same time, a collective presentation of young designers in a portfolio can be a disadvantage if there is a lack of individual presentation and selection.

Approaching agencies who represent established fashion companies is much more difficult for young designers. However, if a big agency is delighted by a young designer, it offers to represent them under rather attractive conditions, in order to make it easier for them.

If you, as a young designer, decide to produce for a local market, if you want to be rooted in a certain area, the cooperation with the local press has to be enhanced. This involves a personal on-the-spot establishment of contacts with journalists, but also with other creative experts. It means establishing a local network. This is an individual strategy, which does not have to be based on a clear decision to be positioned locally.

What are the *rules* for dealing with the media, what do you have to know, what do you have to avoid?

This may sound mundane, but even the press agencies sometimes neglect the basics: to take a look at and read the media in which you want to be presented. You have to know what they usually report about, who are their authors, how they write, what is their style. Only then can you decide whether that medium is right for you at all, whether the contents and attitudes presented there are in accordance with your own designer work.

The second important thing is to be informed about the conditions and rhythms of production; you have to know when the press releases have to be sent in order to be considered in time. A daily paper functions completely different from a monthly magazine. Big magazines have a minimum of three months of pre-press work, the avant-garde magazines even more, especially if they are published only twice or thrice a year.

It is important to establish personal contact with the journalists, to make phone calls, to meet the right people, to be able to describe briefly what it is that one does and what it is all about. In addition, a good press portfolio is of essential importance, since fashion is communicated visually and haptically. When you send your portfolio, you have to make

subsequent phone calls, although not right away, you have to wait for a couple of days. You have to make sure that your contact has received everything, you have to ask him for his opinion and whether he needs further material. And once you have established a relationship, you have to nurture it. This might require a little patience, but it pays off. Especially in case of magazines, the report is seldom published straight away; a relationship with the media has to be built over a longer period of time.

The question of obtrusiveness is the next important issue. How importunate do you have to be, and when does it become too much? By being obtrusive you can achieve a lot, a report on your work can be published at least once. The disadvantage of this approach is the fact that people start hating you. If you want to establish a good long-lasting relationship, you have to remind the press of your work without putting anyone under pressure.

Another issue is honesty and the question of how many legends are allowed to be created. Generally speaking, the creation of legends is in any case permitted. You don't have to hide anything, but you don't have to invent anything either. The only interesting thing is the story you decide to tell. Some stories develop into fixed points in a CV, even if nobody else can witness them any more, and that is how legends are created. However, what you do need to avoid is faking facts, for instance with regard to the number of copies sold. This is what destroys the charm of the story.

Discussion with Giovanni di Pasquale and Bernd Skupin, moderated by Yella Hassel

HASSEL: How can a young designer find an appropriate agency to represent him or her? How much does this representation cost?

SKUPIN: Generally speaking, one should be bold and fearless when contacting the press. The address of a magazine can be obtained relatively easy by reading the edition notice; this is where you can find the phone number as well. And then the best thing to do is to make a list and phone one number after another. If eight out of ten contacts refuse you, there is still a chance of two of them saying *maybe*. The same goes for press agencies. You can try to address all of them, and one of them might like your work. If that doesn't work you could find other young designers together with whom you might get more attention.

HASSEL: If a fashion student wants to work in the field of journalism, how can they achieve that? How can you reach a magazine such as, for instance, Vogue?

SKUPIN: Applying for an internship is certainly a very good way to do that. You might not stay with Vogue, but you might find an editorial position in another medium more easily. Lately, there has been an increasing demand for experts in journalism, in the sense of fashion journalism.

BUXBAUM: Verbalising the visual phenomenon of fashion is very important. Everyone who dresses nicely and is interested in fashion thinks they can write about it too. Cultural journalism can now be studied in various institutions, but fashion journalism is not a field of study in the German-speaking area.

SKUPIN: There is actually a lack of specialised lecturers in this area. The first serious generation of fashion journalists in the German-speaking area has only been around for ten years.

DI PASQUALE: How many students actually intend to become famous, to be the best? Not everybody can become famous like Dior, but the fashion field needs many employees; it is a huge field and an immense employment market. The most important thing for the students is to find out where their own qualities lie. Not even a fashion show is the most important feature, although it is like a drug for the students. What is important is the product, the substance, the service, because the actual fashion show does not start when the lights go up, but when the lights go down, when the bills have to be paid.

MATHIAS: Communicating with the press can help your company's services or you can use it to become famous very quickly. When setting up a business, too many orders can lead to consequences of catastrophic proportions, if you aren't at all in the position to produce so much. In that case you've had very short fireworks.

SKUPIN: We share the same opinion here. You have to be very careful if you don't want to burn out like a falling star. The magical image of your company mirrored in the media isn't real, it's just pure media magic.

BUXBAUM: Giovanni di Pasquale remarked that a fashion show isn't the most important thing, yet all the schools and institutions are compelled to produce a fashion show because the public wants to see it. The question which arises then is to which extent can or should fashion shows of a school be professional? None of the schools can afford to pay professional models, that's why students usually act as models. How can a school present its work to the public at its best?

DI PASQUALE: Fashion is visually determined, and the contribution of the media regarding visual perfection is essential. Fashion designers work with *fitting models*, with completely normal proportions, all year long. In spite of this, the ideal image of fashion is the world of glamour. The plausibility of product lives on this illusion of fashion, and it is extremely difficult to take that frame away from fashion. It would be like presenting a frameless painting with poor illumination and claiming that it was a fascinating work of art.

AUDIENCE: The professional world of fashion and schools function on two different levels. The opportunity for each student to present their products belongs to a good formal training. Comparing the fashion shows of a school with those in Paris or Milan, however, would be fatal.

KÖHLER: The shows in our school, for which Georg Mathias is responsible, are presented by both professional models and students. The soon-to-be designers should bear in mind that wearing their own clothes changes the perception. It is actually another criterion to be tested: what kind of clothes do I create at all? What happens with the clothes when they are worn?

BEISSER: It is, of course, impossible to send all the students on the catwalk, but there are always students who look like proper models. Selecting the model is as important as fitting. In our school the whole choreography is rehearsed for three days. The students back the outfits they have created; they wear them together with their colleagues with all due respect. The choreography is always linked to a short story, which is included to support the statement of the collection.

BUXBAUM: Hetzendorf, for instance, opts for a mixture of professional models and people taken from the streets, yet the basic dilemma lies in the public acceptance. The media are feeding us with visually highly-polished impressions, which then become standard in our minds and perception. We have already sent people over 60 or children on the catwalk – fashion is, after all, created for all people. The radical production of youth and beauty ideals is closely related to eating disorders, and this is the terror that our students should not succumb to – to only be able to parade down the catwalk.

(edited by rd)

TECHNOLOGY & INNOVATION

TECHNOLOGY & INNOVATION

TECHNOLOGY: FRIEND AND FOE

"In this new erotic world there is a lack of any illusionistic element. The body is present, even over-exposed, but only as a part of a technical instrument." (Jean Baudrillard)

Many experts agree: the only new thing that fashion can offer is the material, the technology – not the design, not the cut. It is the technology – packed in shock and provocation.

A brief look at history reveals that times of hardship and deprivation, times of being isolated from international trade were the most innovative times in terms of creativity and technology: How else would it have been possible to come across the idea of using fish skin for blouses or Plexiglas for shoe soles during World War II? When the silk was not available in World War I, artificial silk was invented as a substitute – it was an epochal invention. Nylon tights were also created by technologies originally not intended for fashion. It is the curiosity, originality and alienation that induces the shock and excitement.

Walter van Beirendonck's *Wild & Lethal Trash* – a collection made from acryl, vinyl, nylon, poly viscose, polyamide and fibreglass fabric – is a reaction to the commercial misuse of natural fabrics. With the current worldwide surplus of textiles, fashion designers are now working with soft rubber and woven plastic strips (Corinne Cobson), carbon (Alaia), tricel (Jean Colonna), neoprene (Gaultier), film roll material melted down into silk (Yamamoto), coated paper (Demeulemeester) and coated polyester felt (Comme des Garçons). The Austrian label Schella Kann uses *condom materials* as protection from the environment – a Lycra mixture for long dresses or t-shirts. In addition to embroidered, crashed and tie-dyed spandex, coated cotton PU mixtures (reminiscent of eraser and tyre profile) and paper-like polyamide fabrics, also copper or viscose with film roll semblance can be used.

"I am not really interested in fashion," states Hussein Chalayan, who presents every year his technical experiments in the form of fashion or clothes, which can also be interactive interfaces.

On the other side of the coin, and the reason for a painful shrinking process in the European textile industry, is the rapid technological development. The pressure to constantly adapt to the latest state of the art and to permanently invest large amounts of money in new equipment, as well as an extreme increase in productivity, are diametrically opposed to the decreased employment figures and a lack of sales markets.

Gerda Buxbaum

LECTURES

PORTRAITS

IMAGES

urban tool / a profile

(edited by rd, statements sabrina tanner and anja herwig) The company and label URBAN TOOL, founded in 2004, is specialised in the development and marketing *wearable technology* and *emotional electronics*. This start-up enterprise with their headquarters in Vienna has already been awarded numerous international prizes, for the focus on linking IT and fashion. Personal gadgets such as cell phone, iPod, wallet or key can be comfortably carried close to the body due to their clever product solutions.

URBAN TOOL enables an emotional approach to technology when incorporating contemporary and future technologies. Today, URBAN TOOL products are distributed worldwide in more than 25 countries ranging from Japan to America.

"Fashion and IT have been completely contrary fields so far. These differences are our challenge. With our products, technology becomes stylish and wearable. Increasing mobility in everyday life requires further development in these, still largely uncharted, waters."

The products and solutions are characterised by an unconventional approach to integration and use of technology and fashion.

"The aspect of fashion is very important to us since it is often neglected in the IT business. Our motivation is to minimise these apparently vast differences and to point out commonalities. Both fashion and technology have to be modern and be connected to the user. Cutting-edge product concepts linking fashion and technology enable us to experience feelings and emotions more intensely."

Development work is a huge priority for URBAN TOOL and thereby much of the know-how and production skills is invested into everyday user-friendly solutions. The significant functions are achieved through unconventional workmanship and a design-oriented approach to tailoring and material technology.

"A serial product has individual requirements – there are different people who wear it and different products that have to be included. That is why materials, cuts and product design play a crucial role. Our departure point is therefore more product design-oriented, which means that we use materials in a function-directed way."

"We have developed an approach that should simplify technology and should create more emotionality. An example of this is our *perCushion*, which is currently in the development phase. It is a cushion used as a phone. The original idea was to make cell phone calls comfortable and cozy – in other words, it is not about enhancing cell phone technology even more. For instance, I come home in the evening and make myself comfortable on the sofa and if I want to make a phone call, without having to look for my cell phone, I could use my sofa cushion instead. It connects to the cell phone via Bluetooth, wherever it is, and it functions as a hands-free system. Technology should be integrated in our lives in such a way to make them better and not more complicated."

The designers behind the label URBAN TOOL are Sabrina Tanner and Anja Herwig. The story of the company beginnings goes back to a personal motivation: Sabrina Tanner designed a bag for her husband in which he could carry all the important objects safely and comfortably, which turned out to be a really hot item. More and more people showed interest in the practical bag – the *primal-holster* was born.

After the first successful product developments, the question of setting up their own enterprise for the design and distribution was raised. Sabrina Tanner and Anja Herwig decided for their own company.

"We come from a design background and we actually did not want to take a step towards business simply because we didn't learn how to do it. We were then rather surprised when faced with the decision to either distribute and sell our products on our own or to use someone who will present them to the world in a way we might not have intended. It was a very serious decision for us, but we are still having fun and we haven't regretted it yet."

The biggest obstacle and challenge is still the work involving technological development and production.

"It is unbelievably difficult to find production plants that are willing to deal with new technologies. As far as accessories or outer wear is concerned, we are trying to keep the production costs as low as possible, especially if we are talking about a series production. It is often easy to produce a prototype, but a series production of a product really involving technology implies dealing with certification processes, making the product ready for export, fulfilling country regulations, etc."

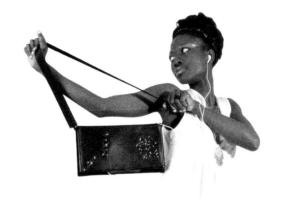

"Nowadays there are many possibilities for a small business to operate globally, even when you are located in Vienna. You can gain access to remote markets – this might be an advantage of globalisation. Earlier, only huge companies could do that. Now we've got partners who don't know us personally at all – we're working with the Taiwanese or the Indians who simply contact us over the Internet."

www.urbantool.de

frencys / a profile

(edited by rd, statements clemens sillaber)
Behind the brand FRENCYS is a family company with a long experience in the general production of functional clothing and skiwear in particular. The tailor shop of the company founder, Rainer Bretschneider, has developed into a modern production plant. The central office is located in Himberg by Vienna. Two production units with the latest technical equipment are operated in Hungary. The production takes place solely in Europe and only materials and equipment of European origin are used.

"We are very proud to be an Austrian-based company, especially in the clothing industry, where a strong migration to the Far East can be seen."

In addition to being a specialised shop, FRENCYS had already established its reputation as a provider of sportswear for skiing instructors in the 1970s. High quality standards, reliability and flexibility in terms of design have resulted in FRENCYS emergence as the market leader in this field over the years. Many prestigious skiing schools and ski teaching teams have been their customers for years. Their tests and experiences are constantly taken into consideration and consequently implemented in the new collections, particularly in regard to material improvement.

"Our goal is to expand our market position both in the field of functional sportswear as well as in the field of professional clothing and clothing for public officials. Our customers are professionals from mountain railways, skiing schools and associations – groups requiring highly functional clothes while maintaining the Corporate Identity of their uniforms."

One of the milestones in the company history was the acquisition of the brand *Panlo*, a company specialised in uniforms for public officials, which enabled FRENCYS to cooperate with the *Gore Company* as well as use the Gore-Tex material, making it one of the few Gore-Tex-licensed manufacturing plants in Europe. The Austrian Police and Armed Forces, the Austrian and the Swiss Federal Railways, the German Air Force and many others have been their customers ever since.

"Official clothing is all about providing the best protection possible. We're not talking about ordinary conditions and requirements here."

"Fashion is also research. New things are created, new materials keep coming in, new pattern cuts are on the market. The new pattern cuts are based on the new body movement types – especially in the field of sports where new types of sports have emerged."

The new FRENCYS Future Lab Team targets a generation of versatile sportsmen and free riders. Supported by the know-how and more than forty years of experience in producing sportswear, FRENCYS Future Lab represents a young team of sportsmen, designers, trend scouts and clothing experts, specialised in developing functional, multi-purpose sportswear. Individuality reflected in the perfect fit and individual design is a huge priority of the company since the individual has priority over the trend.

In 2007 FRENCYS was awarded the Personal Design Award at the *Munich ISPO* – the biggest international trade fair for sporting equipment and fashion.

"What does personal design mean in this context? Our manufacturing techniques have become so flexible over the years that our customers can be offered what we refer to as *Individual Style Programme*, which guarantees individuality on several levels. It's all about a personal style, a personal colour, a personal size. Not every customer has the same leg or arm measurement, not everybody has the same

proportions – that's why our shops are offering personalised design in addition to the official collections. It works fairly simply. You can log onto our website and determine your Personal Style. Depending on whether you are a skier or a mountain guide you can select between a Comfort Style and an Action Style. The difference lies in the materials, in the lining. Then you select the colour and the size, and your order is sent to the retailer."

"In the end, it's all about interaction of fashion and movement, of form and function."

www.frencys.at

Frencys®
FUTURE LAB

sarah taylor /
fibreoptics. light emitting textiles

In my work as a textile designer I was always fascinated in how the yarns could be utilised to create new and diverse fabric properties. Light, form and transparency have been instrumental in my textile development. My inspiration came from types of light sensitive yarn. Research into fibreoptics came with a natural progression for these woven expirations during the 1990s. The focus was on the development of the nylon one-filament fabrics. The experimentation with the contrasting yarn types created diverse fabrics. So, the idea of incorporating light emitting fibres within a transparent medium initiated research into fibreoptic technologies. Since the emergence of fibreoptics as a commercial proposition in the 1950s, there has been a marked increase in their use for decorative purposes. Which, of course, continues to reflect today's interest and involvement in the development of high technology materials.

LEFT AND RIGHT: FIBREOPTICS. LIGHT EMITTING TEXTILES

Basically, fibreoptics are light conducting fibres. They are typically solid and are composed of two types of transparent materials, which comprise an inner and outer core, and are of a lower reflective index. Light is conducted along the length of the fibre and in order to light the fibre you need a light source. For example, the light bulb now is being replaced by fibreoptics. Light emitting material has been produced since the 1980s by the American company Lumitex. They create woven optical fibre panels; however the main applications of the technical products are high-efficiency backlighting, such as membrane switches, liquid crystal displays, etc. One special application that they produce is called the *Billy Blanket*, which was developed for photo therapy treatment for newly-born babies with jaundice. The baby is put into a sort of sleeping bag lined with woven light emitting material. The light acts as a healing force for the disease. Conventional photo therapy involved risks of retina damage and dehydration from infrared light. The properties of fibreoptics allow for more flexibility in design because they do not transmit ultraviolet light, emit heat or conduct electricity. The woven layer is actually within two layers. The fibres are attached to a LED, a light emitting diode, at the end with two metal prongs that come out. This is actually just a battery. The woven baric is in-between a diffusal layer, which is obviously creating a random light. It also has a reflective panel underneath that helps to reflect all the light outwards.

In order to achieve the best possible design solution, it is fundamental to gain an understanding of the technology in it's broadest sense. The research I did explored many englove polymer-based fibres. The fibres that I tested are actually specifically used for decorative applications. In this case, the fibreoptics are encased in a plastic jacket of sorts. The purpose for this is that it retains all the light within the fibre in order to make information, in telecommunications, visible.

I was testing various optical fibre types that would be suitable for woven fabric manufacturing. These included colour fluorescent optical fibres. Fluorescent fibres actually generate their own colour. They are coloured during the manufacturing process, but they absorb the light from around them and therefore do not require a light source. I looked at both clear polymer-based fibres and fluorescent optical fibres. In experiments, the loose ends of the optical fibre were inserted into a 150-watt light projector so that the penetrating light passes along the length of the fibre. The addition of colour wheels within the light source can create colour options within the fibre and fabric. The object of my research was to design and produce functional textiles incorporating optical fibres for aesthetic effect as opposed to technology products as well as exploit the optical properties of the fibres to generate light within woven fabrics. They are very fine and flexible. The combination of structure and fibre type was deemed to be most suitable in terms of the quality of material I was after. Due to it's light weight, the material can be draped naturally or manipulated to create 3D forms. Finishing effects, such as creasing and embossing the material, would create additional points of light. As the research concluded, the effect of the weaving process caused light to escape by damaging the fibre. The material is best exploited in darkened environments, but with suitable light sources, such as lasers, the material can actually be appreciated in daylight conditions. Colour from a rotating colour wheel within the light projector produces dramatic effects within the woven material. The colour wheels can be designed specifically to create continuous or intermittent light. This intermittent light produces the power of movement. Use of time effects also creates further dimensions to possible visuals. By using two layers, each with a different colour, you can achieve a marvelous effect as well. There are so many possibilities for the fashion world in collaboration with this field.

This research work has continued to gain much publicity and attracted interest from both technical and fashion fields. The findings of the investigations prompt further research into new markets and the questioning of functionality and aesthetics. Within the realms of interior and fashion design, designing with colour in the form of light allows for a broad scope in the development. The potential markets include safety wear, military clothing and product design. Coloured light could either be used for therapeutics or the stimulation and calming the senses. They could be designed to meet individual requirements; where colours are programmed into a yarn and high output light sources are developed that would allow the fabric to be worn.

"Design is uniquely capable of interpreting and humanising the discoveries of science and technology by acting as an interface between producer and consumer and between technology and the end user". (Robert Colemann)

Perhaps the future of textiles looks brighter after all.

max r. hungerbühler/
the european textile industry
at crossroads

In spite of the diversity of our actions, in spite of our different tastes and independent of our probably divergent ideological attitudes there is a fascinating common ground we share: the interest in textiles and in fashion as a market. It just might be the oldest market of the world if we think back to the magic beginnings of fashion when the hip cord and amulet set the wheel of fashion in motion and when shells were used as jewellery and currency at the same time.

It is undoubtedly the biggest market in the world since it comprises more than 6.8 billion people on all continents, who are at the mercy of the inner and outer fashion trends they have to or want to follow. It is the only market that functions, so to say, as a perpetuum mobile – and it will as long as there are human beings.

The intensity of this perpetual motion has increased over the last years, which has created completely new requirements for the textile industries in Europe but also in the Far East. It is these modified conditions that I would like to address subsequently.

The negative image of the textile industry

Unfortunately, the textile industry does not enjoy a good reputation. It is certainly anything but easy to sieve through the daily shower of various information created by the media to find the picture of the textile industry that matches reality. The image of the textile industry is constantly affected by negative news such as child labour, protectionism or environment-unfriendly production methods. Very often, this happens without a profound or differentiated fundamental research.

Many textile specialists delivering outstanding performances in the field of creation, production and marketing are rightly annoyed by the fact that numerous media sources usually tend to report only the negative aspects while concealing the good ones. The image resulting from these reports is often very distant from the truth.

Moreover, the very different type of public relations on the part of the textile industry enterprises and associations often goes unheard in this vast flood of news. The publicity generated by these sources is verifiably highest whenever it is about short-time work, outsourcing or factory closures. The best remedy against such one-sided reporting is a constant personal cooperation with serious news agencies. At the same time, one should accept a certain risk that a piece of information might be received by the consumer in an unintended manner. This might be one of the predominant reasons why many textile industrialists shun news representatives.

Main causes of negative growth

One of the main reasons for a profound process of concentration in the European textile industry in the past years is the rapid technological development, which has experienced a further enormous leap forward with the introduction of electronics. The textile entrepreneurs who do not constantly adjust their production plants according to the latest technological developments lose their international competitiveness within a very short period of time. Expensive machines are often outdated after several years and have to be replaced by more powerful machines, even though they could have been kept in use for a long time. Hand in hand with these never-ending investments that consume substantial capital there is an essential improvement of productivity. The high cost of capital is accompanied by somewhat lower wage payments given the reduced numbers of employees, but for the production, which has increased on the whole because of expanded production possibilities, there is an inadequate market capacity of demand.

Compared to other products, textiles are fabricated in more or less every country in the world – in completely unequal conditions. Generally speaking, but also from the point of view of the textile companies subdued in this demoralising battle, the negative growth of the textile industry in the Western industrial countries does not represent a shake-out. The surviving companies are not able to take over the market share of a local competitor who leaves the market, rather they lose it to the offers from low-wage or low-cost countries. Stringent import prices from developing countries are the main cause of the current unsatisfactory profit situation in the European textile industry.

Every modernisation of a machine park usually involves, along with increased productivity, a reduction in the number of employees. On the other hand, the increase in the number of employees in the new production areas, assuming a fixed production rate, is not as significant as it used to be only a couple of decades ago. The best development aid would therefore be, on top of the creation of as much employment as possible, the local sale of textiles produced in low-wage countries to their own largely underprovided customers, instead of exporting them to the already supersaturated textile markets of Western Europe or North America at cut-throw prices. Since this remains a pious hope and technical progress cannot be held back, the growth of the Western textile industry is hardly imaginable in a foreseeable time. On the contrary, we can count on the continuation of the concentration process.

The European textile machine industry has a leading position as far as world-wide consignments are concerned. In this business only a few manufacturers are competing. Their profitability is significantly higher than it is the case in the textile industry. The forced expansion of the modern textile

industry into many of the third-world countries with the help of various means such as investment aids, export subvention or import limitations would lead to positive growth of the traditional industry in the Western countries only if the new production, as already mentioned, could be used to satisfy the enormous textile needs of these young production countries. But as this is not possible due to their too low purchasing power and the strong desire to export as much as possible to obtain foreign currency, the import of cheap textiles in the industrial countries is on the constant increase, which results in slow elimination of their own textile industries. For political reasons, none of the Western countries have dared to significantly reduce the import of supplies from those countries so far – an endeavour that the distressed textile industry of various countries has already asked their national governments to carry out.

Deflecting the stream of commerce could be primarily realised in the field of apparel such as ready-to-wear articles. The production of these articles, which involves sewing as one of the especially important and labour-intensive production processes, is the cheapest in low-wage countries with infinite number of employees. The cost of transport from the Far East to the Western sales territory is still very low, which has motivated European clothes manufacturers to increasingly manufacture their products in those areas. Cheap import of ready-to-wear products also negatively influences streamlined and capital-intensive companies of the European textile industry, since the required components are increasingly bought locally.

Future perspectives for the remaining textile industrialists in Europe
In the past, the textile industry used to be a forerunner for the whole economy. An economic boom or a recession could be first seen in the market-sensitive textile industry. The textile industry was the first to feel the strength of a currency or the criticism of the media. There are many indications that the consequences – reflected in the European textile industry in the change of structure due to globalisation – will become more and more decisive in the entire European activity area.

The current situation, as has been already noticed, is characterised by a worldwide surplus of textiles. Surplus production and a too large capacity in Europe, as well as in most emerging nations, cause an immense raid on prices. In addition to that, the local textile industry is protected by the state and subsidised financially in numerous third-world countries, which results in grave market disequilibrium. Relatively low transport costs only insignificantly increase the export prices from low-wage countries.

The opening of the new large markets, above all those of China and South East Asia with their significantly lower labour and production costs, has

changed the world textile market profoundly. This dynamic process of change is by no means completed. The use of telecommunication and the global transparency which goes with it, the transfer of know-how and also the opportunity of e-mailing the latest designs within seconds to the cheapest production country are being used more often and ever-more professionally. Additionally, the intensity of competition is increasing, since the growth markets of today lie in the Far East while the European sales markets are saturated with fashion products. Short fashion cycles without distinctive trends, as well as counterfeiting, additionally increase the commercial risks of companies. In the past, the high labour cost in Europe could time and again be at least partially compensated through an above-average increase in productivity owing to appropriate investments. An advantage that has lapsed in the meantime.

In spite of these negative aspects, there is still a remarkable number of commercially successful European textile companies. Only they are not heard from very often, not least because they want to avoid the danger of being copied. According to management theory, there are three types of really successful companies: the low-budget companies, the innovative companies and the niche companies. Since we, on the European continent, hardly have a chance any more as far as the first company type is concerned, we have to focus on the other two company types. We need production plants producing globally-recognised specialties, whose added value allows for high personnel costs as well as niche companies led by experienced, successful business people. Marketing and accounting play an important role in both of these future-oriented company types, but being close to the market and the customer or a high creative performance, are important issues too. In addition, a wide range of already available resources should be better exploited as well – for boosting the European textile company network, more coordination and alliances are called for in order to ensure the security of production partners.

The love our wide industrial circles have for textiles as well as the feeling of happiness that emerges when working with our products will continue to stimulate our branch in the future. With this positive attitude, the problems concerning the surplus of textiles, the immense raid on prices as well as the unpredictability of the market development can be successfully solved. Open markets without customs, no trade barriers as well as an economic system and legislation allowing us equal terms as is with our competitors in low-wage countries are important requirements for the future success. Then the textile industry will be able to develop further, produce highlights of technology and fashion that can stand up against the products from low-wage countries. All of those involved in fashion in any way are called upon to contribute their share to achieving this important aim.

sabine seymour /
fashionable wearables –
aesthetic interaction interfaces

This article is in large parts based on excerpts from Sabine Seymour's book *Fashionable Technology, The Intersection of Design, Fashion, Science, and Technology* that was released in May 2008 by SpringerWienNewYork.

Fashionable wearables are *designed* garments, accessories, or jewelry that combine aesthetics and style with functional technology.

The potential for collaboration between the worlds of fashion and technology has been ever-present since the initial explorations of Hussein Chalayan almost ten years ago with the *Remote Control Dress* in 2000. It marks the starting point for *soft computation* in wearable computing, which was until then dominated by engineers and computer scientists. *Soft computation* is described by Joanna Berzowska in her article *Electronic Textiles: Wearables Computers, Reactive Fashion, and Soft Computation* as "the design of digital and electronic technology that is composed of soft materials such as textiles and yarns, and predicated on traditional textile construction methods to create interactive physical designs."[1]

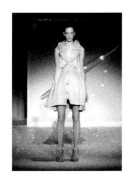

LEFT: HUSSEIN CHALAYAN, ONE HUNDRED AND ELEVEN, SPRING/SUMMER 2007

A synergy between the fields of fashion and technology will create a future Marshall McLuhan had long ago anticipated in *Understanding Media*. He writes "... the electric age ushers us into a world in which we live and breathe and listen with the entire epidermis."[2] Are our clothing and accessories the epidermal interfaces with which our senses will communicate and share our emotions and information?

Hussein Chalayan shows in his Spring/Summer 2007 collection *One Hundred and Eleven* that dresses can be interactive interfaces. They are story-telling *devices* that convey the transformation of fashion over a period of 111 years through mechanical dresses. Each of the five beautifully hand-constructed dresses/fashionable wearables represent a particular period in fashion history, incorporating contemporary vision and complex engineering.

Angel Chang explored the aesthetic interactive interfaces when she presented a heat-sensitive Manhattan map print on a top, which only becomes legible when exposed to warmth in her Spring 2008 collection.

Jayne Wallace focuses on the use of technologically enhanced jewelry to extend and enrich intimate interpersonal communication. Her 2007 work *Journeys Between Ourselves* is a pair of digital neckpieces that are responsive to touch. The touch of one causes the second to tremble gently.

1 Joanna Berzowska, 'Electronic Textiles: Wearables Computers, Reactive Fashion and Soft Computation' in Janis Jeffries (ed), *Textile. The Journal of Cloth & Culture, Digital Dialogues 2*, Vol 3, No 1 (Biggleswade, UK: Berg Publishers, 2005) 67

2 Marshall McLuhan, *Understanding Media – The Extension of Man* (Cambridge, MA, USA: MIT Press, 1995) 122

The *Hug Shirt* by *CuteCircuit* was first conceived in 2002 and allows remote users to exchange the physical sensation of a hug over distances. When a friend receives a *hug message* on their phone from you, the *Hug Shirt* will start to vibrate and get warm in the same spot that you touched on your shirt.

A conceptual aesthetic intervention is the media garment by Ariel by KnoWear, which theoretically allows a user to create their own media space using the body as the point of conductivity.

TOP RIGHT: ANGEL CHANG, SPRING 2008

MIDDLE RIGHT: JAYNE WALLACE, JOURNEYS BETWEEN OURSELVES, 2007

BOTTOM RIGHT: KNOWEAR, AERIAL, 2006

These inspiring designs show how the great expressive potential of fashionable wearables is amplified through the use of technology. They incorporate technological elements that transform them into interactive interfaces. An aesthetically pleasing design is an integral part of their success, but in fact the context determines the functional and expressive definition of a fashionable wearable. Early wearables were functional but awkward to wear and to look at. Today wearables are rapidly rising to meet the fashion world on its own terms by producing garments that are both stylish and comfortable. Personalisation of wearables allows for new modes of self-expression, which is an essential factor in making fashion items that appeal to the public.

Through technology the functions of clothing can be enhanced and new ones can be defined. Andrew Bolton emphasises in *Supermodern Wardrobe* that "all clothes have social, psychological and physical functions."[3] Malcolm Barnard describes the various functions of clothing in *Fashion as Communication*. Material (or physical) functions are protection, concealment, and attraction. Cultural functions (including social and psychological functions) are communication, individual expression, social or economic status, political or religious affiliation.[4] Technology and scientific advances enhance or modify these functions. Fashionable wearables can enhance the cognitive characteristics of our epidermis. Our clothing is often referred to as our second skin. Today this is more than just a metaphor as advances in technology produce fabrics that mimic many of the skin's properties.

Donna Franklin's explorations with the Pycnoporus coccineus fungus produced a living coloured surface in the form of the 2004 dress *Fibre Reactive*.

3 Andrew Bolton, *The Supermodern Wardrobe* (London: V&A Publications, 2002) 10

4 Malcom Barnard, *Fashion as Communication* (London/New York: Routledge, 2002) 49–71 describes the various functions of clothing.

The Italian company Grado Zero Espace's mission is to develop new materials like the recent innovation *Hinoki LS*, which is made from the Eastern Cypress tree. The collaboration with Corpo Nove resulted in the *Wearable Cooling System* for the McLaren Mercedes racing team, which was developed already in 2002.

TOP LEFT: O'NEILL, NAVJACKET, 2008/09

BOTTOM LEFT: GRADO ZERO ESPACE, WEARABLE COOLING SYSTEMS, 2002

Today, fashionable wearables are mediators of information and amplifiers of fantasy, ranging from lifestyle-enhancing clothing to the safety gear of a mountaineer.

www.fashionabletechnology.org

urban tool / images

bluetooth stereo perCushion

hungerbühler / images

double-frame embroidery machine

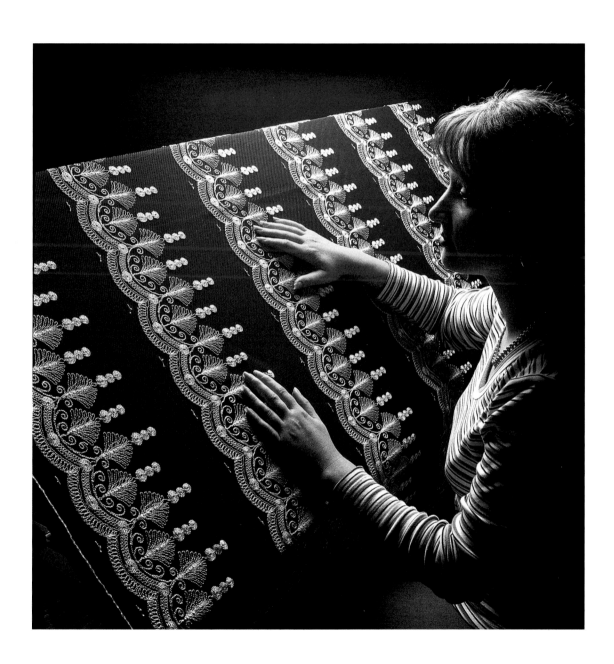

manual quality assurance

sabine seymour / images

left: angel chang, spring 2008
right: donna franklin, fibre reactive, 2004

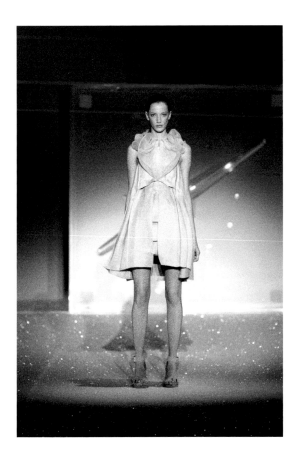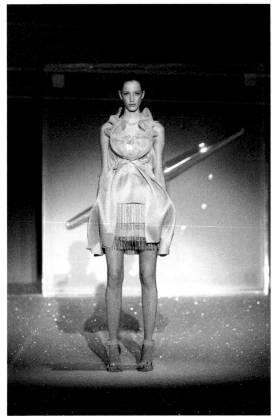

hussein chalayan, one hundred and eleven, spring/summer 2007

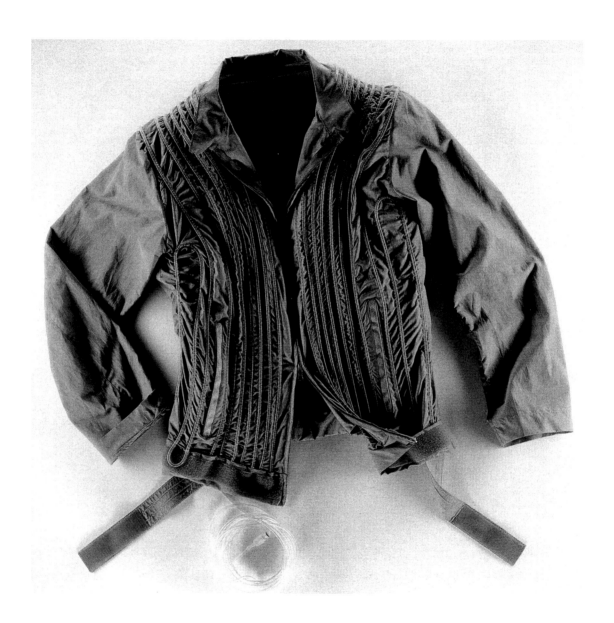

grado zero espace, wearable cooling systems, 2002

credits / images

VIRTUALITY & SMART CLOTHES

PERSONIFICATION OF TEXTURES

Fashion and Technology was the theme of the First Hetzendorf Symposium in 2000, and it admittedly sounded somewhat dry. The decisive factor for this choice were the spectacular reports about wearable computers or smart clothes auguring a new dimension in fashion, and it was only a question of a very short time until our everyday life would be ruled by it. A special trade fair was even founded, the Avantex in Frankfurt, where a broad range of scientists, researchers, technicians and fashion experts gathered for the first time. Since then, a lot of money has been invested in research and many new technologies have been tested. In contrast, the design industry has offered relatively few solutions for design and practical application.

A jacket by Philips with a collar that can be used to phone and issue instructions, skiing gloves with odour absorbing materials in the tourist industry and cold/heat resistant ceramic coatings for expedition gear are already in use although still extremely expensive. Now – ten years later – the situation on the market does not seem to be cardinally different. Many problems with connecting technology and fashion still have not been solved and are still in the early stages of nevertheless fascinating prototypes.

Technology, however, is also a medium of inspiration. The botanical as well as the human microcosm offers an enormous amount of inspiring imagery.

Reflecting this microcosm or the human surface onto clothing – bringing the *inside* out, so to say – is a remarkable process and a shift in intimacy. This topic seems to be fascinating for a wide range of artists who create depictions and transformations of the body with a medium foreign to the human body, with an artificial skin.

In doing so, a new dimension of intimacy and transparency comes to life in fashion. Yet, there is the concession that the designed body is in the foreground, in contrast to the natural body, which is only dramatised in fashion on occasion.

What else can fashion offer? New materials and additional functions – many experiments are in progress, many technologies await a practical integration into clothing, new fibres are being tested… Do people want this at all? At the moment, it looks as if they are only interested in small precious toys and accessories like IT tools or cult bags, glasses and shoes. As has always been the case in the history of fashion, the function, the protection, is secondary.

The fields of high-performance sport and the work world are exceptions to this case, yet corporate wear also employs certain elements of seduction. No androgynous, boring uniforms for the employees; they should feel good; the clothes should enhance both the motivation to work and the identification with the company.

Gerda Buxbaum

LECTURES

IMAGES

karin macfelda /
living surfaces – a journey through textures of life

A long time before human beings thought about clothes to protect their bodies against environmental influences, evolution had solved these problems by developing specific mechanisms. From the very beginning, biological systems matured to protect organisms against environmental conditions. On the other hand, these systems also serve as communicative devices.

For example, the cell membrane surrounds the cytoplasm of a cell and, in animal cells, physically separates the intracellular components from the extra cellular environment. The cell membrane consists primarily of a thin layer of amphipathic phospholipids, which spontaneously arrange so that the hydrophobic *tail* regions are shielded from the surrounding polar fluid, causing the more hydrophilic *head* regions to associate with the cytosolic and extra cellular faces of the resulting bilayer. This forms a continuous, spherical lipid bilayer. Specific proteins embedded in the cell membrane can act as molecular signals that allow cells to communicate with each other. Protein receptors are found ubiquitously and function to receive signals from both the environment and other cells. These signals are transduced and passed in a different form into the cell. For example, a hormone binding to a receptor could open an ion channel in the receptor and allow calcium ions to flow into the cell. Other proteins on the surface of the cell membrane serve as *markers* that identify a cell to other cells. The interaction of these markers with their respective receptors forms the basis of cell-cell interaction in the immune system.

In fungi, some bacteria, and plants, an additional cell wall forms the outermost boundary; however, the cell wall plays primarily a mechanical support role rather than a role as a selective boundary. The cell membrane also plays a role in anchoring the cytoskeleton to provide shape to the cell and in attaching to the extra cellular matrix to help group cells together in the formation of tissues. The barrier is selectively permeable and able to regulate what enters and exits the cell; thus facilitating the transport of materials needed for survival. The movement of substances across the membrane can be either *passive*, occurring without the input of cellular energy, or *active*, requiring the cell to expend energy in moving it.

In our days the modern man tries to create functional clothes including, for example, means of communication. In doing so he mimics the evolution step-by-step. A journey through the textures of life could depict these evolutional processes. Our itinerary includes simple organisms such as bacteria and viruses, as well as plants and animals, and finally men.

Bacteria are a large group of unicellular microorganisms. Typically a few micrometers in length, bacteria have a wide range of shapes, ranging from spheres to rods and spirals.

Viruses consist of two or three parts: all viruses have genes made from either DNA or RNA, long molecules that carry genetic information; all have a protein coat that protects these genes; and some have an envelope of fat that surrounds them when they are outside a cell.

Seeds and pollen are germ cells for plants. Surfaces of pollen are quite different according to the specific requirements, such as temperature and wind. Corresponding to these factors pollen need a tough envelope. Depending on the mode of propagation, some pollen have developed specific surface extensions, for example flukes. Plants, grown out from seeds, also have highly specified surfaces adjusted to function and environment.

Within the animal kingdom there are several animals that seem to be very simple. On closer examination these creatures bear very complex structural designs. The water flea, for instance, offers a translucent surface but also features highly specialised structures. The division of the body into segments is nearly invisible. The head is fused and is generally bent down towards the body with a visible notch separating the two. In most species the rest of the body is covered by a carapace, with a ventral gap in which the five or six pairs of legs lie. The most prominent features are the compound eyes, the second antennae, and a pair of abdominal setae. The antennae are covered with highly sensitive vibrissae, which are important for navigation.

Insects, for example mites, also display vibrissae on their surface to facilitate orientation processes. As a protection system against negative environmental stress they developed a chitinous exoskeleton.

In many cases these carapace-like structures are not sufficient enough to protect the animal completely. Therefore nature developed additional protective mechanisms such as striking colours. This equipment should simulate danger and defend from natural enemies.

Specialised surfaces also act as support for behavioural patterns. In many cases the colouring of feathers should attract potential partners. The structural design of surfaces also influences physical and mechanical qualities. The shark's quickness is attributed to V-shaped ridges on its skin called dermal denticles, which decrease drag and turbulence around its body, allowing the surrounding water to pass over the shark more effectively. These outstanding qualities are of use for the development of functional tissues and clothes (e.g. swimsuits).

Bionics is the application of biological methods and systems found in nature to the study and design of engineering systems and modern technology.

The transfer of technology between lifeforms and synthetic constructs is, according to proponents of bionic technology, desirable because evolutionary pressure typically forces living organisms, including fauna and flora, to become highly optimised and efficient.

In medicine, bionics means the replacement or enhancement of organs or other body parts by mechanical versions. Bionic implants differ from mere prostheses by mimicking the original function very closely – or even surpassing it.

Additionally, researchers attempt to develop living tissue under in-vitro conditions. Tissue engineering is the use of a combination of cells, engineering and materials methods, and suitable biochemical and physiochemical factors to improve or replace biological functions. While most definitions of tissue engineering cover a broad range of applications, in practice the term is closely associated with applications that repair or replace portions of or whole tissues (i.e. bone, cartilage, blood vessels, bladder, etc.).

For this purpose, cells are *seeded* into an artificial structure capable of supporting three-dimensional tissue formation.

TOP LEFT: CARDIAC MUSCLE CELLS

These structures, typically called scaffolds are often critical to recapitulating the in vivo milieu and allowing cells to influence their own microenvironments.

MIDDLE LEFT: POLYETHYLENE WITHOUT CELL GROWTH

Scaffolds usually allow cell attachment and migration and exert certain mechanical and biological influences to modify the behaviour of the cell phase.

BOTTOM LEFT: OVERGROWN POLYETHYLENE

For years healthcare professionals working in burn units have hoped for the day that they could pull substitute skin off a shelf. In 1997, a new synthetic product, which is made from living human cells, became available to doctors and patients.

Damaged blood vessels could be replaced by tissue engineered vessel prosthesis (e.g. Goretex™). Therefore the prosthesis material will be seeded with autologous endothelial cells.

RIGHT: ENDOTHELIAL CELLS

As soon as the whole prosthesis is covered with a cell layer the construct could be implanted.

Each system needs an efficient coordinator for optimal function. In living organisms the nervous system has to cover this specific duty. Together with high efficient neurotransmitter substances, neurons and other cell types (e.g. Schwann Cells) can meet the specific demands.

Concerning the latest developments in fashion and clothing design, an essential question arises for biologists and medical scientists: is it necessary to construct a *wearable computer* by using artificial materials or could biotechnology provide a useful alternative?
As mentioned before, bionics serves as a promising feature for the development of functional prosthesis, which also should work by remote control (e.g. by mental activity). To realise this vision a *neural interface* – the cooperation of men and engines – is of immense importance.

Verner Vinge, Professor of Mathematics at San Diego State University and scientific author, wrote in *The Digital Gaia*: "By 2007, the largest control systems are being grown and trained, rather than written."
It is absolutely imagineable to design functional, biological *living* clothes in the future. Nature has allocated the drafts – we only have to understand them.

christiane luible /
body – clothing – virtual reality

"The human body, whose fundamental structure remained identical for 50,000 years, was plugged together in the course of evolution for a completely different condition than the contemporary environment. Is the human body thus a discontinued model? Was, on the other hand, the human body ever only body? Didn't he only become a human body, since the prosthetic, the replacement and the extension of physical functions by technology, came into play?"[1]

Introduction

Clothing is a symbolic language, which makes cultures and epochs apparent. Clothing serves visual identification and is hence a medium of communication. Completely new possibilities occur for the representation of the human body and clothing in virtual space, since new conditions such as those in reality are finally valid. Thus, new methods for a visual identification and communication can be conceived. An interesting aspect of this is the reciprocal effect between body, clothing and the virtual reality (VR), as well as the resulting consequences for fashion due to the absence of a material body.

LEFT: EXAMPLE VIRTUAL CLOTHING SIMULATION (EXTENDED BODY)

However, in the future completely new scopes of creativity will be available, resulting from an alliance between VR and fashion. Today, virtual clothing simulations are primarily exploited for an accurate reproduction of the real world. Beside film productions and computer games, clothing simulations are in particular utilised in the apparel industry, in order to optimise and simplify complex manufacturing processes.

Potential

Each reality possesses its own framework (consisting of atoms, bytes or mental processes) and regularities. In the real world, other laws are applicable than in the virtual or a dream world. Criteria which are of importance in one existence do not necessarily play an important role in another one. VR is a technology which allows a user to interact with a three-dimensional computer-simulated environment. The virtual space as well as the virtual characters and its appearance can be composed of an unlimited set of parameters, thus allowing the imitation of the real world in a realistic or a completely abstract way.

"The main potential of cyberspace can be seen in the liberation from the constraints of our physical condition. In cyberspace, we can assume different identities, superhuman powers or define hyper-worlds that may or may not have a correspondence to the physical counterparts."[2]

For an abstract representation of a character, its overall visual appearance has to match a previously defined concept. The dimensions of a character are not limited to the realistic body dimensions any more, and the factor

1 Florian Rötzer

2 G. Proctor

accuracy, a terminology of the real world, becomes marginal. The grade of abstraction depends on the idea of the application. Many new possibilities of representation and communication can be imagined.

In a more realistic representation of a virtual character, the main goal is to visualise all details as identical to reality as possible. The easiest way to attain this goal is by simulating the clothes, constructed out of 2D patterns from a CAD-system, on a 3D mannequin. Realistic virtual representation of clothing is most often employed in the virtual prototyping of garments, where accuracy is essential in order to define the important manufacturing processes. The core technologies of these systems have been adapted to the actual needs of the clothing industry through collaborative projects. The main challenge in the creation of virtual characters is to find the adequate grade of abstraction, in order to give the user the possibility to identify him/herself with his virtual counterpart, which he interacts with in VR. Hence the final aesthetic of the output consists of a balancing act between artificiality and realism.

"Recently, however, researchers have come to the realisation that the total abandonment of the physical condition limits rather than expands the potentiality of virtual reality worlds." [3]

The search for an adequate representation and aesthetic can be conducted through the following questions:
• Which parts of the human body can be abandoned in the virtual space?
• To which extent will our avatar (our virtual counterpart) be different from ourselves?
• Does a virtual character distinguish/adapt itself by clothing or can she/he communicate via different means of representation?
• How will this representation evolve in the future after a process of identification?
• Is the avatar transformable?
• Fashion possesses functions such as protection and communication. Does the virtual fashion obtain new functions?

In the course of time, human beings will identify themselves with more and more abstract representations, after respective phases of identification. A new visual communication language will appear and evolve, based on new characteristics and rules.

Existing applications

Today virtual mannequins and clothing are typically accurate or idealised replicas of the real world counterparts. These *copies* are mainly used for movie productions (Final Fantasy, Lord of the Rings, Shrek) and for computer games. Avatars in computer games are often exaggerations and projections of real beauty ideals (Lara Croft).

[3] G. Proctor

Another important field of application is the apparel industry, which discovered virtual clothing simulations for the improvement of their clothing production processes. The available technology[4] enables the creation of virtual garments that look incredibly realistic. The implementation of these new technologies ultimately revolutionises old-fashioned manufacturing processes and pushes the garment development process to a higher technological level, saving both time and money.

TOP LEFT: EXAMPLE VIRTUAL CLOTHING SIMULATIONS

LEFT: EXAMPLE VIRTUAL CLOTHING SIMULATIONS (OPTITEX/SYFLEX LLC)

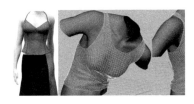

The impact of these tools is multifold. On the one hand, precise numerical fitting data is generated by the simulation systems, allowing designers to better control the interaction between the body and the clothing. Garment prototypes become more *transparent* and misfits are better and more quickly identified. On the other hand, misfits are directly corrected on the 3D garment without the need to produce another prototype. This resulting acceleration of garment fitting, and thus saving of time, allows the designer to execute many more correction possibilities for one prototype and hence, to improve the design.

Virtual fitting mannequins are easily created to any possible bodily dimension and allow for an easy switch between different garments sizes, once designed. Thus, virtual applications facilitate a fitting process in all available garment sizes with negligible extra work.

Traditional real garment fittings are generally performed on simple comfortability movements. However, to guarantee a high quality of clothes, it is increasingly important to also ensure a garment's comfort during special exercises (work clothes, sports clothes, etc.). Virtual fitting mannequins can be animated with any kind of specialised movement, thanks to motion capture technology. Virtual fitting processes are then able to accurately visualise the garment's comfort during any kind of movement, generating exact fitting data for each position.

Moreover virtual garment prototypes are *produced* with no raw material waste and resources are conserved. Automatic, robotised manufacturing processes are a long term goal for the apparel industry. First attempts are being conducted[5], where robots partially sew together a garment. Therefore, an accurate simulation of the garment prototype is also used as a *sewing reference* for the adjustments of the robots.

Comparing real garments and virtual simulations
Comparing real procedures with those virtually simulated return interesting results. Today, a real mannequin can be precisely scanned with a 3D body scanner in order to obtain the corresponding virtual 3D body model. From this scan, exact body measurements are derived, which can be used in the

4 Browzwear, Optitex, ClothReyes, ClothFX

5 Leapfrog 08

construction of a real *made to measure* 2D pattern. For the corresponding virtual garment, real 2D pattern can be digitised and imported to the simulation systems. Inside the simulation systems, clothing can be virtually tailored using similar tailoring tools. Subsequently, both the real and the virtual fitting procedures can be performed and are compared in parallel.

More precise fitting information can be retrieved today from the virtual simulations in the form of numerical fitting data. These new tools allow the designers to optimise their garment designs on a high technological level.

RIGHT: COMPARISON OF REAL AND VIRTUAL GARMENTS [MIRALAB – UNIVERSITY OF GENEVA]

Conclusion

Today, virtual simulations are mainly used for the re-creation of the real world. Computations are implemented and utilised in important production processes to improve and rationalise important tasks. This pushes the traditional garment industry to a higher technological level in order to face structural problems.

However, with these very realistic representations of garments, we are still in the Stone Age, the beginning of a long process of abstraction. In the future of VR, traditional concepts of body and clothing will vanish. Their representation in this new presence questions existing conditions and rules. New aesthetics and new ways of communication will be created. Today, the computer simulation should not be seen as a visualisation tool but already as an own creative space, where new ideas and aesthetics can be found, which could not have been developed without this tool.

literature

· Adler U, 'Structural change – The dominant feature in the economic development of the German textile and clothing industries' (2004) Emerald, Vol 8, No 3 *Journal of Fashion Marketing and Management* 300–319
· Browzwear <http://www.browzwear.com>
· Florian Rötzer, 'The future of the body' (1996) *Art Forum*
· Hohenstein <http://www.hohenstein.de/>
· Leapfrog 08 <http://www.leapfrog-eu.org>
· Optitex <http://www.optitex.com>
· Proctor G, Jabi W, 'Special Issue on the Space between the Physical and the Virtual' (2003) Vol 6 *International Journal of Design Computing* ISSN 1329-7147
· Reflexstock royalty free images <http://www.reflexstock.com>
· Hunt M C, 'Fashion's changing face' (5 Feb 2000) *The San Diego Union-Tribune website*
· Syflex <http://www.syflex.biz>
· Taplin I M and Winerton J, 'The European clothing industry-Meeting the competitive challenge' (2004) Emerald, Vol 8, No 3 *Journal of Fashion Marketing and Management* 256–261
· Volino P and Magnenat-Thalmann N, 'Accurate Garment Prototyping and Simulation' (2005) Vol 2, No 1-4 *Computer-Aided Design & Applications*, CAD Solutions 645–654
· Volino P and Magnenat-Thalmann N, 'Simple Linear Bending Stiffness in Particle Systems' (2006) *SIGGRAPH-Eurographics Symposium on Computer Animation 2006 Proceeding* 101–105

winfried mayr /
functional electrical stimulation (FES) in space – alternative muscle training based on the MYOSTIM system

Introduction

Long-term flights in microgravity cause atrophy and morphological changes of skeletal muscles. Extensive daily physical training using mechanical devices (treadmill, bicycle ergometer, expander, etc.) raises the caloric intake, shortens the operational activities and requires extreme motivation of the crew members. Given the limitations on active muscle training during a long-term space mission in terms of time and space, an automatic support needs to be taken into consideration.

Functional Electrical Stimulation (FES) is well-established in terrestrial rehabilitation and sport training since many years. It has a high potential to serve as an efficient counter-measure to avoid most of the cited impairments, as long as the equipment is comfortable and easy to handle under space conditions.

The necessary accurate placement of electrodes on the skin surface above the targeted muscles and their connections to a stimulator unit play a crucial role for the safe and reliable operation of the entire system and the acceptance by the users. The functional integration of electrodes and leads in electrode trousers – in fact one of the early developments in the field of *Intelligent Clothing* – turned out to be the key solution for the success of our space project MYOSTIM (funded by the Austrian Ministry of Science, principal investigator Prof. Gerhard Freilinger, Vienna University).

The main goal of MYOSTIM, in cooperation with the Institute for Biomedical Problems (IBMP) in Moscow, was the investigation of effectiveness and practicability of FES as a counter-measure against neuromuscular atrophy under microgravity conditions. It ultimately led to two successful and revolutionary applications on board the MIR space station.

Material and methods

Principle of training: FES was applied to four muscle groups of both lower extremities. Electrodes were placed on the skin above the quadriceps femoris muscles, the hamstrings, the tibialis anterior and peroneal muscles, and the triceps surae muscles. Synchronous and force balanced stimulation of antagonistic muscle groups prevented unwanted joint movements.

The training was performed for three respectively six hours per day, with 1 sec *on* and 2 sec *off* cycles at intensity levels of 20-30% of maximum tetanic force (MTF). (A tetanic muscle contraction is a sustained functional contraction of a skeletal muscle in contrast to a twitch contraction, which is a non-functional reaction to a single stimulus.)

FES was additionally applied to the routine Russian physical training programme, which consists predominantly of intermittent treadmill exercise for 1-2 hours/day and resistance exercises with bungee-cords, organised in a 4-day cycle scheme.

Equipment and parameters: The technical equipment consisted of electrode trousers, carrying electromyography (EMG) and stimulation electrodes including cables for eight channels, and two interconnected 4-channel stimulators mounted on a belt. After an initialisation procedure with parameter adjustments and safety checks, the system begins with automatic training at a default stimulation frequency of 25 Hz. Electrode impedance and M-wave (motor-wave, evoked EMG following each stimulation impulse) are monitored permanently to identify potential electrode problems or early signs of muscle fatigue.

Assessment: Data assessment was done in accordance with the standard protocol of the Moscow IBMP, which was routinely used to investigate the effectiveness of various counter-measure means. The protocol contained physiological as well as morphological pre-flight and post-flight examinations, and in-flight ergometric tests. In addition, the stimulation device recorded and stored stimulation intensity, M-wave and impedance data throughout the training sessions.

Results

The Vienna research team was responsible for technical and technological research and development. A practical solution was found for the electrode trousers. Placement of the electrodes on the skin is simplified by a patented construction (AT 404 979, by D. Rafolt) of two flexible flaps, which carry the electrodes and corresponding protection foils, that are alternatively exposed to the skin.

RIGHT: ELECTRODE TROUSERS WITH HANDLING MECHANISM FOR ELECTRODE PLACEMENT; THE HYDRO GEL ELECTRODES NEED WETTING FROM TIME TO TIME

The developed stimulation equipment consists of the circuitry for M-wave and impedance-recording, the stimulation output stage, micro-controllers for impulse generation and measurement purposes (one for each channel), a co-ordinating micro-controller, the power supply, the graphical display, control elements and a bus-interface. The 8-channel stimulator is divided into two 4-channel modules interconnected by an I2C-bus. The circuitry is miniaturised in SMD (surface mounted devices) technology and integrated in a robust metal case. With a personal computer (PC), the stimulation and training parameters can be adjusted and the stored training downloaded via the RS232 link.

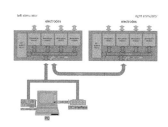

All technical solutions were tested in-vivo and underwent the standardised Russian qualification and certification test procedures.

The equipment was transported to the MIR space station for the first applications on October 27, 1998. It was successfully applied by a cosmonaut between December 98 and February 99 and by a second cosmonaut between March and August 99. Both cosmonauts had went to the MIR station in August 98 and used the equipment in a later phase of their flight, and then continuously until their landing.

In the case of the first pilot, MYOSTIM was used for 3 hours per day at intensity levels of 20-30% MTF in additional to the standard physical training programme. Four other control cosmonauts from different missions with similar flight durations performed only the routine on-board counter-measure training and no FES.

In comparison to the control cosmonauts of crew 26 and crew 27, who used only the routine counter-measure physical exercise programme, the commander of crew 26, who had additionally used MYOSTIM, was in much better condition both during the flight and after landing. All performed tests showed significantly better functional results and a much earlier recovery rate. The second test cosmonaut used the system for 6 months, 6 hours per day. The outcome was similar.

The subjective judgement of both cosmonauts was extremely positive: there were no complaints concerning the daily handling of the equipment over months and the practicability of the training during routine work. They reported improved fitness and well-being, the feeling of *complete muscle integrity* and the lack of previously experienced muscle pain.

Discussion

To substitute the terrestrial muscular load during long-term space flights, exercise and training programs are required. The training and the devices extensively consume time and space – an alternative would be helpful. The objective of our project was to provide an alternative method for avoiding or at least reducing the changes in the skeleto-muscular system with minimal impairment to the cosmonauts' comfort and daily activities.

The results of the functional tests, the faster functional recovery after landing and the subjective judgement of the cosmonaut, who had already previously experienced a long-term flight without FES training, lead to the assumption that – besides pure muscle preservation – a major benefit of daily extensive low-level FES training lies in the stimulation of the proprioceptive system and the induction of afferent nerve activity.

These first applications have provided us with data on both the handling of the equipment in microgravity and effectiveness of FES muscle training in space. However, we have only initial test results that call for further systematic investigations. Provided that the technique further proves to be effective, the application should be extended to the trunk and neck muscles to preserve the posture of the astronauts and cosmonauts.

The application of specific *Intelligent Clothing* was crucial in the success of the project and will remain crucial for potential further distribution of the method. However, it is unthinkable that a user attaches – in our case – 16 single electrodes and sets up all the necessary connections prior to daily training over a longer period of time. Furthermore, it would be extremely unreliable for one to move around with unprotected electrodes and cables attached all over the extremities, and potentially also on the trunk surface. Thus we were able to demonstrate that the integration of electrodes and cables into specific trousers based on a smart handling concepts was the key for safe and accepted permanent use.

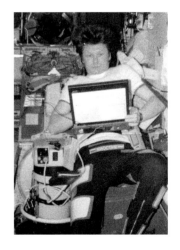

Benefits for terrestrial applications in medicine can be expected, since long-term immobilisation and, in particular, long-term bed rest cause morphological changes in skeletal muscles and neuromuscular atrophy that are similar to those in microgravity conditions. For all potential applications of this kind, safe and simple handling will again be crucial and the development of such *Intelligent Clothing* will be the strategy of choice.

dietmar rafolt /
polygraphic belt and jacket for
physiological tests on cosmonauts

Abstract

To study cardiorespiratory and neuromotor functions in cosmonauts, novel intelligent clothing and special measurement devices, such as a force sensing expander or a handgrip- and an ankle dynamometer, were developed. With relation to the experiment, a polygraphic sensor jacket and/or a belt equipped with numerous sensors and electrodes were used.

The sensors of the belt are: a three-electrode ECG/impedance plethysmographic system to capture cardiac and respiratory activity; two triaxial accelerometers to record limb micromotions and tremor, ballisto- and seismocardic signals; and an infrared reflex-sensor to detect peripheral pulse waves in the finger.

The sensors of the jacket are: an eight-electrode vector—ECG; another optical sensor to record the pulse contour in the food artery; a piezoresistive pressure sensor to access carotis pulse; and a thermal flow sensor for nasal breathing.

The expander consists of an elastic cable in series with a load cell to measure the extension force and to adjust the extensions through visual feedback.

The ankle dynamometer for isometric plantarflexion was added to study the time course of leg muscle atrophy.[1] In addition, this device was equipped with a three-channel EMG system.

The equipment was designed for and tested in the Russian space station MIR during long-term flights.

Introduction

When man enters microgravity (0 g) body tissues become unloaded because of the absence of weight-induced torques and pressures. Therefore, the muscle tone, heart rate and, consequently, metabolic rate of a free-floating cosmonaut are expected to be lower than when in earth's gravity (1 g). Results from flight missions, however, often contradict such predictions. For example, heart rate typically increases at the onset of a space flight. About this effect, such factors as stress and reduced venous return are discussed. During long-term space missions, further neuromotor changes such as leg muscle atrophy and increased extensor reflex excitability have been reported.

The first system to track cardiovascular and neuromotor variables on MIR crew members was the KYMO instrument system developed under Prof. Eugen Gallasch, Department of Physiology, Graz, and commenced on the space station in 1991. This system included a microprocessor with interactive video features, a set of six bodily sensors bundled into a jacket and an isometric handgrip dynamometer to produce systemic loadings.[2]

Some years later, the 2nd generation of KYMO with extended features was brought to MIR and was used for long-term space missions until the end of the space station in 2001.

1 Gallasch E, Rafolt D (1996)

2 Gallasch E et al (1996)

A new generation supplement to the KYMO instrument system was developed in a cooperation between the Department of Physiology, Medical University of Graz and the Center of Biomedical Engineering and Physics, Medical University of Vienna. It consists of a polygraphic belt (used for the experiment MIKROVIB and SLEEP) and jacket (for the experiment PULSTRANS) with additional sensory channels, a force-sensing expander and an ankle dynamometer (the latter both for MIKROVIB).

The additional sensors became necessary because the uniaxial accelerometers in the old jacket could not record three-dimensional limb and body micromotions. This problem was solved by integrating two triaxial sensors in the novel belt. Furthermore, the research of one group had turned to cardiorespiratory coordination[3], therefore a respiration signal was also needed in addition to the ECG- and pulse signals. Finally, a viscoelastic load scheme using a force sensing expander was developed to assess reflex action in arm muscles. The measurement principle is based on the observation that an elastically loaded limb turns to involuntary oscillations at higher contraction levels. As the spinal reflex servo is dynamically involved in the control of a compliant load, any changes in the reflex pathways will be reflected in the limb's oscillation dynamics.

Design objectives
The objective was to make a user-friendly multi-sensor equipment for physiological tests in the microgravity force environment. In this environment, objects cannot simply be put on a table as they would drift away; furthermore, the handling of the equipment during experimentation often has to be done by the cosmonaut himself. These specific ergonomic conditions originally led to the concept of a *sensor jacket* with pockets around the chest for assessing and stowing the sensors with their cables[2]. The long-term experience using this first jacket on MIR, however, revealed two problems. The first problem was that the jacket did not exactly fit all of the cosmonauts' body sizes. To avoid this problem, we changed to size-adjustable clothing using Velcro tapes and elastic elements. The second problem arose from sweating and the limitations of periodically cleaning the jacket. So we put all the necessary sensors for the sleep experiment and for the neuromuscular experiments into a small belt.

RIGHT: DESIGN OF THE POLYGRAFIC BELT WITH EMBEDDED SENSORS, ELECTRODES AND PREAMPLIFIER ELECTRONIC BOX

The belt was made of cotton, including elastic elements to fit around the waist and Velcro closures to adjust for the body size. At the front, five pockets are arranged. The pocket on the far left includes the interface electronics with the main cable to the KYMO microprocessor. The other

3 Moser M et al

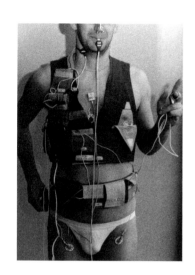

four pockets support the sensors and electrodes with their local cables, which are internally wired to the electronic box. As the accelerometer sensors are interfaced to the skin by double-sided adhesive tapes, a flat and light-weight design was chosen in order to avoid movement artefacts. To shorten the setup procedure, a three lead electrode system was developed to capture both cardiac and respiratory activity. To measure respiratory activity during sleep, the principle of impedance plethysmography was applied.

The upper body belt (jacket) houses the vector ECG, a second optical pulse sensor, a mechanical pressure sensor, a nasal flow sensor and the corresponding preamplifier.

LEFT: COMPLETE OUTFIT WITH JACKET AND BELT WITH SENSORS FOR: RESPIRATORY DETECTION, PULMONARY PRESSURE, CAROTID PULSE, SEISMOCARDIOGRAPHY, BALLISTO-CARDIOGRAPHY, TREMOR, FINGER PULSE AND ELECTRODES FOR VECTOR-ECG

OPPOSITE PAGE: DESIGN OF THE JACKET. THE OUTLETS OF THE ELECTRODE CABLE ARE QUITE CLOSE TO THE POSITION OF THE ELECTRODES IN ORDER TO MINIMISE CABLE LENGTH AND TO AVOID CONFUSION DURING PREPARATION

To record correct physiological data, the exact placement of the sensors and electrodes is essential. Managing up to 15 cables is very complicated and time consuming. Thereby, the main tasks of intelligent clothing in a multichannel measurement system are: 1. to locate the sensors at the final position on the body, 2. to hide the cables in textile cannels and 3. to store the sensors in a safe way when the equipment is not in use. The integration of the preamplifiers in the textile increases the quality of the signal, since the leads to the sensors and electrodes are shorter, further decreasing the number of leads to the control device KYMO. It distributes the energy consumption of the electronic components and therefore reduces the heat production in the control unit KYMO.

Conclusion

Up to 1996, three cosmonauts had performed repeated experiments with this equipment, one of them on a 14-month long term mission. All three users described the equipment as reliable in its long term usage and ergonomic in its functionality. Therefore, even after 1996, when the Austrian–Russian MIR programme ended, the equipment was employed in several ground studies.

Acknowledgement

This work was supported by the Austrian Ministry of Traffic, Innovation and Technology, Grants GZ 700.031 (MIKROVIB) and GZ 140.607/1 (MULTIVIB).

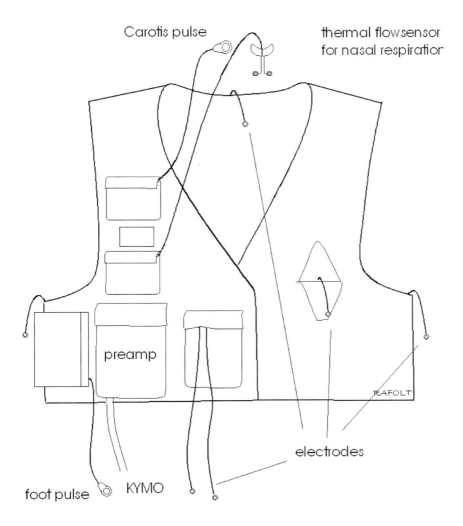

Carotis pulse

thermal flowsensor
for nasal respiration

preamp

RAFOLT

electrodes

foot pulse KYMO

literature

- Rafolt D and Gallasch E, 'Body fixed ankle dynamometer for isometric tests in space flights' (1996)
 41 *Biomed. Technik* 91-97
- Gallasch E, Rafolt D, Moser M, Hindinger J, Eder H, Wießpeiner G and Kenner T, 'Instumentation
 for assessment of tremor, skin vibrations and cardiovascular variables in MIR space missions'
 (1996) BME43 *IEEE Trans* 328-333
- Moser M et al, 'Cardiorespiratory Coherence in long term space flights' (29 May – 2 June 1999)
 Proc. ESA-Conf. Maastricht

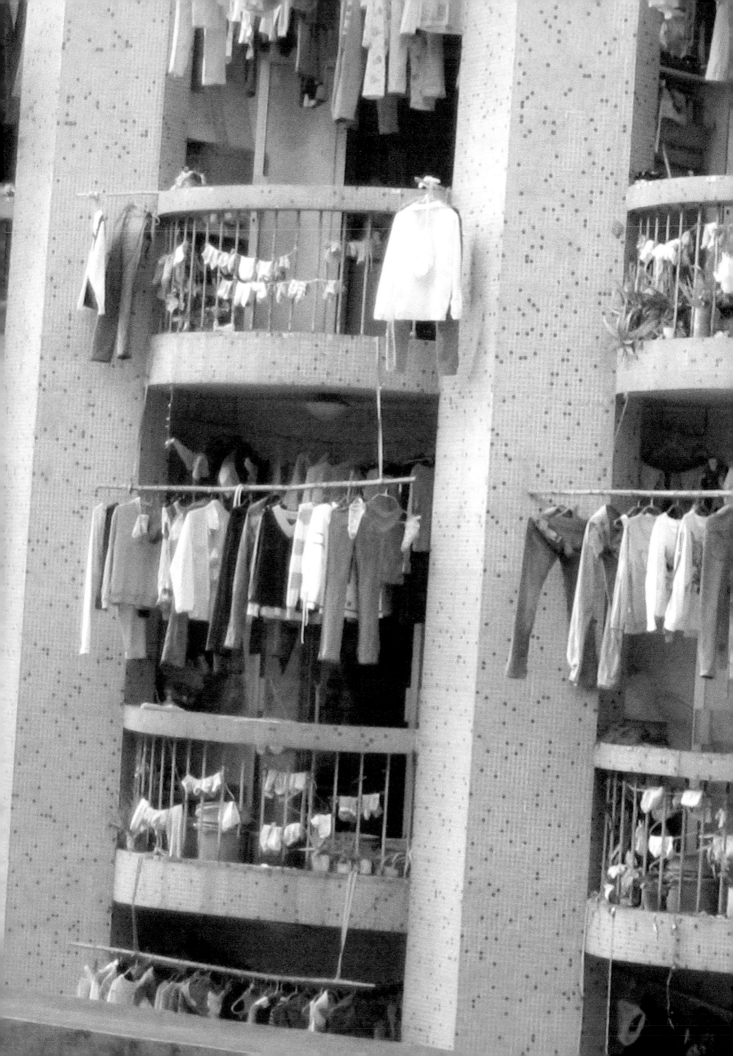

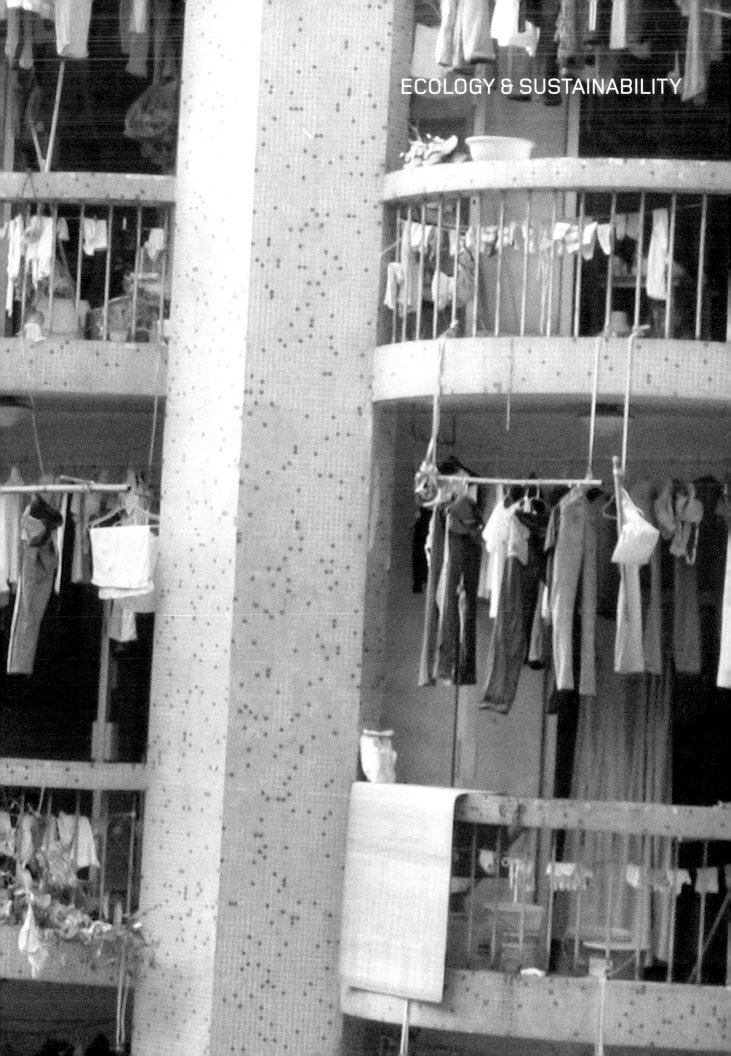

ECOLOGY & SUSTAINABILITY

WEARING RESPONSIBILITY ON YOUR BODY

The language of responsibility – with reference to the language of fashion by Roland Barthes – should have become fashion itself, and we should, in the sense of Kant's intelligible character, make use of our freedom to make personal choices. These are the demands of the philosopher Arno Böhler in order for responsible thinking and consumption to become sustainably effective.

Problematic social developments (globalisation, price decline, social injustice, environmental and health problems) are reflected in the fashion industry in particular. Sustainability is still perceived by the public as too theoretical and political, too abstract and complicated. There is often an insecure behaviour between consequence and compromise and an oscillation between the two poles – Design & Lifestyle and Sustainability & Ecology. What we need are images and symbols, a sensuous appearance. This is where the Fashion Institute of Vienna with the project *Stoffwechsel* comes in – the aim was to dress celebrities in a sustainable fashion. The project focuses on *pattern designs* and *fabric exchange* between fashion and sustainability with regard to ecological, social, health and economic aspects, as well as their global and local impact. Ever since this project we have been continuously working on various aspects of sustainability in selected projects. The students should become conscious of their special role and the opportunities at the beginning of or before the *supply chain*, as well as the requirements and general conditions. The topics in the following chapter involve recycling natural fabrics (loden, linen, organic cotton), transparency about origins achieved through environmental reports and ecological labels etc., environmentally friendly production of high-tech fabrics, durability (durable fabrics that are easy to mend and combine), social factors (locally and in the developing countries) and fair trade (health problems in the production or the consumption).
In addition to the global and international dimension, the Austrian solutions to the problem are presented: above all, the revival of traditional handicraft and small workshops (from loden to linen), the question of growing raw materials as well as ecological design and the production of high-tech fibres.
Committed designers and fashion creators are *trendsetters* in the best sense of the word, and they need transparency as far as production conditions or origins of the materials are concerned; they need informed customers and fair workplaces and finally, a market for their high-quality products. A sensitivity and an interest in a fair and ecological production of textiles, however, is increasing due to high-value design and convenient prices: international labels such as American Apparel or Noir, for instance, are producing extremely successful fashion lines, for which they have developed an everyday, sensuous language and symbolism.

Gerda Buxbaum

LECTURES

PORTRAITS

IMAGES

arno böhler /
trauma *fashion*

This is an attempt to fulfil the demand for wearing responsibility on the body in three steps. Three, because every step will turn out to be the wrong track, one which does not lead us anywhere, yet leaves traces that hopefully provide ample food for thought nevertheless.

Step 1

The first approach follows the path of the Kantian philosophy of Enlightenment. To Kant, responsibility is a possible manner of making use of our freedom. With every action in which we decide in favour of something, against something else, we make use of our freedom and take responsibility for whatever we have decided (not) to do. The history of these decisions, according to Kant, illustrates what he calls the *intelligible character* of a person: the character which by passing various decisions enables the human being to develop a completely personal aura, which again testifies to the ways in which he has made use of his own freedom.

This aura arising from our actions is, according to Kant, the aura responsible for wearing responsibility on our own bodies. The more assiduous our decision, the more respectable our actions; the more dignified – in Kant's terms – the aura and the charisma of the *intelligible character* of a person becomes.

Step 2

In the twentieth century the answer is shifted to the question where this aura in objects and people arises from. There is an increasing suspicion that it is the language that provides the good or the bad aura. In *The Language of Fashion* Roland Barthes suggests that objects – above all objects in the world of fashion – are attributed their aura by language. Not the clothes themselves, but rather the language of fashion is what bestows glamour, glory and aura to the clothing; the discourse of *fashion* (or the fashion industry) assigns, allocates, governs and controls the criteria and the codes that are crucial for the fashion world: the distinction between *fashionable/unfashionable, in/out, trendy/passé, cool/uncool* etc.

Since these fashion discourses – whatever one hears, reads and sees about fashion – get *randomly* associated with the garments that we have before our very eyes. Already Roland Barthes could claim that we never see pure clothes at first, rather what we have been told about them, because as soon as we see things, we read them and interpret them with an aura of a language that ascribes them a place in the middle of the world.
Wearing responsibility on your body, from this perspective, can only mean that the fashion world would first have to generate a *language of fashion* in which it should declare the *responsibility principle* a fashion word and

furnish it with markers such as *hype*, *in*, *trendy*. For even before we start wearing responsibility on our bodies, the *language of responsibility* should already be in fashion.

Step 3

The third approach turns to the questions of what the motto of these talks *wearing responsibility on your body* could mean to the people who – to take the pressure off of a suffered trauma – have decided to wear explosive belts on their bodies? Which language and aura is blended here with the personal decision to carry out such an action? Isn't a piece of garment blended here with the language and the explosive power of religions? Yet how do clothes, how does fashion relate to religion at all? Or to put it in a more serious manner: what would happen if religion came into fashion again?

clean clothes campaign / a profile

(edited by hb, statements elisabeth schinzel)
What is important when buying clothes?
Quality, price, colour.

We hardly ever ask ourselves where the clothes were produced, and even more rarely do we ask ourselves under which conditions.

The clothes we buy in Europe are mostly produced in Asia, Latin America, Africa and Eastern Europe. Outsourcing clothing and sporting goods industries to the low-wage countries allows the companies extremely low production and wage costs. In spite of working overtime, the employees often can't provide for their families due to their – even for the local conditions – extremely low wages.

Social services such as sick-leave or maternity leave rarely exist and the founding of trade unions is often nipped in the bud by the threat of dismissal. In addition to the constant uncertainty in terms of employment and wage, the employees also must cope with health problems caused by terrible working conditions. Moreover, the employees are often exposed to abuse, discrimination and mental pressure on part of their superiors.

The Clean Clothes Campaign, founded in the Netherlands in 1990 and supported by numerous NGOs and labour unions all around the world, aspires to improve the working conditions in the clothing and sporting goods industry.

"The Clean Clothes Campaign requires that the social minimum standards as well as international labour rights for the people tailoring and sewing our clothes are respected, since clothes are not only a question of style."

The work of the CCC focuses on exerting pressure on brand name companies in order to compel them to take over the responsibility for the conditions of production in their ancillary industries as well as to see to fair working conditions. Employees, trade unions and NGOs in production countries are supported. But above all, the consumers should be made aware of the working conditions in the global clothing and sporting goods industry so that they get motivated to make use of their power as consumers.

Another goal involves making the most of legal options and vitalising lobbies for legislation in order to ensure good working conditions and compel the governments and brand name companies to produce ethically.

The idea behind the CCC is not to boycott famous brand name companies or to prevent individuals from buying their favourite clothes. The campaign strategy rather involves reaching people about personal involvement and creating the awareness of the importance and the impact of collective action. A combination of the pressure on part of the consumers and targeted discussions with the companies has proven to be very successful.

The Campaign has been present in Austria since 1996. National platforms are currently present in twelve European states. From 1997 to 1998, the European Clean Clothes Campaign, consisting of more than 150 organisations and trade unions from the North and the South, developed a Clean Clothes Code of Conduct.

The aim is to protect the employees from exploitation and to provide them with means enabling them to assume and defend their rights. Unfortunately, in contrast to other European countries, nobody in Austria has signed the Code of Conduct yet.

"The fashion industry is international just like the production of clothes – the Clean Clothes Campaign requires humane working conditions everywhere."

Within the project *My Design – my Responsibility*
the CCC focused on cooperating with fashion
schools. Numerous lectures concerning social
responsibility as well as projects with fashion
schools are offered nation-wide. In a debate
with fashion students in September 2008,
Sergio Chávez, human rights activist from
El Salvador, discussed working conditions of
seamstresses in Central America.

"You – the future designers and decision-mak-
ers in fashion companies – have the choice to
do all you can to respect fair working conditions
in the fashion industry."

www.cleanclothes.at

forum environmental education / a profile

(edited by hb, statements monika lieschke)
Sustainable fashion does not only feel good on the skin, it also tells *a good story*, starting from the soil in which the fabrics were grown to the people involved in the production process.

Today, both the consumers as well as the producers have already begun to appreciate the value of organic and fair-trade food products. Now, this mindset is slowly being established in fashion as well. Step by step, beautifully designed garments from of hi-tech fabrics (fabricated from natural resources such as corn, bamboo or soy) are capturing the attention of designers, catwalks and shops. There are also opportunities for Austrian fashion and agriculture ranging from the revival of traditional handicraft and loden and linen workshops to the industrial production of new fabrics.

"The future should belong to a fashion that bears both social as well as ecological responsibility and can survive on the market nevertheless."

"The time for a fabric change is on our side and a couple of tendencies seem to be emerging which could develop into something more than a trend. New technological options in the fabric production meet the interests of designers as well as the needs of more and more consumers who are not satisfied with only *looking good*. *Conscious Commerce* is the new keyword that encourages the consumers to base their shopping decisions not only on their taste but also on their convictions."

FORUM Environmental Education is an initiative of the Federal Ministry of Agriculture, Forestry, Environment and Water Management in cooperation with the Federal Ministry of Education, Science and Culture. Education and communication can significantly contribute towards changes directed at creating a sustainable and fair society. It is from this background that

FORUM Environmental Education is trying to illuminate the often complex issues around the term *sustainability* as well as raise awareness and action competence for sustainable lifestyles. *Education for sustainable development* reveals the problems of a globalised world in a comprehensible way, exploiting the basic principles and suggesting anxiety-free ways of solving challenges through education.

FORUM Environmental Education is promoting education for sustainable development through a wide range of services offered nationwide. The initiative has set itself the goal to integrate the paradigm into the educational landscape as well as create and support a leading educational offensive for sustainable development.

"The idea is not to provide definite answers and recipes but take the 'thread' and spin on."

"It is about learning new ways of problem solving – it can be creative and fun, even if it is all about serious topics."

There is an ongoing close collaboration with Austrian schools. For instance, during an *Awareness-Raising Project*, students from the Fashion Institute of Vienna in Hetzendorf Castle have, as designers of the future, designed sustainable clothes for Austrian celebrities such as Markus Rogan, Hubert von Goisern or Vera Böhnisch among others.

"In order to become sustainable, fashion should become more timeless. The new style will be created by shifting our focus from ultra-hype to fair products in the production chain. When trendsetters start showing their social skills as far as fashion is concerned, when they start paying attention to environmental issues and condemning child labour – that's when the latest craze is going to be defined: smart, sustainable and fashionable."
(Markus Rogan)

"Sustainable fashion has to undergo a test as far as the young generation is concerned. Is it hip and cool? Who is wearing it and where? What does it look like? How much does it cost? If it all adds up, it's certainly coming in. Moby, for instance, is wearing a T-shirt made out of corn, produced under fair-wage conditions, without child labour or environmental pollution – that's what I call great advertising."
(Vera Böhnisch)

"It's not about reinventing the wheel, but rather about giving it the direction in which it should roll. The question isn't which style, but does it have style? For me, the examination of traditions and the testing of their suitability for the present belongs to this just as much as the passion in the collaborative formation of this world does. And clothes are always a disguise, protection and shield, display or camouflage, it's a game with your own and collective identity. I adopt a position via the garment, ideally a self-confident and open, dynamic position."
(Hubert von Goisern)

www.umweltbildung.at

karin macfelda / images

top row from left:

woven polyethylene

polyethylene without cell growth

knitted polyethylene

overgrown polyethylene

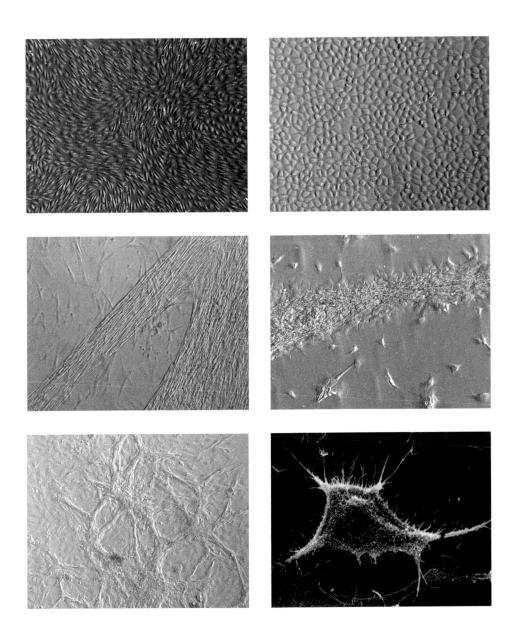

top row from left:

endothelial cells

endothelial cells

skeletal muscle cells

skeletal muscle cells

skeletal muscle cells

fibroblasts isolated from connective tissue

christiane luible / images

examples virtual clothing simulations

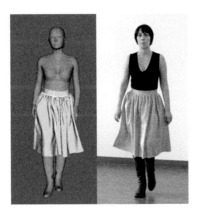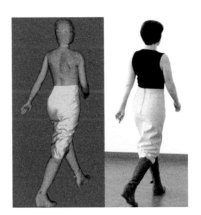

comparison of real and virtual garments

clean clothes campaign / images

dormitory, china

accommodation of the employees, china

left: nathalie dindeleux for peter iwniewicz
right: andrea gergely for gerald votava

sophie pollak for hubert von goisern

luisa hirsch, mirza sprecakovic for markus rogan

credits / images

page 154: Polyethylene without cell growth, © Macfelda, Biomedizinische Forschung, MUW

karin macfelda / page 158–161

page 160: Cardiac muscle cells, © Macfelda, Biomedizinische Forschung, MUW

page 160: Polyethylene without cell growth, © Macfelda, Biomedizinische Forschung, MUW

page 160: Overgrown polyethylene, © Macfelda, Biomedizinische Forschung, MUW

page 161: Endothelial cells, © Macfelda, Biomedizinische Forschung, MUW

christiane luible / page 162–165

page 162: Example virtual clothing simulation, oversized pair of pants (extended body), © Christiane Luible

page 164: Examples virtual clothing simulations, © Pendulum Studios from the 2004 video game L.A. Rush, published by Midway Games

page 164: Examples virtual clothing simulations, © OptiTex, <http://www.optitex.com> / © Syflex LLC, <http://www.syflex.biz>

page 165: Comparison of real and virtual garments, © MIRALab – University of Geneva

winfried mayr / page 166–169

page 167: Electrode trousers with handling mechanism for electrode placement,
 © Center of Biomedical Engineering and Physics, Medical University of Vienna

page 168: Complete stimulation equipment in flight case and notebook with control software and database, 4-channel stimulator unit,
 © Center of Biomedical Engineering and Physics, Medical University of Vienna

page 169: Commander of crew 26 applying MYOSTIM on board of MIR space station, © Institute for Biomedical Problems, Moscow

dietmar raffolt / page 170–173

page 171: Design of the polygrafic belt with embedded sensors, electrodes and preamplifier electronic box. © CBMEP

page 172: Design of the jacket, © CBMEP

page 173: Complete outfit with jacket and belt, © CBMEP

page 174: © Sacom

clean clothes campaign / page 180–181

page 181: Dormitories, China, © Sacom

page 181: Dormitories, China, © Sacom

forum environmental education / page 182–183

page 183: Kathrin Gromek, Maria Szakats for Eva Schlegel, © Fashion Institute Vienna

karin macfelda / page 184–185

page 184: Woven polyethylene, © Macfelda, Biomedizinische Forschung, MUW

page 184: Polyethylene without cell growth, © Macfelda, Biomedizinische Forschung, MUW

page 184: Knitted polyethylene, © Macfelda, Biomedizinische Forschung, MUW

page 184: Overgrown polyethylene, © Macfelda, Biomedizinische Forschung, MUW

page 185: Endothelial cells, © Macfelda, Biomedizinische Forschung, MUW

page 185: Endothelial cells, © Macfelda, Biomedizinische Forschung, MUW

page 185: Skeletal muscle cells, © Macfelda, Biomedizinische Forschung, MUW

page 185: Fibroblasts isolated from connective tissue, © Macfelda, Biomedizinische Forschung, MUW

christiane luible / page 196–187

page 186: Examples virtual clothing simulations, © MIRALab – University of Geneva

page 187: Comparison of real and virtual garments, © MIRALab – University of Geneva

clean clothes campaign / page 188–189

page 188: Dormitory, China, © Sacom

page 189: Accommodation of the employees, China, © Sacom

forum environmental education / page 190–193

page 190: Nathalie Dindeleux for Peter Iwniewicz, Andrea Gergely for Gerald Votava, © Fashion Institute Vienna/Forum Environmental Education

page 190: Sophie Pollak for Hubert von Goisern, © Fashion Institute Vienna/Forum Environmental Education

page 190: Luisa Hirsch, Mirza Sprecakovic for Markus Rogan, © Fashion Institute Vienna/Forum Environmental Education

ART & ARCHITECTURE

FREE STYLE

Is a bathroom carpet or a gift wrapping paper *art*? This question was posed by Stephen Gan (founder and editor of Visionaire – half magazine, half art object) when pondering the knitted sweater by W. & L.T.

Since the 1990s onwards, we have experienced a previously unknown range of crossovers between art and art-related aesthetic genres such as fashion, architecture, music and design. Latest since pop and punk in subcultural contexts, cultural hybrids have triumphally found their way into the established art scene… Ever since, the favourite child of the art scene is fashion, which is hardly surprising in times of postmodern affectivity with its secularised faith in the constructibility of the body, beauty and gender, or with its belief that identities are contradictory and unstable.

Fashion designers are borrowing principles and forms of expression from art, and they find encouragement to break the rules of fashion. The Japanese fashion designer Issey Miyake was accused by a newspaper of cutting up the substantial terms of fashion, architecture and design and using the snippets to tailor airy, light garments. The clothes of the Japanese designer – and other important designers – have been presented in exhibitions by the most renowned art temples of the world.

His latest creations can be classified into several categories at the same time: Miyake himself is responsible for the material and cuts, while painters and object artists such as Anselm Kiefer, Frank Stella, Bruce Nauman and others act as designers of surfaces and transform the models into dynamic sculptures.

In the context of architecture, the tent as the epitome of *textile architecture* conveys most clearly an image of the house as the third skin of human beings, following our skin and clothing. Yet can a tent be compared to a tent-dress?

"The village surrounds the inhabitants like a light elastic armour, more comparable to the hats of our women than to our cities... The nakedness of the residents appears to be protected by the velvet grass of the walls and the fibres of the palm trees: they slip out of their homes as if doffing giant robes made of ostrich feathers."

In the Western world, this poetic image depicted by Claude Levi Strauss finds a close equivalent in the designed environment, in the thematising of social movements, in garden installations like those in the French Chaumont every year... and it also leads us to the issues addressed in this chapter: To which extent do works of architecture respond to people's needs? To which extent do they borrow the creative elements and textures we are familiar with from the world of clothes? Where can we find parallels, crossovers and overlaps, and how is the evaluative difference in the public perception and reception articulated?

Gerda Buxbaum

erwin wurm / a profile

(edited by rd, statements erwin wurm) Erwin Wurm counts among the most internationally successful Austrian contemporary artists. His career began in the 1980s – since then he has been represented in approximately one hundred individual exhibitions, in several hundred group exhibitions in more than twenty countries and his works can be found in numerous international collections. Since 2002 he has been working as a Professor of Sculpture/Plastic Arts and Multi-media at the Institute of Fine and Media Arts of the University of Applied Arts in Vienna.

Erwin Wurms's origins, as well as his self-image as an artist, are definitely those of a sculptor. His works are based on a expanded concept of the term *sculpture* as well as on a disbe-lief in fixed form, as implied by the classical interpretation of art and, above all, sculpture. By arranging temporary, staged people and everyday objects and recording them on film or camera, Wurm creates temporary sculptures on the fly. His arguably most important work cycle is entitled *One Minute Sculptures*. He puts his actors into scurrile, absurd situations and defunctionalises objects through equally scur-rile new arrangements – either for real or in form of behaviour instructions.

"I use the term sculpture as a catalyser. I am trying to question the whole spectrum of our everyday lives, the environment we live in, the advertising, the body cult, the beauty ideal, the fashion, the purity, the world of game, the eroti-cism. I try to process all the things that define us. But I always try to look at it through the lenses of sculpture. A good example is working on volume: the gaining and losing of weight is work on the volume. One could go even further and say: gaining and losing weight is sculpting. Whenever I work on a sculpture, whenever I work on volume, I modify the content. When I present myself as a thin or a fat man – those are different shifts in content. We interpret the thin version – even it is unfair – as a dynamic and future-oriented. Suddenly, a new social component is added."

Therefore, the mechanisms of the world of fashion and advertising are increasingly a theme in Wurm's work.

"I feel somehow connected to the world of fashion. Perhaps differently than one would expect, because I don't deal with fashion in the sense of clothes, but with the world of fashion as a paradox, as a social phenomenon."

"When I use garments in my work – and this happens relatively often – then I use them as a symbol of a human being, a symbol of a missing human being. You see the human being even if they are not present."

"The fashion-world as a world within the world, similar to the art-world as a world within the world, represents an enhancement of the everyday. This is what I'm interested in, the absolute enhancement, the spiritual ascen-sion from the everyday, the way fashion shows, models and designers deal with certain terms and certain values."

Already in 1998, one of Wurm's first sweater works could be seen at an exhibition in New York. It was a work about *Super freaks, Post-Pop and the New Generation.*"

"The original idea for my sweaters were com-mon sweaters, the ones you and I wear, and fifteen various ways of hanging them, in a form which separated the object from the con-ception. You don't recognise a sweater, but a sculpture. The second principle was to allow the will of the curators, the critics and the collec-tors to be involved in the creative process too. They had free will to choose the colours and patterns of the sweaters. They could go into a shop, buy a sweater and hang it according to my instructions."

His witty, ironic visual language as well as his love for lifestyle symbols from everyday culture have also inspired advertising and pop culture, such as a photo sequence for a fashion magazine or a music clip by Red Hot Chili Peppers.

"The entire music industry, just like the fashion industry, exploits the works of visual artists. Red Hot Chili Peppers were extremely professional, they asked and paid for the copyright. They made sure that I receive a credit for my work, which almost never happens on MTV."

"Irony or humour is an essential part of my work because it allows me to look at realities which are not always fun or pleasant from a different perspective. It helps make unpleasant realities more endurable."

gudrun kampl / a profile

(edited by rd, statements gudrun kampl)
Gudrun Kampl is a breed of artist who intensively focuses on material and function of human bodies and clothes. She sews symbols of beauty and sexuality to subtle fetish objects, puts them in sarcophagi-like showcases and arranges them to form psychedelic topographies.

"Already during my time as a student, dealing with the canvas as a material led to a preoccupation with the material itself. I started to paint upon printed décor fabrics, on one hand because the fabrics were cheaper than canvas, and on the other because the printed fabric spared me painting work. After that I wanted to improve or change fabric patterns, or I began to just cut out the patterns completely. Later I would glue the fabric patterns together again – this is how I became an object artist..."
[…]

"The body consists of intestines and skin, of inwards and surfaces. An interplay I want to make visible and tangible with my art. I'm interested in looking into the entrails. They make the body seem completely void of face and history."
[…]

"The idea of transforming materials into forms has been present in philosophy, history of art and art criticism for centuries. The material as such used to be regarded as raw and ugly or natural and feminine. The hierarchy of arts, as taught at art universities and academies up to today, aims at conquering the material. Demolishing (Schiller) or abolishing (Hegel) the material, or conquering it by formation, is still today a measure of what is regarded as art. In spite of that, or maybe because of that, artistic counter movements time and again appear because the physical quality of a material defies purely optical perception. In light of the growing importance of media images, material takes over the task of reassuring the world and is called upon as proof of the authentic."
[…]

"In the history of crime, clothing counts among the oldest and most convincing pieces of evidence. The traces left on or in the clothes serve to reconstruct the manner in which a crime has been committed. Even generally speaking, clothes seem to be an authentic testament of the body because they are witnesses of physical contact. This image has been present in the Christian veneration of saints for centuries. The holy shroud and numerous *Saint's Garments* are among the most widely spread relics in the world. The garment becomes the representation of the body through the intimate contact to it. Every spot on the garment or fabric seems to prove the authenticity of the saint's ordeal."
[…]

"My fabrics are mostly findings, they are testimonies of personal use, already loaded with a story. I'm interested in these histories … I'm also interested in preserving the traces originating from physical contact – with the ageing of the material, also the transience of their users becomes legible..."
[…]

"My coats are all about social exaggeration. They aren't about sexual, intimate bodies – therefore it's not about the intimacy at all, but rather about the social body."
[…]

Virgin with a Cuddly Toy Cloak from the year 2002 represents the continuation of a traditional representation of Virgin of Mercy. In addition to pink silk, used cuddly toys become my materials in this case. The usage aspect of the toys provides them with a story to tell. That's what they share with the relics – they

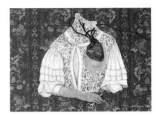

bear witness to a past and attain a strange aura of contact, a certain *fabric sanctity.*"
[…]

"Now and then clothes have the same importance as cuddly toys. They are here to be cuddled, cherished and to keep you warm but also to be shown around and to be presented, as fetish or as protection. Velvet, just like fabrics in general, is not associated with femininity only because of the way it clings to the body, but also because it is a very absorbing material. It absorbs liquids, it changes colour, it assumes odours and it is vulnerable. The velvet feels erotic and comfortable on the skin. By using it I can produce a feeling of intimacy and familiarity."
[…]

"*Wishing to Move Forward* is a shoe sculpture, a childhood memory of mine about a big toe nudging the shoe cap. It consists of many laces, like umbilical cords – a symbol of being tied and captured. The foot leaves traces on the leather forcing it to assume its shape. The personal use by a human body can be detected here. As the shoe assumes the form of the body, it gets older. Shoe leather is not only used functionally as a second skin, rather it is also an animal pelt free of hair, thus an animal skin. Owing to its smooth quality, the body is enabled to participate in the shaping process so that the leather retains a long-term foot imprint. It is only with this personal marking that even mass products become individuals and tell their stories."

Gudrun Kampl was born in Klagenfurt in 1964. She studied at the University of Applied Arts in Vienna, under the guidance of Maria Lassnig. A wide-range of scholarships led her to Paris, New York, Brazil and India. She has participated in many single and group exhibitions in Austria and abroad.

www.galerie.steinek.at

literature

• Wagner, Monika: *Das Material in der Kunst*, C.H. Beck

___fabrics interseason / a profile

(edited by rd, statements wally sallner, johannes schweiger) The art/design label ___fabrics interseason has been interdisciplinary active in the fields of fashion/design, fine arts and electronic music since 1998. Twice a year, the fashion label launches a collection that has already become internationally renown and regularly presented at the Paris Prêt-à-Porter Fashion Week. In the artistic context, ___fabrics interseason regularly presents various art editions and contributions to exhibitions such as in the 3rd Berlin Biennial for Contemporary Art (2004), the Grazer Kunstverein (2007) or Manifesta7 (2008).

Their conceptual approach – unusual for fashion – addresses socio-political phenomena and their codes, such as the construction of social and cultural identity through clothing. The collections are not only an analysis of these codes, or even the analyses of a life within a surface (with all the socio-political implications), they are also infiltrations of an exclusive and individualised fashion awareness through their lifestyle-compatible wearability, deliberately proclaiming a critical or political stance. In accordance with their artistic method, the projects, collections and their presentation are based upon concepts that depart from an intensive research of socio-political discourses and phenomena.

The shift from fashion to art contexts (and vice versa) can be seen mostly within a single project or a single topic. The use of various media hereby makes the difference: if the presentation of the collection takes place during a performance, the same topic is often treated as an exhibition installation, for example a sculpture, video or painting. The garment or the collection is then usually omitted.

The logo of ___fabrics interseason is an important element of the entire concept as it stands for three features which characterise the work of the label: the discursive level, the visual level and the auditory level.

The famous motif *see no evil, hear no evil, speak no evil,* illustrated by three monkeys covering their eyes, ears and mouths, has been replaced here by a group of women with hyena's teeth and additionally enhanced by old-fashioned glasses and a loudspeaker (see evil, hear evil, speak evil!).

Wally Salner and Johannes Schweiger, the founders of the label, both attended the Academy of the Fine Arts in Vienna. The origin of their interdisciplinary work lies in their desire and need to expand the traditional image of the artist as they came to know at the academy. They regard their label as a mobile autonomous institution and an international platform and network for like-minded people. They understand autonomy as an active search for their own public, as opposed to the passive hope for acknowledgement and recognition that predominates the art world.

In the following paragraphs are some projects from their biography that exemplify their artistic philosophy:

The summer collection 2006 was entitled *Product Placement,* a term from the film industry involving the strategic promotional introduction of products, services, brands or companies as props in the plot of a movie, a TV series or a video clip.

The experimental movie by Claude Lelouch from 1976, in which Paris is seen from the perspective of a Ferrari, was taken as the setting for the collection. In the uncut speedy ride at dawn, the eight-minute ride from the banlieu up the Montmartre is shown. Presented in a cinema, the urban setting, the feeling of speed and the flair empty streets on a dead-quiet Sunday morning formed the performative backdrop for the catwalk of the show.

After the summer collection 2006, which consisted of 35 outfits, ___fabrics interseason decided to make a radical cut – tabula rasa – in order to process and archive their existing work

and at the same time find a new orientation. In accordance with the artistic method, they developed the project *Surface:Tapisserie No 1*, in which all the left-over fabrics from the last ten years were cut to pieces and woven into a patchwork rug.

This form of *archiving* their collections resulted in the birth of a new collection: a collection of rugs with a total surface area of 180 m²; the smallest rug being only five metres, the longest one, twenty-five metres.

"The recycling aspect and the use of remnants were very exciting for us, a two-dimensional reproduction of the contents of all collections through the fabrics. We have a very special relationship to each and every one of these fabrics, we chose each of them with careful consideration. To see the now flattened fabrics next to each other – luxurious silk placed next to artificial fur or plain cotton – again set in motion a process of reflection."

The next step was a rather small collection.

"In our concept, it was no longer interesting to create collections with forty outfits, but rather fifteen concentrated outfits where every piece is perfect; without repetitions in the individual pieces or the models, such as different trouser or jacket lengths, rather every garment can stand on its own. That's how we have found an ideal – and also economical – way of creating collections."

The presentation of this first small collection was set up rather classically, like a Haute Couture Show in the 1960s. It took place in Paris in an Ottoman apartment, moderated by a Conférencière who commented on every single garment, its manufacturing techniques and particular fabrics.

www.fabrics.at

studio aisslinger / a profile

(edited by hb, statements werner aisslinger)
Werner Aisslinger runs his own design studio in Berlin. Modular systems, construction kits, flexibility – these issues are at heart of his designs. Some pieces of his furniture are represented in internationally renowned museum collections, such as in the Pinakothek der Moderne in Munich or the Metropolitan Museum in New York. Additionally, they can be found in the showrooms of Zanotta, Magis, Cappellini and Vitra. Just in 2007 alone, his studio took part in exhibitions in Paris, Bordeaux, Prague, Zurich, Taiwan, New York, Berlin, Milan and Köln.

"I would describe myself as an author-designer because my work is very personalised. I have a set aim and attitude and work very personally. My office isn't a huge service-based machinery, it is still rather small and creative."

There is more to his products, such as the gel furniture, than just the beautiful forms; they express his joy in experimenting with new, innovative materials. With his Loftcube he attempts to deal with contemporary issues and demonstrates how to live on rooftops by using simple construction systems.

"Innovations have been and still are coming through materials."

Design alone is not enough for Studio Aisslinger. Innovation and discovery of interesting materials as well as new production methods are a top priority.

"There is an incredible variety of materials being invented that can be used by designers as well. That's why I would put those projects in the category of material innovation. A designer is a catalyser who brings new materials on the market in the first place. You should simply be alert and try to find possible uses for them."

The studio also possesses huge know-how as far as modular furniture is concerned, where the key issue is modularity and modular systems.

"It's all about creating items which are easy to dismantle and expand, rather than static, so that you can take them with you like objects. I'm interested in creating items which can be used for a longer period of time."

Werner Aisslinger studied design at the Berlin University of the Arts. Before founding his own studio in 1993, he worked for famous designers such as Jasper Morrison and Ron Arad in London as well as for the Studio de Lucchi in Milan. In the previous years he has been working as a visiting professor at the Berlin University of the Arts, the Lathi Design Institute in Finland as well as the professor at the Karlsruhe University of Arts and Design.

In his presentation at the Fashion Institute Vienna in Hetzendorf Castle in 2001, Werner Aisslinger presented the history of development of the Soft Cell Collection. Several excerpts from his presentation follow:

"At the end of the Nineties a new material entered the market – polyurethane gel, used for instance in medicine or for bicycle seats. The good thing about it is that it is a non-fade material which maintains its biomechanical properties for years. It remains the same as when it was produced, the spring effect does not disappear. The cushioning effect is achieved by suppressing the material, the material behaves like a liquid."

"In 1998 and 1999 I went to the company that produces this material. Together we considered various uses of this gel in furniture production. As a first step, I designed a small collection at my own expense, prototypes that were presented at the Milan Fashion Fair in 1999. There press around the globe reported about it and several published articles in professional journals followed. My project made the gel famous. Nowadays many product designers work with it."

"The gel is relatively heavy and that is why the

chairs are still rather heavy at the moment. High thermal conductivity of the material partly causes problems – when you sit down your body warmth is withdrawn at first. Even Bayer, the company producing the chemical substance of the gel, is constantly working on reducing thermal conductivity and the weight. The material is going to be further developed in the future."

"Gel pads cannot be produced by themselves. The gel has to be mixed with two more components and filled at 70 degrees Celsius. It is a high-tech industrial product, you have to cooperate with the manufacturers."

"That is why my next step was to cooperate with Zanotta. Together, we brought a chaise lounge on the market and presented it at the Milan Fashion Fair in 2000. It has an aluminium frame outside in which the gel pad is mounted. The gel pad is two metres long and sixty centimetres wide. At that time it was the largest gel chunk ever moulded. Another problem was the fact that the gel sets quickly. The lounger was very expensive on the market, which means that naturally it only reached a small number of customers. It is a real niche product."

"Then there was the third step as far as gel technology is concerned. It was a project with Cappellini. The main structure of the furniture, designed in cooperation with this company, is integrated into the gel so that it resembles a kind of honeycomb or grid. In this case, the gel is not only a part of the cushioning system – it also encases the chair. It is smooth all over. Design experts were fascinated by the Cappellini Gel Collection, which can be regarded as a quantum leap in material evolution. To quote Philipp Starck: 'Here it became clear that there is no need for designing but simply for experimenting with a balanced minimum of nodesign which is only concerned with the material itself.' In my opinion, it was simply a fascinating project – the first gel furniture on the market."

www.aisslinger.de

jean-paul pigeat / international garden festival chaumont-sur-loire

Chaumont-sur-Loire, an area classified by UNESCO as a world heritage site, has invariably been at the forefront of creation, elegance and fantasy. The idea of the annual festival is simple. The park of the Chaumont Castle, designed by the Belgian landscape architect Jacques Wirtz, consists of twenty-six gardens. Since 1992, contemporary gardens have been designed and exhibited here. Several hundred projects submitted from all over the globe compete every year in an international competition. The projects involving state-of-the-art of modern landscape design are carried out – 400 projects have been realised so far since the establishment of the festival in 1992.

A mine of ideas and a seedbed of talent, this festival re-energises the art of gardens and the public and professional interest alike through the presentation of original arrangements, new materials, innovative ideas and approaches. The diversity, the creativity and the quality of the projects all contribute to establishing the world-renowned reputation of the festival, which has become an imperative rendez-vous where the new generations of landscapers, architects scenographers and gardeners unveil their creations.

Jean-Paul Pigeat was director of the International Chaumont Garden Festival from its beginning in 1992 until his death in 2005. He was one of the most prominent experts on contemporary garden culture and has greatly elevated the theme of the garden in general. His ambition, renewed each year, has ensured the area's status as a beacon for such activities.

Dear Jean-Paul Pigeat, what do you think it is that has for centuries fascinated people about gardens?[1]
"When people try to design and shape a garden, they actually try to find and represent paradise. Through their garden, people always try to create an image of the real world that they can control and where they can find themselves. People have always been fascinated by and passionate about gardens since the beginnings of civilised culture – and I would say that's not such a big surprise."

What should a beautiful and appealing garden look like?
"I can't really say what a beautiful and appealing garden should look like but I know what I expect from a garden. For me, a wonderful garden has a special mixture of plants, for instance one that includes the senna shrub. When I stroll around the garden, I expect a lot of surprises. For my part, I never design a garden without creativity and humour. For me, a garden is a place of happiness rather than an object of representation. I'm not really such a big fan of these straight, almost unemotional French gardens."

In our world full of technology and growing conurbations, people are increasingly longing for nature and *green* landscape. How do you think that

1 In the following interview, Jean-Paul Pigeat talks about the fascination, the stimulating atmosphere and the great significance of the garden.

the significance of gardens has changed over the last years and centuries?
"I think that gardens have gained much importance over the last couple of years. In my opinion, there have been two basic *movements*: the first movement consists of individual people with a great passion for flowers and plants. These plant-lovers make ever-more exact choices and have become much more competent. Their great love for gardens is shown at numerous gardening events where they get a very positive response. The second big garden movement becomes evident in public places: people want more freedom. They don't just want a garden or park to stroll around in, they also want to use the lawn to play, have picnics or rest on it, they want to *feel* nature. This freedom in dealing with one's body has been one of the most important and significant elements in the evolution of gardens in the last 15 years."

People long for straightness, reduction and minimalism in many areas of life. However, when it comes to gardens, they practice the exact opposite: the meadow of wild flowers blooms next to the compost heap, weeds grow next to the rosebushes. How would you explain this contradiction?
"I have quite a strange attitude towards the term *weeds* – actually we have dedicated a whole festival to this expression (laughs). It's our attitude towards nature that we have to change. Why not put the question differently: what are those terrible rosebushes doing amidst the wonderful weeds…?"

Would you say that the garden reflects the source and origin of all life?
"I would say that the garden indeed represents our origins, a kind of ancient paradise. You can also find this idea in Arabic gardens where four water paths symbolise the four cardinal points at convergent or divergent positions to the centre of the garden. Another area where you can find this heavenly image is on many Persian carpets where the garden is a symbolic place where people always feel happy."

The garden is a place to indulge in reminiscence, to *lose* oneself, to dream … would you say that the garden is something like a symbol of romance?
"I would rather say that the garden is a place where happiness is fulfilled. Happiness is much stronger than a symbol because you have to bring it into reality yourself."

Many poets and artists draw from the creative powers of the garden. Why do you think that gardens have always been a place of inspiration where you are *kissed by the muse*?
"The *muse's kiss* is what gardens are all about …"[2]

2 Jean-Paul Pigeat gave this interview to Helmut Wolf, editor in chief of the European-wide publication *pool_life & culture*, issue pool_11, July 2005.

www.chaumont-jardins.com

jörg seifert / woven architecture and constructed clothes. on blurring of boundaries between the second and third skin

In February 2008, *Mobile Art* – a mobile museum for Chanel – was opened in Hong Kong. It was designed by Zaha Hadid, while the idea came from Karl Lagerfeld. This temporary pavilion, which should to allude to the Chanel-handbag in terms of shape, is only one current example, one of several indications, that a lively dialogue between fashion and architecture has unfolded in recent years.

LEFT: ZAHA HADID ARCHITECTS, MOBILE ART CHANEL CONTEMPORARY ART CONTAINER, HONG KONG, CHINA, 2007/08

Amongst others, the exhibition *Skin+Bones, Parallel Practices in Fashion and Architecture* at the Museum of Contemporary Art in Los Angeles in 2006/2007 also pursued this phenomenon. The exhibition curators observed two essential tendencies which they perceived as evidence of a mutual enrichment between the two creative disciplines. On the one hand, reputable fashion labels have in recent years increasingly had their flagship-stores designed by first-class architectural offices – a trend that has increased architects' general interest in fashion. On the other hand, some architects explicitly draw their inspiration from the work methods of fashion designers: from the schools and studios which have been striving to explore the possibilities and boundaries of the new digital design tools for years, attempting to create unconventional forms far beyond the right angle. The designs of Zaha Hadid, who has since also created her own shoe, are also prototypical of this development of computer-based architectures.

One of the best known examples for the first trend – flagship-stores by star architects – is the Prada Epicenter Store by Rem Koolhaas in New York, which opened in 2001, as well as the Prada Store in Tokyo by Herzog & de Meuron, which was realised two years later. Already in the late 1990s, the London-based office Future Systems also designed various shops for fashion labels such as Comme des Garçons and Marni in New York, Tokyo, London and Milan.

Representatives of the second trend – architecture directly inspired by fashion design – are the Californian architects Peter Testa and Devin Weiser, who have been experimenting with carbon fibre for years. It is claimed that the *Inside Out 2Way Dress* by the Japanese fashion designer Yoshiki Hishinuma from 2004 directly served as a model for their exceptional architectural design of the *Carbon Beach House* in 2006. The fabric of this dress, which mostly consists of gauze, is held in shape by irregular-running, opaque strips, reminiscent of masking tape, which cover up various body parts at the same time.

Testa and Weiser's design for the *Carbon Beach House* envisions a façade of irregular panels held together by prepreg-tape – a carbon fibre adhesive tape from the aerospace and sports industry. This design, however, has not been realised yet.

INTERSECTIONS – FIVE LEVELS

The intersections between architecture and fashion generally occur on five different levels. These are in particular:

1. The metaphorical level
2. The level of the design process
3. The material level of the designed objects
4. The formal level of the objects
5. The functional level of the objects

1. The metaphorical level

The terms *skin* and *shell* are often used as linguistic images, referring to the common intersections between architecture and fashion. The metaphor of the skin is equally used by both disciplines: fashion boutiques are named *Zweite Haut* (second skin), whereas a Berlin-based architectural office, for example, calls itself *Dritte Haut* (third skin). The title *Skin+Bones* also plays with the image of the body. However, by simultaneously thematising the correlation between the inner support structure and the outer shell, it implicitly refers to one decisive difference between the architect and the fashion designer: while the former has to *invent* both the support structure and the exterior enclosure and conceive them as corresponding parts of an unitary whole with the involvement of expert planners, the fashion designer is left with focusing on the shell and takes its wearers for granted.

The mutual borrowing of terms, which serve each corresponding industry as metaphors, is also deeply rooted in the cultural memory and is widespread in everyday language as well as in expert discourses. Architects along with investors and producers of construction materials like to refer to the façade as *the dress of the building*, while the term *architectonic design* is popular in fashion. Christian Dior is said to have designed his lines like an architect. An exhibition on fashion design, shown at the Massachusetts Institute of Technology in 1982, after all did carry the title *Intimate Architecture*.

However, the metaphorical level alone is not proof of an actual dialogue between the two disciplines; it merely provides an initial starting point – a *suspicious fact* – for possible, further reaching intersections.

2. The level of the design process

According to Brooke Hodge, the curator of *Skin+Bones*, the dialogue partners from fashion and architecture can, above all, pick up the discussion in the striking similarities regarding the design process. In both disciplines the first task consists of creating three-dimensional objects from two-dimensionally sketched-out ideas, which have to fulfil both protection as

well as identity functions. Houses and clothes alike form volumes for which highly succinct forms need to be found. According to Hodge, architects and fashion designers are generally influenced by the same aesthetic tendencies, ideological and theoretical principles as well as the same technological innovations. This becomes apparent, for example, when comparing – as in the exhibition – the clothing designs from the sketch books of Narciso Rodriguez with form studies like the ones that Frank O. Gehry produced for the *Walt Disney Concert Hall* in Los Angeles, or upon learning that the same tools are used in both disciplines. The Italian fashion designer Elena Manferdini, for example, designs her clothes using Maya – a 3D-modelling software that was originally developed for the film industry but is also used by numerous architects.

However, it has to be pointed out that in general the analogies between the work processes of architects and fashion designers remain either relatively abstract or manifest themselves more clearly when they are also reflected in various equivalents of the results. Hence it comes as no surprise that these three levels often condition each other: materials are subject to their own laws, of which certain forms are therefore typical, while others seem virtually absurd. And when it comes to functional overlappings, one sometimes cannot even clearly differentiate anymore between second and third skin or between the disciplines that were initially responsible for them.

3. The material level
On the material level there are basically two forms of borrowing from the corresponding industry: on the one hand, constructing with textiles and on the other, the inclusion of construction materials in fashion design. Moreover, it might also be the case that a material equally untypical in both branches is estranged from its intended use and thus tested for its usability in architecture and fashion. With textile construction, this is not a new tendency, as is well known. On the contrary, this tradition is in fact even much older than the massive architecture of sedentariness. Long before wood and stone houses were built, nomadic peoples were moving around with yurts, teepees and black tents, and textile shells for temporary pavilions or for flexible purposes are to this day highly relevant.

Since an in-depth discussion of the long history of textile construction would go beyond the scope of the publication in hand, only a few, recent examples shall be mentioned here. First of all, Frei Otto, who in 1964 founded the *Institut für Leichte Flächentragwerke* (Institute for Light Surface Structures) in Stuttgart and significantly influenced the development of spanned membrane roofs in the 20th century, has to be mentioned in this context. His tent construction for the *German Pavilion* in the Montreal World Expo in 1967 as well as the roof design of the Olympic Stadium in Munich, which he was significantly involved in, caused a furore.

In the 21st century, numerous huge sports arenas are still equipped with membrane roofs such as the *FNB-Stadium* in Johannesburg, where the Football World Cup finals will be held in 2010. It is currently being built by the South African architectural office Boogertman and Partners. The design of the textile membrane roof came from the Stuttgart-based office Schlaich, Bergmann and Partner – who were incidentally also in charge of the versatile roofing in the Arkadenhof of the *Vienna City Hall*.

In 1995 Shigeru Ban pursued an entirely different approach in Tokyo. His *Curtain Wall House* displays an ironic-literal handling of the theme of the curtain façade. While it is actually the glass façades suspended in front of the support structure – as known from office towers – that are called curtain walls or curtain façades, Shigeru Ban instead chose a textile curtain for the exterior completion of his house. White fabric lanes billowing in the wind underneath the deep-blue Tokyo sky – these images were all over the architecture press throughout the world. But in everyday life textile construction mostly makes itself felt in a much less spectacular way and sometimes is so mundane that one cannot even call it architecture anymore. One only has to think of the countless party tents, marquees and balcony claddings – in contrast are many semi-transparent building site scaffoldings, which reveal unforeseen and often entirely overlooked, aesthetic qualities.

TOP RIGHT: SHIGERU BAN ARCHITECTS, CURTAIN WALL HOUSE, TOKYO, JAPAN, 1995

So while textile shells are a permanent fixture within the realm of construction, it in turn only happens very rarely that fashion and textile designers resort to materials from architecture and the construction industry. However, if one specifically searches for such examples, one also finds them – for example, in Vienna: the fashion designer Katha Harrer used white roofing underlays for the jackets and coats of various collections for her label *km/a*. These roofing underlays are in part also covered with an additional black coating, which bears individual signs of wear and tear after it has been worn a couple of times, thus making every item unique. The originally white material is normally used for loft conversions where it is placed under a tile cover, serving as protection against wetness, dirt and snow.

BOTTOM RIGHT: KATHA HARRER, COLLECTION K/WEISS DO IT YOURSELF FROM KM/A, 2000

However, while fashion designers from time to time also use materials that are more often found in architecture, this is not a systematic appropriation of construction materials on the part of the fashion industry. There is, for example, the Italian Gaetano Pesce, who designs belts out of resin – a material that architects like to use for floorings. But Pesce is actually a furniture designer and artist who, in addition to industrial design, also studied architecture. And Katha Harrer? She is more likely to be intuitively

searching for the creative potential of untypical materials for her collections, for which she also employs worn out prison blankets, used parachutes or dish racks from the gastronomy sector.

4. The formal level

By contrast, examples illustrating the formal relationship between architectural designs and fashion collections are found considerably more often than examples of the transfer on the material level. The *Skin+Bones* exhibition also juxtaposed some projects from both industries, resulting in more or less astonishing mutual points of contact. For example, the pointed, origami-like roof folding of the 2002 *Yokohama harbour-terminal* by Foreign Office Architects were contrasted with the multi-layer look of the Fall/Winter Collection 2003 by Viktor & Rolf. Such associations might not be so obvious in the following example: the curved façade of the Selfridges store by Future Systems, completed in Birmingham in 2003, is covered in its entirety in sequins – a design element which has long been common practice in fashion and which designers such as Alexander McQueen have repeatedly made use of.

The use of floral motives seems rather to be an exception in both the disciplines of architecture and fashion. Moreover, the quite rare examples are often inspired by entirely different motivations: on the façade of the *Ricola production and storage building*, Herzog & de Meuron quote one of the numerous close-ups of plant material that Karl Blossfeldt took in the 1920s. The same 1x1m scale petal is printed on translucent plastic plates and repeats across the entire façade. The Belgian fashion designer Dries van Noten also works with floral prints, however, in contrast to the Ricola hall, his collections, most of shiny and strong colours, are inspired by traditional Far Eastern and North African cultures and his prints are assembled through overlaying various patterns.

LEFT: HERZOG & DE MEURON, RICOLA – EUROPE SA. PRODUCTION AND STORAGE BUILDING, MULHOUSE, FRANCE, 1992/93

However, a larger comparability is again apparent within the various strategies to structure a shell by means of perforation. So it seems quite obvious to compare the organic hole patterns of various items of clothing by Elena Manferdini with Toyo Ito's *Mikimoto-Ginza-2-Tower* in Tokyo, whose even façade is covered with numerous irregular windows with rounded corners. But conceptual cross-connections to Manferdini's slitted clothing designs could also be established with the *SBB signal tower* in Basel by Herzog & de Meuron (1998/99), whose façade openings consist of horizontally bent up copper plates. The fashion designer, who also completed a degree in architecture, believes that the human body is ideal for testing out things on a small scale, which can later on be transferred to building designs.

The designs of the *Moebius Dress* by J. Meejin Yoon/My Studio (2005) as well as of the Möbius House, designed and realised by UN Studio in Het Gooi between 1993 and 1998, are both intellectually charged. J. Meejin Yoon works simultaneously in the fields of architecture, art and fashion. The Moebius Dress, which takes the form of an endless, Möbius felt-strip once turned upside down, is a conceptual piece dealing with aspects of form and performance. For the *Möbius House* by UN Studio, however, the principle of the endless strip was applied in an abstract manner: the house has corners and edges, but the organising principle of the house consists in a continuous flow that ties together the individual areas.

5. The functional level

The comparison of mutually informing formal aspects between fashion and architecture could still be continued, however the intersections on the functional level are not any less interesting. In the more recent past, numerous hybrid designs have emerged – objects that can neither be clearly assigned to architecture nor to fashion. Some are intended to be serious, some ironic, some are design objects and others again artistic interventions.

This frequent, subtle blurring of boundaries between the second and third skin refers to important social transformation processes of our time, such as the steadily growing mobility and – in close relation – the revolution of information technologies and forms of communication, but also to the increasing softening of the private and public sphere as well as the ongoing individualisation tendencies. On their own or in their interdependency, these factors play a part in clothing's increasing adoption of functions that are traditionally ascribed to housing, while the façades of houses adopt the visual and haptic qualities of clothing, resulting in a whole palette of said hybrid structures. From case to case, these may have a tendency either towards the second or third skin, or they completely defy conventional patterns of classification.

Final Home, for example, is the name given to an orange nylon parka designed by Kosuke Tsumura in 1994, which was conceived as wearable shelter. Tsumura deals with the value of clothing in the case of the loss of one's house. "When one loses his house, the thing which protects him in the end is cloth." In his design, he focuses on the space between the outer shell and the inner lining of the parka. Here he installs forty-four equal-sized pockets, both on the front and the back as well in the sleeves, which can be used for storing food, medication, tools and other items, but also filled with newsprint or other insulating materials for the cold times of year. However,

in connection with such ideas, the question of the target group arises: does the fashion industry in any way reach the homeless who could make use of such hybrid structures and to what extent are design-oriented lifestyle groups seriously interested in such concepts?

But *Final Home* – at the same time also the name of Tsumura's brand – is by no means an isolated phenomenon. In the 1990s numerous artists and designers increasingly dealt with the theme of *emergency shelter*: Lucy Orta's *Refugee Wear Habitent* from 1992 can be regarded as the prototype of so-called *body architecture*. However, this design can also be interpreted as a civil and artistic variation of the tent squares principle, known from military use, which can either be worn individually as rain ponchos or buttoned together to form tents. An aluminium-coated polyamide rain coat can be transformed into an igloo by means of a telescopic frame, however it is more reminiscent of an ABC protection suit than of a rain poncho. Orta has since continued to work on this approach and also introduced a version for several people – an example that illustrates that this is more of an artistic intervention than a design sketch.

In his *Transformables Collection* from 2001 Moreno Ferrari presented rain coats that unfold into tents, which can also be inflated to air mattresses and chairs. In contrast, *paraSite* by Michael Rankowitz from 1997 uses the exhaust air from a ventilation system to keep a tent-like accommodation made out of a transparent polyethelyne membrane inherently stable. The *Basic House*, designed by Martín Ruiz de Azúa, is a cube of golden-silver rescue foil with an edge length of two metres that automatically unfolds but also fits into every pocket when folded. It hereby represents another example of transportable architecture from the field of *emergency shelter*.

The design study by the German architect Oliver Oechsle was not conceived for emergency purposes, but for the mobile flaneur of the 21st century. *schlafwandler stehst du still?* (sleepwalker are you standing still?) is the title of his 2004 project: a light tent construction that can be spanned over the head and upper-body from a backpack to offer a partial retreat in the public sphere. Functionally speaking, it can be described as a third skin that encompasses a new spatial typology, however technically and structurally the tent has to be assigned to clothing. This design should primarily serve as food for thought.
It responds to the growing dissolution of the boundaries between private and public space. Its concern is evident: in a time when people openly talk about the most intimate things in public by means of mobile phones, a piece of privacy should be recaptured. But whether the wearer of this hybrid would succeed in doing so is doubtful, at least at this point in time. It seems more likely that the wearer would, like a showman, draw the attention of many people towards themselves, as opposed to finding retreat.

All functional hybrids discussed so far share the extension into the public sphere and that they are intended for mobile users. The design *Cries and Whispers* by the Scottish designer Hill Jephson Robb seems almost complementary to them. His elliptic cave made from pink felt with a diameter of 1-1.5 metres was conceived for interior spaces, a retreat for a small child whenever it is searching for physical and emotional safety. A very similar design was also on display in the spring of 2008 as part of an exhibition at the Vienna Fashion School Hetzendorf.

The projects of the Parisian designers Ronan and Erwan Bouroullec are conceptually related to this one. Informed by the house-in-a-house idea, the two brothers have for years been preoccupied with structures that constitute an additional layer between the second and third skin in order to create possibilities of retreat that can be adjusted by the user. For the Stockholm showroom of the Danish textile design brand Kvadrat, they developed a modular partition wall system based on the so-called *North Tiles*. Elements made from polyethylene-foam covered in wool or polyester can be assembled to form straight or curved partition walls. The textile qualities unfold their very own visual, haptic and acoustic qualities.

As part of their *Stich-Room* at the Vitra Design Museum in Weil am Rhein in 2007, Ronan and Erwan Bouroullec inserted a shell into the space, which was intended to elicit associations with animal hides. With this design, the design duo explicitly referred to traditional tents such as the teepee or the Mongolian yurte, in the hope of acquainting the visitors with the freedom of a *modern savage* who appropriates his/her spaces and sets him/herself individual boundaries.

RIGHT: BOUROULLEC, STITCH ROOM, 2007

Prospects

To conclude I would once again like to emphasise both of the external processes which, in my opinion, influence architecture as well as fashion and in such a way that both are independently moving in a similar direction – even without deliberately searching for mutual points of contact. As already mentioned, these are, on the one hand, mobility without boundaries and, on the other, the continuous development of information technologies.

The swift rise of mobility and the resulting effects have already been discussed very often and the aforementioned hybrid constructions respond to this development in various ways. A critical, intellectual examination of an enforced mobility was already delivered by Hussein Chalayan a few years ago. In the performance accompanying the *Afterwords Collection*, fall/winter 1999/2000, the London-based Turkish-Cypriot fashion designer dealt with the theme of a hasty flight. Four models in underskirts entered a setting composed of chairs and coffee tables, removed the throws from

the chairs and immediately transformed them into uber-stylish dresses. While a fifth model was removing the middle section of the circular table and transforming the outer segments telescopically into a wooden *skirt*, the others folded up their chairs into bags and suitcases – ready for their departure into the unknown. In the past, Hussein Chalayan consistently used his works to reflect on themes such as the Balkan conflict and his own migration background.

The advancement of information technologies has already led to numerous intelligent items of clothing and intelligent examples of architecture, and in future, we will surely be in for many a surprise. The intersections between technology and the clothing industry are manifold: already in 2001, Corpo Nove presented a shirt with the so-called Thermal-Shape-Memory-Effect. Woven-in titanium fibres, which return to their original form when supplied with heat, make the shirt iron-free, and it can be programmed in such a way that the sleeves automatically roll up at a certain temperature.

In 2003 Apple and snowboard-manufacturer Burton together developed various jackets and a backpack with an integrated iPod. In 2004 Infineon wove a voice-operated, washable MP3-player directly into a jacket, and they have also been experimenting with a conductive cotton with integrated silver wires for a couple of years. Philips offers *E-rain coats* equipped with mobile phone, GPS and mini-camera. In Finland, *the Lapper* – an intelligent clip for swimming trunks that counts the laps while swimming – has been available since 2003. And jackets with an integrated PC and Internet access have also been developed.

No one captures the liaison between architecture and technology better than the civil engineer and architect Werner Sobek. His fully glazed *Haus R 128* from 1999/2000, which he lives in himself, seems to be an almost literal translation of typical 1990s-utopias, such as in Michael Marshall Smith's sci-fi novel *REM*. This emission-free, zero-energy house, whose energy system can be controlled from every place in the world, is equipped with non-contact sensors and a voice-operated regulation system instead of the usual switches, fittings and door handles. In contrast, the cocoon *Paul*, developed by Sobek and his team at the University of Stuttgart, embodies a new generation of adaptive façade systems. A multi-layer construction that is only 14 mm thick possesses non-constant aesthetic and physical qualities and can thus automatically adjust itself to changing environmental conditions.

LEFT: WERNER SOBEK, SINGLE-FAMILY HOUSE R128, 2ND FLOOR: LIVING AREA, STAIRCASE, STUTTGART, 2000

But high-tech products are not always of the highest artistic value. In the Appenzellerland, for example, a doctor built a house which, from the technical point of view, is in no way inferior to Werner Sobek's *R 128*. However, it

was planned without the involvement of architects, and it falls far short in technical finesse on the conceptual level of the construction design. However, if one compares the palette of intelligent items in clothing with regard to this aspect, one finds a certain one-sidedness concerning the style, which seems to be linked to the fact that the developers of such products often focus relatively strongly on the outdoor and sports sector. Could it be that they lack an openness for aesthetically more demanding solutions, or are they simply not seeing the whole range of possible target groups yet? There surely must be a demand for the smart three-piece business suit with an integrated diary and Internet access or the evening dress with a built-in mobile phone.

So there still are a great number of exciting design tasks awaiting architects and fashion designers alike. Intrinsic to these tasks is the challenge of raising the general public's awareness of aesthetic qualities. The communication of architecture is currently an important topic at least in Germany, while countries like Austria and Switzerland are fortunate to already have a quite good architecture scene and a relatively high culture of architecture. Whether the corresponding communication facilities – comparable to the houses, clubs and forums in architecture – would also be necessary and useful for the fashion industry remains to be seen. But perhaps a heightened exchange between architecture and fashion could help the representatives of both industries to create a greater awareness of aesthetic qualities in the future – in the form of an transdisciplinary communication of design.

karin harather / house-dresses – comments on dressing architectural bodies

The subject of *clothing* is without a doubt a multi-layered and multi-faceted field, which has been my personal preoccupation for already more than two decades. During this long time, I have explored *the phenomena of clothing* in various ways. Already as a student at the Vienna Academy of Arts, a twofold dimension in my personal approach to this pertinent subject was established: I developed a style where the fluctuation between artistic, praxis-oriented work and theoretic-scientific involvement is inherent, a way of working that for the most part continues to this day.

Fashion and Art Projects

At the end of the 1980s and the beginning of the 1990s several fashion collections[1] were created. They were conceptual contributions to the topic of clothing in a more narrow and literal sense of the term – namely, clothes for the human body. Experimental tendencies and the focus on content were always in the foreground.

TOP LEFT: KARIN HARATHER, DAS THEMA: DIE FRAU, 1987

The collection *Das Thema: Die Frau* (The Subject: The Woman) (1987) was designed as a bold attempt to dramatise the subject/object role of the woman by exaggerating the indicative oversubscription of *typically feminine* body forms.

MIDDLE LEFT: HARATHER/LECHNER, STADTSTRAND, 1990

In contrast, the collection *GE-WAND* (1988) addressed cultural-historic issues and the versatile, flexible use of the textile material: a simple piece of fabric, a panel of fabric that can be both wall as well as garment. With the collection *Stadtstrand* (City Beach) (1990) we developed a conceptual contribution to the theme *Veiling and Unveiling*, the interplay between *dressed or naked*.

We created minimalist veils for the (female) body – a long zipper forms a *backbone* to which, varying between each model, an elastic *veil* was fastened. Parallell to these collections, various art project were created, which directly involved object and/or architecture-related clothing practices.

BOTTOM LEFT: HARATHER/LECHNER, DER ROTE TEPPICH, 1989

Our project entitled *Der Rote Teppich* (The Red Carpet) (1989), for instance, addressed an extremely symbolic traditional architectural clothing element: a temporary installation on the staircase leading to the main entrance of the Vienna Academy of Fine Arts on Schillerplatz, which actually was not a carpet but a ramp spanned with textile. Given the high elasticity of the material, one could really walk on the *carpet ramp*, but you had to be very

1 Fashion and art projects were created mostly in cooperation with Norbert Lechner.

careful when taking a step as there was a potential danger of stumbling and falling. In this way, the extremely motivic *red carpet* stood in (ironic) contrast to the *classical version* of the red carpet with which one usually associates the *graceful stride* and the *grand appearance*.

In contrast to that, the concept for the *made-to-measure* interior work we implemented in St. Pölten in 1998 was principally conceived in a different manner. Instead of translating *the formal language of textiles* into architecture, we did quite the opposite – through the textile material, architectural structures were redefined, as well as visually suggested.

In the style of *Thread Games*, where various figurations can be *drawn* through an appropriate weaving of the threads within a pre-determined grid, we further *drew* the very dominant architectural structure of the exhibition space. There was indeed a single 240-metre long *Der Rote Faden* (The Red Thread) (1998), which ran through the whole piece, passing through various wall openings such as windows or doors. Conforming to the six existing wall panels, the thread created transversal relief patterns resembling column shafts so that the characteristic ceiling vaults and ledges were enriched by *textile pilasters*.

RIGHT: HARATHER/LECHNER, DER ROTE FADEN, 1998

With extremely reduced means – literally with just a roll of string and some pins – an apparently self-evident total spatial concept could be implemented, which, in addition to its wall-dressing *simplicity*, generated a strong optical effect – primarily the subtle and well-calculated *tilting effect*.

House-Clothes
My theoretic-scientific approach to the dressing theme can be found in, among others, the book: *House-Clothes. On the Phenomenon of Dressing in Architecture*[2], which comments on this thematic spectrum from a cultural and architectural-historical perspective. In addition to that, various analogies and correlations are pointed out, primarily with *the second and the third human skin*. By means of selected architectural examples, various dressing categories are presented and explained in a definite subjective, interpretative manner.

Gottfried Semper and the Dressing Theory
The role of textile in architecture seems to be of scientific interest not least because of the writings on art and architectural theory by the German architect Gottfried Semper (1803-1879). In his main work in two volumes *Style in the Technical and Tectonic Arts; Or, Practical Aesthetics*[3], Semper explained in depth one of his central propositions – *the principle of dressing in architecture*. Semper's theory basically aims to explain the origins of various architectural (dressing) forms as well as clarify the influence and the effect of the dressing principle on the changing styles in

2 Karin Harather, *HAUS-KLEIDER. Zum Phänomen der Bekleidung in der Architektur* (Vienna/Cologne/Weimar: 1995) out-of-print

3 Gottfried Semper, *Der Stil in den technischen und tektonischen Künsten oder praktische Ästhetik*, 2 vol (Frankfurt/Munich: 1860, 1863)

architecture and other arts. In accordance with that theory, he designed a concrete system in which the *textile art* – in the sense of the original art from which all the other arts borrowed their typologies and symbols – plays a central role and functions as a starting point for all other considerations.

The Stoffwechsel Theory

As far as architecture is concerned, Semper stresses the fact that also a basic architectural element, namely the vertical room closure, originates from the (perishable) textile archetype – the wickerwork, the mat, the carpet – rather than from a stone wall. According to Semper's theory, the proliferation of these original forms *borrowed from nature*, happens on the path of a *metabolism*. This *Stoffwechsel Theory* suggests that specific forms of a material can be transferred to another material and subsequently to another field, or likewise be adapted for other purposes. The appearance of the form, according to Semper, does not necessarily depend on a certain *material*, but far more on the *basic typology*. By changing the material, the form is subject to modification – something like a metamorphosis takes place and the original, material purpose loses its influence. The actual determination of purpose as an important style-forming element is preserved for the most part only in its *symbolic* meaning.

The Formal Language of Textiles

This *metabolism* in Semper's terms can be comprehended in many concrete (architectural) examples even today – the most impressive implementations of *architectural dressing* can be found in the Islamic architecture [4], where the decoration, in all its stylistic and material-related diversity, is largely based on the *textile language*. A façade dressing, which resembles many single carpets joined together at the seams, is suggested by the colourful ornamented tiled cladding of the *Lutfullah Mosque* in Isfahan.

LEFT: LUTFULLAH-MOSQUE, ISFAHAN, IRAN, 1602-16

Various examples of transferring the textile motifs of carpets and curtains into durable material can be found also in our part of the world. For instance, *petrified* rudiments of ephemeral, festive façade decorations remind one of the customary hanging of decorative carpets, garlands, wreaths and flower decorations out of the windows on special occasions. The transfer of these (perishable) textile decoration forms into significantly more durable materials, such as stucco or plaster, became an established decoration practice primarily in the *Gründerzeit* era of the later 19th century.

BOTTOM LEFT: GRÜNDERZEIT FACADE, VIENNA, AUSTRIA, AROUND 1900

The streets in those times were supposed to look impressively representative, almost as if in *permanent festive dress*.

4 Werner Finke, 'Die islamische Architektur: Eine Bekleidungsarchitektur' (1986) vol 26 *Bauwelt*

In addition to this *draping* of buildings with antique-esque decoration forms, it was also popular to completely *dress* a façade in a historic style (the Viennese cityscape is characterised by many buildings with their *style costume* from *Historicism*, such as the Parliament in the Neo-Greek style or the Votive Church in the Neo-Gothic style). Decorating the façades by copying exotic role-models, which was particularly popular at that time, is another extravagant curiosity. An example of preserved *Oriental clothing* is the so-called *Zacherl-Haus* of insecticide manufacturer Johann Zacherl in Vienna-Döbling.

TOP RIGHT: KARL AND JULIUS MAYREDER, ZACHERL-HAUS, VIENNA-DÖBLING, AUSTRIA, 1892/93

This *dressing and disguising* effect of façade decorations is clearly reflected by recent history of architecture.
In contrast, the great Viennese architect Otto Wagner (1841-1918) found an interesting design balance between tradition and innovation. He is often referred to as *the father of modernity* or, as suggested by Roland Schachel[5] , as "the executor of Semper's will": in many of Otto Wagner's buildings, Gottfried Semper's (dressing) theories appear to be implemented in their ideal. One of the most decorative examples of this is the so-called *Majolikahaus*, built in 1898/99 on the Wienzeile, whose façade is decorated by a frothy and flowery, elaborately draped throw.

RIGHT: OTTO WAGNER, MAJOLIKAHAUS, VIENNA, AUSTRIA, 1898/99

Dressed or Naked?

The increasing distance from traditional principles of design and dressing in the beginning of the 20th century is represented by the predominant puristic architecture, clearly expressing the contrast between *dressed* and *naked*. "The first actions of these forces were used to free the objects from the traditional dress they had to endure" – as has been suggested by Hugo Häring in his book *vom neuen bauen*[6] .
Steel constructions, such as of the Gallery of the Machines or the Crystal Palace, cast a completely new light on architectural design. Material and construction manifested themselves in these engineering constructions in a pure and genuine manner, they presented themselves in their *naked* beauty, without *decorative* clothing, without applied ornamentation. There is no doubt that this wall-dissolving, yet simultaneously enveloping and space-enclosing, transparency deeply influenced the aesthetic perception of the following generations of architects. With the progressive decoupling of supporting structures and non-load-bearing shells, the issue of dressing also gains a completely new meaning. The *skin of the building* comes to the *foreground* in the truest sense of the word since it increasingly unites both basic functions of (architectural) dressing: *protection* and *decoration*.

5 Roland L Schachel, *Das Groß-stadtmiethaus des Wagnerkreises. Studien zur Entwicklung der 'modernen Architektur' in Wien*, Diss. (Vienna: 1977)

6 Hugo Häring, *vom neuen bauen* (Berlin: 1952)

The construction envelope can therefore act as a *protective* element that encloses the space and *simultaneously* as an architecturally-designed, representatively effective carrier of meaning.

However, rapidly progressing industrialisation, with its new working and production conditions, did not lead to a *new body awareness* only in the field of architecture. Almost in analogy, the purpose of our clothing increasingly came to the fore. With growing hygiene and health awareness based on the postulation *light, air and sun*, a special attention was directed towards the body. The aestheticising design of the (naked) body to reach archaic ideals finds its most immediate translation in many buildings of the (early) modern era.

The *Envelope* has since then advanced to become a central term, an adequate design of this envelope seems to be more topical than ever. If you look at the façades of modern architecture from the point of view of (textile) dressing, you will doubtlessly detect a common trend in the abundance of various *dressing patterns* – the trend towards (formal) reduction. Sometimes, this *new simplicity* results from economic constrictions yet often what appears to be a *simple* solution at first glance turns out to be, in terms of design and technology, a sophisticated understatement.

House-Clothes – an Exemplary Selection

Basically, the most elementary and primary functions of clothes are those of *decoration* and *protection*. The correlation between and emphasis of both basic components is significant to the appearance and the representative character of clothing. In accordance with this basic thought, I have selected for the following interpretation of concrete examples of architectural clothing a scheme of thematic differentiation, which is based on this emphasis of protection and decoration and can be divided into three general categories: *Work Clothes*, *Everyday Clothes* and *Party Clothes*.

Work Clothes

The appearance of work clothes basically arises from purely functional requirements.

LEFT: MUSEUM OF NATURAL HISTORY ENVELOPED, VIENNA, AUSTRIA, 1996

BOTTOM LEFT: BAUMSCHLAGER/EBERLE, RESIDENTIAL COMPLEX MITTERWEG, INNSBRUCK, AUSTRIA, 1997

Example: Construction Nets

In their absolute functional and economical orientation, many of the these *work-overalls* are characterised by impressive formal qualities – they are presented in a succinct, almost *naked* aesthetic, which is especially obvious when largely or even completely lacking representative design, either due to

7 Duden Fremdwörterbuch, 4th edition.

financial reasons or their predictable short lifespan. Thereby, the pretence of *beautiful design* is fundamentally missing and perhaps that is why a very primal, unspoiled formal language predominates. Entire buildings with their individual characteristics disappear behind temporary working coats in white, orange red, light and dark green, glaring blue … (and, with increasing regularity, behind oversized billboards).

In this manner, one can experience how an everyday yet surprising and often very unique dressing of architecture takes place today.

Everyday Clothes

Analogous to human clothing and my perspective, the category of everyday clothes, also in the field of architecture, includes basically those characteristics of the building that offer protection from atmospheric conditions and other influences, yet display a form of aesthetic design, decoration and artistic discourse that transcends the pure functionality.

Example: Residential Complex Mitterweg, Innsbruck

The plain yet remarkable outer envelope of both residential complexes-designed by the Austrian architect duo Carlo Baumschlager and Dietmar Eberle in 1997, can be interpreted as having a fabric-like quality.

Built on the outskirts of Innsbruck and surrounded by the impressive scenery of the Tyrolean mountains, this residential complex features a completely different style than the common *Tyrolean house*. Nevertheless, it can be seen as a prime example of a rustic façade decoration, assuming one takes the word *rustic* in its true sense, namely *rural-clean construction* or *of robust uncomplicated nature*.[7] Both of these explanations are highly accurate descriptions of the light yet optically effective oak wood lattice surrounding the massive cubic structure. Generous loggia openings as well as the specific transparency of the wooden lattice guarantee that the dress of this building is *as translucent as needed and possible in these circumstances*[8]: depending on the perspective there is an infinite range of ways of looking at and through the building.

A simple yet sophisticated variation of rustic dressing which demonstrates how refreshingly contemporary even the *traditional fashion* of façades can be.

RIGHT: HERZOG & DE MEURON, SCHÜTZENMATTSTRASSE APARTMENT AND COMMERCIAL BUILDING, BASEL, SWITZERLAND, 1992/93

Example: Schützenmattstrasse Apartment and Commercial Building, Basel

Similarly, in case of this façade example, both of the basic functions of *protection* and *decoration* are equally and evidently intertwined – an extravagant urban outfit for a residential and commercial building in Basel (realised in 1992/93) *tailored*, by the Swiss architect duo Jacques Herzog and Pierre de Meuron.

8 Liesbeth Waechter-Böhm, 'Baumschlager & Eberle - Wohnbau, optimal optimiert' (May 1998) vol 215 *Architektur Aktuell*

The subject of skin-shell-clothing is for these architects a central one. Each of their buildings addresses and redefines it in surprisingly new ways. On this narrow and high façade on Schützenmattstrasse, a traditional façade element has been interpreted in a completely new manner: the storey-high shutters of the street-front glass façade are made of cast-iron with discreetly decorative, dynamic patterns but are light and seem like curtains – an artistic solution completely stripping them of their common character.

Operable by a single person, the opening and likewise enclosing aspect of this façade provides it with a *constantly changing face and a fabric-like character...* [9], which is especially effective when back-lit by night.

Party Clothes

In this case the outer appearance is significantly influenced by the ornamental aspect of the building, the clearly representative character is emphasised.

I have already mentioned *permanent festive clothing* of many *Gründerzeit* façades – especially along the Viennese Ringstraße, as well as the oppulent religious-cultic traditional façade dressings, such as the impressive examples found in Islamic architecture.

LEFT: MASSIMILIANO FUKSAS, SHOPPING MALL EUROPARK, SALZBURG-KLESSHEIM, AUSTRIA, 1995-1997

Example: Shopping MallEuropark, Salzburg-Klessheim

A temple of our times, in particular a temple for consumers, is the *Europark* shopping mall by Massimiliano Fuksas in Salzburg-Klessheim, realised in 1997.

The ornamental function of the generous glass façade is overwhelming, especially due to the sophisticated double-layeed etched and silk-screened dot matrix. The two visual layers are constantly intertwining to create a constantly changing, very plastic Moiré-esque pattern effect. The self-promoting visual message *Europark*, written in a façade-high font, provides the entire building with an almost *cultic* character.

This cultic character is even more enhanced by a sophisticated lightning system, built in-between the outer and inner building skin, which provides equal illumination of the entire building *from inside* at night. The nightly appearance – a magical and theatrical mixture of self-dissolving body form – of bluish-green hues and strong symbolism is even more attractive and spectacular than its, in comparison, discreet day version. It is the party clothes of architectonic Haute Couture, which unashamedly tries to seduce...

9 Gerhard Mack, *Herzog & de Meuron 1978-1988*, vol 1 (Basel/Boston/Berlin: 1997)

erwin wurm / images

untiteled, trousers, iron, wood, 1989

erwin wurm / images

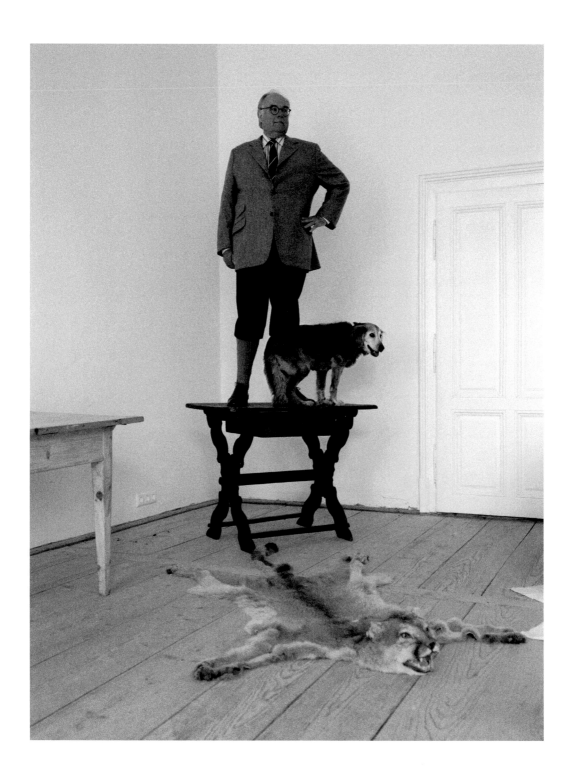

top: landed gentry, hermès, 2008, c-print

opposite page: the psychoanalyst, hermès, 2008, c-print

gudrun kampl / images

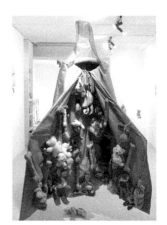

top: rotes herz, 1996/2000

middle left: reliqie von frida, 2002
middle: herkulesmantel, 1996
middle right: kuscheltierschutzmantel, 2001

opposite page left: adernkleid, 1999
opposite page right: stiefelobjekte, 1999

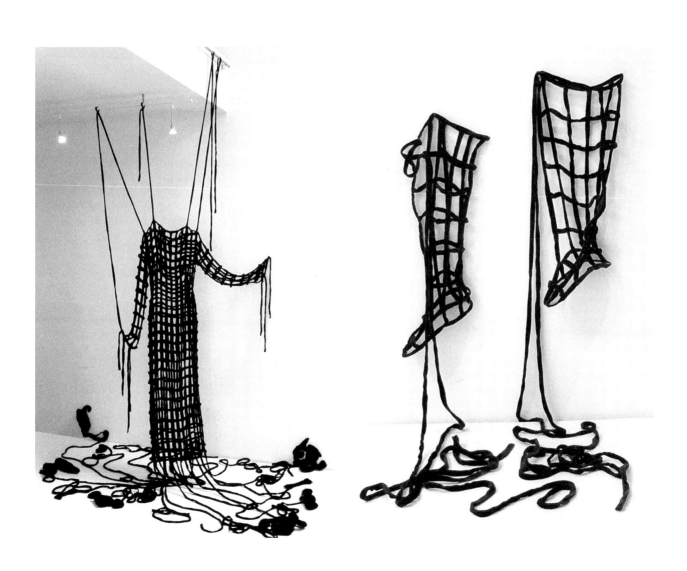

___fabrics interseason / images

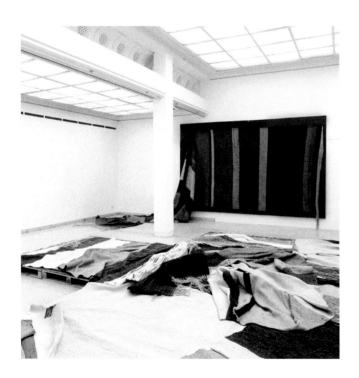 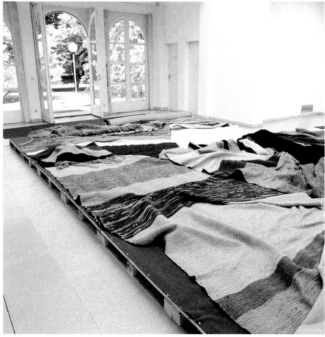

surface:tapisserie no 1, 2006

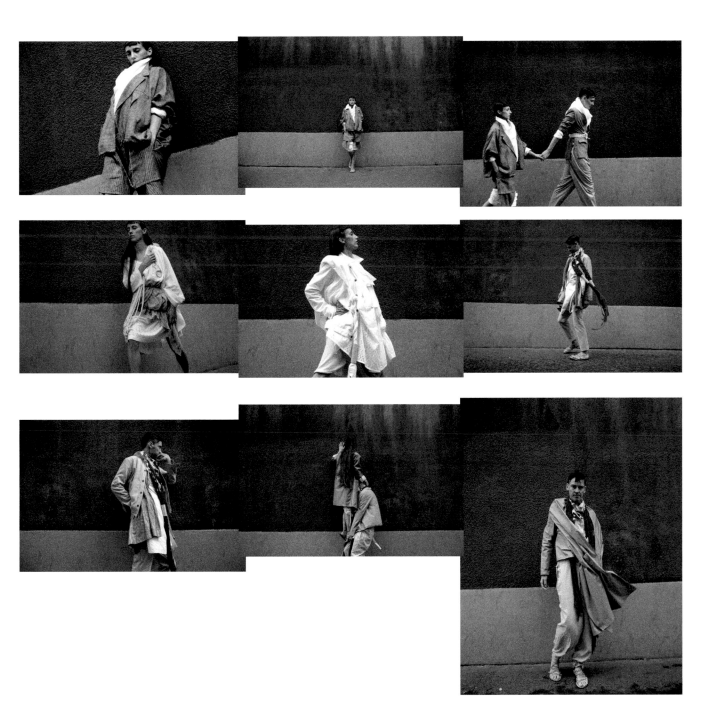

from the collection dominant design, spring/summer 2008

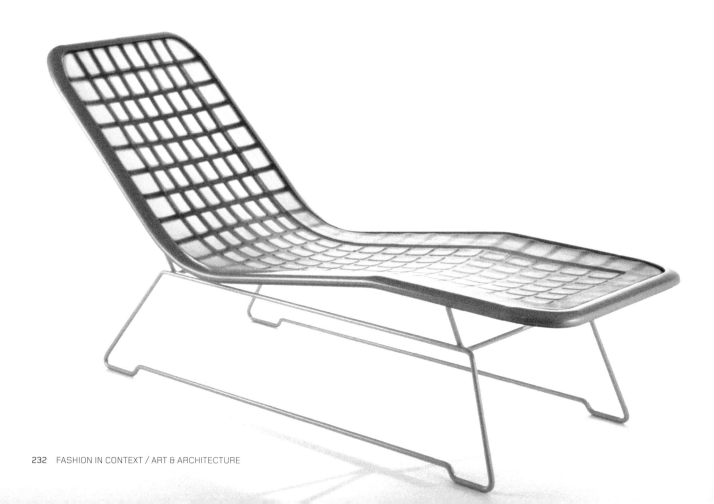

opposite page top: gel chairs, cappellini, 2002
opposite page bottom: soft chaise, zanotta, 2000

top: wire island, unic design, 2006
middle: light wave, bombay saphire – blue collection, 2006
bottom: microdome, 2003/2006

jean-paul pigeat / images

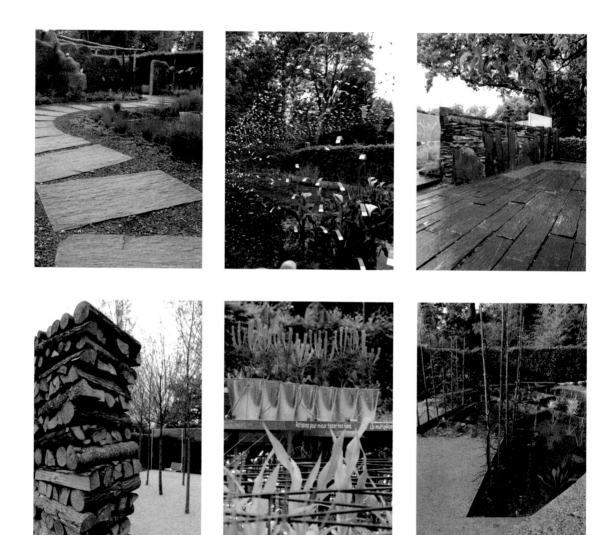

festival international des jardins

domaine régional de chaumont-sur-loire, france, projects 2008

jörg seifert / images

bouroullec, stitch room, 2007

left: herzog & de meuron, central signal box, münchensteinerbrücke, basel, switzerland, 1994–1999
right: herzog & de meuron, ricola – europe sa. production and storage building, mulhouse, france, 1992/93

karin harather / images

left: otto wagner, majolikahaus, 1898/99, vienna, austria

middle: lutfullah-mosque, 1602-16, isfahan, iran

right: massimiliano fuksas, shopping mall europark, 1995-1997, salzburg-klessheim, austria

left: harather/lechner, der rote faden, 1998

middle: museum of natural history enveloped, 1996, vienna, austria

right: herzog & de meuron, schützenmattstraße apartment and commercial building, basel, switzerland, 1992/93

credits / images

page 195: © Claus Haiden

erwin wurm / page 198-199

page 199: *Gebrauchsanweisung Pullover*, One Minute Sculptures, 1990, felt-tip pen on paper, 29,7x21cm, 1990, © Atelier Erwin Wurm

page 199: *Jakob/Jakob Fat*, One Minute Sculptures, 1994/2002, c-print, 115x180cm, 1994/2002, © Atelier Erwin Wurm

gudrun kampl / page 200-201

page 201: *Rosendurchwachsen*, 1992/2002, oil on interior fabric, embroidered, velvet, 130x130cm, 1992/2002© Courtesy Galerie Walker

page 201: *Reliquie von Frida mit Schere*, 2002, oil on interior fabric, 80x110cm, 2002, © Courtesy Galerie Walker

page 201: *Herkulesmantel*, 1996, taffeta, cotton, polyester, 200x160cm, 1996, © Courtesy Galerie Steinek

page 201: *Kuscheltierschutzmantel*, 2001, silk, soft toys, 210x160cm, 2001, © Courtesy Galerie Steinek

page 201: *Rotes Herz*, 1996/2000, padded velvet, photo, 110x80cm, 1996/2000, © Courtesy Galerie Walker

page 201: *Schuhe: vorwärtsgehen*, 1999, velvet, polyester, 1999, © Courtesy Galerie Steinek

___fabrics interseason / page 202-203

page 203: logo ___fabrics interseaseon

page 203: logo *see no evil, hear no evil, speak no evil*

studio aisslinger / page 204-205

page 205: *Microdome*, 2004, © Steffen Jänicke

page 205: *Loftcube*, 2003/2006, © Steffen Jänicke

jean-paul pigeat / page 206-207

page 206: Le château de Chaumont-sur-Loire, © Philippe Perdereau

page 206: Le jardin poubelle de Michel Pena, Domaine Régional de Chaumont-sur-Loire, 2008, © Mayer - Le Scanff

jörg seifert / page 208-217

page 208: Zaha Hadid Architects, *Mobile Art Chanel Contemporary Art Container*, Hong Kong, China, 2007/08, © Zaha Hadid Architects

page 211: Shigeru Ban Architects, *Curtain Wall House*, Tokyo, Japan, 1995, © Hiroyuki Hirai

page 211: Katha Harrer, Collection k/weiss *do it yourself* from km/a, 2000, © ingo folie

page 212: Herzog & de Meuron, Ricola - Europe SA. Production and Storage Building, Mulhouse, France, 1992/93, © Margherita Spiluttini

page 213: Herzog & de Meuron, *Central Signal Box*, Münchensteinerbrücke, Basel, Schwitzerland, 1994 – 1999, © Margherita Spiluttini

page 215: *Bouroullec Stitch Room*, 2007, © Ronan et Erwan Bouroullec

page 216: Werner Sobek, Single-family house *R128*, 2nd floor: living area, staircase, Stuttgart, 2000 , © Roland Halbe/arturimages

karin harather / page 218-224

page 218: Karin Harather, *Das Thema: Die Frau*, 1987, © Sepp Berlinger

page 218: Harather/Lechner, *Stadtstrand*, 1990, © Harather/Lechner

page 218: Harather/Lechner, *Der Rote Teppich*, 1989, © Harather/Lechner

page 219: Harather/Lechner, *Der Rote Faden*, 1998, © Harather/Lechner

page 220: Lutfullah-Mosque, Isfahan, Iran, 1602-16, © Bitter/Weber

page 220: Gründerzeit Facade, Vienna, Austria, around 1900, © Karin Harather

page 221: Karl and Julius Mayreder, *Zacherl-Haus*, Vienna-Döbling, Austria, 1892/93, © Karin Harather

page 221: Otto Wagner, *Majolikahaus*, Vienna, Austria, 1898/99, © Karin Harather

page 222: Museum of Natural History Enveloped, Vienna, Austria, 1996, © Karin Harather

page 222: Baumschlager/Eberle, *Residential Complex Mitterweg*, Innsbruck, Austria, 1997, © Norbert Lechner

page 223: Herzog & de Meuron, *Schützenmattstrasse Apartment and Commercial Building*, Basel, Switzerland, 1992/93, © Margherita Spilluttini

page 224: Massimiliano Fuksas, *Shopping Mall Europark*, Salzburg-Klessheim, Austria, 1995-1997, © Norbert Lechner

erwin wurm / page 225-227

page 225: Untitled, trousers, iron, wood, 110 x 170 x 40 cm, 1989, © Atelier Erwin Wurm

page 226: *Landed Gentry*, Hermès, 2008, c-print, 180x112cm, 2008, © Atelier Erwin Wurm

page 227: *The Psychoanalyst*, Hermès, 2008, c-print, 180x112cm, 2008, © Atelier Erwin Wurm

gudrun kampl / page 228-229

page 228: *Adernkleid*, velvet, size 38, 1999, © Courtesy Galerie Steinek

page 228: *Rotes Herz*, padded velvet, photo, 110x80cm, 1996/2000, © Courtesy Galerie Walker

page 228: *Reliquie von Frida mit Schere*, oil on interior fabric, 80x110cm, 2002, © Courtesy Galerie Walker

page 228: *Herkulesmantel*, taffeta, cotton, polyester, 200x160cm, 1996, © Courtesy Galerie Steinek

page 228: *Kuscheltierschutzmantel*, silk, soft toys, 210x160cm, 2001, © Courtesy Galerie Steinek

page 229: *Stiefelobjekte*, velvet, skin, size 38, 1999, © Courtesy Galerie Steinek

___fabrics interseason / page 230-231

page 230: *Surface:tapisserie no 1*, 2006, © Günther Kresser

page 231: From the collection *Dominant Design*, Spring/Summer 2008, © Maria Ziegelboeck

studio aisslinger / page 232-233

page 232: *Gel Chairs*, Cappellini, 2002, © Steffen Jänicke

page 232: *Soft Chaise*, Zanotta, 2000, © Studio Aisslinger

page 233: *Wire Island*, Unic Design, 2006, © Studio Aisslinger

page 233: *Light Wave, Bombay Saphire* – blue collection, 2006, © Steffen Jänicke

page 233: *Microdome*, 2004, © Steffen Jänicke

jean-paul pigeat / page 234-235

page 234: *Jardin Le Parfait*, Domaine Régional de Chaumont-sur-Loire, 2008

page 234: *Jardin Réflexions*, Domaine Régional de Chaumont-sur-Loire, 2008

page 234: *Jardin Graines de conscience de Florence Mercier*, Domaine Régional de Chaumont-sur-Loire, 2008

page 234: *Jardin Nordic dreams*, Domaine Régional de Chaumont-sur-Loire, 2008

page 234: *Le jardin de la ville de Paris: Méli-mélo*, Domaine Régional de Chaumont-sur-Loire, 2008

page 234: *Le jardin bien partagé*, Domaine Régional de Chaumont-sur-Loire, 2008

page 235: *Jardin Forest table*, Domaine Régional de Chaumont-sur-Loire, 2008

page 235: *Jardin Espèce de...!*, Domaine Régional de Chaumont-sur-Loire, 2008

page 235: *Jardin Cinq pour un*, Domaine Régional de Chaumont-sur-Loire, 2008

page 235: *Jardin Un champ partagé*, Domaine Régional de Chaumont-sur-Loire, 2008, Aménagement de la ville de Beauvais

page 235: *Jardin Eloge du silence*, Domaine Régional de Chaumont-sur-Loire, 2008

page 235: *Jardin Le Parfait*, Domaine Régional de Chaumont-sur-Loire, 2008

page 235: *Jardin Entre 2*, Domaine Régional de Chaumont-sur-Loire, 2008

page 235: *Le jardin qu'on mange*, Domaine Régional de Chaumont-sur-Loire, 2008

page 235: *Jardin Entre 2*, Domaine Régional de Chaumont-sur-Loire, 2008, all images: © Mayer - Le Scanff

jörg seifert / page 236-237

page 236: Bouroullec, *Stitch Room*, 2007, © Ronan et Erwan Bouroullec

page 237: Herzog & de Meuron, *Central Signal Box*, Münchensteinerbrücke, Basel, Schwitzerland, 1994-1999, © Margherita Spiluttini

page 237: Herzog & de Meuron, *Ricola - Europe SA. Production and Storage Building*, Mulhouse, France, 1992/93, © Margherita Spiluttini

karin harather / page 238-239

page 238: Otto Wagner, *Majolikahaus*, 1898/99, Vienna, Austria, © Karin Harather

page 238: *Lutfullah-Mosque*, Isfahan, Iran, 1602-16, © Bitter/Weber

page 238: Massimiliano Fuksas, *Shopping Mall Europark*, 1995-1997, Salzburg-Klessheim, Austria , © Norbert Lechner

page 239: Harather/Lechner, *Der Rote Faden*, 1998, © Harather/Lechner

page 239: Museum of Natural History Enveloped, 1996, Vienna, Austria, © Karin Harather

page 239: Herzog & de Meuron, *Schützenmattstrasse Apartment and Commercial Building*, Basel, Switzerland, 1992/93, © Margherita Spiluttini

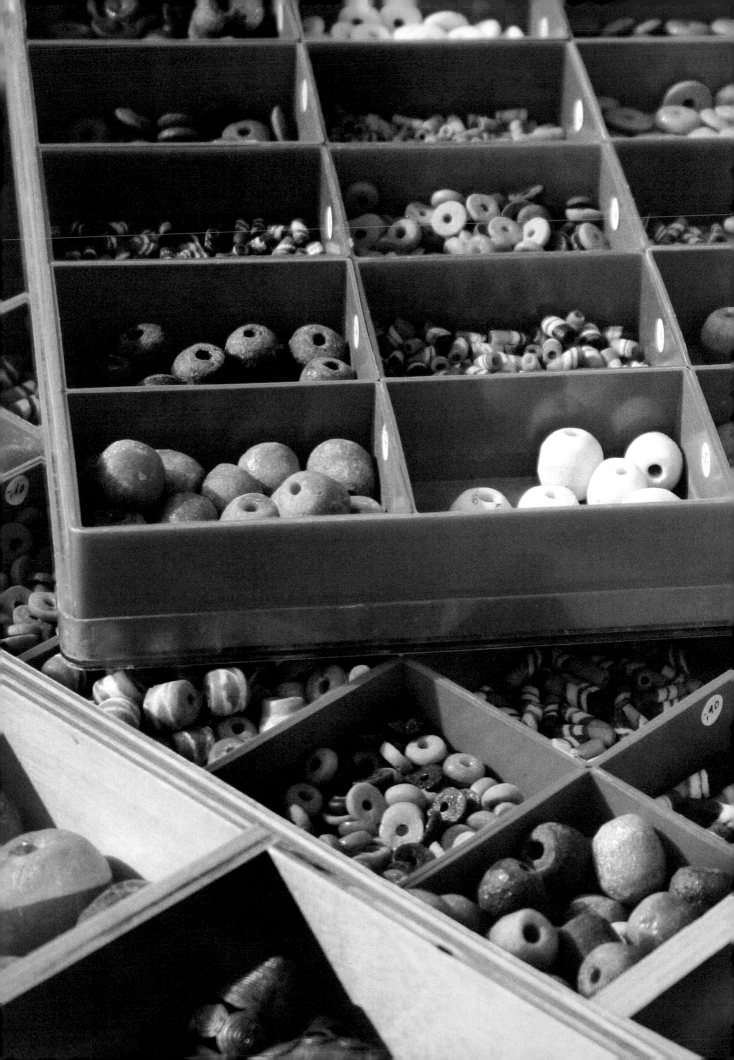

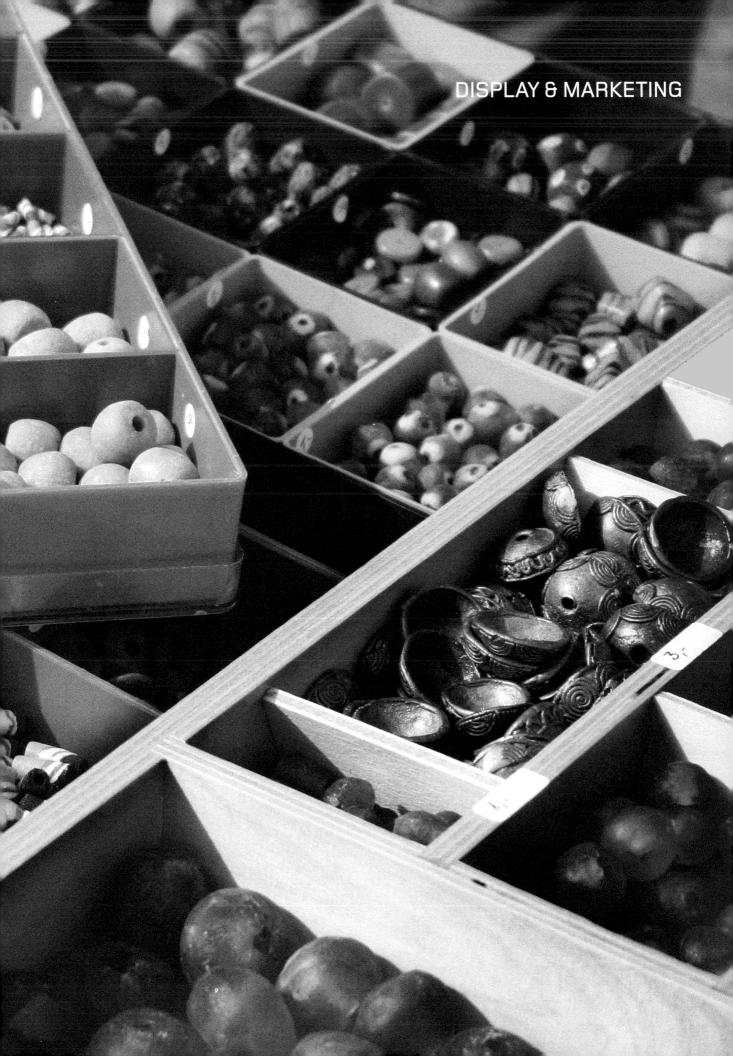

DISPLAY & MARKETING

HOW TO SELL

We are not living in the good old world any more; we are living in a beautiful new world. As its name implies, aesthetics has a greater importance than substance in the neoliberalism we are living in. The most important break in the history of the perception of people is technical – it is the invention of photography. The images are not a part of the imagination any more; they circulate all over the world.

Furthermore, the technical hardware's expectation of beauty is not only certain body assets but rather a photogeneity, a capacity for self-presentation in front of the camera. The twentieth century has not only significantly expanded the mass production of fashion processes, it has also discovered the human body in its material, organic reality as an organ for fashionable imprinting. Highly advanced technical, medical and mental grades of freedom have been metaphysically achieved well beyond the circumstances of natural life. There is a constant distancing from the so-called natural. Today, naturalness must be produced.

What is ultimately presented and demanded is a plastic, beautiful, naked body.

As Nancy Etcoff writes in *Surviving of the Prettiest*: "The Twentieth Century's biggest fashion use is the unveiling the body" – thus unveiling and exposing the body. Internationally, the strategies of styling and shaping are pursuing by all means the goal of an analogue participation in aesthetic judgment communities, those who can read these codes. They determine communicative incidents of acceptance and refusal, of inclusion and exclusion, of collection and dismissal; incidents that in their whole constitute the social field. In a vast game of social communication, they assist individuals in articulating their place, or at least their personal image of it, and thereby allow them to become part of this game.

Dethroning the beautiful in modern art, on the other hand, stands in a reciprocally proportional relation to the increasing affirmation of the beauty in the everyday aesthetic fashions, in design, in advertising and in the cosmetics industry.

In its aspiration to be different and always new, art can only be saved by refusing to call itself beautiful art and by rejecting the beautiful.

Even when advertising and marketing strategies shift to target the broken, the ill, the sloppy or simply the average look, the desired effect of increased attention can only be achieved because such campaigns are perceived as an expected crisscrossing deviation from the standards of the beautiful new world of advertising. In other words, the average is what catches one's eye in advertising.

So how is fashion or the body staged? Advertising experts, two architects who designed the stores for international fashion designers and a photographer who describes his perceptions and perspectives in front and behind the camera while working on various advertising campaigns answer this question. All of them deal with visual merchandising, selling fashion, awakening desires and creating an atmosphere, a scenario.

Rem Koolhaas made a gigantic project about shopping, about the dramatisation of consumption as art in the modern world of shopping, and demonstrated in the book *S,M,L,XL* what architects do to construct a temple for fashion or to put the products – in an almost deifying fashion – on a pedestal.

Gerda Buxbaum

LECTURE

PORTRAITS

IMAGES

mariusz jan demner /
fashion does not matter

Fashion and advertising have a lot in common. Both fashion and advertising are affected by constant changes, things become out of fashion before they even become fashionable. Anything fashionable at the moment has actually been outdated for a long time. It is not in vain that the term *mode* resembles the word *modern*, suggesting that it is easily perishable. That is what we should be aware of.

Fashion and advertising are interchangeable: embracing the ideology of the popular slogan *Geiz ist Geil* (stinginess is cool) can be compared to accepting the trend of wearing your baseball cap backwards. That is the dangerous thing about fashion – everybody acts the same, thinking at the same time they are something special. In the world of advertising there is this cynical saying that a trend is born when many blind people run after a one-eyed person. Fashion only matters as long as it is at the outset of becoming a fashion in the first place.

Both fashion and advertising love recycling. The best example of this is the Austrian designer Rudi Gernreich, who invented the topless look in the 1960s – in prudish America, on top of that. This look has been fashionable ever since the '70s. It is similar with advertising – some motifs emerge in every decade, they smooth their path into the annuals and receive awards. Everything emerges again.

Art historians do not consider the new to be really interesting. Since people have been repeating themselves over and over again, there is a need for something that can reflect this repetition. Repetition of familiar patterns makes us feel secure because they have already been well-tested.

Both fashion and advertising are unpredictable. There are trend researchers, market researchers, market analysts… but what is really going to work, one never knows for sure – neither in fashion nor in advertising.

In fashion and advertising there are no answers, there are only a lot of *mights*. It might work, the people *might* like it, we *might* achieve something. Consciously dealing with those *mights* is an important requirement for people willing to work in these fields. If you want to play it safe, you will end up nowhere.

Fashion and advertising aspire to the same goals. The main goal is to attract attention, to enter people's minds, since all products and people are similar. The services offered by the mobile operators are similar just like the tastes of different mineral waters are similar. All successful fashion school graduates have learned to sketch, to draw, to design patterns, and they basically offer the same services. All of them go onto the market to find someone who is going to select them. In order to achieve that, they

advertising campaign XXXLutz handelsges.m.b.H., agency: demner, merlicek & bergmann

advertising campaign XXXLutz handelsges.m.b.H., agency: demner, merlicek & bergmann

have to stand out and create a distinctive characteristic. If you are unique, if you are recognised at first sight and, moreover, if you can tell a good story every time, you will be successful. This is where the advertising agencies come in.

The product package is like a piece of clothing. In the 1990s – maybe already at the end of the 1980s – a mineral water was the market leader in Austria. Even the Berlin cocktail bars served this water in the green bottle. And because it was so successful, green was THE colour for mineral water. There are plenty of mineral water brands in green bottles. However, there are no more than three or four food experts in the country who can tell the difference between two types of (mineral) water. Generally speaking, different water types do not differ at all. When blind taste-testing mineral water you will in most cases experience the same thing as when testing different beers or even cars. People do not drink beer – they drink beer advertising, they do not drive cars – they drive car advertising, they do not drink water – they drink water advertising.

There are three aspects to a successful product, and this is true for both advertising and fashion. You must be either better, cheaper or different than the rest. If you combine two out of these three aspects, you are definitely going to be successful on the market.

If you want to assert an image, it is necessary to repeat the same pictures and signs over and over again. Image advertising or self-advertising is based on the combination of word-picture-brand or word-outfit-brand. Just try to close your eyes and imagine Karl Lagerfeld and you already receive an image: a black suit, a pony tail, sunglasses, high collar. Public people are as they appear – brands and trademarks.

When you make advertisements for fashion, in how far do you work with fashion or, to put it differently, how easy or difficult is it to rivet attention with fashion today?

The answer is really simple: it is difficult to attract attention with fashion without breaking the rules. It is not a coincidence that fashion is more noticeable whenever people undress and less noticeable when they dress. It is a very simple concept. Fashion is undoubtedly important, it is going to become more and more important with time, as everybody is trying to stand out and express their affinities. Just think of the uniformity of the women wearing a Hermès bag. And whoever finds that too simple – just invents new labels.

(Mariusz Jan Demner held this presentation in a white Roman toga with a laurel wreath on his head – the outfit of the renown Viennese art activist Waluliso.)

studio pichelmann / a profile

(edited by hb) The Viennese architect Gustav Pichelmann is a *master of precision*. Many of his construction and renovation projects excel on the level of detail and have became architectural manifestos – constructions drawing their strength from precision, appropriate materials and intelligent use of available structures. Definitely, one of these examples is the shop design for Helmut Lang in the 1990s, where Pichelmann made the international headlines for the first time. Munich and Vienna were Pichelmann's first bases in 1995 and in 1996 Paris and Nagoya, Japan soon followed.

For the shop design in Vienna, Pichelmann worked against the traditional, broad shop windows fashioable at the time, opting for a more classical, reserved and discreet solution, seen already at the entrance. The façade is divided into 3 segments with a central entrance and is informed by the existing structure of the historic building on Seilerstätte 6. In restructuring this former bank branch, characterised by an L-shaped floorplan of remarkable depth, Gustav Pichelmann accepted the position of the load-bearing columns and used them to partition the space. They provide a rhythm for the longitudinal axis of the room. Along the entrance axis, a long table – the only piece of furniture in the room – leads the visitor back towards the sales space and simultaneously separates the men's area from the women's area. Wood-revetted pillars at the end of the table mark the divide with the back area. While one part of the room is characterised by the massive pillars, a glass skylight enhances the spatial generosity of the other. Opposite the pillars in the larger back room, fitting rooms constructed of white glass are located. Massive doors give the fitting rooms a quiet and private atmosphere. The dark panels and wood floor contrast the white glass, establishing a reserved background in a succession of light and dark sections. The colour concept is reduced to the non-colours of white and black. The inner space is lit by pearl light bulbs in modest ceiling fixtures as well as directly from the skylight, which gives a sense of abundant light. The use of intimate elements in a unfamiliar arrangement generate a new, supreme elegance.

The architectural studio of Gustav Pichelmann, founded in Vienna in 1980, is responsible for a wide-range of private residences, business offices, hotels, galleries and museums in Austria, Germany, Italy, Israel, Greece, Japan and Canada. Gustav Pichelmann prefers a reserved architectural style, which establishes a clear communicative structure between the general organisation, the specific definition of function and the individual solution of the project. In 1990 Pichelmann was awarded the Austrian Housing Prize. His works have been presented to the public in numerous exhibitions and publications.

www.pichelmann.com

helmut lang shop, groundfloor, vienna, austria
helmut lang shop, vienna, austria

studio hanns joosten / a profile

(edited by hb) Landscape architecture, architecture, people and fashion are the motifs that internationally active photographer Hanns Joosten finds exceptionally fascinating. He typically works *from the space outwards*. His works display a multi-disciplinary approach and incorporate several different media.

Particularly noticeable is how much the photographs often look like graphics due to their geometric formal vocabulary and intense colour contrasts. And yet Joosten time and again incorporates *sources of interference* within the frame that undermine the graphic pattern and work to highlight the actual three-dimensionality of the motif.

The photographer deliberately avoids defining fashion too precisely, as this would only end up restricting the development of his ideas. Currently, Joosten is working with Berlin fashion designer Andreas Rohé, among others. In this project he is trying to convey the designer's styles without actually photographing them. The collection is evoked and marketed through emotion.

In the exhibitions Joosten conceives, this multi-layered quality likewise plays an important role. He usually works with several media at once, describing things through different facets with varying frames of reference. For example, photographs featured in a recent exhibition in Freiburg emitted associative noises.

In 2008 Joosten created a new image for *RBB*, Radio Berlin Brandenburg, using short trailers consisting of animated photos. A making-of film is currently being produced as a cinematic portrait of the photographer.

Another important field of endeavour for the photographer is his longstanding collaboration with the *Comic Opera* in Berlin, for which Joosten is in charge of creating a memorable visual identity. By constantly changing the setting in which the protagonists are depicted, a new and yet always recognisable image is created year after year.

Photographs by Hanns Joosten are in the meantime on view in Rotterdam, Berlin and Venice as well as in Shanghai, Peking and Montreal. Many of his exhibitions are developed especially for the respective venue. *Video pictures* continually pop up in-between the photographs. These at first look like stills, but then something happens: they move — very, very slowly.

Born in 1961 in Haarlem, the Netherlands, Joosten studied photography and audio-visual design at the Academy of Fine Arts in Breda. He has been a guest lecturer at the Berlin University of the Arts and at the Amsterdam Academy of Architecture. He is now teaching at the Weissensee School of Art in Berlin, where he conducts workshops and advanced seminars with students from a wide variety of creative fields. Since 1987 the photographer, who has a studio in Berlin, has published regularly in newspapers, magazines, books and catalogues both national and international. His subject areas are diverse, ranging from fashion and lifestyle to architecture and the fine arts.

www.hannsjoosten.de

david chipperfield architects / a profile

(edited by hb) David Chipperfield Architects is driven by a consistent philosophical approach, not a predetermined house style. As a result the studio aims to create specifically detailed buildings that are intimately connected to context and function. The work is based upon a solid foundation of design excellence, budget and programme control, proficient project management and the achievement of best value and architectural quality.

In addition to museums, galleries, urban concepts, offices and residential constructions, the architectural office has implemented numerous ideas for international designers' shops in the previous years. Among others, these include flagship stores for Issey Miyake, Joseph and Dolce & Gabbana.

The first shop design undertaken by the office was for the Japanese fashion designer Issey Miyake, completed in 1986. Miyake's designs are inspired by material and texture often referring to traditional colours, finishes and forms. The approach was to avoid the normal rhetoric of fashion shops, where the shop becomes a fabricated image, a sort of graphic packaging for the clothes. Miyake's clothes should hang as objects in a museum. Materials and elements with a typological clarity – a wooden bench, big doors, a long rail, a stone floor – give the space of the shop its architectural order.

From 1999 to 2004 Chipperfield Architects realised flagship stores for the Italian designer duo Dolce & Gabbana worldwide. Over many years, Domenico Dolce and Stefano Gabbana have become distinguished designers of great style and originality, producing consistently innovative clothing that challenges our ideas of material, form, and colour. The identity redesign for Dolce & Gabbana worldwide and its subsequent manifestation in shops from Osaka to Los Angeles was informed by the often-overlooked concept of positioning the clothes as the principal element within each shop.

Rather than competing with the clothes, the shops were all conceived to maintain a contrast between these extravagant, sometimes fantastic costumes and a sparse, somewhat minimalist architectural setting. Unifying this calm, uniform backdrop, grey basalt stone extends across the entire floor area of each shop, enveloping stairway and perimeter benches that lie in ascending heights throughout the spaces, and providing an atmospheric monochrome surface against which the clothes appear.

In contrast to this dark stone, the wall and ceiling surfaces maintain a more ethereal sense of lightness – pristine white walls and laminated glass screens act as a canvas for special display items and delineate the sales floor from the fitting room areas. Additional material elements include rich burgundy velvet curtains in the fitting rooms and specially designed room-height polycarbonate luminaries that give an even distribution of light across these spaces.

These contrasts between lightness and darkness, contemporary and antique, and textured and smooth surfaces are mirrored in the furniture of each store. Developed parallel to the architectural space and manufactured by B&B Italia, the display systems have been designed like household objects – easily repositionable within each shop – and consist of both wall-mounted and free-standing teak components with illuminated glass cases containing black stained oak accessory drawers. These modern furniture elements are placed alongside signature Dolce & Gabbana pieces (Baroque chairs, paintings, zebra skins, Mediterranean plants and sculptural Sicilian urns), blending the character of the spaces with that of the clothes, and highlighting Dolce & Gabbana design as distinct from all others.

David Chipperfield Architects, founded in 1984, has its main offices in London, Berlin and Milan and a representative office in Shanghai.

The practice works internationally providing full architecture, master planning and interior design services for both the public and private sectors. David Chipperfield Architects is multilingual and multicultural, employing over 180 staff from 15 countries. The practice has won over 40 national and international competitions and many international awards and citations for design excellence.

www.davidchipperfield.com

studio pichelmann / images

helmut lang shop, munich, germany
helmut lang shop, vienna, austria

helmut lang shop, vienna, austria

studio hanns joosten / images

zwischenschichtensichten / nl 1

ichten/NL

SUPERFICIAL SURFACES

studio hanns joosten

zwischenschichtensichten / nl 2

david chipperfield architects / images

dolce & gabbana, worldwide shop concept, 1999–2004

david chipperfield architects / images

dolce & gabbana, worldwide shop concept, 1999–2004

credits / images

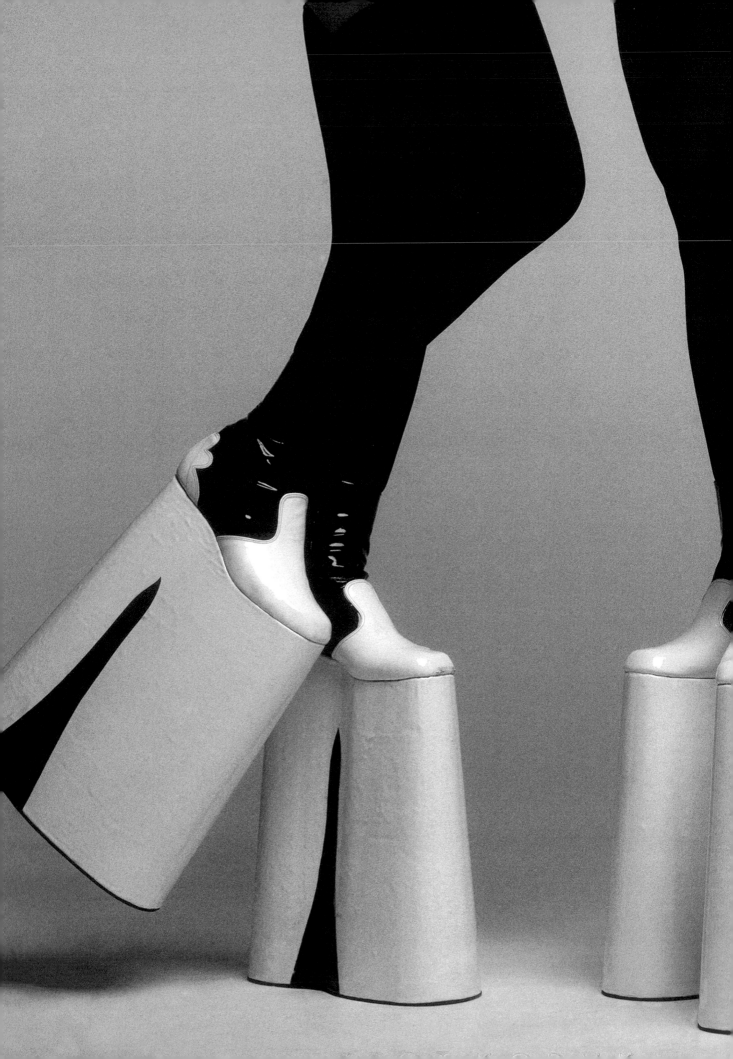

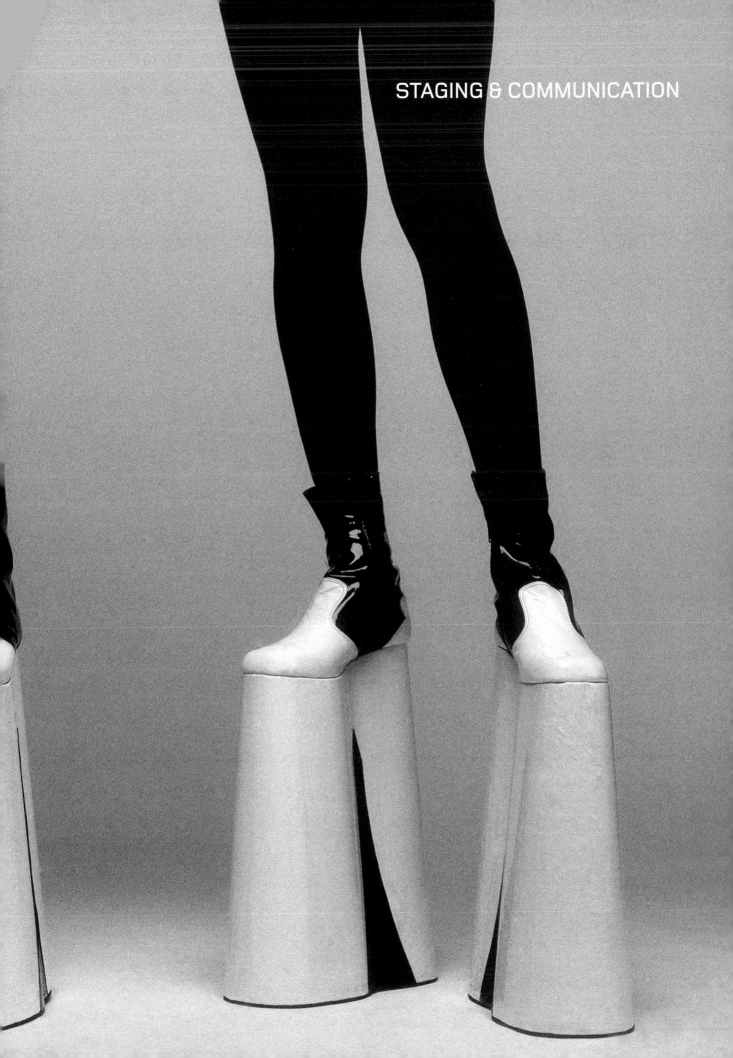

STAGING & COMMUNICATION

FASHION VERSUS COSTUME

Fashion on stage? – *Costuming* in the streets?
Endless questions and vigorous discussions have been provoked by this topic. Today, the occupation of costume designer essentially does not exist any more since the specialised training to become a costume designer has been abolished from the art academies. It is primarily the stage designer, the set designer, a famous architect or painter/artist who also creates the costumes according to their own vision. Furthermore, the budget makes it necessary to simply buy the appropriate clothes in fashion stores.

The departure point for the Hetzendorf Symposium titled Fashion and Costume was the topic: fashion as a medium of non-verbal communication – how, in which environment and what exactly can be communicated with fashion?

Can fashion be used on stage at all; can it be transposed from the catwalk to the stage? Which function does fashion have on stage?

Can fashion designers create costumes, and can costume specialists create fashion? History is full of examples of how this failed. Major fashion designers – for example, Coco Chanel – could not assert themselves in the movie industry or in Hollywood simply because they thought and designed in a different manner than was required by the film medium. Is the education the same?

Are fashion and costume identical; can they be identical at all? What is the function of props in modern theatre, film or advertising?

What has happened to the good old costume? Which significance do clothes assume on the set or in the scenery? Can or should advertising create a separate dress code?

In the dialogue fashion designer versus costume designer, debate participants discussed various aspects and issues from the perspective of their own work in an attempt to sketch out the fundamental differences.

In order to distinguish between these two professions, they started by comparing clearly defined work stages such as idea, research, design, production, presentation, collection and target group or effect. Design/Idea/Styling: for whom? To conform to a trend or to visualise the character traits of a stage figure?

What is the intention of research and production? What impact does clothing have on stage? What effect does the same design have in public? How can we determine success indicators for the sale of a collection or the acceptance of a costume? What is the difference between customers and actors as a target group?

In the discussion of *fashion* as a means of communicating content and messages, representatives of both professions tackled the following questions: What is the role of clothing in the professional context? How can fashion or costume be employed? Which considerations are inherent to the design process? Ultimately, it also addressed the contexts, contradictions and requirements of – and between – the text, screenplay, director or actors with regard to the costume.

Gerda Buxbaum

karin resetarits, alois luigi schober,
melanie pfaffstaller, gerda buxbaum /
the medium of fashion in TV,
film and advertising – a discussion

In the Hetzendorf Talks VIII in March 2007, actress/director Karin Resetarits, advertising expert Alois Luigi Schober and producer Melanie Pfaffstaller discussed the significance of fashion for the media of TV, film and advertising and conversely, to what extent these media influence fashion. The discussion mediator was Gerda Buxbaum, director of the Vienna Fashion Institute (Modeschule Wien).

Melanie Pfaffstaller has made commercials for a wide variety of major clients, such as Raiffeisenbank, Volksbank, Casinos Austria, Austrian Lotteries, Danone or Teekanne, and knows the special features of this medium inside and out.

"An average commercial is 25 seconds long, which is really short. You have to get to the point quickly and speak a clear language. You tell a story with the goal of selling something. The target audience has to see themselves in this story, has to be able to identify with it."

"Often, prominent public figures are used who are not professional actors, for example, champion skier Hermann Maier for Raiffeisen. The right costume is an enormous help for the actor for getting into character; you can already see at the dress rehearsal how his posture changes, along with his facial expression and gestures. We try to portray so-called real life, but what is real life in advertising is usually a strongly exaggerated world."

"In film and TV the demands are completely different. There isn't a desire or necessarily a need to sell anything; what counts here instead is the use of story to play on the viewer's emotions, without him having to identify with the characters. The advertising world by contrast shows what is nice to have, what we should buy or how we should look."

How does one depict normality for a wide audience that comes from various parts of society? Can a commercial or the clothing worn in it, the costume, be readable for everyone?

"A lot more precision work goes into a commercial than you might think. We shoot around fifty films a year. The main work takes place before shooting, in the creative team. Fashion is extremely identity-defining and thus represents an insane amount of work. Everything is carefully thought through, from the colour of the outfit to the accessories and the haircut."

"That said, you don't have to please everyone. Advertising can also be successful when it polarises, because this is also one way of grabbing attention. It's a success, for example, if people talk about ad campaigns in their free time, in the subway."

How is it possible to measure the part that the apparel played in this success? There is a new trend in fashion where Madonna, Beyoncé, Anastacia and other pop stars are doing signature collections for H&M, Oliver and other companies, where they, so to speak, lend their face and popularity to a fashion chain. Is it possible to distinguish in a commercial between the people themselves and their styling?

"I think that this detail is of tremendous importance. Basically we work by defining characters, everything is planned out verbally. We write down a personality description, and this is then fleshed out with the help of a creative team. You can be either right or wrong – it's ultimately a question of what you want to communicate to specific target groups. We often test a script first. In some cases we can even tell from the second-by-second playback where the high points are, where identification takes place. Of course, the implementation still harbours plenty of risks, but also opportunities."

There is a budget for every commercial. Is it possible to say how much of the budget percentage-wise is reserved for clothing or costumes?

"No, it's not possible to generalise. In the case of the Casinos Austria commercial, for example, where all the actors were dressed in *Haute Couture* from Milan, it was as much as 10 percent. Normally, though, the costume budget is much lower, and it also depends on how many actors and extras I have to work with."

Would it also be possible to work with a fashion institute?

"In principle, I think that collaborations of this kind can be very exciting. However, we have a major interference factor in advertising, and that's time. Everything has to go very quickly and efficiently. The more people involved, or the more bureaucratically something is organised, the more difficult it becomes."

Ms. Resetarits, in your position you work both in front of and behind the camera and experience costume from both sides – how do you find this dual function?

"I experience the two positions separately, since I never take them both on simultaneously. As an actress I have my problems with having to achieve perfection through a costume. I find it more exciting not to be perfect, because it offers more possibilities and doesn't intimidate me… otherwise, I find myself thinking more about my dress than my role."

As an actress, how much influence do you have over a costume?

"That always depends on who I'm working with and where. In America, for instance, the actor has much more influence because he's the one who pulls in the audience. You need a star to

be able to make a film in the first place – otherwise, you wouldn't find a producer. And if the star says, I won't wear that, then that's the way it is. I also would not wear certain things I don't feel comfortable in, even if it's artistically necessary."

How is it possible to depict everyday life, or *normality*, on film using a costume?

"It is a major challenge for the costume designer to make sure a costume doesn't look like it came right off the rack, but instead as if it's been worn for awhile. We call this patina. On the other hand, it shouldn't look as though it has been artificially treated or dragged through the dirt. For example, a well-worn pair of jeans. If the actor has an office job and comes home in the evening, the jeans have to look like he sat in them all day. And then there are the technical restrictions or necessary contrasts with the actor's complexion. With black, for example, you have the problem that it can look like a black hole because it swallows the light. If you want to use black clothing, it's usually better to choose a very dark blue or brown instead."

What other colours should be avoided?

"White is in any case problematic. Black and white are in actuality not true colours. Everything else is possible."

Are trend colours that are currently in vogue used deliberately in films or advertising?

"With commercials you have to take care, because corporate brands are often associated with specific colours – for example, the colour blue from the Erste Bank. If I were to dress the actors in a commercial for another bank in blue just because it's in style, I would have a problem. In advertising, you use colours more systematically, for example, when they are supposed to create a feeling of identification

with the brand or a connotation in terms of the ad's content. If I want to convey freshness, for example, I will choose a cool colour and not a warm tone. This then takes priority over using a colour that's the latest fashion."

How do commercials that run internationally function? How do you deal with people's different reception and mentality?

"Let's take Erste Bank again as example, for which we produce commercials. These ads run in ten countries, from Austria to the Ukraine, addressing a market of a hundred million people. The most important thing is that the brand remains identical in all countries. We analyse the markets and take a close look at people's values, attitudes and future visions. To do so, we use a target group cluster. There is a globally valid system of psychological clustering based on Maslow's needs hierarchy. Seven different segments are identified, from the reformers to the adventurers to the mainstream."

How long does it take to produce a commercial?

"About one month. A month's time from the award of the contract to the finished film. For the individuals involved, the time is even shorter. A stylist normally has just one week or so from the moment he's confronted with the project to the moment he has to provide finished images."

How do you see the relationship between market-orientation and creativity?

"The more provocative the creative film is, the better. Advertising is an interface between art and commerce, and one of my fundamental principles is that we apply the methods of modern art to advertising. The really good creative talents in advertising borrow from the art world – that is where the engine comes from."

"It is getting harder and harder to break with

clichés, because clichés spread so quickly. In a film you create a new picture, a new image, and with incredible speed it then appears in advertising; it has become another cliché and a marketing tool."

"Today, uniformity is the new terror."

But where are the trendsetters in advertising and the visionaries in film?

"Advertising is an extremely tough return-on-investment business. When a company spends ten to twenty million euros a year – and that's a lot of money – then you have to show results at the end of the year. It's a really hard job. There is not much room here for avant-gardism, because if it doesn't work, you're out of a job."

"In advertising we call this 'a beautiful death', when you try to push forward and step out in a new direction. I may be out front in terms of fashion, but the minute I irritate the public and they turn away from the campaign, I die a *beautiful death*."

"Take Cannes for example. These days even professionals have trouble understanding the Cannes Reel. But that's not the point of communication, that you need to read a dissertation in order to understand a commercial. On the other hand, the South Americans are still the top stars amongst the creative talents vying in Cannes. Why? Because they have such a high rate of illiteracy at home that they are forced to communicate non-verbally, using visual cues instead."

"The reality of advertising has nothing to do with Cannes, but we're still happy there is such a thing as Cannes. This is where the topic of art comes in again, because if highlights are presented there and people feel motivated, which needs to be the case when the top nine thousand creative minds in the world meet up, then

at least this provides an impetus. The advertisers don't get anything out of it, even if their ad wins a Golden Lion. A study was once done showing that everyone who won a Golden Lion in Cannes had lost his client six months later. So much for reality."

"I maintain the following: I divide the world into two classes – some have a feeling for their second skin, their clothing, and the others don't. The stronger characters are those who do have this sense, because they are more defined and secure in their identity. The consequence is that when I advise a brand or a company today, I focus first of all on the corporate culture. This is where clothing is an elementary component and a factor for success, which is taken advantage of much too rarely. There is enormous potential here. The significance of dress is still much underestimated in our society."

The second group, who don't pay much attention to how they dress – is this only a coincidence or do they simply take up the codes in advertising without reflecting on them?

"When you walk through the streets, you notice a huge amount of uniformity. That isn't necessarily a bad thing. It's mainstream, with everyone orienting himself on what his neighbours are doing."

There is an argument, albeit from the 1980s, that the phenomena of fashion and advertising play similar roles in transferring art into the everyday. We know by now that art absorbs a great deal from fashion. Some even say that fashion has taken over the function of art. To what extent does advertising still take its cues from the world of art?

"In my opinion, it does so far too rarely due to the immense economic pressure. I think that this is the answer if advertising is to become better again."

"Despite all the meticulous planning that goes into it, we shouldn't forget that advertising is made by people. These are creative minds who constantly draw inspiration somehow, who continue to educate themselves, to develop, who possibly had training in the art field. These are people who constantly deal with visual and audiovisual input. A creative director who sits all alone in his office, isolated from the world, would sooner or later run out of ideas. A constant interaction takes place."

"I came across an international study yesterday, which demonstrates that good-looking people who are well-dressed earn on average 15% more for doing the same job. There are occupations where clothing, along with other professional skills, is an absolute criterion for success. Politicians for example."

"I hope that at some point the time comes again – and I hope it's soon – when people don't let themselves be taken in by the first impression they have of a well-dressed politician."

"In fashion, one also creates needs, because, in truth, no-one really needs more stuff."

The Dove ad focusing on the overweight or normal-looking woman – is this just conceit, or what are we to think of this tactic?

"It's simply clever. I don't think the Dove company has the ambition to change the image of women. It just sells insanely well. If all products, all brands would make use of this type of image, then that would completely defeat the purpose. Dove was the first to adopt this strategy, and they create an enormous identification factor through it, but this makes them outsiders, and that's where they'll stay."

eva maria schön / theatre costume – from idea to presentation

Theatre costume or costume design, which can consist of one or more costumes, is made for a play, staging or performance in accordance with the very special ideas of the costume designer and produced by costume workshops and makeup artists. Thus, the finished costume unites the designer's ingenuity and the workshop's professionalism. It is created in order to express a personality of a character, of a role, of an actor. It is a symbiosis of creative and technical skill, an ideal visual carrier for the type and content of a character in a play.

The design work starts off with concept discussions between the members of the creative team, which consists of a director, stage designer, dramaturgist as well as a costume designer. First they read the play, analyse the plot and the characters, write a scenario determining the plot, study the biography of the author and composer as well research any practices in previous performances. Interpretations, past discussions of the piece, the time in which the author lived – all of this is examined very carefully. The play is then revised, shortened, edited, expanded. The intention of production, what needs to be narrated and how the play should be perceived are formulated. The actors and the roles are discussed and defined.

In this phase, it is basically the director who determines what happens. The contribution of the costume designer is the world of images in form of figure sketches, examples from the history of costume, fashion, films, visual art and photographs. He enriches the discussion with his own experiences and observations from everyday life as well as with thorough research when dealing with precision in the details. Thus, a costume designer starts drafting a design already in the discussion phase and finishes when the director accepts the figure drafts. At the beginning, a fiction develops on paper and this process can take various forms: in written descriptions and notes not unlike a shopping list if one, for instance, decides to look for costumes on a flea market or in a fund; or in props or collages, figure sketches, drawings, aquarelles, photos, copies of books or newspapers.

The material collection compiled for the costume design is based on various approaches: abstraction ability, simplification, exaggeration, caricature, sorting according to colours, materials or fits, sorting according to historical criteria, playing and experimenting with colours, forms or materials, swapping and reversing, researching the actual historical image, the vision, the fiction, the fable, the combination, the association and the compilation. In doing so, the costume designer has to be able to access a wide range of skills and competences: his knowledge about facts from the history of art and costume, a refined sense of form and colour, his experience with dealing with materials, the ability to imagine characters in the middle of the dramatic action. He must possess the sense and the eye for the essential as far as the interpretation of the play is concerned.

In the phase of practical costume design, the costume designer works alone. When playing and experimenting with forms, colours and fabrics, the line between creating a useful working model and an autonomous work of art might be blurred. The costume designer designs and creates an image, an arrangement of sculptures. At the end of the design phase, characters and actors become a work of fiction — an art work has been created out of costumes, which is realised and evident only in the costume production and in the play of the actors on the stage.

Artistic work and drafting is followed by practical implementation. There are three elements which primarily influence the translation of a design into a finished costume: the budget, the time frame and the professionalism of the people working in the workshops.

In order to gain an overview of what can be done at which point of time and to define the main aspects, an estimation needs to be done. Then materials, colours and patterns are selected, form and cut of the costume, masks and haircuts are discussed. Subsequently, fabrics, materials, equipment, accessories, costume parts are selected, ordered and acquired. This is the period of researching, inviting offers, ordering the goods. Persistence, responsibility, specialised knowledge but also luck and coincidence are of major importance here. Flexibility is essential in order to find alternatives in the case the desired product is too expensive or unavailable.

After ordering the materials, the costumes are prepared for the first fitting. During the fitting in the costume workshop, individual conversations with the actors take place, which should be led with a lot of sensitivity and understanding for the characters and the actors impersonating them. The skill of persuasion and a psychological sixth sense is often necessary to provide the actor with a good feeling for their costume. While the costumes are being finished in the workshop, stage fittings take place as well. The actors are provided with rehearsal costumes which substitute the original costumes as much as they can. The results obtained from these stage fittings provide the costume designer with important information necessary to finish the costume, such as information about wearing and acting in a costume or various requirements regarding changing and transforming it. Conversely, the finished costume influences the work of directors and actors. The rehearsal, the director's ideas and the desires, ideas and abilities of actors constantly imply modifications and adjustments. In this phase it is crucial to communicate with each other, the ideas have to be defended, implemented, rejected or corrected. Trusting the ideas during the production process could also mean that the whole design process starts anew and completely new costumes develop. Often, the design and fitting of the costumes do not take place until the first weeks of rehearsal. In that case, the phases of preparation, design and finishing overlap during the rehearsal and everything turns into a work-in-progress.

Now it is the time to finish all the preparatory work. The dramaturgy, the stage design, the lighting, the costumes and the make-up can be seen on stage for the first time. It is only now, when all the individual parts interact, that it can be determined what should remaine untouched, what should be modified or what should be completely taken out. The costume can for the first time be judged from the perspective of the audience. The costume is not a mere draft anymore, not a rehearsal costume, not a costume in front of a tailor's mirror, but a component of a production, of an image, of the total work of art, which is being polished in detail in this final phase.

Fits, colours and finishings are checked and corrected. Actions such as putting the costume on and taking it off are rehearsed. Shortly before the premiere, there is usually little scope left for changes. Perfection and improvisation often clash at this point. The costume design is slowly beginning to cut the umbilical cord connecting it with its maker as it starts leading its own life on stage. Dressers and make-up artists take over the responsibility for the correctly worn costume and the perfect make-up. The actor wears it as if wearing his own clothes, it has become an important and natural part of his stage character.

The theatrical costume does not exist on its own – the performance is the linchpin of every theatrical costume. If you really want to judge the quality of a theatre costume, you have to see the play and experience the costume in that environment.

An example of symbol, metaphor and abstraction is *Waiting for Godot*, a stage production of the *City Theatre* in Klagenfurt dating from 2005, with scenery by Frank Asmus and costumes by Alexander Arotin.
The actors are almost entirely constituents of a video installation, they are characters in a play unable to make their own decisions. Their elbowroom is minimal, they are tied to a steep slant resembling an open notebook.
By creating this kind of stage set, the stage designer placed a tight corset on the director: comfort and functionality of the costumes support the artistic performance of the actors.
The costumes are neutral, simple and schematic, impossible to classify in terms of time or social status. They transform the actors into Lego or Playmobil figurines. At the beginning of the play, every character is assigned a colour which disappears in the second part of the play, resulting in a complete fusion of the characters with the virtual image. The actors are swallowed by the stage, by the image.

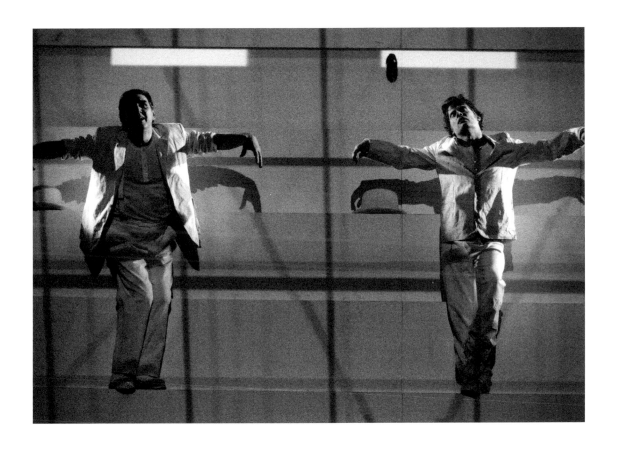

waiting for godot, samuel beckett, 2005, staging: frank asmus, scene/costume: alexander arotin

monica jacobs /
finding and inventing a film costume
using the example of *run lola run*

In 1996 Tom Tykwer first told me about his project *Run Lola Run*, and in 1997 the film was produced. *Run Lola Run* was supposed to be a low-budget movie, technically less sophisticated but interesting because of the story and its pace. At the end of February 1997 I received the first version of Lola, unedited and still uninviting, but you could already recognise different movie structures. Tykwer used various formats in this movie: he wanted to combine black-and-white with colour, slow motion and fast motion, stop motion animation, video and digital imaging, photo processing, double exposure, steady cam, hand-held camera and standard camera. At that time I was not familiar with the effects those different genres and methods were supposed to achieve. Tykwer wanted the movie to be *real and extreme*; everything else was debatable.

Run, Lola, Run is a movie about opportunities in the world. It is not a film about a complete determinism or complete randomness, but rather a film about the small gap in between, about a no man's land of desire and longing, about the tiny chance you have in life to influence something and redirect the course of events.

The movie blurb says the following:
Actually, it's all Lola's fault. If only she had picked up Manni like she was supposed to – but she didn't. So he has to take the subway, and when the ticket inspectors get on the train Manni has to get off quickly and forgets a plastic bag in his rush – much to the delight of a grinning bum. The bag contains 100,000 German marks belonging to Manni's mobster boss, Ronni, who doesn't like to be messed around with. Manni makes a phone call to Lola to tell her that he desperately needs the money in twenty minutes or he'll end up dead soon – otherwise he will rob a supermarket with a machine gun. Lola urges him to wait and starts running. *Run Lola Run* is a quick, vital game of coincidence and destiny. Lola gets three chances to save her boyfriend's life: one turns out good, one turns out bad and the third time, everything turns out different than expected. New twists and turns await around every corner, and in the end Lola and Manni have 100,000 marks too much.

This is the movie plot in brief. Now comes the question of which came first – Lola in the animation or Lola in the costume? In the beginning, Lola's character was not clearly defined. She was supposed to look somewhat wild – a punk with dishevelled hair, black fingernails, Rasta look, piercings, tattoos, etc. Short or long skirt, trousers or a jacket – nothing was defined. There was no talk of fashion. Tom only knew that a red-haired woman should run through the city.

At the beginning of April, it came to the point where Franka Potente came for the first short meeting. Normally, I lead the first meeting with the actors, during which we discuss the screenplay and the costumes, suggest

various ideas and more or less get to know each other. Since at that point nobody involved in the project had much time, I suggested to Tom Tykwer that we could work without designs and rather could simply develop the character with, and on, the actress. Tom's rambling ideas first had to be focused before we could start working on detailed plans and designs. This meant that, when I went to our meetings, I brought along a large bag full of various garments, photo material and newspaper clippings. The makeup artist had wigs and makeup, everything on hand. The cameraman also came to this meeting. We three girls for ever dressed up, put wigs and make up on, took photos, presented it, endlessly trying out new ideas. In the meantime, we studied newspaper clippings and various photos from books and magazines, and examined and discussed their usability. We had to come to an agreement, because the animation team wanted to start working. An animation consists of twenty-four images per second. Our film was supposed to consist of at least fifteen minutes of animation, and all of this had to be drawn.

That evening, we decided that Lola should wear a flowered skirt, a belt, a belly top, a green jacket and black boots – much to Franka Potente's chagrin, who had already started to work out. She had to readjust her running technique as there is a difference between running in common leather shoes and running in sneakers.

The first images of the animation were painted with Lola in this costume. In this version, Lola is still running wearing a jacket and skirt, and still wearing a belt. I found the Polaroids very difficult and pretty unsatisfactory.
I did not really like the character. So the first fitting could only be a trial.
I asked myself what Lola's costume should be like. First of all, it had to be functional: Franka Potente had to be able to easily run in it, she had to be able to move freely; she was supposed to look attractive and sexy, strong and convincing, and to rivet the viewer's attention for ninety minutes. That was difficult, because Franka only wore one costume during the whole movie – none of the actors changed clothes, by the way. It is difficult to create a costume that lasts for ninety minutes.

In our first attempt we were too extreme. During the second meeting with Tom Tykwer, we agreed to take the trousers instead of the skirt, as Franka could move more easily in them. This despite her somewhat protruding bottom, the reason for choosing a skirt in the first place. He said then: "This looks totally different now. But good, simply with red hair." And that was the sentence which, in my case, set a series of crucial thoughts in motion. It would be nice if Lola runs through the city like an inflamed match, in solid-coloured clothing with the red hair as a signal. We tried out her silhouette on photos – standard trousers, a cropped men's sleeveless undershirt, a belt, a chain and black shoes. We then washed and dyed the undershirt and

cropped it a little more. The bra and underwear were supposed to be visible. 70s hipster trousers with large trouser cuffs, a men's belt, a lot of rings, earrings, tattoos, no piercings and black ankle-high Doc Martens for safety reasons. What we aspired to was a special corporeality without being blatant and offensive, powerful like a bomb, direct and clear.

Today it is nothing spectacular anymore; ten years ago it was already. Underwear edges showing, belly top and a bra – none of this was common; it was provocative. You can see now what a difference ten years make – it's the progress of time.

The viewer should not notice that designing a costume involves a long working process. The solution has to be self-evident. "What did you actually do with Lola?" I was often asked. "She's only wearing a pair of trousers." We spent approximately six weeks developing that character. The practical work, for instance, also involved deciding on how many copies of the costume we needed. In total, we needed seven copies of Lola's costume for doubles, stunts, car rides, sweating, etc. I found twelve pairs of trousers in various sizes in a second-hand shop but none of them were right. We then opted for a specific pair of trousers because there was this fifties look about them – the fabric was rather comfortable and unusual. I was in Berlin but could not find this kind of fabric in a hurry anywhere. You always have to keep in mind how much time you have at hand to create a costume. The actress was not there either. The undershirts were appropriately fitted and dyed. Several bras and pants were bought and decorated with lace; the shoes were tried on once more and special insoles were inserted.

Manni – that's Lola's partner – was supposed to be tattooed and be different from Franka. At that time Moritz Bleibtreu was already a pretty famous actor due to his role in *Knocking on Heaven's Door*. Nevertheless, Manni's costume had to be based on Lola's. It also had to be simple clothing, but trendy. Since he already had an image, we had to be a bit careful – we wanted to use it, but also break with it. We decided to dye his hair blonde, but to leave the dark roots. At that time this was also unusual; it only came into fashion later. That was actually enough of a change. On the one hand, his costume had to differ from Lola's, but on the other hand it had to complement it. Manni had to be modern and the colours had to match Lola's costume. Manni wears a simple pair of jeans from the beginning of the seventies, a belt with a wallet chain, Converse sneakers (painted but very scruffy), an old long-sleeved men's undershirt with buttons, a visible tattoo but no earrings, and a short blue vest with a zip and many pockets in which you could presumably stuff a lot of objects. In addition to that, he wears a jacket during the car and diamond delivery. Later on, the bum gets hold of this jacket.

There are further roles: Lola's father is a typical bank clerk; Lola's mother wears a negligee. The role model for the father was the classical man in a Brioni suit – a nice three-piece suit with a decent tie and a good-quality shirt. The mother wears a negligee by La Perla. Ronni, who actually owns the money, wears an expensive leather jacket with padded shoulders; he is bald and wears sunglasses. He is supposed to look mean and threatening.

Additional characters include, for example: Mr. Schuster, a stereotypical American security guy, once wearing a leather jacket and once a shirt; the father's girlfriend, Ms. Jäger, the head of the bank; Ms. Hansen, a working girl in a tailored suit – we played with clichés a little bit here. There are further bank clerks: the cashier, for instance, was supposed to be quite narrow-minded and very orderly; the bank clerk, Suzanne von Borsody, was given a wig to change her looks a bit; and a woman with a child was supposed to look working class.

Furthermore, there are sequences in the film of future visions: we called them *flash forwards*. These are always stories, photomontages showing various options in the life of every person. The woman with a child, for instance, appeared in three photomontages, each consisting of ten images. You could see, for example, that she won a jackpot. The family bought a car, a house, a swimming pool – all of it had to be furnished. That means that at the end of our photomontage we had all in all 120 to 140 costumes, although the movie leaves the impression of only a couple being necessary. That was actually the formula for success or, as Tom said, "Monika, so much fuss about so much clothes – we'll never be this minimalist again."

susanne granzer /
cutting costumes

The word fashion transports us into the present. The word costume, on the other hand, transports us first into the past. Fashion unfolds its effect in the here and now. Thus, in order to introduce the theme of fashion vs. costume one could start off by locating the two terms with regard to their positioning in time. If the question up for debate is explicitly linked to theatre and actors, one would have to ask what kind of time art transports us into. Into the unfashionable, which Friedrich Nietzsche often spoke of?

In our everyday lives we perceive time as a linear sequence of points in time. They mark and govern us, and our agendas, with appointments, listing a certain date and a certain time, which can be numbered and calculated. We find ourselves determined by this type of classification of time. We feel compelled to fulfil it. We chase and even hunt it.

The measure of time, set by art, is a different one. One could understand it as a musical measure. It has far more to do with the *propitious moment* (KAIROS) than with appointments. Is it not the musical that inspires the consilience of the divergent? This would mean that art is committed to a different classification of time and not to the linear one. A more complex one. One that is skipped and forgotten in everyday life. This form of time is not assembled through the mere stringing together of *now-points* rather it simultaneously commands/joints all three forms of our classification of time: the past, the present and the future. Past, present and future then do not sit side-by-side in isolation, but they swing into each other and instantly must be unified at any given moment. This *Augenblick*[1] (a glance of the eye) as the 4th ecstasy of time means that the future also constantly interferes with the present just as what already happened in the past does. Both co-determine the present and the successful unification of these three forms of time is what has been mentioned as the musical time and defies any form of calculation.

The theatre is an art form bound to the here and now. One could therefore call it an art form of the moment as it is exposed in its temporary occurence. Its peculiar exposedness, its peculiar nakedness reveals itself in this dependency on its happening in the moment. For this reason there is also no medium that could preserve it adequately. It is far more the living breath that defines the auratic[2] of the theatre, and the actors never possess a calculable, mechanical repeatability of that what they have already once done. Again and again, they must freshly expose in the present what was developed in the past for a future success, and this necessary difference in every repetition of their performance is the particular charisma that distinguishes every stage performance when it succeeds.

Wherein lies the connection to fashion and costume then? As mentioned at the beginning, fashion orients itself towards the present, whereas costume

1 Heidegger, Martin (1979)

2 Benjamin, Walter (1966)

orients itself towards the past. *Costume* is etymologically derived from *consuetude* (Lat.), from *habit, custom*; the verb *consuescere*, *to accustom oneself*, *take up a habit*. *Custom* (Eng.) also means *convention* or *tradition*. *Costum made* establishes the first connection to clothing. For example, the historical clothing of the privileged classes prescribed by convention or custom. But also, with civic connotations, costume as the term for a certain type of women's wear consisting of skirt and jacket, such as the classic two-piece by Coco Chanel. Finally, costume, in theatre terms, also always has something to do with play, with masquerade, with disguise, as illustrated by the costumes of the Commedia del'Arte, carnival parades, costume workshops, costume dramas, as well as the masquerades seen at carnival balls, life balls and parades.

Looking up the word *fashion* in terms of its etymology, one interestingly first comes across *mode*, *manner* and *shape*, from its Latin origin *modus*. With reference to the French *à la mode* (17th century), the sequence meaning *the taste of the day*, and time sets in. Thus, with *fashion* we usually understand the latest, the most contemporary (with regard to clothing and hairstyle), as well as *fashionable*, *according to the fashion* as well as *new-fashioned* and *old-fashioned*.

So are stage costumes supposed to be *modern* or *historical*? And above all, when are they considered a success? Playing the times off against one other does not make much sense within their mentioned scopes. From a musical or creative point of view, they cannot be separated from one another. Moreover, the fact that something has become old does not automatically make it immortal, nor is the most current a guarantee for its quality. Because once the historical is no longer, preserving it – in the best case – becomes museological, it mummifies life, freezing it in history. Favouring and adoring a hip present is equally a modernist one-way street. In musical terms of time, one could emphasise that everything is a matter of dosage.

In his observations *On the Advantage and Disadvantage of History for Life*, Nietzsche analyses the dilemma of man regarding his handling of time. In particular, as the title of his ensuing *unfashionable observations* indicates, the dilemma of man concerns his handling of the past. But is the extinction of all history, the attempt at its radical destruction, also not cataclysmic? Does it not mislead into the nihilism of Mephistopheles, who observes: "I am the spirit that negates! And rightly so, for all that comes to be, deserves to perish wretchedly!" His cynical claim is only consistent when he continues: "'Twere better nothing would begin."

To conclude his observations, Nietzsche talks about the first and second nature of man. The first nature of man is the one that we carry over from

the past as heritage. Familial, social, geographical, cultural. This means that we have inherited as well as acquired and internalised our first socialisation process through mimetic imitation without having critically questioned it. According to Nietzsche, the creative scope of our freedom only finds its expression in the second nature. This is the one where we can give ourselves a posteriori. This is where we select our heritage, maintain or rewrite it. In our second nature we can try to execute the future, what we want to become – and this always means the attempt at a successful unification of past, present and future in the moment.

Taking this as a point of departure, one could also consider the question of costume vs. fashion in connection with the theatre. In the successful interplay of the three times, costume and fashion would lose their frontline positions and rivalry. On stage, the historical and the current would fruitfully partner in both their aspects, and the clothing on stage wouldn't depict the actors either historicisingly or fashionably rather it would equally inspire them in their performance with its magic.

There is no recipe for inspiring consentaneous conditions. No figure or number that codifies or prescribes the consentaneous, because it simply cannot be codified – it is only findable. But maybe one could say that clothing in the service of creativity on stage responds to its particular time in its particular context at the very point when it becomes unfashionable. As we understand it, this would mean *tailoring in* difference into the sketches, into the designs, which leaves the present (fashion) as well as the past (costume) open, and idealises neither of the two. To appear unfashionable therefore means, in unison with Nietzsche, "to work against the time and thereby have an effect upon it, hopefully for the benefit of a future time."

Cut.

literature

- Bahr, Hans-Dieter, 'Zeit der Muße – Zeit der Musen' in GRENZ-film (ed) *Philosophy On Stage*, DVD-Buch (Vienna: Passagen Verlag, 2007)
- Benjamin, Walter, *Das Kunstwerk im Zeitalter seiner technischern Reproduzierbarkeit* (Frankfurt am Main: Suhrkamp Verlag, 1966)
- Heidegger, Martin, *Sein und Zeit* (Tübingen: Niemeyer Verlag, 1979)
- Nietzsche, Friedrich, *Unzeitgemäße Betrachtungen II*, Kritische Studienausgabe Vol 1 (1999)

left: suzanne von borsody (left) and susanne granzer (right) in ulrike meinhof's bambule, 1982, theater frankfurt

right: susanne granzer as rosaura, calderon de la barca, das leben ein traum, 1984, burgtheater vienna

arno aschauer / the costume – textile subtext of the film character

In contrast to the literary form of the novel, the time issue plays a stricter role in a dramatised, cinematic presentation of reality. The narrative film – Narrative Cinema – is characterised by three different time levels:

- The real time – the film length in minutes, e.g. 90 or 120, broadcasting time on TV.
- The narrated time – this term refers to one of *Aristotle's three unities*. All three unities can still be found in the modern mainstream cinema – time/place/action.
- The psychological development of the main character.

The third level is very difficult to imagine as a time level, but the protagonist goes through an emotional timeframe, which is portrayed as the process of change. This level is so difficult to imagine because it reaches us on a subconscious level. The first and second time level serve to define a concrete timeframe in which the third level can be developed.

The real time is obvious; it is the time the consumer spends in the cinema or in front of TV. It constitutes the basis for organising a creative production process. It is the basis for the economic framework and it defines the production time, i.e. the number of days of shooting as well as the number of days in the cutting room.

On the level of the narrated time, the viewer needs to be provided with clear hints regarding the progress and the length of time within the filmic narration – for instance day or night, the four seasons, visible outer changes of the characters. *Moonstruck*, for example, is set within four days and nights, *Pretty Woman*, within six days and nights, *Gone with the Wind*, within ten years and *Mr. Holland's Opus*, within thirty-five years.

The biggest challenge for all creative forces lies in the third level – for scenarists, actors and directors as well as for the entire creative team (picture/ sound/art direction/costume design). This is the level of sensations and emotions, of things that are often not explicitly said but rather implied between the lines – also referred to as subtext. It is the level of emotion-dependent non-verbal body language of the actors with all of the positive and negative emotional facets of their characters. In this area, the second skin of an actor, his costume, is an important component significantly supporting his acting.

In order to be easily understood, the process of change should follow a structure – a narrative structure which was developed in order to interact with the audience, to make them identify with the protagonist and to prompt an emotional response as well as to point out the dynamics of the process of change. In addition to that, the structure allows for the development of the difficult play of forces between the protagonist and his opponent, the antagonist.

In his work *Poetics* Aristotle (384 BC – 322 BC) presented for the first time the model of his Plot Curve in the audience-oriented context, which is still used today.

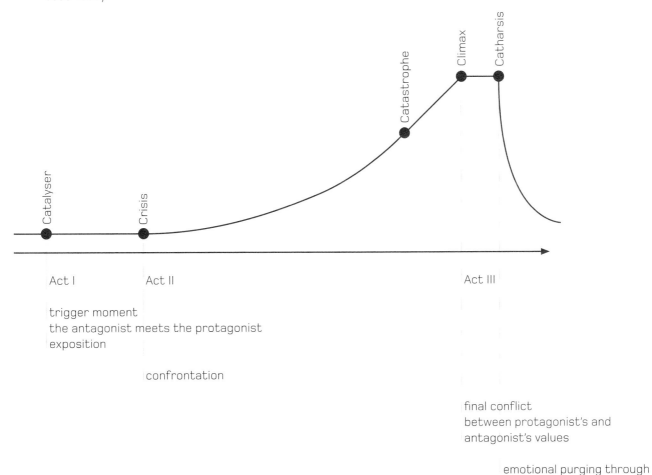

Catalyser

Crisis

Catastrophe

Climax

Catharsis

Act I

Act II

Act III

trigger moment
the antagonist meets the protagonist
exposition

confrontation

final conflict
between protagonist's and
antagonist's values

emotional purging through
affective commotion

While individual book readers can dictate their own individual timing – put the book aside and take up reading again whenever they want, whenever they have time or whenever the emotions aroused by reading call for it – the collective film consumption needs to follow other requirements due to the mass media aspect of the film. In other words, the film must provide so much information on a pre-defined, continuous timeline that the audience can both completely understand the story and get into the basic emotional mood in relation to the story and its characters. This mood, again, depends on the genre – comedy, melodrama, action, horror etc.

The film makers have to compress the content so intensely that it is reduced to the maximum – an apparent contradiction which however leads to the beautiful tool of audio-visual coding. The code is, in this case, a visible and audible element that the audience can receive, understand and fit into the entire story in as little time as possible – all simultaneously on the conscious and subconscious level of perception. This means that the code conveys its prior meaning as well as a subtextual meaning at the same time. The film is a synthesis of the arts in which many aspects are woven into one unity. Those aspects, in addition to the dramatic aspect of the screenplay and its implementation into acting, also include music, architecture, painting, fashion and film technique. And the key code has to be found on all of these levels, the key code which conveys both the plot and the theme – in the sense of the story – to the audience.

The subtext, whatever is said between the lines, creates an emotional basis for a particular scene and has to find its expression in the actor's body language in an appropriate manner. Very often, the information contained in the subtext stands in contrast with the written words of the dialogue. The characters do not actually mean what they say, a phenomenon that we are all familiar with, which generates tension and conflict in a scene. In contrast to the theatre, steering the viewer's attention towards a particular detail of the image is simultaneously the bliss and the curse of the film. It is a bliss because, in comparison to the stage, an incomparably rich microcosm is at disposal of the film creators, and a curse because they are responsible for shaping that microcosm right down to the last detail. In addition to that, the microcosm is supposed to establish a link to the consumers' daily reality and to enable the chance of association and identification. By fulfilling these requirements, the film creator is provided with an ample, often excessive, scope of the audio-visual code in the dramaturgic context of the story. The costume is an element of this codification, as can be seen in the following list.

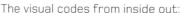

The visual codes from inside out:

- · body language – mimic/gestures, presence, charisma and authenticity
- · costume – dress code, historic or contemporary, gender-specific and socio-cultural role models, interface between body awareness of the actor and the character.
- · make up/special make up
- · props – natural handling with objects required for the role
- · space – architectonic-emotional structure of space and time
- · lighting – light and shadow, what should be seen and what should remain in the dark

The remaining codes are determined by the film technology – image composition, camera support (tracks, crane, steady cam), the special look and finally the editing. Coding of the auditory level is also rich but it plays a subordinate role as far as the costume is concerned. In terms of the subtext, however, there are examples in which the acoustics of the costume play an important role. Just think of the rustling taffeta petticoat of Mammy, the black housemaid in *Gone with the Wind*. When Rhett Butler, the main male character, perceives this sound, she implicitly gives him the signal that she has accepted him as a person.

A very good example of visual coding of the costume can be found in the film *Sister Act*. It is a story about the self-discovery of an unsuccessful nightclub singer who, to evade the police, must unwillingly hide in a convent where she ultimately finds the purpose of her musical talent. Before she realises that, she has to go through a process of change which catapults her from the seemingly safe world of luxury into the ascetic atmosphere of a convent cell. A woman, who is used to wearing the most expensive of furs and change her outfit several times a day, suddenly finds herself in a six-square-meter apartment wearing a scruffy uniform. The genre in which the protagonist is fluidly taken out of his familiar frame of reference and thrown into a completely new one is, in the professional jargon, tellingly called *Fish out of Water*. In order to prepare the viewer for what comes up next and simultaneously cross the threshold dividing the familiar and the new world, the film uses a so-called technique of *foreshadowing*.

This is the beginning of the film. With both of her colleagues, Deloris van Cartier and her colleagues have just finished one of their numerous performances politely ignored by the audience and received the information from her Mafia boss lover Vincent la Rocca, that he is not getting a divorce after all. Frustrated, Deloris decides in the presence of her choir members, to quit the job.
The scene begins at minute 6:24. As far as the colour is concerned, gold and purple prevail in the costumes – the colours symbolising dignity and power, which can be seen in the pompous clothes worn by kings and the Pope. Vincent's two bodyguards dash into the house of the three girls and bring a reconciliation present for Deloris, a lilac mink coat. Deloris puts it on her right shoulder and looks at herself joyfully in the mirror. Suddenly she realises, by looking at the embroidered initials, that la Rocca has simply given her his wife's coat. Deloris confirms her decision to quit it all and leaves the dressing room deeply hurt.

Already at this point, the space and the costume, through the colours and the furniture, portray the life Deloris is leading in the present and in the near future. The present only seems perfect – in one of the shots a naked green brick wall can be seen. When Deloris stands in front of the mirror she

is split in half by her mink jacket. The half of the present, clad in gold, can be seen very well in the mirror, however it is just an illusion. The half representing the real future in the foreground is symbolised by the lilac mink on her shoulder. Lilac or violet in the Catholic symbolism stands for penance and Lent, as can be seen in the tunicles during the Holy Week. The mink symbolises the apparent present wealth, the colour symbolises the approach of hard times. One costume functions here on two different levels, two different codes: text (admiring comments on the mink) and subtext (the colour). If you look at the scene more closely, you will discover that Deloris is already wearing a violet top and a violet money belt under her gold clothes. While she is opening the box, an advertising board in the background is constantly turning from red to violet. Those two colours symbolise the process of change in Deloris – from the dissonant world of make-believe through sobering austerity to the resurrection as a new personality. All of this is packed in the colour dramaturgy of a single scene.

With this short example, one can guess how elaborate it is to develop and implement the microcosm mentioned above. The creatives must possess a balanced combination of intuitive and analytical skill. On a conscious level, the viewers will not recognise many of these codes yet they will definitely perceive them on a subconscious level – this will influence their mood and, as a result, the manner in which the whole story is perceived. In this way, the costume becomes the materialised subtext in the true sense of the word. On the other hand, it demonstrates which professional and artistic qualities a costume designer should possess in order to adequately support the screenplay, the director, the actors and the production team. By means of the costumes, the costume designer communicates directly with the audience. Hollywood honours these attempts with the same words every year: *And the Oscar goes to…* An ironic paradox – the best costume is awarded with a naked man made of gold.

eva maria schön / images

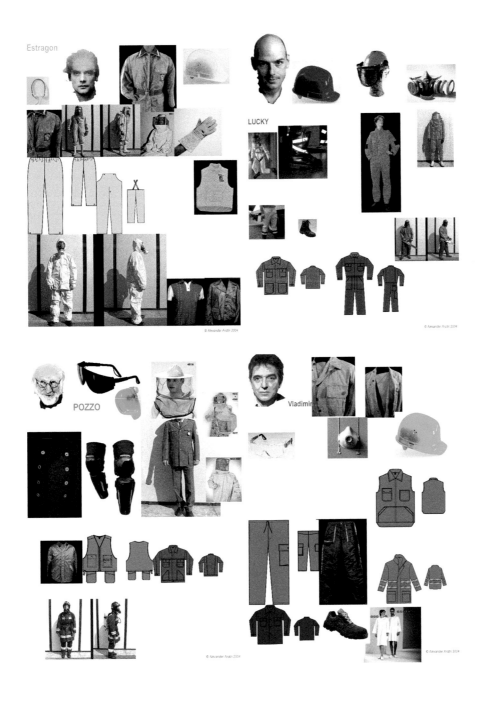

waiting for godot, samuel beckett, 2005

staging: frank asmus, scene/costume: alexander arotin

eva maria schön / images

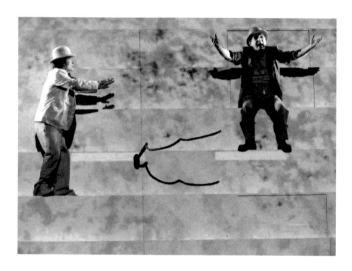 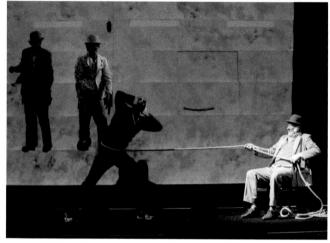

waiting for godot, samuel beckett, 2005
staging: frank asmus, scene/costume: alexander arotin

monica jacobs / images

left: illustration run lola run

right: franka potente (lola) and moritz bleibtreu (manni) in run lola run

left: franka potente (lola) in run lola run
right: franka potente (lola) and nuns in run lola run

susanne granzer / images

susanne granzer and arno böhler in philosophy on stage # 1, 2005

credits / images

page 266: *Leigh Bowery Looks: Photographs 1988-1994*, Thames & Hudson, 2005, © Fergus Greer

eva maria schön / page 274–277

page 277: *Waiting for Godot*, Samuel Beckett, 2005, Staging: Frank Asmus, Scene/Costume: Alexander Arotin, © Stefan Zoltan

susanne granzer / page 282–285

page 285: Suzanne von Borsody (left) and Susanne Granzer (right) in Ulrike Meinhof's *Bambule*, 1982, Theater Frankfurt,
 © Inge Rambow

page 285: Susanne Granzer as Rosaura, Calderon de la Barca, *Das Leben ein Traum*, 1984, Burgtheater Vienna, © Palffy

arno aschauer / page 286–290

page 287: Aristotle's plot curve in an audience-oriented context, Illustration © Julia Oppermann for Arno Aschauer

page 288: Visual codes, Illustration © Julia Oppermann for Arno Aschauer

eva maria schön / page 291–293

page 291: *Waiting for Godot*, Samuel Beckett, 2005, Staging: Frank Asmus, Scene/Costume: Alexander Arotin, © Stefan Zoltan

page 292: *Waiting for Godot*, Samuel Beckett, 2005, Staging: Frank Asmus, Scene/Costume: Alexander Arotin, © Stefan Zoltan

page 293: *Waiting for Godot*, Samuel Beckett, 2005, Staging: Frank Asmus, Scene/Costume: Alexander Arotin, © Stefan Zoltan

monica jacobs / page 294–295

page 294: Illustration *Run Lola Run*, © X Filme Creative Pool GmbH

page 294: Franka Potente (Lola) and Moritz Bleibtreu (Manni) in *Run Lola Run*, © X Filme Creative Pool GmbH

page 295: Franka Potente (Lola) in *Run Lola Run*, © X Filme Creative Pool GmbH

page 295: Franka Potente (Lola) and nuns in *Run Lola Run*, © X Filme Creative Pool GmbH

susanne granzer / page 296

page 296: Susanne Granzer and Arno Böhler in *Philosophy on stage # 1*, 2005, © GRENZ-film, Susanne Granzer and Arno Böhler

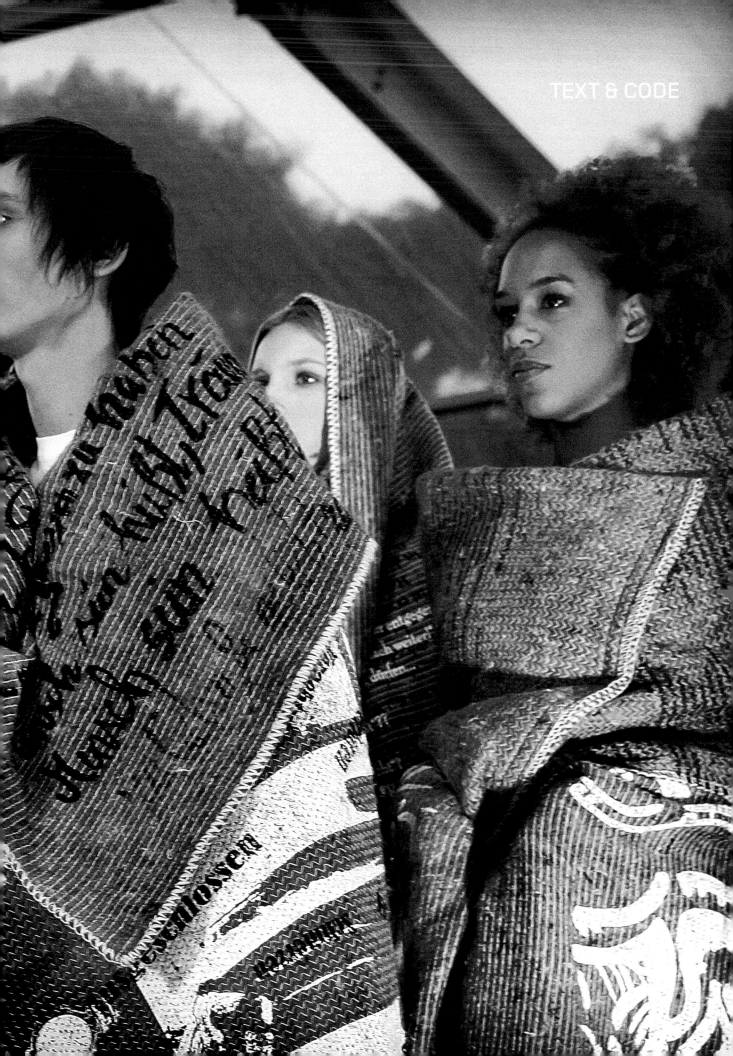

TEXT & CODE

FASHION INFORMS

Ever since Roland Barthes' standard work *Système de la Mode* (1967!), where he described fashion as language and assigned it its codifications, the scientific view on fashion has changed. It was pretty much the same time when T-shirts started being used like leaflets or flyers, and the peace message of the hippies, short harmless love messages or provoking paroles of revolutionary youth cultures, could be bought in innumerable variants.

A rapidly increasing number of competing pop music bands used T-shirts as merchandising articles that turned into collector's items and reached a cult status. American jeans combined with a printed T-shirt – initially with comic strips – were a symbol of a new worldview and had an aura of the free, uncomplicated life without clothing prescriptions and middle-class conventions.

The English fashion designer Katherine Hamnett has been printing critical slogans like *58% don't want pershing* and *stop the acid rain* or *no war, blair out* on her shirts since the beginning of the 1980s.

In an attempt to answer the question *What is fashion?*, Andreas Braun of Swarovski invokes a necessary *rhetoric* of fashion: "They are artists, language creators, young poets; they let something emerge on the body or beyond. But then one must also sell these things, there must an increase in significance through rhetoric... These things are only good as long as you have a *user's manual*, a description and a value codex. One can trace the success of crystals back to Swarovski's attempt to tell a fairy tale – and "the fairy tale worked. We have provided it with meaning, lent it a soul. We are living in an industrial society, in a technological world, in a mediatised society where, so to say, it comes down to self-assertion, to cultural arrogances and competences."

Walter Pamminger describes another aspect: The body is conceived as a screen for images and words, as a data skin. This unrestrained semantic availability, of the female body in particular, correlates with other contemporary phenomena ranging from tattoos and piercings to medical procedures in which the body can be colonised with miniature synthetic organisms.

As illustrated by Birgit Richard and Sabine Seymour in this chapter, the repertoire of fashion texts as written language or readable images is expanding and becoming more and more complex all the time.

Gerda Buxbaum

LECTURES

IMAGES

birgit richard, jan grünwald, alexander ruhl / fashion victims? young and stylish self-portraits as communication lubricant on flickr.com

This essay explores the media staging of youth self-portraits via body and fashion images. We look at the pictures young people post on the global photosharing Internet platform *flickr.com* and the way fashion is employed therein. A considerable number of these pictures reveal patterns of self-presentation. The focus of this examination is the new form of *pop picture*, understood as a hybrid category between amateur and professional photography in the online *Web 2.0* environment. The study presented first localises the media structure phenomenon in order to conduct a representative evaluation of the material surveyed, despite the inherent dynamics that account for flickr's appeal.[1]

The collective content of the *Web 2.0* (O'Reilly 2005), and especially that of *flickr (http://www.flickr.com)*, clearly illustrates that publishing is no longer the exclusive privilege of professional image producers. The pop picture, a form of image created by amateurs in which both trivial details and impressions of the representational schemes used in the fine arts are deposited, is regarded as an authentic pictorial expression, apparently oriented on the everyday observed reality. However, the amateur techniques are at the same time an occasion for artistic and designer-like styles as seen in trends such as Super 8, Lomo photography and video production with the cellphone camera. The amateurs use and generate images that correspond to their visual socialisation and their perceptual universe, demonstrating the obvious influence of commercial images created by professional image-makers such as photojournalists, and thus they are in turn informed by artistic models. Individual pictorial understanding is therefore firmly anchored in social and cultural practices (Mitchell 1990). In addition, numerous decisions are made in the course of creating a picture that represent a direct intervention in the *authentic*. Whether consciously or unconsciously, technical as well as aesthetic decisions shape the (self-) portrait – for example, the choice of camera, lens, resolution, storage size as well as aesthetic features like pictorial composition or framing. Image production is hence always moulded by interpretation and selection (Knieper 2005).

Social software and visual hypertext as part of fluid communication
The continuously generated pictures create the opportunity for communication on the online platform; they serve as *communication lubricant*. Behind an interface that is kept relatively plain, but only at first glance obeys the principle of *simplicity* (Maeda 2006), many complexly structured grades of the generated data are hiding. What's important is how the visual information is organised: it can be sorted according to the most frequently used keywords, the author or chronologically, for example in photos of the day or of the month in a calendar form. *flickr* is a social network and a *visually motivated social hypertext* (for a more detailed media structure characterisation of *flickr*, see Richard/Grünwald/Ruhl 2007). Every single image thus forms both the centre and the periphery in this pictorial universe,

1 cf. Richard/Zaremba (2007) on the methods of netscan, key images and clusters as triangulation of quantitative and qualitative methods.

which is created, maintained, structured and modified second-by-second by the users themselves. The individual profile page is the ideal stage for self-dramatisation, the impact of which is heightened by the aura of authenticity inherent to photographic production (Bourdieu 1983). An indication that the platform is in fact used as a setting for self-aggrandisement and constant narcissistic self-reflection is that the number of pictures found using the search terms *me* and *I* is higher than when searching for baby – a motif that is without doubt photographed very often (Walker 2005). At this point, it would seem expedient to introduce the theory put forth by George Herbert Mead and in particular the concepts of *me* and *I* (Mead 1973: 216), which have to do with identity and the self, i.e. with inner psychic reality and the associated way in which individuals deal with their culture as relevant social setting. We can then apply this thesis to the concrete field of *flickr* and interpret it in a way appropriate for media study. As a place in which visual representations of the self are presented, *flickr* offers a projection surface for the staging of identity from the assumed point of view of the generalised other (*me*), which serves as a parameter for one's own presentation. It is within this projection surface that the personal, individual – the wholly innate and unpredictable – self-dramatisation is located (*I*). The differentiation between the two concepts provides us with a way to identify pictorial innovations and independent visual representation options in the interplay between *me* and *I*.

The dramaturgy of this economical way of drawing attention to the representative pool of images also entails furnishing one's own images with popular keywords thought to promise the desired success, i.e. with tags. *flickr* taps into new virtual action spaces for communication, beyond one's close circle of family and friends. The goal is to create one's own pictorial methods and to find others that look familiar; there is thus a striving toward *uniform* images that guarantee rather than endanger one's feeling of belonging to the community.[2] On *flickr* we see extraordinary variations on a single motif, in which the artistic use of Photoshop is evident. The motifs uploaded to the site are supposed to attest to the event and mood depicted; they are narrative and free of abstraction. The point is not to deviate aesthetically in the creation of an image. Instead, other principles are at work here: the exaggeration of certain motifs, humorous and absurd snapshots showing how accident plays a role in daily life. On *flickr* we can trace how a social network urgently requires aesthetic redundancy to come about.

The visual product is a demonstration of *skills* and of identity: the objects included in the picture characterise the self presented on the user's personal page, arranged on a stage of self-aggrandisement.

What's more, an amateur photo exudes a high degree of authenticity (Gapp 2006); the photographic self-portrait of *me* is usually accepted as

2 On the concept of *uniform* cf. Richard/Grünwald/Betten (2007).

an unfalsified representation. On *flickr* we can see how an unconscious mixing of self-portraits and those made by others takes place, making it almost impossible to distinguish between the concepts of *me* and *I*. Unlike our treatment of artistic images, authentic individuality is not questioned here. But not all users strive for global self-expression: often, the message conveyed to a small circle of friends and acquaintances is most important. The goal is not to show everyone everything, but instead – in the spirit of so-called *privacy management* (Moorstedt 2006) – to publicise one's life in various self-chosen stages.

The picture thus forms an occasion for communication; it does not depend on any valuation as a medium in and of itself. Technical and social networking on *flickr* requires furnishing pictures with verbal data (*tags* = keywords, categories). Networking takes placed based on similarities between pictures, i.e. through redundancies in motif. The classification of individual images depends on assigned terms, and rarely on the pictures themselves. The pictures are exchangeable and are therefore nothing more nor less than signs of presence designed to stimulate communication. They generate connectivity to global networks, for example how rural party portals supposedly verify the fact that someone exists and is leading an excessive life.
This is also evident from the sober, apparatus-heavy picture production, characterized by template-like, repeatable motifs or artistic programming effects based on image editing (Sturm 1987) and not by individual creative interventions.

Egoshots: Methodological strategies for studying youth self-portraits
A special challenge is to ascertain basic patterns in the poses and clothing chosen for youthful self-portraiture, which, despite the second-by-second change in content on *flickr.com*, remain constant at their core – i.e. a typology of the depiction patterns and conventions introduced and further developed by the community. In view of the millions of pictures, a quantitative approach is only possible by means of a random sample, which can only inadequately capture the definitive characteristics of the visual presentation due to the lack of objective criteria for the motifs in the images. It would seem much more promising to create parallel access points by undertaking a qualitative survey of the content as well [3]. Using a research design specially developed for this purpose (for its definition, see Richard/Grünwald/Ruhl 2007), we are able to do justice to the dynamics of this field. The guiding idea is to trace the processes observed by applying intuition and creativity in the form of *mimetic* research (Amann/Hirschauer 1997: 20).

3 cf. the concept of key images and relational image clusters in Richard/Zaremba (2007).

In dealing with these fashionable self-portraits, it is in particular useful to transfer the category of *egoclips* (see Richard 2008) from the world

of moving images to that of still photographs. This coins a similar term – *egoshots* – to refer to the narcissistically motivated pictures that concentrate only on depicting one's self, with stylish self-portraiture as a sub-category.

In this specific case, we must first formulate the required *tags*. Terms such as *beauty* (360 325 photos) or *beautiful* (907 764 photos) miss the mark in defining the subject matter. Since they are also appended to a variety of other motifs (portraits, nature shots, pictures of children, fashion…), they are too diffuse to yield a satisfactory result. The *tags* that would seem to be helpful in drafting a typology[4] refer to forms of self-representation, to the photographer's self-image, but also his/her aspirations as a photographer (*me* (1 209 948), *I* (10 083 460), *self* (586 985), *selfportrait* (303 601)), or to the format of the media self-portrait (*sexy* (316 222), *posing* (409 731), *posers* (41 573), *naughty* (29 196), *body* (192 572), *male body* (4 677), *female body* (4 668), *my body* (33 012)) and to sexual orientation, which frequently implies at the same time a defined depiction or body mode (*gay* (293 586), *lesbian* (49 982), *hunk* (9 267)).

Men's self-portraits on flickr: Indie Boy vs. Macho Man

We can discern various gender-specific typologies in the *flickr* picture universe. Masquerades of masculinity are therefore – more than masquerades of femininity – likewise performances of *authenticity*, even when men play the part of a wholly *unmanly man* (Benthien 2003: 56). This results in the paradox that even the *disguised* man is the *genuine* man, which has implications for the parody-like exaggeration of gender identity. Femininity that is blatantly showcased can, according to Benthien, easily be read as artificial exaggeration, while in the case of masculinity it is more an attempt to demonstrate potency, especially in contemporary culture, where excessive manliness is primarily exhibited in the physique. Thus, the subversive aspect of the representation of masculinity perhaps lies more in the act of the performance than in the photograph itself.

Two male types can be teased out, between the poles of which are diverse possibilities for self-expression. The first can be described as Indie Boy, a picture of androgyny and sensitive boyishness. Susan Bordo (1999: 187) calls this type the *leaner*, because the subject is usually depicted leaning against something. The poses taken by the *leaner* can be classified as more traditionally *feminine*. In the commercial pictorial representation of gender stereotypes, the visual rule of thumb promulgated by John Berger (1972: 45, 47) also applies here: "men act and women appear". The figure type of the *leaner* is thus more closely related to *appearing* than the active posturing of the traditional male portrait. The passive, sensitive self-rendering of the Indie Boy should not however be regarded as a game with set pieces from gay culture (even though its origins may very well lie therein).

As an example of the Indie-Boy, we can use the *flickr* profile of Brazilian-born Eric Phillips, in which the above-described attributes can be found (www.flickr.com/photos/eric_phillips). Besides the sets *Friends* and *Nature*, in which the indicated subjects are depicted, we also find here the set *Myself*, containing 15 photos. On the opening page of Phillips' profile is a picture from the myself set. The photos in this set show Phillips in like poses and are framed similarly. His face is the focus, with the body usually cropped by the frame. Exemplary is the photo titled *Herz* in Eric Phillips' *myself* set, in which he is holding a heart-shaped, diamond-faceted glass object in his right hand. He looks into the camera. His longish brown hair falls over his face, covering his left eye. His head is slightly tilted and is located in the right half of the picture. His light-coloured complexion and the slight over-exposure make the face look softer and more youthful. The right hand holding the heart is located in the lower left third of the picture, at chin level. The hand holding the heart is open. In the background we can see a green field on the left, and in the upper right corner a piece of sidewalk. The close-up was taken by Phillips himself from a slightly elevated camera position, holding the camera in his left hand extended out in front of him. We can see here how Eric uses his gaze, head position and styling to stage *cuteness*, further reinforced through the addition of the heart. He seems almost disembodied, with the face standing in for the body. The delicateness of his facial features, the dreamy gaze and pouting lips make him look reserved. This picture is furnished with the tags *lovely* and *heart*, indicating that Eric is aware of the impact of his staging. The comments of the viewers refer almost exclusively to the technical execution of the picture.

The second male type, embodying the opposite end of the spectrum of masculinity, can be called the *Macho Man* (Cole 2000), showcasing an expressive masculinity. This hyper-masculinity commands the (pictorial) space through sheer physical presence. It conveys the impression of physical and psychic strength, the absence of sensitivity to pain, and thus an archaic form of manliness that communicates the promise of power and potency. In contrast with the leaner, the term *rock* (Bordo 1999) applies here, a form of masculinity that presents itself as forceful, armoured and emotionally impenetrable. The pictured self thereby enters into a competition with the picture's viewers. And it always emerges victorious, because the observer has nothing to set against this corporeal/militant manliness.

The *flickr* profile created by Calgary56 can serve as example of the *Macho Man* (www.flickr.com/photos/40376425@N00). The *Narcissism* set (13 images) shows photos Calgary56 took of himself. Only one of the eight pictures following this pattern of self-portrayal can be conclusively identified as a self-portrait because we see Calgary56's outstretched arm within the frame, his hand holding the camera and photographing his reflection in a mirror. The other pictures were taken using a self-timer or by some-one else. The self-portraits are all black-and-white, the other images also sometimes in colour. The eight images that Calgary56 uses for his stylised self-portrayal always show specific, well-toned parts of his body such as the abdomen, chest or back. His face is either not in the frame or deliber-ately masked by a cowboy hat.

The self-portrait has no title – it seems to speak for itself. It shows the muscular torso and head of Calgary56. The face is covered except for the mouth by a black cowboy hat. The body is standing sideways to the camera. His right arm is bent and reaches across his chest to the left shoulder. The arm thus conceals the chin area, which, tilted downward, points in the direction of the camera. The black cowboy hat takes up the whole upper right third of the picture, while the body, somewhat to the left of centre, fills a major portion of the remaining picture space. The background is white or grey, and the shadows cast by the body and hat indicate that Calgary56 is standing directly in front of a screen or wall and has carefully lighted the picture, i.e. that this is not a snapshot.

Calgary56 depicts himself as a strong man. His only piece of clothing or accessory is the cowboy hat hiding his face. What's special is that the body is shown down to the beginning of the genital region. In this self-portrait the face plays only a minor role, with the spotlight on the body instead. The choice of the cowboy hat as mask, together with the muscular body, is a further symbol of expressive masculinity, referencing the historical Ameri-can brand of machismo as manifested in Westerns and in the gay com-munity. Shaun Cole (2000) describes how important the archetypes of the cowboy and the biker were for the development of *gay style*, representing as they do a traditional but at the same time non-conformist aspect of manhood. The gay scene in the 1970s sought in this way a positive departure from the *feminised* homosexual stereotype. The word *Macho* and the asso-ciated world of imagery and style were regarded as more masculine with its borrowings from traditional manliness and was therefore of great interest to the *gay community*. Thus Calgary56's self-portraiture also draws on the repertoire of *gay imagery*. Only one picture in his profile, which carries the caption *Wife took this over my shoulder*, reveals his sexual orientation.

We can see here how hetero- and homosexual male images overlap and co-exist. Both male types (Indie Boy and Macho Man) correspond in their

pictorial, representational and accessory repertoire with roots also inherent to the gay scene, but fit all sexual preferences in contemporary self-portraits. However, this does not mean that the heterosexual image producers deliberately play with ambivalence and ambiguity. Only seldom do we find a deliberate break with stereotypes. The subversive pose thus remains within the bounds of the above discourse on the respective typologies, which, when they appear in *flickr*, have long since become part of mainstream culture. Face and body are often separated. The division between portraits and body-shots is only resolved when this is conducive to the completion of the male image. Despite the references described, we can confirm that it is hard to find a technically abstracted or subversive treatment of the male body image.

Female flickr pictures: Amateur eroticism, ugliness and arty pics

Using three profiles as examples, we would like to show how femininity is represented on *flickr*. The profile of Violet1980 is a pro account with three sets. The set *Portraits* contains 341 images (March 2007), which show exclusively Violet1980. Amidst the classic *arm's length self-portraits*, we also find body images in which the subject stylises herself as a seductive, dreamily erotic vamp. Her face is almost always readily recognisable. When her eyes aren't closed, her gaze, in its efforts to look seductive, winds up looking awkward instead. The pictures are usually taken from an elevated perspective, at arm's length, and thus show above all the subject's face and décolleté. The captions try to underline the erotic gesture of the pictures, for example *Bad Girl* or *When the seduction it is only a game* (sic!). Nudity is rare, as it is in the strict sense prohibited on *flickr*. The self-portraits in lace underwear correspond to the conventional understanding of eroticism we have become inured to from images frequently seen in magazines and posters for erotic fairs. Exemplary here is the picture *Presences*, to which Violet1980 has appended several tags, e.g.: *look*, *bed*, *body*, *skin*, *shoulders*, *portrait*, *selfportrait*, *I*, *me*, *myself*, *girl*, *woman*, *sexy*, *hot*. The *tags* not only help to get attention within the flickr universe; they also show how the maker of the pictures sees and interprets herself. Her *ego tagging* aims at the familiar buzzwords for eroticism and sexiness; she emphasises her *market value* and thus her body's aspect as merchandise.

In the black-and-white self-portrait, as in most of her portraits, Violet1980's face is set in the middle to upper part of the picture. Her body, which is only seen down to slightly below the shoulders, is in a prone position. Because she is lying on an unidentifiable surface, her breasts are only hinted at. This suggests the promise of nakedness and brings into play the principle of the striptease. Her hair is worn loose, falling slightly over her face, which is turned toward the camera. Her eyes are closed and mouth slightly open – the typical facial expression meant to signalise *female*

seduction and readiness. The picture looks like an action scene – rather than static – and was probably edited using a digital soft-focus tool. Violet1980 arranges her body in conventional poses, wanting to stage herself erotically. She draws here on the pool of pseudo-artistic erotic photographs from Hamilton to Playboy. She joins in the commercial imagery programme for the depiction of the female body, turning herself into an erotic offering in her self-promotion. Violet1980 thus demonstrates how narrow the line is in female body images between being sexy and being an object up for sale; in male images this is not such a pronounced issue.

TOP RIGHT: WWW.FLICKR.COM/PHOTOS/MYRIEL/289984616/IN/SET-72157594176327778

In the album posted by a user named Myriel there are 109 photos. In contrast to Violet1980, Myriel tries in her set *Mee* to break with typical female cuteness by grimacing into the camera (www.flickr.com/photos/myriel). Various series of self-portraits experiment with her own facial features. Thanks to the normal, grimace-free self-portraits that are also included, the viewer is aware that the staged *ugliness* is only a pose and a temporary manifestation. The pictures show Myriel's face very close up. The lack of distance opens up a field for experimentation in which the effects of her physiognomy can be tested. The proximity of the camera lens makes what is shown look slightly distorted. This underlines the aspect of absurdity in the self-portrait. Makeup and clothing change – the distorted face remains. In the picture *stupid poser*, exemplary of Myriel's self-portrayals, she sticks out her tongue, curls back her upper lip and squints slightly. Her head almost fills the frame. Only in the outer left picture area can the background be seen (presumably a public toilet). Myriel is looking slightly obliquely toward the centre of the picture. Her longish, dark blond hair hangs in her face. Her eyes are strongly ringed in black. She is wearing a black tank top. Her right hand is on her hip. With her left hand she holds the camera, which shoots her photo from a slightly elevated perspective. The pose Myriel has assumed and the facial expression look like an imitation of Johnny Rotten or Billy Idol. The punk attitude is further reinforced through her makeup and dress. The setting in a public toilet also serves to localise the image within this subculture. The caption *Mommy, I'm drunk, I'm bad and I'm outta control* does the rest. If we were to regard this image in isolation, without the rest of the set, we would assume that Myriel is part of this subcultural setting. But in the set *Mee* there are also other images, showing her in a Santa Claus costume or in clothing not typical of the punk scene, thus making way for completely different interpretations. Myriel uses *flickr* as a playing field upon which she can experiment with her looks, blurring the lines between different styles.

BOTTOM RIGHT: WWW.FLICKR.COM/PHOTOS/BELLJAR/49304884/IN/SET-1070568

The third profile we will analyse is that of Esther_G. These photos are clearly recognisable as artistically motivated works and appear professional in their presentation, technique and image editing (www.flickr.com/photos/belljar). In her pictures Esther_G deals with the themes of gender, femininity and masking. The images are all staged, usually carefully edited and often alienated. Esther_G's profile contains 58 sets, with titles such as: *Identity Crisis, Woman, Ego Defense Mechanisms, Stop hurting me now* or *Mirror mirror*. The pictures reflect not only the difficulty of depicting oneself outside of conventional stereotypes, but also the position of the woman as image producer within the *flickr* universe. In the artistic context, the appearance of these images is not unusual. The set *another way* shows self-portraits dealing with themes such as metamorphosis and fusion. The picture titled *Thorazine*, which is presented in this section, is a photomontage with two half-faces conjoined. The double portrait is a close-up and shows the head cropped by the frame. The first face looks from the centre of the image toward the left. The second looks toward the right. The chin is the starting point for the photomontage, where the two faces come together. Both faces gaze with a melancholy air toward a point outside the frame. The line of separation between the faces is rendered as a scar running along the shared cheek. The black-and-white portrait has soft-focus lighting and a black background. This picture, perfectly realised technically, generates through the use of Photoshop tools a mood reflecting the feeling of being torn. Through technical manipulation, the consensual area of what is considered beautiful is left behind in an attempt to portray a specific emotion. This constitutes a break with a societal ideal of beauty in order to adhere to an artistic one instead, which generates its beauty by means of abstract self-representation.

Fashion victim: Women act – men appear?

Fashion plays a vital role in youthful self-expression on *flickr*. The tag *fashion* can hence be found attached to 1 564 582 entries (queried November 2008). *Fashion victim* is used to describe only 4 786 entries. If we try to sort the photos according to gender, we find under the extended search criteria even fewer correspondingly tagged photos. Adding the tag *girl* to the *fashion victim tag* turns up 229, and with *boy* only 9 entries.[5]

In general, the term *fashion victim* describes a person who is more than merely fashion-conscious. The *fashion victim* is a product of consumer society, a person who feels compelled to purchase and wear the latest fashions, to always stay on top of trends in order to enhance his or her own cultural capital. This self-*victimisation* on the one hand represents a critique of the structures of the consumer society. But at the same time, pointing a finger at the *victim* is also prototypically used to highlight the weaknesses of the individual concerned, who is only able to acquire status through the consumption of fashionable garments, and not through the force of personality

4 All tags were queried on 1 May 2007.

5 Status as of 28 October 2008

alone. The *fashion victim* is not regarded as having his or her own personal sense of style. People who have style are able to elude such commercial, manipulative mechanisms by means of individuality strategies. How we handle fashion (or consume articles in general) is thus subject to a dichotomy: the slavish obedience to prescribed fads exhibited by the *fashion victim* is to be rejected in favour of celebrating instead the creative potential of the style-conscious individualist. The *fashion victim* is therefore necessary as a foil allowing young people to position themselves as independent-minded as opposed to blinded by fashion. They demonstrate that they are competent to participate in consumer society without being obsessively subject to its dictates. The fact that this dichotomisation involving the rejection of the position of the *fashion victims* is just one of several possible self-expression strategies, which in turn adapt themselves to the consensual compulsion toward individualism, can be demonstrated by inverting the concept of *fashion victim*. The positive re-interpretation possible through self-stigmatisation as *fashion victim* thus counteracts the moralising authority of style.

The *flickr* profile of Lorena Cupcake[6] illustrates exactly such an inverted self-description as *fashion victim*. One of her sets is titled *Style Diary* and shows 254[7] self-portraits in changing, extremely colourful outfits. A text added to the side of the photos describes the intention and fashion influences on Cupcake as presented in this set. Elsewhere she explains that she took the pictures with the help of a tripod or classic *arm's-length* technique. The exemplary photo analysed here[8] bears the title *spring is fucking finally here!* and has been given 32 tags, including *fashion victim*.

RIGHT: WWW.FLICKR.COM/PHOTOS/JULIETBANANA/2419680768

Lorena Cupcake is seen in a full shot, posing frontally for the camera. Her arms are in front of her body holding a handbag strap with both hands. She is standing erect, her feet turned slightly inward, her head tilted a bit. She looks into the camera, her eyes open, but her gaze a bit dozy. Her mouth forms a neutral, closed smile. Her long brown hair is parted on the side and combed back behind her ears, leaving her face freely visible. She wears glasses with a large, light-coloured frame in a vintage style. The title of the self-portrait probably refers to the colour scheme of her outfit. She's wearing a knee-length yellow dress with spaghetti straps and lace along the hem. Underneath the dress she wears a brightly striped bikini top, tied halter-style behind her neck. Her knee-highs are likewise brightly striped. Her shoes are yellow. Around each wrist are three pink plastic bracelets. The handbag Cupcake dangles in front of her is brightly striped and adorned with pink feathers at the upper left edge. Lorena Cupcake is standing in a front yard, before the grey veranda of a light-blue-coloured single-family home. Between her and the veranda is a narrow flowerbed sprouting yellow daffodils.

6 www.flickr.com/photos/julietbanana/

7 Status as of 28 October 2008

8 www.flickr.com/photos/
julietbanana/2419680768/

The cuteness of the protagonist as presented here, as well as the whole-some, idyllic character of her surroundings, create a charged atmosphere veering between the snapshot-like idealised small-town world and a colour-ful hyperreality, which through the very excess of cuteness is a parody of itself. Lorena Cupcake presents to us the simultaneity of an affinity for fashion and its exaggeration with a seemingly passive and yet all-knowing look on her face. The surfeit of colour is staged with self-assurance, crowned by the tag *fashion victim*. The original meaning of *fashion victim* is inverted here, with the term being lent a positive connotation. The play-ful aspect and costume-like character of fashion are foregrounded – and with the use of the word *fashion victim* are given a designation that jux-taposes them with the more serious and thoughtful discourses on style consciousness.

LEFT: WWW.FLICKR.COM/PHOTOS/LIFESPARKSPHOTOGRAPHY/502276788/IN/SET-72157604783699242

Only a few men are found under the tag *fashion victim*, and none who present themselves stylishly and choose corresponding titles. The image examined here of a male image-maker carries the title *fashion victim: the tie*[9]. This black-and-white self-portrait can be found on the *flickr* profile of Life Sparks and is furnished with the *tags fashion*, *victim*, *boy* and *tie*. The treatment of the description *fashion victim* is completely different here than in Lorena Cupcake's *flickr* profile. *Fashion victim: the tie* shows a close-up of the face of Life Sparks. His head, tilted toward the left edge of the frame, is slightly cropped. He gazes into the camera. His dark blond hair falls over his forehead and covers part of his right eye. Life Sparks has wrapped a dark tie decorated with small, light-coloured rectangles around his head. The tie covers his nose, mouth and chin. The eyes are thus framed by hair and tie. Part of the subject's upper arm can be seen in the left background. Life Sparks is wearing a light-coloured T-shirt, of which only fragments can be discerned. His eyes and the part of the tie covering his nose are in sharp focus, while the outer reaches of the pic-ture are blurred. The photo is professionally-styled and resembles a clas-sic black-and-white portrait, whose aesthetic is however broken through the disguise. This disguising is done without intending subversion, though. It conveys instead the morally connoted original meaning of *fashion victim* – namely a slavish follower of fashion who, due to fashion's uniformity, sym-bolised here by the tie, is robbed of his individuality. Life Sparks describes his series on *fashion victims* – there are a total of three images dealing with this theme – as a *new style (that) is supposed to be inviting, humorous & deep*[10]. From the images and statement we can conclude that, for Life Sparks, a critical treatment of the dictates of fashion is the only one that seems possible. His reflections are situated on a level of *cultural criticism* achieved through a clear pictorial design. The artistic potential is realised

9 www.flickr.com/photos/
lifesparksphotography/502276788/in/
set-72157604783699242/

in a technically sophisticated, professional manner. It does not approach the discourse of the *fashion victim* in a critically reflective way. Nor does it play with clichés and expectations or deliberately dramatise them, as is the case in Loretta Cupcake's picture. The theme of *fashion victim* as a special form of *egoshot* exhibits gender differences similar to those seen in gender-specific self-portrayal in general: the female photographer appears to be so comfortable with the respective self-representation discourse that she is herself in a position to call into question the critical positions. But the male photographer must first localise himself by applying already established patterns of criticism. A role is still played here by the stereotypical assumption that the body is ornament enough for a man and fashion is not part of the realm of active self-portrayal.

Men act – women appear? A comparison of youthful body and fashion images on flickr

This guideline for visual representation of gender still describes very aptly why men find it so much harder to visually formulate their role imagery or even to call it into question. Women are in possession of a pool of visual resources for shaping their *appearance*. Self-definition via the body and its appearance harbours the inherent possibility of breaking or undermining stereotypes of femininity to achieve an act of liberation – one which is however hardly in evidence on *flickr*. In the traditional representation of maleness, the man does not enter the stage just to be seen, but rather in order to actively perform. For men, it's therefore not about the role of being an object to look at and thus emerges the need to stage oneself as such, i.e. to embody a *look*.

This terrain is something new for the male (heterosexual) image-maker, and a platform like *flickr* makes this abundantly evident. For this reason, fashion also plays an important part in helping men to take the step toward pure self-representation, and can be understood in this context as a kind of freedom, i.e. it need not be subversively called into question here. This lack of experience in *performing gender*, due to a disequilibrium in the value placed on the visual display of men versus women, might be the cause for the under-representation of subversive aspects in male self-imaging.

It is noticeable that men, when depicting their bodies, usually remain face-less, while women combine showing off their body with indirect, non-offensive gazes and facial expressions, as communication with the viewer. In the *fashion victim* portraits, this rule is suddenly reversed; here the effects on the face are shown.

There are many more women who in the genre of self-portraiture first show their body and its decorative apparel. This is rooted in women's socialisation, where a girl's first thoughts on how to present herself focus on her

10 www.flickr.com/photos/ lifesparksphotography/501375601/in/ set-72157604783699242/

body. Up until now, men have defined themselves less through the direct exhibition of their whole body, and when they do so, it's likely to be a case of a well-toned, muscular upper body.[11] Images of women are more diverse within certain boundaries, but by no means more subversive. The only thing that's conspicuous is the greater range of variations in the presentation forms, which does not per se indicate a liberation from clichés – on the contrary: the larger the spectrum of poses offered, the more difficult it is to transcend the boundaries, unless the women are acting directly in the context of certain artistic or subcultural milieus.

Therefore, the ways in which *flickr* is used largely adhere not only to individual and local gender attributions, but also to visual ones, which are thus significant for the construction of identity. This means that the assumption that gender, place, time, ethnicity and social class are suspended in virtual space, becoming meaningless or at least weakened (as Sandbothe alleged in 1997) must be relativised. Although such attributes can in principle be overcome via the socio-technical network that is the Internet, they continue to play the central role for an individual's own positioning, in particular, his or her placement in gender-specific arrangements and sets.

Youthful self-portrayal in the fluid iconic communication worlds of flickr.com

It is not possible to illustrate one's whole life, but, for the first time, the Internet has made possible a fluid communication by means of images (Boehm 2008). The iconic communication that takes place on *flickr.com* is prototypical for a "superacidification of the life context with images" (ibid.). At the same time, *flickr's* organisation as a database medium leads to specific modes of representation (Ernst 2008). This includes for example the rules in the so-called *community guidelines*; there are apparently only a few prohibited image types, and these are not made explicit (*nothing prohibited or illegal* may be posted). Internal moderators remove any depictions of *nudity*, for example, even in the tiny *buddy icons*. Users can in addition finger pictures they find offensive and report them to *flickr/Yahoo!*. This is an important structural default for the representation of the body, as it dictates the limitations of what can be shown. Without his restriction, *flickr* would certainly be instantly deluged with pornographic photos. This is why it's no wonder that very little *trash* can be found here and hardly any baring of the body; self-portrayal happens within safe channels, but does venture to the limit of what is permitted.

The metastructure within which the self-generated masses of technical images are organised through *tags*, *sets*, *groups*, etc. generates a redundant iconic staccato, which through ongoing image production is continually fed with new pictures. This makes a subversive handling of self-portrayal in the technical picture more difficult, and any deviations

11 On boys' body images cf. Richard (2005).

from the stereotypical presentation pattern an exception. A similar phe-nomenon can be observed when it comes to the technical execution of the photographs, which is closely tied to the character of the media used as apparatus. The two most common snapshot-taking modes are the *arm's-length self-portrait* and the *party snapshot*; the *spontaneous* party photo as a representation of the body is primarily notable for the close-ness of larger groups to the camera. The new form of photo known as the *arm's-length self-portrait* is spreading through the use of cellphones and digicams. Here, there is no risk of wasting film if the narcissistic act fails to produce a good shot.

The *flickr* images show staged scenes, which, guided by pictorial specifica-tions and visual conventions, create a *Me*, i.e. my visual identity(ies) from the point of view of others, my social self. It is the Self from the standpoint of the generalised Other, my idea of how others see me, that is visualised.

Just because breakouts are low in number, in the area of fashion as well, we should not assume that users succumb completely to the standard patterns. In fact, a special form of communicative and networking compe-tence is being acquired here. Sometimes a pronounced expertise in image production evolves that allows the users to modify prescribed stereotypes. Self-dramatisation by all means takes place in full awareness of the artifici-ality of the staging of the body and of the media principles at work. Despite the users' knowledge of image manipulation, they still tend to aspire to the most widespread consensual external ideals of beauty.

Beauty means above all an immaculate surface. This surface is plastically moulded by the muscles of the upper body in men, and in women by empha-sising the sculptural qualities of the breasts and posterior by twisting the body just so. Little appreciation is shown for extremes, such as the emaci-ated bodies of anorexic models or plump Rubens figures. Seen most often are pleasant plastic body landscapes: the body stands on its own, usually bereft of visible setting or context. Territorial body images dominate. The body as territory is associated here with pre-modern body images.[12] In men's self-portraits we find a new type of hybrid of hetero- and homo-sexual male images, the muscular body in *Emo* pose juxtaposed with rigidly frontal body shots. Women's images diverge from the mainstream by using subcultural distortions that are regarded as ugly.

"For Karl Rosenkranz (*Ästhetik des Häßlichen/The Aesthetics of Ugliness*, 1853) the Beautiful could be divided between what is actually beautiful, the negatively beautiful and the comic. The negatively beautiful, i.e. the Ugly, seems more familiar to us. Rosenkranz describes it as un-free, torn, form-less, fussy, common, clumsy, despicable, vulgar, empty. In short: it is current." (Schmitt 2007)

12 On the significance of the female body landscape cf. Richard/Zaremba (2007).

On the quest for the biggest thrill in the area of sexuality, any deviation is otherwise quickly appropriated as a new fetish and obsession. The body images offered by men and women are understood as self-promotion, often of the sexual variety, which is why the boundaries of uncensored representation are explored. Calgary56 shows himself down to the groin, with only his genitals covered; Violet1980 exposes her breasts to the extent allowed. But the image producers always act within representational patterns typical of the scene and of their gender, and very few genuine visual transgressions take place. Expressed are either artistic aspirations – with the help of black-and-white photography or special techniques (morphing, HDR) – or erotic ambitions, using the well-known visual signals familiar from film and TV. Such are the ambitions of the users: to be attractive merchandise or artists.

There is thus a chance that a small community of creative users will take advantage of this medium in such a way that new kinds of visual products will come about. *flickr* provides not only a way to communicate through images, but also serves as a portfolio of the user's own work and a platform for exchange with other (semi-)professional photographers. The individual artistic approaches allocated to the *I* field (individual, personal self) are hence those that are shaped by the user's very personal, unpredictable reactions to what he or she is faced with in society/from others/in culture (i.e. by the *me*). The *I* is likewise influenced, but not determined, by the *me*. In the realm of visual construction of identity via the *I*, independent pictorial expressions can by all means be found. The study demonstrates that various factors, such as randomness, abstraction, ugliness, exaggeration or the unmasking of exaggeration, theatrical poses and backdrops featuring *unadorned bodies*, can facilitate the departure from conventionally beautiful and showcasing poses.
The self/individuality results from an interplay between the *me* and the *I*, and this is where the beauty of the fashionably defined pop picture on *flickr.com* evolves within the scope of its own category of youth portraiture: egoshots!

literature

· Amann, Klaus and Hirschauer, Stefan, 'Die Befremdung der eigenen Kultur. Ein Programm' in S Hirschauer and K Amann (eds), *Die Befremdung der eigenen Kultur. Zur ethnographischen Herausforderung soziologischer Empirie* (Frankfurt am Main: 1997) 7-52

· Benthien, Claudia, 'Das Maskerade-Konzept' in C Benthien and I Stephan (eds), *Männlichkeit als Maskerade. Kulturelle Inszenierungen vom Mittelalter bis zur Gegenwart* (Cologne: 003) 56

· Berger, John, *Ways of Seeing* (1972) 45, 47

· Boehm, Gottfried, 'Interview conducted by Birgit Richard for "Denken 3000"' in B Richard and S Drühl (eds), *Kunstforum International* (2008)

· Bordo, Susan, *The Male Body* (New York: 1999)

· Bourdieu, Pierre et al. (eds), *Eine illegitime Kunst: die sozialen Gebrauchsweisen der Photographie*

(Frankfurt am Main: 1983)

- Butler, Judith, *Das Unbehagen der Geschlechter* (Frankfurt am Main: 1991)
- Cole, Shaun, 'Macho Man: Clones and the Development of a Stereotype' in *Fashion Theory*, Vol 4, Issue 2
 (Great Britain: 2000) 125, 140
- Ernst, Wolfgang, 'Ästhetik der Datenbank, Interview conducted by Birgit Richard for "Denken 3000"' in
 B Richard and S Drüh (eds), *Kunstforum International* (2008)
- Flusser, Vilém, *Ins Universum der technischen Bilder* (Göttingen: 2000)
- Gapp, Christian, 'Von Hobby-Knipsern und Profi-Kriegern' (19 August 2006) *Telepolis*
 <http://www.heise.de/tp/r4/artikel/23/23362/1.html> (accessed 23 December 2006)
- Knieper, Thomas, 'Krieg ohne Bilder?' in T Kniper and M G Müller (eds), *War Visions.
 Bildkommunikation und Krieg* (Cologne: 2005)
- Maeda, John, *The Laws of Simplicity* (Massachusetts: 2006)
- Mead, George Herbert, *Geist, Identität und Gesellschaft aus der Sicht des Sozialbehaviorismus*
 (Frankfurt am Main: 1973)
- Mentges, Richard, *Schönheit der Uniformität – Körper, Kleidung, Medien*
 (Frankfurt am Main/New York: 2005)
- Mitchell, William J, 'Was ist ein Bild?' in V Bohn (ed), *Bildlichkeit* (Frankfurt am Main: 1990)
- Moorstedt, Tobias, 'New Blogs On The Kids. Neun Thesen zur Blogosphäre' (4/23 December 2006)
 Süddeutsche Zeitung, No 279, 33, <http://jetzt.sueddeutsche.de/texte/anzeigen/349449>
 (accessed 4 October 2008)
- O'Reilly, Tim, 'What is Web 2.0 Design Patterns and Business Models for the Next Generation of
 Software' (22 December 2005) *Oreillynet* <http://www.oreilly.de/artikel/web20.html>
 (accessed 4 October 2008)
- Richard, Birgit, 'Beckham's Style Kicks! Die metrosexuellen Körperbilder der Jungendidole' in
 K Neumann-Braun and B Richard (eds), *Coolhunters. Jugendkulturen zwischen Medien und Markt*
 (Frankfurt am Main: 2005) 244-258
- Richard, Birgit, 'Art 2.0: Kunst aus der YouTube! Bildguerilla und Medienmeister' in B Richard and A
 Ruhl (eds), *Konsumguerilla. Widerstand gegen Massenkultur?* (2008) 225-246
- Richard, Birgit, Grünwald, Jan and Ruhl, Alexander, 'Me, Myself, I: Schönheit der Gewöhnlichen. Eine
 Studie zu den fluiden ikonischen Kommunikationswelten bei flickr.com' in K Maase (ed)
 Die Schönheiten des Populären. Zur Ästhetik der Massenkünste (Frankfurt am Main: 2008) 114-132
- Richard, Birgit, Grünwald, Jan and Betten, Inga, 'Uniformität ist bilderfreundlich! Vestimentäre und
 choreographische Strategien als Aneignung von Nicht-Orten im Musikvideo' in G Mentges, D Neuland
 and B Richard (eds), *Uniformierung, Kostümierung und Maskerade* (Münster: 2007)
- Richard, Birgit and Zaremba, Jutta, *Hülle und Container* (Munich: 2007)
- Schmitt, Caspar, 'Ästhetik des Häßlichen' with reference to Karl Rosenkranz / 1853 (9 September
 1998) <http://www.nadir.org/nadir/periodika/jungle·world/·98/37/04a.htm> (accessed 29 April 2007)
- Sandbothe, Mike, 'Interaktivität - Hypertextualität - Transversalität. Eine medienphilosophische
 Analyse des Internet' in S Münker and A Roesler (eds), *Mythos Internet* (Frankfurt am Main: 1997) 56-82
- Sturm, Hermann (ed), *Artistik, Jahrbuch für Ästhetik*, Vol 2 (Aachen: 1987)
- Walker, Jill, 'Mirrors and Shadows: The Digital Aestheticisation of Oneself. Proceedings, Digital Arts
 and Culture' (23 December 2005) *Hdl-Handle* <http://hdl.handle.net/1956/1136> (acccessed 4 June 2008)

harald gründl /
in the cathedral of capitalism.
pictures of the death of fashion

Fashion is Sentenced to Death

Opening the daily paper, we notice an advertisement of a high fashion brand. It looks more like a death announcement than a usual fashion brand advertising. It is a black canvas, with only a few words on it: the high fashion brand's logo, *fall/winter collection* and *sale begins today*. It is the end of the season, and soon the spring collection will be on show. But before, the shops need to get rid of the previous collection. They do this by staging the seasonal sale for a couple of weeks. There is no doubt about the ritualistic nature of high fashion. It is introduced in a ceremonial manner in the fashion cities around the world. The catwalk show is a contemporary interpretation of an ancient procession, a ritualistic form of displaying power to the public. For thousands of years, this form has remained unchanged, only the content has changed. Models are walking in a ritualistic manner up and down the catwalk, in front of a select audience, which has been invited to enter the ritual circle. They watch and applaud to the kings and queens of fashion design and renew their power for another half a year.

Fashion Houses Lose their Brand Names

While during the introduction of fashion, brand names and logos are emphasised, during the seasonal sales the brands vanish. One really poetic example can be found in London. On the corner of one of the biggest and most famous department stores the brand name is written with light bulbs. During the whole year, the brand name is highlighting the brick façade. But when the seasonal sale starts, the light bulbs are turned off. From the ash of the company's letters, a new word appears: *SALE*. This is the death-bringing judgement on the past collection. No more will it be in fashion once the word is announced by the fashion shops. Rituals appear to manipulate societal crises in a way for people to deal with it. And when fashion pieces are reduced by up to fifty percent and more, this is a very basic economic crisis. If you would have bought the piece a day before the sale starts, you would get angry. And for those who have used the pieces for a season, it is also a style crisis that the fashion will most probably be outdated the next season.

Fashion Windows are Clothed in Darkness

Darkness is a strong intuitive image of ancient rites of passage. These types of rites ensure that a society becomes aware of (social) change through dramatising it in a symbolic manner. During the seasonal sale we can find lots of show windows that are totally covered by paper. This blocks our gaze, separating us from the usually presented fashion items. The fashion window falls into darkness. Rites of passage have most of the time three different phases. The first phase is the separation phase, where the persons who witness the rite are separated from the rest of their

community. Darkness is such an intuitive image of separation. In the case of our contemporary consumer culture, it is striking that the seasonal sale is performed like a rite of passage, however unconsciously. The darkness of the past enters the highlighted shop windows of today. Rituals can survive for hundreds or thousands of years, only changing their clothes from time to time.

Fashion Mannequins are Robbed of their Clothes

The mannequin witnesses fashion's rite of passage for us. While they are representing the fashion victim's community the rest of the year, during the seasonal sales they must perform the ancient ritual. A common way to dress up the seasonal sale is to pull down the clothes from the mannequins. In the holy time, they must face the passersby naked. They are separated from the glittering theatre of fashion, entering the second step of ritual dramatisation. Mannequins have their predecessors in religious service. In many cultures and religions, mannequins are used to perform religious beliefs. Their use in religious ceremonies like processions are common. In archaic rituals, the undressing of a statue strips off the power from the represented god. If the statue is dressed up again, the power returns. What happens in the fashion show window is exactly the same symbolic performance, which can be found around the world at every time.

Fashion Mannequins are Dressed in Paper Clothes

The ritual dress is essential in ritual performance. The ritual dress has the function to separate the wearer undertaking the ritual from the ritual audience. Ritual dresses have some basic characteristics. Androgyny is such a feature of archaic ritual dresses, often used by priests or shamans. The ritual dress transcends the everyday. This can be achieved with a very elaborate and artistic piece of cloth, but it can be also realised with a very poor and simple piece of cloth. Paper clothes, made by the window dressers and not by the fashion designers, are such pieces of ritual clothing. Most of the time, it is made from a simple piece of packing paper, where a hole is cut for the head of the mannequin. Dressed like this, the mannequins look like the priests of the seasonal sale, performing the most important rite of consumer culture – the change of fashion.

Fashion is Robbed of its Individuality

Those who witness a formal rite of passage are commonly dressed in the same ritual dress. Entering the stage of communitas, they are robbed of their individuality. Everybody is made the same. During the year, the mannequins wear different clothes, showing individuality. During the seasonal sales, they often wear the same ritual dress, which is often decorated with

a percentage sign or with *SALE*. During the period of the seasonal sales, there are many show windows that do not show any fashion for sale. They only dramatise the seasonal sale itself: a time in which nothing can be purchased; a real sacred time in the retail calendar of consumer culture. We pass by windows where all the mannequins wear a white T-shirt with a printed percentage sign. Or we pass by a ritual procession, where four mannequins wear only one letter on their breasts that together form *S-A-L-E*. The brand logos are replaced by the holy prayer.

Fashion Mannequins are Bound

When the scapegoat is brought to the ritual slaughter, it is decorated with ribbons to stand out. For the ritual treatment in general, it could be said that sacrificial animals are either treated exceptionally good before the ritual murder, or exceptionally brutally. Both separate it from the everyday treatment and emphasise the ritual condition. In fashion display windows, the decoration with ribbons during the sales is a common visual strategy as well, a preparation for the ritual slaughter of the expiring seasonal collection. It comes as no surprise, when naked mannequins are in bondage with a red and white barrier tape, inviting us to enter the shop with reduced fashion items. What could be a sex shop window becomes an appropriate decoration for a middle-class jeans shop for teens during the sales. The rite of passage confronts us with ancient intuitive images and practices. Since the beginning of humankind, such practices are common. In some archaic cultures, the king is tortured on the eve of his coronation. He must endure the suffering before he receives the crown.

Fashion is Removed from the Pedestal of Fetishism

Fashion is the master discipline of fetishism. All staging is done to perfectly worship the fashion pieces. Pedestals are built to glorify a pair of shoes. During the sales, the pedestals are empty; the shoes might pile up in a window corner. The fetish is thrown into the dirt, right in front of the ritual audience. This sacrilege is done by the anonymous window dressers – they do the dirty work of the fashion business. They ritually sacrifice the seasonal collection to make place for a new one. For the fashion business, the old collection is a taboo, as soon as the new one arrives. The empty pedestals remind us of fashion's seasonal reincarnation.

Fashion is Thrown into the Rummage Box

The second phase of the rites of passage is the dramatisation of the change. Things are turned upside down, structure turns into anti-

structure. The perfect translation of such archaic and intuitive images is the rummage box. During the year, everything is in order. The various sizes are hung in increasing order, so that customers and sales assistants can easily find the appropriate piece. During the sales, the reduced items are often thrown into rummage boxes, where it is difficult to find the right things. A temporary disorder is needed; this is an inevitable act in the cycle of fashion. The rummage box is also a kind of quarantine for the dying fashion collection. It is separated from the remaining collection that is not to be sacrificed at that moment. Also in high fashion stores, the reduced items are separated from the rest of the clothes. Sometimes in a dark corner of the shop, sometimes in an extra room. The reduced fashion represents a state of impureness – it must be isolated.

Fashion is Laid down on the Sacrificial Altar

Now it is time to sacrifice the seasonal sale collection. A stage is prepared on the biggest shopping street of the town. The backdrop is dressed up in signal red. On the red flags hung from the ceiling are huge white percentage signs. The backdrop totally blocks the view into the fashion shop. In front of the backdrop an altar had been erected. It is also painted in red, has a square shape and is about seventy centimetres high. Two female executioners are standing on the side, prepared for the sacrificial murder. Both have a long sleeve red T-shirt with a white percentage sign on it. The ritual audience witnesses a window dresser laying down a white sheep wool pullover atop the altar.

Fashion's Throat is Cut by the Percentage Sign

The holy moment draws near. A crowd gathers in front of the shop window. More and more people huddle together. The window dresser now takes a black marker and cuts the price. A line runs through the original price. This is the death of the commodity. This is the analogy to the archaic cut through the throat of the sacrificial animal. The commodity dies slowly. First, it is reduced by twenty percent, days later the reduced price has been cut once again. It is a last fight against the death, which end up with a seventy percent reduction, during the *Last Days*.

Fashion is Attacked by the Infuriated Victims

The ritual audience has followed the last moments of the life of the seasonal fashion collection. After the ritual murder, the crowd becomes furious. Everybody tries to get into the shop first. People are fighting outside. It is like the ancient Greek *Dionysia*, where everybody was invited to the collective meal after the slaughter. It was the only time in the year when the poor where also invited and had a chance to eat meat.

Fashion's Body is Torn Apart with Bare Hands

The ancient Greeks had a very special sacrificial practice: they killed the sacrificial animal with bare hands, a ritual known as *sparagmos*. This is what comes to mind when we see the shoppers plunder the rummage boxes. They literally tear apart the body of fashion. Infuriated, they dig into the past collection, hoping to find a piece that satisfies their hunger. Dionysus is the ancient Greek god of wine and fertility. His mythology is in line with several other corn god myths around the world. The corn god usually dies in spring, before nature starts growing. The corn god is usually represented by an animal, sometimes by man. The myth is based on the belief that nature will start to grow again with the resurrection of the god after his ritual death. It is a magic belief based on a symbolic action, which influences nature in a given way. When the corn god resurrects, nature will do so as well, and the plants will grow again after the winter. Agriculture was the major source of survival in many cultures, so it comes as no surprise that the major myths are built upon the rebirth of nature in spring. In consumer culture, some of our ancient myths are redressed, but they still articulate fears and hopes of humankind.

Fashion's Dismembered Body is Buried in its Grave

The last image of the passion cycle of fashion is the dismembered manne- quin in the shop window. The parts of three dismembered mannequins are piled up as if after a barbarous slaughter. It is a memento mori, not only for the inevitable death of each fashion collection, but also for the ritual audience in the days of the *Last Reductions*. Days later, the mannequins are reassembled again and the new fashion collection is presented. After fashion's long and frightening rite of passage, the *New Collection Arrived*. It begins with the renewed magic power of the resurrected fashion god. Beauty once again falls across the shopping streets.

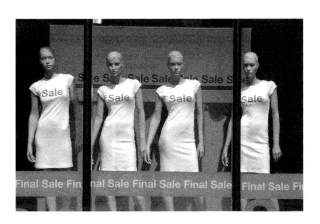

top: four mannequins wearing the same ritual dress

middle: fashion is thrown into the rummage box

bottom: fashion's dismembered body is buried in its grave

gabriele mentges /
when a picture becomes a text.
remarks on fashion texts

When Matthäus Schwarz, the bookkeeper of the powerful mercantile family Fugger in Augsburg, started his *Costume Book* in 1519, he equipped it with rudimentary texts but also with a very opulent picture supplement. In this *Costume Book*, his life course is presented in the form of 137 pictures, in which he is portrayed in constantly changing clothes. That he is primarily interested in his clothes, in the fashion of the times, is already confirmed in the preface of the book.

The scarcity of text should not mislead us to believe that the concept is not very systematic and thorough: "On the 1st of May 1538, I went to church for my wedding in a black velvet robe with black lining. I was 41 years and 69 days old."[1]

The written remarks above the picture contain information on the occasion, such as "celebrating with my friends, at the wedding, hunting, recuperating after illness". Underneath the picture, subjective time information can be found: "I was 41 years and 69 days old." Thus, he denominates the fashion time, the context and the description of individual garments or fabrics. Fashion description, context and time – these are the features that display a structural pattern, which can be found in the fashion journal later. Roland Barthes abstractly called a so-conceived environment the *world* – these features need to be present at the same time in order to define clothes as fashion.[2]

Schwarz indeed pursues the concern which connects the personal presentation with the focus on the economic dimension as well: the luxury of the fabrics bring him a personal fame.[3]

Previous history

My area of interest is not focused on literary descriptions of fashion or the presentation of the textile business, production or marketing. Rather, it is focused on the relationship between fashion and text in the fashion press. This limitation involves certain requirements: I am focusing on texts for target groups, texts with advertising effects, which display a connection to business.

I have selected examples from the fashion press of the two leading German newspapers of nationwide significance: the *Frankfurter Allgemeine Zeitung* and the *Süddeutsche Zeitung*.

I will analyse the characteristic features of these text types, investigate their historical implications and briefly compare them with other fashion texts.

Previous history of the press

However, before I start, I would like to briefly explain the previous history of this text typology with regard to the early example of Matthäus Schwarz. If you analyse the relationship between the text and the picture, you can consider the following: what would the pictures by Matthäus Schwarz tell

1 Quoted according to August Fink, *Die Schwarzschen Trachtenbücher* (Berlin: 1963) 163

2 id. Roland Barthes, *Die Sprache der Mode* (Frankfurt am Main: 1985)

3 Matthäus Schwarz, *The Costume Book* (Augsburg: 1496-1564)

us without the text, and what would the text tell us without the pictures? The pictures alone teach us about the various fashions, you somehow guess that it is all about one and the same person yet the physiognomic similarities are rather vague. The gaze can, however, focus on other picture contents in order to provide the context for the clothes. The gaze can be searching, straying, guessing, suspecting and, in doing so, be animated for a short story. Thus, if there were only the picture, you would recognise the clothes but not Schwarz's biographical intention or his interest in the clothes. On the other hand, what would the purely linguistic text convey? "Black biretta, red jacket ... worn in Milan ... was together with friends." The linguistic message is very precise, it does not allow an intense ambiguity as is the case with the picture. This corresponds to the position of the text in the book: the text frames the picture and places it into an order, which follows the logic of Matthäus Schwarz and his illustrator or the techniques of the picture composition.

The picture and perception theorist Ernst H. Gombrich finds analogous functions when comparing the picture and the text. However, according to Gombrich, the picture as a means of communication takes over the appealing function whereas the language as a means of communication fulfils an informing function.[4] Gombrich furthermore argues that the reproduction of reality does not only follow the perception of reality[5], but it has its own rules. He proves this theory with the example of visual perception of space, which is not consistent with the physical or geometrical calculations.

It is in this discrepancy between perception, its visual presentation and reality, where the room for fantasy, play and experiment comes into existence.

However, the costume pictures by Schwarz in the 16th century display a relation to his historical everyday clothes – he did not invent them, yet they have been put into a different context and therefore convey different messages. Thus, his pictures narrate more than the linguistic message, and they do so in a different way. They represent, as Pierre Bourdieu once phrased, an excess of meaning that stimulates, frees and leads the fantasy of the beholder.

What about the language? Inserted in the picture, the text is a part of the picture, which gives it a function. The text is unambiguous and, in this case, subordinate to the picture.

Another example is provided by the so-called traditional dress books of the Renaissance with their rich illustrations of costumes originating from all continents. They are regarded as the first decent publications of fashion and some, such as the one by the Italian Vecellio from 1590, can by all means be regarded as forerunners of fashion journals. They captivate with the dominance of the picture, which is accompanied by a short, often uncapitalised text underneath or above the illustrated costume.[6]

4 cf. Gernot Böhme, *Theorie des Bildes* (Munich: 2004) 87

5 Ernst Gombrich, *Das forschende Auge* (Frankfurt am Main) 104

The linguistic information contains only rudimentary messages regarding geographical origin, occasion, status, etc. Still, they are examples of a structure superior both to the picture and to the text, namely with the page as the format and the frame of the picture. The format of the page has become a sensual form of knowledge transfer and thus a fixed component of our mnemotechnic order.[7] Neither the picture nor the text can escape this design principle.

The fashion journal

At the end of the 18th century, *The Journal of Luxury and Fashions*, the first German fashion journal founded by the Weimar publisher Bertuch in 1887, enters the market.[8] Here a similar structure strikes the eye, but with significant differences: the text and the picture are spatially divided. The text is as dominant as the picture and even excels in its quantity. The quantity, however, does not imply any structural modifications as far as the information content is concerned – the readers find out things to know about fashion, learn how to decorate their homes or even which equipage is regarded as especially elegant. They are informed about the political events, such as the French Revolution, and anything else that belongs to the context of fashion, such as society and culture. The information is organised according to a similar pattern as was the case in The *Costume Book* by Matthäus Schwarz.

One would come to conclusion that nothing has changed – yet this is by no means the case: one only needs to take a quick glance at the historical situation around 1800 to realise what it meant for the cultures of clothing and fashion.

The fact that the period of fashion press starts with the end of the 18th century has to do with the fundamental changes in social positioning and the perception of the clothes. It is only from this time on that we can speak of proper fashion, which requires an emerging serial production, a wide-ranging structure of distribution and trade and, above all, a sophisticated consumption. The journal advertises this consumption by informing the readers about the fashion products and by raising their style and taste awareness.

This taste awareness is the new aspect in fashion. It is necessary because the clothing style is not prescribed by state authorities to correspond the social status anymore, rather it is left up to every individual to decide. It is left up to every individual to wear the clothes they favour – that was one of the decrees of the French Revolution.[9]

This decree demands skills of individual taste, which need to be taught, studied and practiced, and the fashion journal provides the relevant help and information. However, the fashion text is used above all as an endowment of meaning – and this is where the actual difference with the picture lies.

6 cf. Gabriele Mentges, 'Vestimentäres Mapping. Trachtenbücher und Trachtenhandschriften des 16. Jahrhunderts' in *Waffen- und Kostümkunde*, vol 1 (Berlin: 2004) 19-36

7 cf. Ivan Illich, 'Von der Prägung des Er-innerns durch das Schriftbild' in Aleida Assmann and Dietrich Hartmann (eds), *Mnemosyme. Formen und Funktionen der kulturellen Erinnerung* (Frankurt am Main: 1991) 48-56

8 cf. for an overview: Anne Zika, *Ist alles eitel? Zur Kulturgeschichte deutschsprachiger Modejournale zwischen Aufklärung und Zerstreuung 1750-1950* (Weimar: 2006)

9 Rose Fortassier, *Les écrivains francais et la mode* (Paris: 1988) 41

This proposition explains why the richness of the text increases and becomes so important. In contrast to the Renaissance period, which regarded the picture primarily as an idea of proper representation, the picture here is primarily used to illustrate the text, and its dominant position loses on importance.

When a text gains importance to such an extent, new skills with regard to stylistic and literary aspects of the text are imposed on the writer, and he must be provided with relevant sources of information in order to do so.

Literature discovers the subject of fashion at the same time as fashion journals. The entire body of novels, tractates and poems deal with fashion and purposefully employ it to describe moods and characters. An important beginning in this respect is characterised by *Traité de l'Elégance"* by Honoré Balzac in 1830, in which he, on the basis of fashion, defines elegance as the new model of distinction, which replaces the *ancien régime*. Literature is inspired by fashion and vice versa. Literature stimulates the fashionable elegance, praises the new aspects and extensively analyses the change in fashion.[10]

Fashion is narrated and – if regarded in its temporarily determined rhythm – it becomes a narration itself.[11] Both novelists as well as fashion journalists must be the masters of narration, although each of them with different rhetorical devices and intentions.

This intensity and power of literary descriptions of fashion in the epic novels of H. Balzac induced Richard Sennett's theoretical considerations on the role of fashion details in the construction of personality in the 19th century. According to Sennet, clothes become a decisive indication of personality, one's position in society and, above all, one's cultural competence.[12] And the latter feature is expected on the part of the beholder who knows how to read and interpret these signs. Under the impression of the power and the persuasive force of the fashion press, Roland Barthes also wrote his cult, and still very often quoted, work *The Language of Fashion*.

Both of them, however, tend to equate the reality of language with the historical/empirical reality, concluding the reality of the worn clothes from their literarily constructed meanings. In contrast, the literary critic Ralf Klein identifies these meanings generated from the context of the work itself as secondary codes, which still display relations to historical, everyday fashion.[13]

Thus, both literature as well as fashion journals significantly contribute to equipping fashion with meaning in order to make it culturally plausible.

What makes up a good text?

This question posed by the art historian Gutmair[14] is also relevant when investigating the text from the fashion press, whose characteristics will be analysed in select examples (the *Frankfurter Allgemeine Zeitung* and the *Süddeutsche Zeitung*).

10 ibid., 47-49

11 Gerhard Goebel, 'Einführung in die Literatur der Mode in den Anfängen des bürgerlichen Zeitalters' in *Ästhetik und Kommunikation*, Vol 21, (1975) 66-88

12 id., *Verfall und Ende des öffentlichen Lebens. Die Tyrannei der Intimität* (Frankfurt am Main: 1983)

13 Ralf Klein, *Kostüme und Karrieren. Zur Kleidersprache in Balzacs 'Comédie humaine'* (Tübingen : 1990) 69; cf. also Ulrike Landfester, Der Dichtung Schleier (Freibourg: 1995)

14 Urich Gutmair 'Gute Texte, schlechte Texte' in *Texte zur Kunst*, Vol 20, 18 (June 2008) 110-115

Their featured articles enjoy the reputation of providing the reader with extraordinary specialised knowledge and stylistic and technical know-how as far as cultural issues are concerned.

Alfons Kaiser, one of the fashion editors of the *FAZ*, however, has complained about the meagre appreciation of fashion in the German press.[15] This issues a particular challenge to (German) fashion journalists to fight against the popular fashion prejudices and clichés. Fashion reports are already nobilitated by their acceptance in featured articles, the noble part of the newspapers. Written in the present tense, the descriptions leave the impression of an apodictic statement – "the buff man is attracted to the sea" (Marcus Rothe, Süddeutsche, 3 July 2007) – and a fashion imperative. This is also part of the tradition in fashion reporting – already in Bertuch's times. This absolute present is what actually constitutes fashion. The subjectively-coloured perspective of the journalist seems to disappear behind the urgency of the present, and fashion emerges as an autonomous action entity.

As my short passage through the press continues, through various places and locations, shows and designers, the reports on *Haute Couture* fashion shows are becoming more and more frequent, and there are longer supplements with special topics, most written in a linguistically ambitious yet entertainingly conversational tone.

The featured articles on fashion have to manage without many pictures – one picture alone is used as an eye-catcher.

For instance, headlines such as "The hat is achieving an impressive success at the moment" (Ingeborg Harms, *FAZ*, 11 November 2008) are not necessarily related to the text. Thus, immediately under the headline you can find remarks on the current financial crisis. The impressions gained during the fashion show are embellished with terms such as fetish, feminism or gender roles, all of which sensitise the intellectual reader and proves to them that fashion can absolutely be regarded in the context of cultural trends. Fashion's apparently endless assimilation ability is used: "Strict lines, subdued colours. The autumn depression on the catwalk reflects the events of the world..." (Peter Bäldle, Supplement, *Süddeutsche*, 23/24 September 2006).

The distributed information is densely-packed, and at the same time, short remarks, both entertaining and informative, are associatively interspersed. In this way, a shimmering network of impressions and information or even an atmospheric picture is created. Here, the words replace the pictures, they appeal to the reader's imagination and ability to establish connections.

Thus, Illich's remarks on the eminent historical meaning of the page become obvious and materially palpable, especially as far as newspapers are concerned. A newspaper page provides the communicated knowledge with a framework that orientates, guides and limits our gaze – a rule valid for both text and picture in equal measure. And this is how every picture becomes a text and vice versa.

15 Alfons Kaiser, 'Schlechte Passform' in Gertrud Lehnert (ed), *Die Kunst der Mode* (Oldenburg: 2006) 298-311

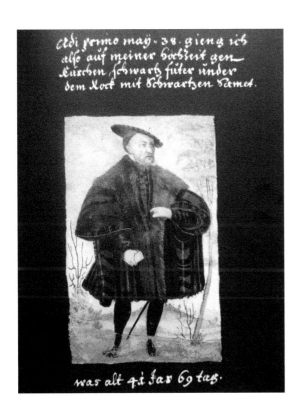

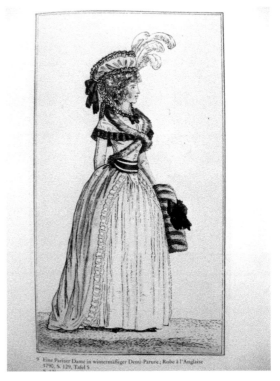

left: matthäus schwarz (1496–1574), citizen of augsburg, in his wedding clothes

right: an elegant parisian lady in the journal of luxury and fashion from 1790. the brittleness presented in the picture is striking

gerda buxbaum /
fashionized

Fashion that is not written about in the press can't be sold, fashion without a label is not recognised, fashion that doesn't say anything is boring, and a collection that does not tell a story has little chance.

In fashion, content and surface are identical. In other words: the texture is also the text. Considering the individual steps to arrive at a finished product, it is not at all surprising that the word *text* can be derived from the Latin *texere* for weaving, braiding, assembling.

Text is written language, language a medium of communication and fashion a medium of non-verbal communication. The new term *fashionize* describes the visualisation of a new non-fashion, a graphic birth assistance and transformation.

LEFT: DANIELE BUETTI, VERSACE, 2003

"A text is not perfect when nothing more can be added, rather when nothing more can be left out." If *text* is exchanged with *dress*, this statement by Antoine de Saint-Exupéry perfectly summarises the endeavour of legions of fashion designers. Reduction of something very opulent into something very simple was not only the aim of Helmut Lang but also that of all designers who are dedicated to clarity, purity, simplicity or minimalism.

My position on this topic is that of a fashion historian. Alone in the reading of fashion magazines from the 20th century, images emerge from the text and the chosen terminology, which clearly illustrate how clothing was being dealt with at a given moment in time.

It is about distinction. The terminology is difficult and with fashion, we all believe we know what we are talking about. In their expert jargon the magazines boldly teach us about the current expressions: we are familiar with *must-haves* and *no-gos*; they polarise and determine our shopping behaviour. Architects design for us key areas, spaces of shopping and selling where we can then enjoy our leisure time. The German language does not have a big repertoire for fashion: *Kleidung* (clothing), *Mode* (fashion), *Kostüm* (costume), *Tracht* (garb), *Volkstracht* (national costume) and *Uniform* – the terms do not differentiate enough, their borders hard to draw. Uniformation has become a very exciting phenomenon.

Every garment is part of the fashion system. Fashion is a universal, cultural phenomenon of design, which is responsible for all that is designable in our everyday life, be it concretely or abstractly.

The *Tracht* (garb) is very often, and not completely correctly, equated with *Volkstracht*, which means a national costume. Since roughly the 16th century, *Tracht* has been used in German as a general expression for clothing. This comes from a time when aristocrats and their assistants travelled around the world gathering and presenting local clothing preferences as

the everyday clothing. On the other hand, the German *Kostüm* (costume) is the scientific term for historic clothing, but it also describes dressing up in the sense of theatre or film costume. Since the late 19th century we also know the *Kostüm* as a two-piece outfit with *Tracht* elements of a certain traditional or classical aspiration.

In English the situation is more simple and differentiated: *costume* is the superordinate expression for *fashion*. *Fashion* actually means *the mode of expression as personal statement*. Furthermore, there is the very general term *clothing* that is applied to clothes, garments, the clothing industry and the broad ready-to-wear spectrum. *Dress* is a very multifaceted expression: first it of course refers to an actual dress, but also to clothing, and in common speech includes outfits, uniforms or garb. Its usage in verb form, meaning to outfit, arrange, prepare and decorate, is likewise interesting. The agricultural term *to topdress* means to *fertilise on the surface*. *To dress down* amounts to *scolding and reproaching* and *to dress up* stands for making oneself pretty or to put on a costume.

Besides essential terms like dress, coat, pants and skirt, which were already in use well before the French dominance of fashion, one could quite accurately read the geographic origin of the contemporary fashion from the moment when a particular fashion detail emerged and determine in each case which regionally influenced style specified the fashion imperative.

Most of the terms within today's basic knowledge of fashion appear to be of French origin. For example: *garderobe*, *façon*, *à la mode*, *boutique*, *prêt-à-porter*, *haute couture*, *accessoire* and *salon*. The German words *Stoff* (fabric) or *Textil* (textile) refer to their French origins, and for many things there is no German word (or it is not commonly used) such as *complet*, *combinaison*, *chignon*, *bustier*, *brassière*, *décolleté*, *négligé*, *ensemble*, *façon*, *garderobe*, *gilet*, *jabot*, *lingerie*, *paillette*, *petit point*, *revers*, *taille*, *trotteur* or *volant*.

In the history of fashion, it is also interesting that it is the French terminology that concisely outlines the structure and characteristics of Western fashion: all modifications of the body (waist binding, overshaping the lower body) that do not come up in Eastern clothing philosophy are described with French terms: *waist* (taille) – the emphasis of the waist is a characteristic of Western fashion. Or for the horrors of the 18th and 19th centuries: the *tournure*, the *Cul de Paris*, the *crinoline*, the *corset* etc.

It is the same case with expressions in the fields of decoration, dressing (headdress), jewellry and textile patterns such as *aigrette*, *application*, *bouillon*, *cloche*, *toque*, *breton*, *matelote*, *coiffure*, *chapeau*, *epaulette*, *ondulation*, *drapée*, *collier*, *bracelet*, *imprimée*… And lastly, *Frou-Frou*, *deshabillé*, *dessous*, *jabot*, *fichu*, *foulard*, *mule*, *lingerie* or *tutu* describe flirtation requisites – the canon of seduction.

When pop culture slowly conquered mainland Europe in the late 1950s, and for the first time in history one made a distinction between lady and girl, one took on junior-fashion and college clothes. With regard to sportliness and refined simplicity – *small, smart and understated* – the terms also came from English. In the 1960s, the new, young and emancipated fashion concept for youth superceded the aristocratic-elitist allure of fashion.

Today, fashion is almost exclusively described with English words. In the end, the language of fashion must be globally understood: in addition to *trends* and *looks*, the *styling* and *feeling* are also important; the *clutch*, *wedges* or *Mary Janes* are well known expressions; Vogue crowned the new head designer of Balmain *the king of sexy cool*; *labels* and *brands* have long overwritten the German *Marke*; beside the *basics* everyone preferably has *it-pieces* in their closet.

Just like how the breastpin became the stickpin, and then the scarf pin, and eventually the button…
With the definite end of courtly life and aristocratic culture in 1918, Europe tried to find a new order and – as it always is in times of crisis – to produce originality and subsequently an appropriate nation-based vocabulary. In the beginning, very few foreign words were taken up in the German language and when they were, then carefully from the realm of materials: one is far from saying *crêpe de Chine*, *voile* or *frottée* and uses in their place the terms *Waschkrepp*, *Schleierstoff* and *Kräuselstoff*.

Who today is still excited by a slip dress or a smock whose brilliance lies in their functionality and simple design? (1920) Who wants to hear about a day dress with its matter-of-fact workmanship or about posh coats with sassy, ludicrous hats towering into the sky? (1939) Who today still wears moderately tailored, straight-cut clothes where sufficient step range is achieved with a kick pleat? (1950s)

The content of words are semantic values matured in and along with a language, and they often have blurry edges. These periodically fashion-relevant, abstractly determined values are often only valid for a certain amount of time. Since definitions in this field are seasonally determined, descriptions from different points of time can even be contradictory. Not only the content of fashion must continuously change, also the characterisations have to be freshly articulated. Should forms not change quickly enough, new contemporary expressions characterise the already known items. To linguistically furnish fashion with an *esprit de l'étranger* tags at the same time the new as foreign or unknown. Also the converse process is possible where in the passing of time the same term describes a different piece of clothing.

The tagging of fashion's content is above all an important instrument for the retail. But from the viewpoint of a fashion historian, the choice of words serves as a meaningful signifier, which helps to date historic fashion.

One could easily represent the history of fashion up to the present and on into virtual space through its messages and language – be they written or unwritten, wrapped in myths and codes, or simply printed on.

RIGHT: A LA RECHERCHE DU TEMPS PERDU, JEAN-CHARLES DE CASTELBAJAC, COAT, RAW LINEN WITH FUR-LINING, PAINTED TEXT BY MARCEL PROUST, WINTER 1988/89

Jean Charles de Castelbajac has turned his clothing creations – most often in the form of a medieval shirt – into a newspaper, a comic magazine, an election or advertisement poster, or a love letter. "I love the elegance of handwriting, the rigour of the letters from the old Thomson typewriters and the futurism of computer fonts, which once transferred onto my clothes form new patterns. The garment has become a message."

je suis tout nue en-dessous, jean-charles de castelbajac, painted dress, text by ben vautier, 1984

credits / images

page 298: © Claus Haiden

birgit richard / page 302-317

page 306: Eric Phillips, flickr profile
<www.flickr.com/photos/eric_phillips/360050747/in/set-72157594395865308> (accessed 28 October 2008)

page 306: Calgary56, flickr profile
<www.flickr.com/photos/40376425@N00/306761862/in/set-72157594392798503> (accessed 28 October 2008)

page 309: Myriel, flickr profile
<www.flickr.com/photos/myriel/289984616/in/set-72157594176327778> (accessed 28 October 2008)

page 309: Esther_G, flickr profile
<www.flickr.com/photos/belljar/49304884/in/set-1070568> (accessed 28 October 2008)

page 311: Lorena Cupcake, flickr profile
<www.flickr.com/photos/julietbanana/2419680768> (accessed 28 October 2008)

page 312: Life Sparks, flickr profile
<www.flickr.com/photos/lifesparksphotography/502276788/in/set-72157604783699242> (accessed 28 October 2008)

harald gründl / page 318-323

page 323: Four mannequins wearing the same ritual dress, © Harald Gründl

page 323: Fashion is thrown into the rummage box, © Harald Gründl

page 323: Fashion's dismembered body is buried in its grave, © Harald Gründl

gabriele mentges / page 324-329

page 329: Matthäus Schwarz (1496-1574), citizen of Augsburg, in his wedding clothes.

page 329: An elegant Parisian lady in *The Journal of Luxury and Fashion* from 1790. The brittleness presented in the picture is striking.

gerda buxbaum / page 330-334

page 330: Daniele Buetti, Versace, 2003, © VBK, Wien, 2008, Courtesy Bernhard Knaus Fine Art, Frankfurt

page 333: *A la recherche du temps perdu*, Jean-Charles de Castelbajac, coat, raw linen with fur-lining, painted text by Marcel Proust, Winter 1988/89

page 334: *Je suis tout nue en-dessous*, Jean-Charles de Castelbajac, painted dress, text by Ben Vautier, 1984

HETZENDORF SYMPOSIA I - X / INDEX

HETZENDORF SYMPOSIUM I – FASHION AND TECHNOLOGY (11/2000)
During the high-tech symposium *Wearcomp Intelligent Clothing* the virtual character of avatars was illustrated through recent examples. *Life Sciences in Space* introduced two examples from the MIR space station, presenting the feedback of clothes with the human body in the form of electric stimulation via special trousers.
Stefano Marzano, CEO of Philips Design, and Peter Ingwersen from Levi Strauss Ltd. Brussels reported from the new product line ICD+TM, which includes the four high-tech jackets *Producer, Gilet, Mooring* and *Beetle,* all equipped with an integrated cell phone and Rush MP3 player.
Detailed electron microscope imaging of skin, cells, cell membranes, cell spacings, fibres, nerve strings etc. served as inspiration for the design of the future. Sarah Taylor demonstrated the versatile and innovative applications of transparent, light conducting, nylon monofilaments (Jibre Optic Weaving).

Participants: Sabine Payer, Winfried Mayr, Dietmar Rafolt, Karin Macfelda, Stefano Marzano, Peter Ingwersen, Sarah Taylor

HETZENDORF SYMPOSIUM II – FASHION AND PERCEPTION (1/2001, 2/2001)
Simultaneity and spatial interference of various programs, functions, concepts, ideologies and representations of artificial worlds.
The disclosure of the to-date unimaginable capacities of our senses proves how profoundly versatile our perception actually is. Fashion design is able to transform a vision into application and allows us to unobtrusively transgress the prescribed orders and linear organisation of information. In this way, we have the opportunity to add a new virtual layer onto the world. Fashion is not fashion, rather happening, performance and entertainment.

Participants: Hanns Joosten, Heidemarie Seblatnig, Barbara Vinken, Christopher Breward

HETZENDORF SYMPOSIUM III – FASHION AND ARCHITECTURE (3/2001, 4/2001)
Having examined the prognoses and tendencies in the clothing, interior and architecture sectors, there was a variety of contributions on the theme of the clothing of buildings: the architectural skin, reports on the newest concepts in fashion shop design – illustrated through the shops of Dolce & Gabbana (David Chipperfield Architects) and the puristic Helmut Lang shop (Pichelmann & Co) in a historic ambience – or garden architectures whose use of botanical structures and *natural* surfaces as clothing elements reveals the garden as a world of design.

Participants: Simon Verlaat, Werner Aisslinger, Karin Harather, Jean-Paul Pigeat, Mark Randel, Gustav Pichelmann, Herbert Lachmayer

HETZENDORF SYMPOSIUM IV – WHAT IS FASHION? (1/2003)

In the attempt to position the phenomenon of fashion today, a confusing diversity has to be dealt with: tangents and intersections, tradition and consumerism, new societal and business structures, professionality and perfect fitting, but also the *soul* of a label…

It was not our aim to come to a concise, universal formula. We rather wanted to lead an exciting discourse with the help of highly qualified speakers from various fields and to raise public awareness around the question of fashion.

The symposium was topped off by the show *Fancy Prints* – fashion from African printed fabrics.

Participants: Andreas Braun, Gudrun Kampl, Elisabeth Samsonow, Andrea Schurian, Wolfgang Kos, Gesine Tostmann, Andreas Bergbaur, Yella Hassel, Fritz Humer

HETZENDORF SYMPOSIUM V – FASHION AND TEXTILES (11/2003)

Subdivided into the topics *Textiles and Economy*, *Textiles and Fashion* and *Textiles and Future*, the symposium ran parallel to the exhibition *Textiles St. Gallen* and an accompanying advertising campaign with provocative banners such as *Naked is boring* or *Tex sells*.

Participants: Max Hungerbühler, Brigitte Medlin, Anne-Marie Herckes, Elisabeth Längle, Albin Kälin

HETZENDORF SYMPOSIUM VI – FASHION AND RESPONSIBILITY (5/2004)

The central idea was for the students of the Fashion Institute to *outfit* various prominent Austrian figures from the angle of sustainability. Informed by the main assignment of the year, the goal of this project was to investigate the patterns and *metabolism* between fashion and sustainability in their ecological, social, economic and health-related aspects as well as their local and global effects.

To strengthen the theoretical know-how, representatives from the Clean Clothes Campaign, the Environmental Education Forum, the Ecological Business Plan Vienna as well as economic specialists and a philosopher were invited to share their experiences in the field of sustainability.

Participants: Arno Böhler, Elisabeth Schinzel, Thomas Hruschka

HETZENDORF SYMPOSIUM VII – FASHION AND EDUCATION (3/2006)

Today the basis of a fashion education is rooted in border-crossing experiment and the in-depth stimulation of fantasy, but it also has to do with real-world, practice-oriented project work. Imparting professional techniques and skills is equally as important as the development of individual artistic creativity. Teachers from international schools such as the Royal College of Fashion in London, Domus Academy in Milan or Esmod in Berlin, among others, have been preoccupied with the question of topicality and the organisation of various subject matters. With different perspectives on fashion education, the lecturers provided statements and reports on the largest (and also the general) pedagogical problem: Fashion is the present – how can students be trained for a successful future with instruments of the past?

Participants: Dorothea Beisser, Gabriele Orsech, Barbara Trebitsch, Ursula Hudson, Georg Mathias, Bettina Köhler, Mari Otberg, Ute Ploier, Giovanni di Pasquale, Bernd Skupin, Alexander Gedat, Angelo Mazzieri

HETZENDORF SYMPOSIUM VIII – FASHION AND COSTUME (3/2007)

The word *fashion* transports us into the present. The impact of fashion unfolds in the here and now. In contrast, the word *costume* transports us a priori into the past. In this way, one could initially temporally locate the two terms. If the subject of fashion versus costume is put up for debate in connection with theatre and actors, a question arises: What kind of time does art transport us to? Should it position us in the outdated?
The symposium was accompanied by an installation by the artist Ewa Kaja.

Participants: Gerda Buxbaum, Olimpia Panfil, Andrea Kirchner, Erwin Wurm, Uli Schneider, Susanne Mader, Eva-Maria Schön, Susanne Granzer, Sabine Derflinger, Arno Aschauer, Karin Resetarits, Alois Schober, Melanie Pfaffstaller, Philip Fimmano, Marika Demner, Mariusz Jan Demner, Monika Jacobs, Michael Ramharter, Arno Böhler

HETZENDORF SYMPOSIUM IX – FASHION AND MOVEMENT (4/2008)

Fashion trends, their origin and their effect, their flexibility and their demands upon material and the mobility and nomadism of modern humans. Corresponding with this year's theme, the focus was on the fluid overlaps between fashion and art. Within the thematic sessions *Movements & Flows*, *Cross Overs* and *Smart Clothes & Fitness*, scientists, designers, artists, fitness specialists and pioneers from the sport fashion sector had their say.

Participants: Elke Gaugele, Florian Moritz, Brigitte Felderer, Viola Hofmann, Christiane Luible, Wally Sallner, Johannes Schweiger, Jörg Seifert, Daniela Mauch, Sabrina Tanner, Anja Herwig, Clemens Sillaber

HETZENDORF SYMPOSIUM X – FASHION AND TEXT (3/2009)
We again benefitted from the multilayered observations and perceptions of the invited lecturers, this time on the theme *de/trans-scribed fashion*: how does journalism deal with fashion?

Fashion in the language of a particular period, the self-representation of youth in the Internet, fashion as language and vestmentary communication, messages on clothes, clothing as a media text and current examples of media interfaces in fashion.

Journalists, designers, art pedagogues and theoreticians, semioticians and fashion historians were invited to a discussion about fashion's signs and symbols – fashion as a medium.

Participants: Gabriele Mentges, Birgit Richard, Harald Gründl, Sabine Seymour, Barbara Schmelzer-Ziringer

BIOGRAPHIES

Aisslinger, Werner (HetzGe III/2001)
Born in 1964, Werner Aisslinger studied design at the Fine Arts University, Berlin. From 1989 to 1992 he was a freelancer at Jasper Morrison and Ron Arad, London and Studio de Lucchi, Milan. Since 1993 he has been running Studio Aisslinger, developing products, design concepts and brand-architecture.
www.aisslinger.de

Aschauer, Arno (HetzGe VIII/2007)
Born in 1953 in Vienna, Arno Aschauer studied music and dramatic arts and film and media sciences at the University of Vienna. Before he became a lecturer at the Institute for Journalism and Communication Sciences, University of Vienna, he worked for the ORF/Austrian Broadcasting Company as a producer, screenwriter and director. Today Arno Aschauer works as a screenwriter, coach and trainer for writers, directors and actors. He is artistic director of the Institute for Film & Transmedia, Vienna, Member of the Screenwriters Guild of Germany and the screenwriting school/film office in Stuttgart, Baden-Württemberg.

Baber, Chris (HetzGe I/2000)
At the time of his presentation Chris Baber was working for Kodak/Royal Academy of Engineering Educational Technology at the University of Birmingham.

Beisser, Dorothea (HetzGe VII/ 2006)
Born in 1951 in Windsbach, Germany. Dorothea Beisser studied fashion at the ESMOD International in Paris, where she lived and worked for fifteen years in the field of fashion, which eventually became her vocation. In 1989 she decided to pass on her acquired skills and opened the renowned private fashion school ESMOD in Munich and in 1994, another one in the German capital Berlin.

Bergbaur, Andreas (HetzGe IV/2003)
Co-founder and creative director of the Unit F Association of Contemporary Fashion from 2000 to 2005, Andreas Bergbaur is today the head of PR Department of Jil Sander in Milan. He is responsible for corporate communication around the globe. He worked as a lecturer at the University of Applied Arts in Vienna from 1998 to 2005 where, in addition to being the head of project development and management, he also taught fashion theory and fashion history.

Böhler, Arno (HetzGe VI/2004, HetzGe VIII/2007)
Born in 1963 in Dornbirn, Austria, the philosopher and filmmaker (GRENZ-film Vienna), teaches philosophy in the University of Vienna's Department of Philosophy. He was research-visiting-professor at the University of Bangalore, New York University (2000-2002) and University of Princeton (2002). Arno Böhler has published widely in his field of research. He is member of the advisory board of the Nietzsche Circle New York as well as GlobArt - Connecting Worlds of Arts and Sciences (Lower Austria).

Braun, Andreas (HetzGe IV/2003)
Born in 1946 in Kitzbühel, Austria. Early in 1995 Andreas Braun became the communications manager of the Swarovski Group. As his first initiative he succeeded in positioning, communicatively and commercially, a new pilot project – *The Swarovski Kristallwelten* – as a fusion of industry, tourism and culture, and at the same time created a new company identity for a traditional industrial company. As part of his work for the Swarovski Group he took on the duties of director of the *Swarovski Tourism Services Ltd.* and consecutively the control over the ecological and cultural profile of the company. His versatility as international lecturer and his literary contributions to culture, industry and tourism are appreciated throughout the media.
http://kristallwelten.swarovski.com

Breward, Christopher (HetzGe II/2001)
Born in 1965, Christopher Breward studied at

the Courtauld Institute of Art and Royal College of Art. He is currently the acting head of research at the Victoria & Albert Museum. He has published widely on the history and culture of fashion, including: The Culture of Fashion (Manchester University Press), The Hidden Consumer (Manchester University Press), Fashion (Oxford University Press) and Fashioning London (Berg).

Buxbaum, Gerda (HetzGe I–X/2000–2009)

Born in 1949 in Linz, Buxbaum studied journalism and art history. She has been the principle of the Fashion Institute of Vienna in the Hetzendorf Castle since 1999. Since 2006 she has been the head of Baccalaureate Fashion Studies launched in co-operation with the University of Arts and Industrial Design Linz. She has published on issues of fashion history, hats, jewellery, art and fashion.
www.modeschulewien.at

Demner, Marika (HetzGe VIII/2007)

Born in Hungary, raised in Vienna, trained in Austria, Switzerland, England and Italy. Affinity for fashion since childhood (her father owned a textile wholesale company). Experience in purchasing and exporting for Marly's (prêt-a-porter label), La Perla, and Palmers. Marika Demner is working as a style and fashion consultant on various projects, furnishing flagship stores such as Liska in Vienna and Budapest. She is a member of Departure Jury and a co-worker on the Mozart exhibition in the Viennese Albertina. She is also a fashion consultant for manufacturers (among others, Schneiders, Salzburg).

Demner, Mariusz Jan (HetzGe VIII/2007)

Mariusz Jan Demner, managing partner of the Viennese advertising agency Demner, Merlicek & Bergmann, grew up in Vienna and on Lake Geneva. He studied law, journalism and art. At the age of 23 he started his own advertising agency with the goal of becoming the country's foremost creative authority. Mariusz Jan Demner was co-founder of the Creative Club Austria (CCA) and is a member of both the ADC New York and the ADC Germany and is also vice-president of the IAA_Austria (International Advertising Association). Mariusz Jan Demner speaks five languages and is married with one child.
www.dmb.at

Derflinger, Sabine (HetzGe VIII/2007)

Sabine Derflinger studied at the Vienna Film Academy and works as a director, writer and producer. Currently she is working on One Of Eight, a documentary portraying two women fighting against breast cancer. Previous films include 42plus, drama, (Prize for Best Foreign Actress to Claudia Michelsen at Film Festival Dalian, China); Little Sister, drama for ZDF (Prize for Best TV-Movie at Munich Film Festival); Step on it, drama, (Max Ophüls Prize at Film Festival Saarbrücken, Femina Prize to Monika Buttinger, costume designer).
http://sabine.derflinger.org

Di Pasquale, Giovanni (HetzGe VII/2006)

Giovanni Di Pasquale is the principal of Koefia, Accademia internazionale d'alta moda e d'arte del costume, Rome.
www.koefia.com

Felderer, Brigitte (HetzGe IX/2008)

Brigitte Felderer is working as a curator and teaches at the University of Applied Arts Vienna. Exhibitions (p.p.): Wishmachine Worldinvention. A History of Technical Visions since the 18th Century, Kunsthalle Vienna 1996; Rudi Gernreich. Fashion will go out of fashion, Steirischer Herbst 2000 / Institute of Contemporary Art Philadelphia 2001; Phonorama. A Cultural History of the Voice as a Medium, ZKM Karlsruhe 2004/05; Thinking without brain, speaking without lips. The Automatons and Machines of Wolfgang von Kempelen, Humboldt University Berlin 2005 (w. E. Strouhal); Rare Arts. Conjuring Arts in Conjuring Books, Vienna City Library 2006; Sound of Art, Museum der Moderne Salzburg

2008 (w. E. Louis); Fashion & Despair, freiraum/
quartier21 Vienna 2008 (w. Eva Blimlinger);
Zauberkünste, Cultural Capital Linz, 2009.

Fimmano, Philip (HetzGe VIII/2007)
Born in 1979 in Adelaide, Australia, he studied
fashion design in Florence and New York and
went on to work in clothing design, public rela-
tions, display and styling. Today Philip Fimmano
manages Edelkoort Etc., the Paris-based con-
sulting company of trend forecaster Li Edelk-
oort, providing seminars and brainstorming for
international companies and conducting trend
studies tailored to individual client needs.
www.edelkoort.com

Gaugele, Elke (HetzGe IX/2008)
Elke Gaugele studied empirical cultural studies,
history and political science in Berlin, Tübingen
and Vienna. Her PhD thesis focus was Apron
and Loincloth. Clothing as a medium of gender
construction. She works as an author, curator
and as a professor for fashions&styles at the
Academy of Fine Arts in Vienna at the Institute
for Education in the Arts. Her recent work
focuses on visual and material cultures, tech-
nologies of fashions&styles and biopolitics, and
the fashioning of life, gender and subjectivity.

Gedat, Alexander (HetzGeVII/2006)
Born in 1964, Alexander Gedat graduated in
business management. After three years as
managerial assistant in the automobile supply
industry, he spent 3 years in Italy as commercial
manager in the waste disposal and construc-
tion supply industries. For over 13 years, he has
been responsible for developing Marc O'Polo
into a modern, successful corporation. Since
2005 he has been co-partner in the Marc O'Polo
AG with a 5% share. He holds the position of
COO Sales.

Granzer, Susanne (HetzGe VIII/2007)
Born in 1950, trained at the Max Reinhardt
Seminar at the University of Music and

Performing Arts of Vienna, PhD in philosophy
at the University of Vienna. At the moment,
Susanne Granzer holds a chair for role-making
at the University of Music and Performing
Arts of Vienna. She was working as an actress
for fifteen years in various state theatres in
Vienna, Basel, Düsseldorf, Frankfurt am Main
and Berlin.

Gründl, Harald (HetzGe X/2009)
Born in 1967 in Vienna, Austria, Harald Gründl
studied industrial design at the University
of Applied Arts, Vienna. In 1995 he set up the
design agency EOOS together with Martin
Bergmann and Gernot Bohmann. EOOS, in their
designs for flagship stores, has become a lead-
ing office for furniture design, architectural
design and design research. Since 2008 he
chairs the Institute of Design Research Vienna
and is a partner at EOOS design, where he is
leading the research activities of the studio.
www.idrv.org

Harather, Karin (HetzGe III/2001)
Born in 1960 in Eschenau, Lower Austria, Karin
Harather studied at the Academy of Fine Arts
and at the University of Applied Arts in Vienna.
She is an adjunct professor at the Institute
of Art and Design of the Vienna University of
Technology's Faculty of Architecture. She lives
in Vienna where she works in the field of arts
and architecture both as an artist and theorist.

Hassel, Yella (HetzGe IV/2003)
Graduate of the Italian fashion academy
Accademia Internazionale d'Alta Moda e d'Arte
del Costume Koefia, Rome, Yella Hassel is a lec-
turer teaching fashion design, design method-
ology and fashion presentation at the Fashion
Institute of Vienna in the Hetzendorf Castle.
She has been working as a fashion designer
for Franco Tomei Alta Moda in Rome, Manfred
Schneider in Munich, Randolph Duke in New York,
Nicole Miller Outerwear in New York as well as
for her own couture label Yella & Saad.

Herckes, Anne Marie (HetzGe V/2003)

Anne-Marie Herckes studied fashion design at the Royal Academy in Antwerp, Belgium as well as at the University of Applied Arts in Vienna. After her studies she worked for Viktor & Rolf in Amsterdam and for the Greek fashion designer Kostas Murkudis in Berlin. With great passion for detail, the Luxembourger Anne-Marie Herckes has been designing miniature collections under the label of the same name since 2006. www.anne-marieherckes.com

Herwig, Anja (HetzGe IX/2008)

Born in 1976, Anja Herwig studied product and industrial design in Hanover, Germany. Anja Herwig joined the Lösungsmittel Ltd. in the year 2003 where she is an associate. Together with Sabrina and Kurt Tanner she founded URBAN TOOL Ltd. in 2004. She is leading both companies in cooperation with Sabrina Tanner, holding the position of CEO and being in charge of international sales and marketing. She has earned several innovation awards for her products. www.urbantool.com

Hofmann, Viola (HetzGe IX/2008)

Viola Hofmann studied comparative textile arts, cultural art history and history at the University of Dortmund. Her PhD thesis focused on The Costume of Power – The Appearance of Politicians from 1949 to 2005 in the Magazine Der Spiegel. Since 2005 Viola Hoffmann has been an academic employee at the Institute of Arts and Material Culture and a lecturer on cultural anthropology of textiles at the University of Dortmund.

Hruschka, Thomas (HetzGe VI/2004)

Thomas Hruschka works for ÖkoBusiness Plan Vienna. www.oekobusinessplan.wien.at

Hudson, Ursula (HetzGe VII/2006)

Ursula Hudson is the director of Fashion Business Resource Studio at the London College of Fashion. The Fashion Business Resource Studio is an independent department of the London Fashion College, which coordinates and accompanies the cooperation with the industry. In addition to encouraging and organising cooperative projects with the industry, the workshops offered by the department also support the graduates who want to set up their own business.

Humer, Fritz (HetzGe IV/2003)

At the time of his presentation Fritz Humer was the CEO and chairman of the executive board of Wolford AG.

Hungerbühler, Max. R. (HetzGe V/2003)

Born in 1945 in Switzerland. Since 1971 sales director for Bischoff Textil AG, 1993 CEO, 1994 global expansion of the company. From 1998 to 2003 president of the Chambers of Commerce and Industry IHK of St. Gallen. Since 2002 university councillor of the University of Applied Sciences of East Switzerland, since 2005 president of the Swiss Textile Federation TVS. www.bischoff-textil.com

Jacobs, Monica (HetzGe VIII/2007)

Born in 1946 in Düsseldorf. After completing a tailoring course, Monica Jacobs studied at the University of Applied Arts of Vienna and at the Berlin University of the Arts, where she obtained her degree in costume design in 1975. Thereafter, she designed costumes for various theatres in Germany and Switzerland as well as for various feature films or TV series such as Run Lola Run (1998), Wolffs Revier, Der geheimnisvolle Schatz von Troja (2007) and The Last Station (2008).

Joosten, Hanns (HetzGe II/2001)

Born in 1961 in Haarlem, Netherlands, Hanns Joosten studied photography and audiovisual design at the Academy of Fine Arts in Breda, Netherlands. Since 1987, the internationally renowned photographer with a Berlin-based

studio has been regularly publishing his works in periodicals, magazines and books. Hanns Joosten is especially fascinated by landscape architecture, people and fashion.
www.hannsjoosten.de

Kälin, Albin (HetzGe V/2003)
At the time of his presentation Albin Kälin was the CEO of Rohner Textil Balgach, Switzerland.

Kampl, Gudrun (HetzGe IV/2003)
Born in 1964 in Klagenfurt, Gudrun Kampl studied at the University of Applied Arts of Vienna under the guidance of Maria Lassnig. From 1995 to 2000 she obtained working scholarships in Paris, New York, Brazil, India and Austria. The artist participated in a vast number of single and group exhibitions in Austria and abroad.

Kirchner, Andrea (HetzGe VIII/2007)
Born in Vienna, Andrea Kirchner studied fashion at the University of Applied Arts Vienna under the guidance of Karl Lagerfeld and Jil Sander. She gained several years of expertise in theme research and design for international colour trend congresses. Presentations on trend and colour-sensitising for fashion companies, jewellery producers and glassware producers. Design coaching across various lines of business. In 2000 co-founder of Preview Vienna – trend office for idea conception and development of concepts of colour, pattern and fashion design / publishing house for specific trend publications. Lecturer at the Fashion Institute of Vienna in subjects design methodology, colour theory and fashion illustration. Numerous fashion illustrations for various trend books and company-specific collection publications.
www.preview-vienna.at

Köhler, Bettina (HetzGe VII/2006)
Bettina Köhler is a lecturer in communication and research at the Institute of Fashion Design at the University of Design and Arts in Basel.

Kos, Wolfgang (HetzGe IV/2003)
Born in 1949 in Mödling, Lower Austria, Wolfgang Kos studied history and political science (PhD) and is working as a historian, journalist and culture mediator. Since April 2003 he has been the director of the Museums of the City of Vienna.
www.wienmuseum.at

Lachmayer, Friedrich (HetzGe III/2001)
Born in 1948 in Vienna, chairman of Da Ponte Institute of Librettology, Don Juan Research and the History of Collecting. He has been working as a lecturer in Berlin, Vienna, London and Linz, specialising in arts and culture studies. He is the curator of historico-cultural exhibitions, since 1991 also a professor at the Linz University of Arts as well as at the Institute of Fine Arts and Cultural Studies.

Längle, Elisabeth (HetzGe V/2003)
Elisabeth Längle, born in 1942 in Kiev, studied at the University of International Trade in Vienna and at the Faculty of Philosophy at the University of Innsbruck. She has worked as a freelancer in the embroidery, fashion and textile industry and is the responsible editor of the specialised magazines Austrian Textile and Austrian Embroideries. Elisabeth Längle lives in Vienna and Wolfurt.

Lieschke, Monika (HetzGe VI/2004)
Born in Baden-Baden, Germany in 1953, Monika Lieschke studied psychology, human biology and educational science at the University of Vienna. For more than twenty-five years Monica Lieschke has been an expert in the field of environmental education as well as in education for sustainable development. She was executive director of the Environmental Education FORUM for twenty years, an agency of the Austrian Federal Ministry for the Environment and the Ministry for Education and Culture. At present Monica develops projects and educational programs in the public and private sectors, as well as

lecturing and writing for national and international magazines.
www.umweltbildung.at

Luible, Christiane (HetzGe IX/2008)
Born in 1973, studied Fashion Design at the University of Applied Science Pforzheim and the Fashion Institute of Technology (F.I.T.). During her studies she obtained, among others, the F.I.T. Critic Award in 1997 and the Lucky Strike Junior Design Award in 2000. After collaborations with various apparel companies, she specialised in research about virtual clothing simulations and obtained a PhD in that field of research in 2008. Since September 2008 Christiane Luible is the head of the Fashion and Jewellery Design Department at the Geneva University of Art and Design – HEAD.

Macfelda, Karin (HetzGe I/2000)
Born in 1965 Karin Macfelda is professor for cell biology at the University of Vienna. Since 1994 she has been the head of the cell culture laboratories at the Core Unit for Biomedical Research, Medical University Vienna. Her main interests are tissue engineering concerning heart tissue and development of new therapies to heal heart failure.

Mader, Susanne (HetzGe VIII/2007)
Susanne Mader is the head of the Costume Department at the Viennese Popular Theatre (Volkstheater Wien).

Marzano, Stefano (HetzGe I/2000)
Born in 1950 in Varese, Italy, he graduated from the Milan Polytechnic Institute with a doctorate in architecture. Stefano Marzano is CEO and chief creative director at Philips Design, the international in-house design group at Philips responsible for all design work within the company since 1991. He is a regular speaker at international design, business and technology conferences and has published widely on design topics. In addition to his responsibilities at Philips, he takes a keen interest in design education.

Mathias, Georg (HetzGe VII/2006)
Georg Mathias is the artistic head with professorship at the Department of Fashion Design of the University of Design and Arts in Basel.

Mauch, Daniela (HetzGe IX/2008)
Born in 1976, Daniela Mauch received her doctor degree in fashion and textile science at the College of Education Heidelberg with her paper Differentiation of Sports Fashion – a System Theoretical Analysis. Since her graduation she has been working amongst others at the College of Education Heidelberg where her focus of research lies primarily in the area of fashion sociology and fashion history as well as in cloth ethnology.

Mayr, Winfried (HetzGe I/2000)
Winfried Mayr received his diploma degree in electronics and control engineering from the Vienna University of Technology in 1983 and his PhD in biomedical engineering in 1992. He has been working at the Vienna Medical University Department of Biomedical Engineering and Physics since 1983, from 1997 on as assistant professor and since 2001 as associate professor. His past and present research includes rehabilitation engineering in spinal cord injury, neural prostheses, and functional electrical stimulation (FES). The main focus of his work during the recent years has focused on FES of denervated muscles (co-ordination of the European research and development project RISE).

Mazzieri, Angelo (HetzGe VII/2006)
At the time of his presentation Angelo Mazzieri was responsible for organisation, marketing and sales at Coccinelle in Parma, where its head offices are currently located. Coccinelle, founded in 1978 in Parma, is a benchmark brand in the production of fashion bags and

accessories. The company became part of Mariella Burani Fashion Group in 2006. Angelo Mazzieri is the oldest son of the company founder.

Medlin, Brigitte (HetzGe V/2003)
Born in 1965, Brigitte Medlin studied political sciences and journalism at the University of Vienna. From 1984 - 1988 technical editor, since 1988 editor for *Elektro Journal*. From 1990 - 2001 editor in chief for *Austrian Textile Magazine*.
www.textilzeitung.at

Mentges, Gabriele (HetzGe X/2009)
Studied ethnology and European ethnology/ folklore/sociology in Hamburg, Heidelberg and Marburg. After that she worked as a curator for the State Museum of Württemberg (representative head of department), as a designer for museums and exhibitions (topics of industrial everyday culture), since 1996 professor of cultural anthropology of textiles at the University of Dortmund. Her publishing and research interests focus on material and visual culture (Renaissance and modernism), history of museums, fashion history and fashion culture in international context.

Moritz, Florian (HetzGe IX/2008)
Florian Moritz is a trend researcher and an expert in brand marketing, currently working as a marketing manager for the Lomographic Society. At the time of his presentation he was responsible for trend research in Austrian advertising. Prior to that position he was the head of the ONE Smart Space Lab for Applied Trend Research of the Austrian mobile carrier ONE.

Orsech, Gabriele (HetzGe VII/2006)
After completing her studies, Gabriele Orsech worked as a designer and had her own women's wear label for eight years. She is currently working as a consultant in design/colour concept and trend marketing. As a fashion expert specialising in fashion sociology and women's wear fashion, she has been the artistic head of the AMD Academy of Fashion & Design in Düsseldorf, where she teaches history of art and costume, fashion sociology and fashion design.

Otberg, Mari (HetzGe VII/2006)
Mari Otberg completed training for a tailor, followed by an art school, before deciding to study fashion design in Bremen and Hamburg. After her studies she went to London where she worked as an assistant for Vivienne Westwood. There the artist founded her women's wear label justMariOt in 1998. In 2001 she presented her show Pearl in a Battlefield in London. Back in Berlin, she opened her first shop in 2003.
www.justmariot.com

Panfil, Olimpia (HetzGe VIII/2007)
Born in 1966, internationally active as textile designer. She acquired her knowledge in the USA (bachelor of science, Philadelphia University), after which she worked in New York with various international fashion labels such as Donna Karan, CK Jeans and Ralph Lauren Home. After completing MBA business studies in Paris, she started applying her wide-range of skills in project development for the United Nations in the field of textile and fashion, where she works as a project manager, predominantly in Africa and Latin America. At the same time she works as a lecturer at the Fashion Institute of Vienna in the Hetzendorf Castle, where she teaches marketing and ethnic clothing.

Payer, Sabine (HetzGe I/2000)
Sabine Payer works for the Institute of Medical Cybernetics and Artificial Intelligence at the Medical University of Vienna.

Pfaffstaller, Melanie (HetzGe VIII/2007)
Melanie Pfaffstaller was born in Bozen, Italy, in

1973. She moved to Vienna in 1992 to study communication science and Italian at the University of Vienna. During her academic years she attended several TV broadcasts as a production assistant and junior producer at Joop van den Ende Producties in the Netherlands. Graduating from university in 1997, she stayed in Vienna and started her job at PPM Film Productions producing advertising spots. After 6 years she changed to Sabotage Filmproduktion, where she is currently working as head of production.
www.sabotage-films.com

Pichelmann, Gustav (HetzGe III/2001)

Gustav Pichelmann founded the Pichelmann Architectural Studio in Vienna. In addition to various residential and hotel projects, the Pichelmann Studio is responsible for designing the sales and presentation area of the shops by the Viennese designer Helmut Lang in Vienna, Munich, Milan, Paris and Tokyo. The field of studio activity ranges from medium to large-scale projects planned in detail.
www.pichelmann.com

Pigeat, Jean-Paul (HetzGe III/2001)

Born in 1946, Jean-Paul Pigeat was program director of ORTF (initial French television broadcaster) in 1970. In 1974, he took part in the opening of the Centre George Pompidou where he would realise approximately thirty exhibitions until 1990. Thanks to the culture minister Jack Land, Jean-Paul Pigeat launched the International Garden Festival in 1992. He managed 14 editions before he died in October 2005.
www.chaumont-jardins.com

Ploier, Ute (HetzGe VII/2006)

Ute Ploier was born in Linz, Upper Austria, in 1976. At the age of eighteen she went to London where she studied fashion and graphic design at the Central Saint Martins College for a year. In 1996 she began her professional training in the fashion department of the University of Applied Arts Vienna, where she was taught by Jean-Charles Castelbajac, Viktor & Rolf and, most recently, Raf Simons. Since 2003, the Vienna-based fashion designer has been working on establishing an own label specialising in men's wear.
www.uteploier.com

Rafolt, Dietmar (HetzGe I/2000)

Born in 1959 in Lustenau, Vorarlberg, Dietmar Rafolt graduated from the Technical University of Graz, where he studied communication technology and electronics, specialising as sound engineer. His PhD focused on the development of sensor technology and intelligent clothing for the space station MIR. He habilitated in 2005 at the University of Medicine in Vienna with, among other things, further developments for space medicine (patented electrically stimulated trousers) and is at the moment working on stimulated nerve regenerations.

Ramharter, Michael (HetzGe VIII/2007)

Born in 1961, design studies at the University of Applied Arts, before that jewellery designer and goldsmith. Since 1993 production designer for diverse commercials.

Randel, Mark (HetzGe III/2001)

Since receiving his diploma in architecture in 1994, Mark Randel has gained 14 years of post-qualification experience. He joined David Chipperfield Architects London in 1995, becoming associate in 1997. In the same year he led the winning competition for the restoration of the Neues Museum Berlin. In 1998 Mark Randel founded the David Chipperfield Architects Berlin office with Eva Schad and Harald Müller. Since then, he has led the office as managing and design director. From 1998 until 2000 he was responsible for the master plan of Museum Island, Berlin. Since 2005, Mark has served as chief representative for the David Chipperfield Architects Shanghai representative office.

Resetarits, Karin (HetzGe VIII/2007)

Karin Resetarits studied journalism at the University of Vienna. In the 1980s she worked as an editor and host of various TV programmes such as Ohne Maulkorb, Trailer and 2x7. In the 1990s the programmes such as K1, Treffpunkt Kultur and Zeit im Bild followed. Since 2005 member of the Liberal Fraction ALDE and a representative in the European Parliament. Karin Resetarits is a mother of four sons.

Richard, Birgit (HetzGe X/2009)

Born in 1962, she studied art and history at the University of Essen, Germany. In 1994 she wrote her PhD thesis under the guidance of Hermann Sturm and Friedrich A. Kittler which was entitled Death images. Arts. Subculture. Media. Birgit Richard has been teaching the new media in theory and practice at the Johann Wolfgang Goethe University in Frankfurt am Main since 1998. Her areas of interest range from image culture (youth-arts-gender), death images, audiovisual media design, aesthetics of modern youth culture (youth culture archive) to research projects focusing on image culture in the media or youth culture. She has published numerous works.
www.birgitrichard.de

Salner, Wally (HetzGe IX / 2008)

Born in 1971, she studied painting, graphics and new media at the Academy of Fine Arts Vienna. Together with Johannes Schweiger she founded the art and design label ___fabrics interseason in 1998. Interdisciplinary active in the realms of fashion and design, fine arts and electronic music, the latest collections of the duo have been regularly presented at the Paris Prêt-à-porter Fashion Week since 2003. As far as art is concerned, ___fabrics interseason frequently presents various art editions and participates in various exhibitions such as the Third Berlin Biennial for Contemporary Art (2004), the Grazer Kunstverein (2007) or Manifesta7 (2008).
www.fabrics.at

Samsonow, Elisabeth (HetzGe IV/2003)

Philosopher and sculptress, professor of philosophy and historical anthropology of arts at the Academy of Fine Arts of Vienna, she is teaching and researching in the field of philosophy and history of religion in relation to the theory of collective memory, exploring the relationship between arts and religion in the history and today as well as the theory of history of the image of the woman or the female identification. Her artistic work focuses on the systematic placement of sculpture in the art canon as well as with its duty to create an equivalent for the body. She has been active as curator for various projects and has been widely published.

Schinzel, Elisabeth (HetzGe VI/2004)

Born in Vienna, studied philosophy at the University of Vienna, specialising in gender studies. Elisabeth Schinzel has been working for the Südwind Agency in the fields of the Clean Clothes Campaign and corporate social responsibility since May 2002. She is the head of the Project for Fair Employment Conditions in Computer Production and is specialising in socially responsible public acquisitions.
www.suedwindagentur.at

Schmelzer-Ziringer, Barbara (HetzGe X/2009)

After studying architecture in Graz, Barbara Schmelzer-Ziringer completed training as a fashion designer at the Fashion Institute of Vienna in the Hetzendorf Castle and the University of Arts and Industrial Design in Linz. As an assistant for designers such as Edwina Hörl (Tokyo/Vienna), Stephan Schneider, Bernhard Willhelm, Haider Ackermann (Antwerp), Frank Leder (Berlin) and Jil Sander (Hamburg/Milan), she produced works characterised by a strong link to art and architecture. Since 2001, she has been living in Berlin, where she is interdisciplinarily active in the fields of fashion, arts, architecture, interior design and culture theory.

Schneider, Uli (HetzGe VIII/2007)

Born in 1960 in Villingen, Germany, Uli Schneider studied fashion design and free painting after completing a technical training. In 1990 she founded the label ULI SCHNEIDER and launched her first women's collection. In addition to her own showrooms in Hamburg and Düsseldorf, Uli Schneider is represented in approximately 120 fashion houses across Europe, Asia and America. www.uli-schneider.de

Schober, Alois (HetzGe VIII/2007)

Born in 1946, graduated from the University of Economics in Vienna with extraordinary accomplishments in 1969. CEO of Young & Rubicam Brands Vienna, member of the European Board. His outstanding career started at Procter & Gamble Austria where he gained valuable marketing experience in the fast moving consumer goods industry. One of his success milestones happened in 1999 when Alois Schober was invited to jury the Cannes Lion International Advertising Festival and nominate the best creative work of the year as first non-creative person from Austria. During his career in the field of brand communication he worked not only for products and services but also for political parties. Today he heads a team of over 60 people, striving to create distinctive work for clients with a 360 degree communication approach. www.yrvienna.at

Schön, Eva Maria (HetzGe VIII/2007)

Born in 1954 in Leipzig, Germany, she studied acting at the Ernst Busch drama school in Berlin as well as at the State Puppet Theatre in Dresden. She completed a training in stage and costume design at the University of Fine Arts of Dresden. Firstly she worked as a stage and costume designer for the State Theatre in Dresden before moving to Klagenfurt in 1997, where she has been working as head of scenography at the Klagenfurt City Theatre since 1999. Since 2000 increasing involvement in painting.

Schurian, Andrea (HetzGe IV/2003)

Writing for various culture and travel magazines (among others Parnass, Globo, Merian, Geo, Vogue) since 1981. In 1982 advancement to doctor of philosophy. From 1985 to 2002 permanent freelancer for ORF arts section. Reports, featured articles on culture and artist profiles for various cultural magazines. From 1995 to 2002 TV presenter for, among others, 3Sat cult series Kulturzeit, ZIB1 Kultur, Kunst-Stücke. Since 2002 freelance hostess, author, columnist, filmmaker and media coach.

Schweiger, Johannes (HetzGe IX/2008)

Born in 1973, studied painting, graphics and new media at the Academy of Fine Arts of Vienna. Together with Wally Salner he founded the art and design label ___fabrics interseason in 1998. Interdisciplinary active in the realms of fashion and design, fine arts and electronic music, the latest collections of the duo have been regularly presented at the Paris Prêt-à-porter Fashion Week since 2003. As far as art is concerned, ___fabrics interseason frequently presents various art editions and participates in various exhibitions such as the Third Berlin Biennial for Contemporary Art (2004), the Grazer Kunstverein (2007) or Manifesta7 (2008). www.fabrics.at

Seblatnig, Heidemarie (HetzGe II/2001)

Born in Vienna, Austria, Heidemarie Seblatnig studied history of art and archaeology at the University of Vienna and graphics and painting at the University of Applied Arts, Vienna. She works as scriptwriter, film director, university lecturer in sciences of architecture at the Vienna University of Technology. Awards of the City of Vienna and the Ministry of Art and Science; visiting professor at the University of Arizona.

Seifert, Jörg (HetzGe IX/2008)

Born in 1971, Jörg Seifert studied architecture in Constance and Lyon. He is a freelance author

and is currently pursuing a doctoral degree in cultural history. Since Fall 2008 he is working as a scientific associate with Angelus Eisinger at the HCU Hamburg.

Seymour, Sabine (HetzGe X/2009)
Sabine Seymour is the chief creative officer of her company Moondial, which develops fashionable wearables and consults companies on fashionable technology worldwide. She is an adjunct professor at Parsons The New School for Design in New York. Sabine curates, exhibits and lectures internationally and has been published worldwide. She floats between New York and Vienna.

Sillaber, Clemens (HetzGe IX/2008)
Born in 1964 in Vienna, Clemens Sillaber studied business management at the Vienna University of Economics and Business Administration. This ardent outdoor sportsman has been active in the sports goods industry in the fields of marketing, product management and product development for more than ten years: 1993-95 Cannondale Europe B.V., 1996-2002 F2 International GmbH and since 2003 FRENCYS GmbH as assistant managing director.
www.frencys.at

Skupin, Bernd (HetzGe VII/2006)
Bernd Skupin was born in 1960 in Braunlage, Germany. From 1979 to 1987 he studied at the Academy of Fine Arts in Hamburg, Germany (drawing, painting, videos, objects). In 1987 he started working as a writer/art critic for local newspapers in Hamburg. Since 1989 he has been writing as a freelancer for German Vogue and became the magazine editor for the art section in 1993. Bernd Skupin lives in Munich.

Tanner, Sabrina (HetzGe IX/2008)
Born in 1971, studied industrial design in Linz, Austria. She is the managing director of Lösungsmittel Ltd. founded in 2001 and URBAN

TOOL Ltd., which she founded in 2004. With her partner Anja Herwig she is successfully leading both companies in a close cooperation. Sabrina Tanner is CFO and head of international sales and product development. She has earned several innovation awards for her products.
www.urbantool.com

Taylor, Sarah (HetzGe I/2000)
Born in 1969, Sarah Taylor studied at the Winchester School of Art and the Scottish College of Textiles. Sarah Taylor's research is inherently multidisciplinary as a textile designer working directly with chemists and engineers. Her areas of enquiry have pioneered the production of interactive, multisensory textile-based artwork, been exhibited worldwide, providing heightened sensory experience by exploiting light-emitting properties of optical fibres, the use of colour through lighting effects and integration of sound and electronics.

Tostmann, Gesine (HetzGe IV/2003)
Born in 1942, Gesine Tostmann studied ethnology (European cultural ethnology) in Vienna. PhD on Interaction of Traditional Costume and Fashion in Austria. Gesine Tostmann is the CEO of the company Tostmann Trachten.
www.tostmann.at

Trebitsch, Barbara (HetzGe VII/2006)
Barbara Trebitsch, fashion designer, has been the director of the Fashion Department of Domus Academy since 2001. She launched her own collection in 2005. She has been visiting professor and jury member in many international institutions and has collaborated with various publications on fashion trends, fashion illustration and analysis of the fashion field.
www.domusacademy.com

Verlaat, Simon (HetzGe III/2001)
At the time of his presentation Simon Verlaat was the general manager of PREVIEW/Dutch Fashion Institute, Netherlands.

Vinken, Barbara (HetzGe II/2001)

Barbara Vinken is a professor for French and comparative literature at Ludwig-Maximilians-University in Munich, Germany. Earlier she held professorships at the universities of Hamburg and Zurich. As visiting scholar, she taught at the École des Hautes Études en Sciences Sociales, Paris, the New York University, the Humboldt University Berlin, and the Johns Hopkins University. Barbara Vinken has published widely.

Wurm, Erwin (HetzGe VIII/2007)

Born in 1954 in Bruck an der Mur, Austria. Since 2002 Erwin Wurm has been a professor of sculpture and multimedia at the University of Applied Arts of Vienna. The artist implemented numerous single exhibitions in Austria and abroad. He is one of the most renowned contemporary Austrian artists, and his work is presented in numerous collections around the globe.

DATE DUE

BRODART, CO. Cat. No. 23-221